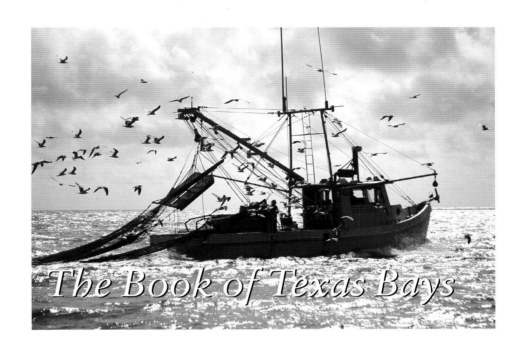

The Book of Texas Bays

NUMBER SIX: GULF COAST STUDIES

SPONSORED BY TEXAS A&M UNIVERSITY – CORPUS CHRISTI

JOHN W. TUNNELL, JR., GENERAL EDITOR

THE BOOK OF

TEXAS BAYS

by JIM BLACKBURN
photographs by JIM OLIVE

Texas A&M University Press
College Station

Unless noted otherwise,
photographs are by Jim Olive,
courtesy Galveston Bay Conservation
and preservation Association

Mapping provided by Bryan E. Carlile
from United States Geological Survey
modis and lansat-etm images,
USGS Eros Data Center

Library of Congress Cataloging-in-Publication Data

Blackburn, Jim, 1947-
 The book of Texas bays / Jim Blackburn ;
 photographs by Jim Olive.-1st ed.
 p. cm.-(Gulf coast studies ; no. 6)
 Includes bibliographical references and index.
 ISBN 13 : 978-1-S844-339-0 (cloth)
 ISBN 13 : 978-1-60344-782-9 (flexbound
 with flaps)
 ISBN 13 : 978-1-60344-275-6 (ebook)

Design and typography by George Lenox

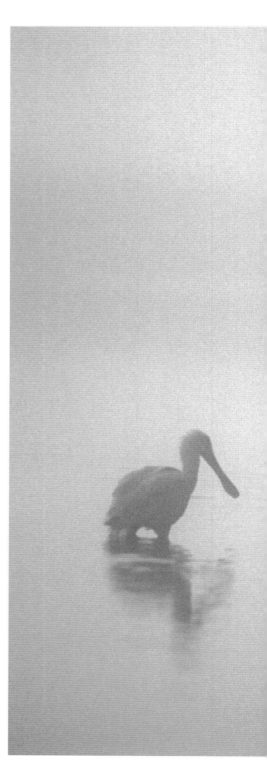

Captions, First page:
Shrimper in the bay. The wood slats
hold the net open when it is pulled
behind the boat. The number of
shrimpers in the bay system has
steadily declined since the mid-1980s.

Title page:
Marsh channels have special magic at
sunrise and sundown, freed from fierce
reflected heat and light.

Facing page:
Roseate spoonbills patrol in the fog.
Galveston Island contains a series of
wetland swales along Stewart Road,
which runs from 61st Street to the
middle of the west end of the island,
providing excellent views of waterfowl.

This book is dedicated to Garland Kerr,
my wife and life partner whom I dearly love,
and to Jo Ann Williams, who — along with
Garland, the white pelican, the caracara,
and the leaping shrimp
— helped me find my way when I was lost.
It is also dedicated to my father,
the late James Bernard Blackburn, Sr.,
a beautiful man whom I miss,
and my mother, Eleanor, whom I love.

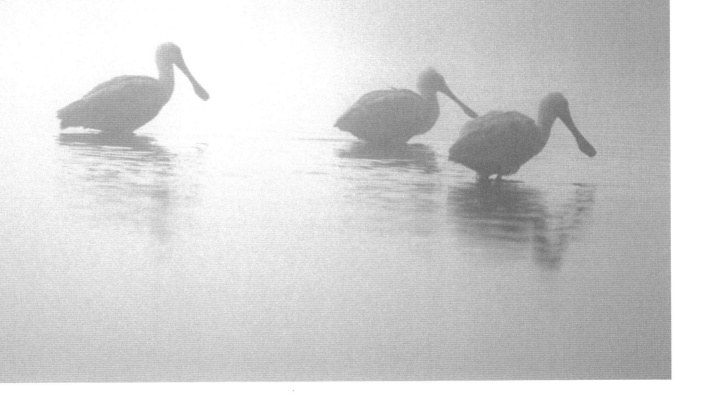

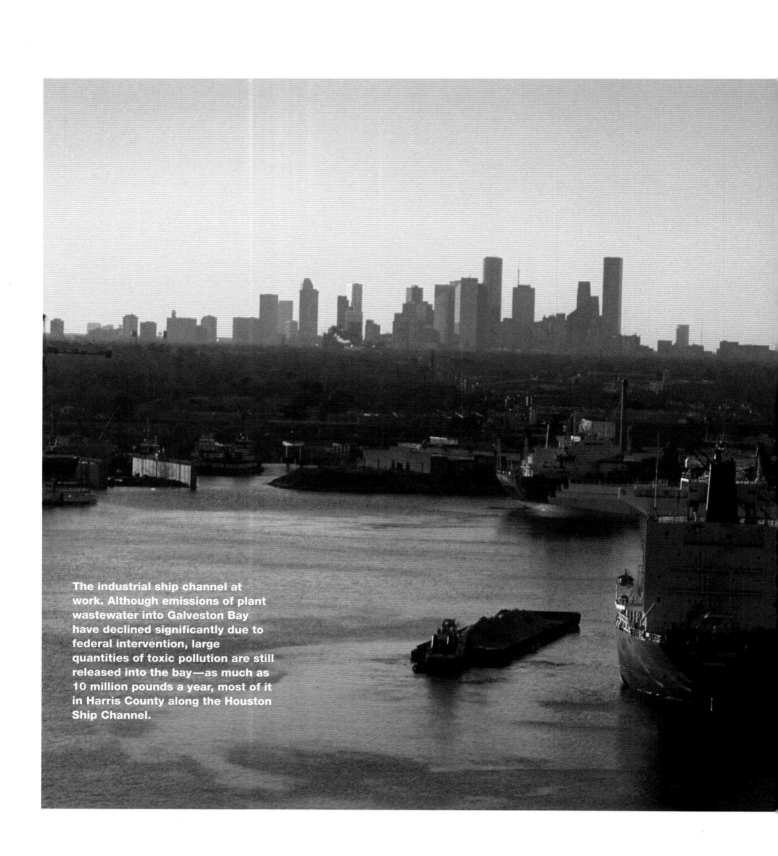

The industrial ship channel at work. Although emissions of plant wastewater into Galveston Bay have declined significantly due to federal intervention, large quantities of toxic pollution are still released into the bay—as much as 10 million pounds a year, most of it in Harris County along the Houston Ship Channel.

Contents

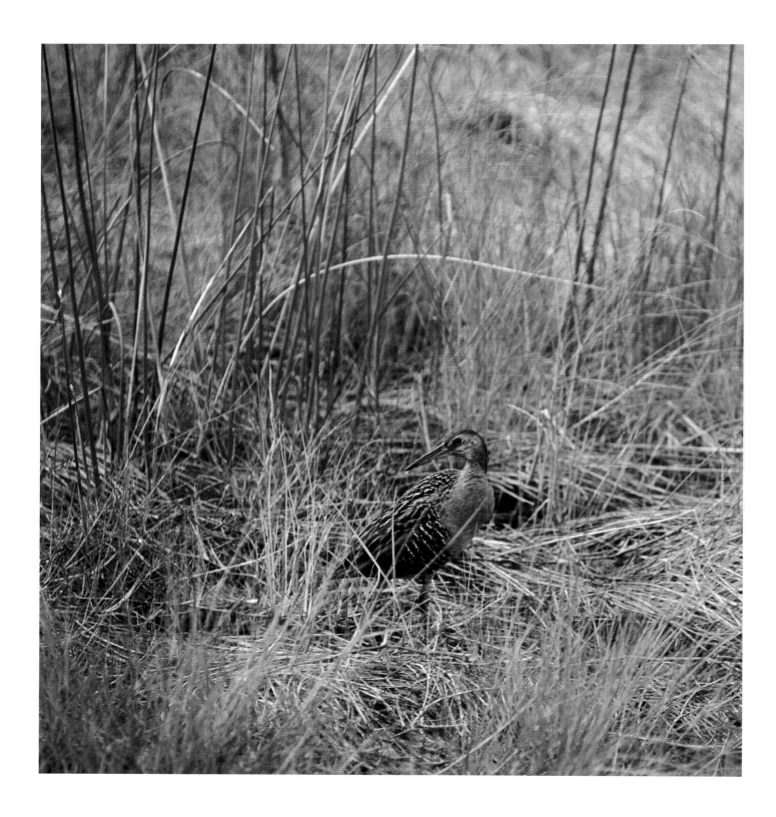

Preface

The Book of Texas Bays is my tribute to the Texas Gulf Coast. It describes the natural and social forces that form the coast as we know it, along with the birds, fish, and people that live there. The coast has been hit hard by human activities, yet so far it has managed to survive. We humans may have altered it, but we have not been able to remove the essence that comes alive out of mud and rain and lush vegetation in the upper and middle reaches and from the sand and scrub brush farther south.

The Texas coast is resilient, much more so than many of the human institutions that have inhabited and affected it. But there are limits to this resiliency—limits to the ability of nature to rebound from continued human assault. And today, ten years after this book first appeared, we are at or exceeding these limits in many regions of the coast.

As I move south along the coast in the chapters in this book from Sabine Lake to the Rio Grande, rainfall and river flow decrease to the point that the Laguna Madre, our southernmost bay, is hyper-saline due to the relative absence of freshwater inflows. What I wrote about the necessity for freshwater inflow into the bays is perhaps more germane in 2014 than when the book was written. And this issue will not go away anytime soon.

Several chapters address other, still relevant, water issues. Chapter five, about Wallisville, describes the decades-long legal and technical fight over a water supply reservoir for Houston, a reservoir that ultimately was determined not to be needed. The chapter on Matagorda discusses the inflows from the Colorado River to Matagorda Bay, a situation that has exploded into a serious dispute between the Highland Lakes residents, the Lower Colorado River Authority, and the City of Austin on the one hand and downstream rice farmers and bay interests on the other. The chapter on the whooping cranes did not foretell the killing of twenty-three whooping cranes by the water management actions of the State of Texas. It did, however, anticipate federal court litigation that led Judge Janis Jack of Corpus Christi to rule that the Texas Commission on Environmental Quality (TCEQ) be required to provide sufficient freshwater inflows to maintain healthy bays with enough crabs to keep the cranes alive. Chapter twenty addresses concerns about the health of Nueces Bay, concerns unfortunately validated by more recent TCEQ studies that determined the bay to be essentially ecologically dead—killed by the absence of freshwater inflow from the Nueces River because of the effects of the dams and diversions also discussed in the book. And, of course, the siltation of the mouth of the Rio Grande described in chapter twenty-six gave us the image that epitomizes what is happening to our rivers and to our bays, an unforgettable picture of a river no longer flowing, a river sealed off from the Gulf of Mexico, something we probably wouldn't have dreamed happening in our lifetime.

The elusive rail is a prize bird to spot on a Christmas Bird Count. It can be a challenge to determine whether a bird briefly seen is a king, clapper, or Virginia rail.

Today, the problems, conflicts, and challenges described in *The Book of Texas Bays* are still very much with us. But I regret to say that now, a decade later, we are missing a major participant in the battle—the commercial fishermen and women of the coast. As documented in the first edition, commercial fishing interests were heavily involved in many past disputes. However, their numbers have fallen significantly due to the successful efforts by recreational anglers to restrict bay shrimping and to eliminate commercial harvests of redfish and speckled trout. Whether or not these restrictions were necessary, the absence of these voices is noticeable. Commercial fishermen were never concerned about being politically correct. They simply told it like it was and would fight to protect the coast and its resources, which they knew extremely well. So with respect to the role of commercial fishing men and women, *The Book of Texas Bays* remains a respectful chronicle of what once was but will probably never be again.

Whether or not recreational fishing interests will step up and use their political and fiscal might to help obtain fresh water for Texas bays is an open question. To date, they have failed to lead the fight for coastal water, although they have certainly studied and discussed the issue and have even participated in legal actions, albeit non-controversial ones. Even so, they have not truly used their power and influence to take whatever actions are necessary to ensure long-term protection of the coast. Make no mistake about it—our bays will die without freshwater inflows. Anyone who cares about fishing must become adamant about supplying fresh water to the bays or there will be no fish.

In the years since this book was published, the ongoing fight to save the only wild population of whooping cranes, which winter in the Rockport area, brought an interesting coalition together to bring federal litigation in the attempt to get freshwater inflows to the bays that sustained their food source. At the same time whooping cranes were being killed because of lack of food, fishermen were also suffering one of the worst recreational fishing seasons in memory. When the fishing fails, home rentals and sales and all the commercial activity that goes with them also fade. What we learned from the ensuing battle was the whooping crane is truly an indicator species of bay health. If the crane is doing well, crabs, shellfish, and finfish are doing well. If the cranes are suffering, fishing is suffering. The coalition that emerged to form The Aransas Project, the plaintiff in the federal litigation, ultimately included the governments and people of Aransas County as well as the City of Rockport and the town of Fulton Beach, along with both the Democratic and Republican clubs of Aransas County. To my knowledge, there has never been such a diverse coalition in the history of Texas coastal battles. Perhaps it is an indicator of things to come.

It should not be necessary to go to federal court under the federal Endangered Species Act to protect our bays, but that seems to be the best option at

this time (although there is no ruling on the whooping crane appeal at the time of this writing). There is another endangered species that might also become important in future battles and that is the Kemp's ridley sea turtle. This endangered sea turtle is found in most of our bays, and its primary food source is the ever-popular blue crab, the same food source upon which whooping cranes depend. So, in a strange way, the fate of the blue crab and the fate of those endangered species relying on the blue crab may be a key element to the future of the coast.

Speaking of things to come, nothing remains clearer than the need to link economics with protection of the Texas coast. While *The Book of Texas Bays* reflects my spiritual relationship with the Texas coast, particularly in the chapter on Christmas Bay, and it is this spiritual connection with the coast that led me to write the book, I may lose an audience in, say, Houston when I start speaking about my love of nature or about the birds I greet each spring as they return from Central and South America. However, if I talk money in connection with the environment, I can usually keep everyone interested.

The Book of Texas Bays presents this economic side in several respects. It sets out the economic downside associated with the loss of freshwater inflows by trying, in chapter seventeen, to identify the full cost issues associated with water policies. Full cost pricing may continue to be the most important concept in water today. Texas gives its surface water away, charging nothing more than a service fee to use the surface water in our rivers and streams. In this manner, we have given away more water than the rivers can provide in times of drought, leading to low inflows and ultimately a dead Nueces Bay, for one example. But, there are costs to these policies. Texas is killing the natural productivity that supports our coastal fisheries, our offshore and bay shrimping, our oyster fishery, and our finfish populations that support recreational fishing, tackle sales, and home rentals throughout the coastal area.

Other chapters explore aspects of the value of the Texas bays. Using values set out by environmental economist Robert Costanza, the dollar value of our Texas bays is explained. The resulting numbers are extremely high, collectively representing about $22 billion per year for all of our bays. Over a fifty-year period, the productivity of the Texas coast represents well over a trillion dollars in value, yet we are killing it without thought to the economics involved because there is no set "price" on these bays. If we placed a monetary value on our bays and on the investment in the water necessary to protect them, perhaps water users would understand the need to explore comparably less expensive alternatives, such as conservation and brackish water desalting. While desalinization is currently considered more expensive than surface water consumption, it would become competitive if the "full" price of surface water, which includes its impact

on the economy of the coast, were utilized. Texas is currently sending to consumers the wrong "signals" about the actual price of water.

If the fresh water issue can be addressed, and it can and should be, then the future of the coast seems bright. The battles set forth in *The Book of Texas Bays* have given us a fairly stable platform from which to work. The major wastewater discharges that marred our bays in the past, such as the one as set out in chapter thirteen, have been addressed. From those battles, we are primarily left with "legacy" pollutants in the sediments, such as those found in Lavaca Bay adjacent to Alcoa. This does not mean that vigilance is not required or that new "legacies" will not be discovered, as was the case with the San Jacinto River superfund site where dioxin was discovered after *The Book of Texas Bays* was published. However, we have a base from which to move forward if we have the will.

One topic not covered in great detail in *The Book of Texas Bays* is hurricanes. Since publication in 2004, the coast has been struck by two major hurricanes: Rita in 2004 and Ike in 2008. Rita, a category 4 storm, was heading for the Houston-Galveston area when it moved to the north, coming ashore near the Louisiana border and wreaking havoc with western Louisiana. Ike, a geographically large category 2 storm, came across Galveston Bay with the brunt of the storm surge pounding Bolivar Peninsula and the undeveloped prairies and marshes of Chambers and Jefferson Counties to the east of the City of Houston. Nonetheless, Ike still caused about $24 billion in damage, a number that would have exceeded $100 billion if Ike had come ashore near San Luis Pass as initially projected.

These two events have exposed a major vulnerability of the Texas coast. The vibrant economy of the Houston-Galveston area is susceptible to Gulf waters that rise with the movement of these low pressure systems across the Atlantic, Caribbean, and Gulf of Mexico, pushing a mound of water with their winds and circulation. As these storms move inland, the major Texas bays magnify the surge, funneling water into the secondary and tertiary bays and bayous and raising water levels ten, fifteen, twenty, and even twenty-five feet. A twenty-five–foot surge tide will cause immeasurable economic and ecologic damage to the Houston Ship Channel and Galveston Bay, with national consequences. It would create an unparalleled environmental disaster as the ship channel spewed out the oil and hazardous substances stored in low-lying tanks and hazardous waste facilities.

Since Hurricane Ike, several efforts have tried to address this vulnerability. Dr. William Merrell of Texas A&M Galveston has proposed the Ike Dike, a levee and gate system that would extend from High Island southward down the Bolivar Peninsula, across Bolivar Roads (the pass that connects Galveston Bay and the Gulf of Mexico), down Galveston Island and crossing San Luis Pass,

and then dovetailing back across the Gulf Intracoastal Waterway. This massive system, in theory, would wall off Galveston Bay and Galveston Island from the Gulf, and, according to its proponents, solve surge flooding problems on Galveston Island and Bolivar as well as in Clear Lake and up the ship channel.

To date, the Ike Dike has not been subjected to detailed scrutiny to evaluate its costs, efficiency, and ecological impact. There will certainly be a residual surge behind the dike as Galveston Bay will hold significant amounts of water even if cut off from the Gulf, and there are substantial concerns about the ecological harm that could result from the potential blockage of Bolivar Roads and San Luis Pass, which are crucial for fish and shellfish migration. As can be seen in chapter seven, the ecological services provided by our bays have tremendous dollar value and much of that value could be lost if the Ike Dike is constructed. The size of this structure relative to the beach and the houses adjacent to the Gulf is also a source of concern. If we choose to construct the dike, West Galveston Island and Bolivar may look like the "beach" adjacent to the Galveston seawall.

Another suite of alternatives has been developed by the SSPEED Center at Rice University, where I am codirector. We have tried to design surge solutions that are smaller and less expensive but also very efficient. To date, we have developed two major concepts that we believe have merit. The first is called the Centennial Gate, proposed to be built near the SH 146 bridge over the Houston Ship Channel, connecting land areas twenty-five feet or higher on the south side of the channel with land areas twenty-five feet or higher near Baytown on the north side. Here, a levee and gate system is proposed that can be built for about $2 billion and will protect both the $100 billion infrastructure investment along the ship channel as well as prevent a major ecological disaster on Galveston Bay. For the money, it is the best surge alternative, but it does not protect the many low-lying residential areas to the southwest, for which we are now investigating further alternatives.

We at SSPEED Center have also proposed two landscape-scale green space solutions for the less developed low-lying areas to the northeast in Chambers, Galveston, Brazoria, and Matagorda Counties. The first of these is a proposal to link federal, state, and local protected lands with lands protected by non-governmental entities and to incorporate this "networked" system into the National Park System. This idea is called the Lone Star Coastal National Recreation Area and is being championed by former Secretary of State James Baker and Houston businessman John Nau. It is hoped that legislation will be introduced in Congress in 2014 to create this unit of the National Park System, which will call widespread attention to our nationally significant natural resources and recreation opportunities.

The second green space alternative is to create a web-based platform to allow buyers and sellers of ecological services to come together. Ecological services are discussed in several chapters of *The Book of Texas Bays* and represent the "value" that we receive from natural production processes such as shrimp and finfish produced by an estuary. Land owned by private property owners can be managed to enhance the natural values exhibited by these lands. Prairies can be restored. Wetlands can be created. Forests can be replanted. Habitat for certain species can be created and maintained. These landowners may be able to sell these enhanced services to the corporate sector, which may be required by law to "offset" the "footprint" of their less environmentally friendly actions. Or, perhaps landowners could sell these services to governmental interests or in the gift market, or perhaps to philanthropic buyers. If we concentrate on the low-lying lands below twenty-foot elevation for restoration and enhancement, we will also be establishing a natural buffer system to absorb the hurricane surges we know will come in the future.

The point here is that there is a way to use the market system to promote conservation on the Texas coast while benefiting private landowners. If we get creative and work together, the Texas coast will be appreciated for all it has to offer by generations to come, but we have to make it happen. Government will not do it. We citizens—we in the private sector—must make it happen.

As I once again launch my kayak from the shores of Christmas Bay, I take a long slow paddle into the future, a future where we have correctly valued the Texas coast, a future where we understand our need for this natural system, its productivity and its beauty, if we are to be whole, as a people and as a society. Texas is tough place. You have to fight for what you believe. This future has been and will be forged by fighters. As I paddle further into the future, I see a coast with adequate fresh water; with green space corridors and storm buffers; and with a population that knows how to have fun on the coast, how to use it and enjoy it, and how to fight for it. I hope that *The Book of Texas Bays* has contributed to that future.

Kayakers checking out the route. The Lighthouse Lakes kayak trail would not exist but for the efforts of coastal environmentalists to stop an unnecessary port development that would have destroyed mangroves, seagrass beds, marsh grass, and other natural wealth.

Acknowledgments

This celebration of Texas bays reflects the help of many people. It was conceived out of discussions I had with Ann Hamilton of the Houston Endowment, whose support was essential. Without Ann's conviction, this book would not have come to be.

Research and assembling of data were originally funded by several foundations. The Houston Endowment provided most of the funding, with additional support from the Hamman Foundation, Trull Foundation, Hershey Foundation, Wray Trust, Seaspace Texas, Mary Beth Maher, and Boyd Moore. Photographer Jim Olive was with me from the inception of the project and received grant support. He was commissioned to take certain shots and also provided stock photographs. His images capture the beauty of the coast with the deft hand of one who loves it.

Michael Berryhill was an early collaborator employed to research and write some segments. He wrote the description of Victor Emanuel in chapter 4, the account of the Neotropical migrant birds leaving the Yucatan in chapter 10, and a portion of chapter 19 about the Lighthouse Lakes trail. Ultimately, we realized that the vision for the book was mine and I had to write it. Students and recent graduates assisting were Chris Johnson, who did excellent work gathering data and helping to develop issues and concepts for graphs and charts; Lyda Smayling, who prepared many of the graphics and gathered a substantial amount of data; and Cara Forster, who researched and contributed to the Mad Island, Port Aransas, Laguna Atascosa, and South Padre Island chapters.

The maps were prepared by Bryan Carlile of Beck Geodetix, using satellite photographs. The General Land Office of the State of Texas sent aerial and satellite photographs that were useful although they are not included. Elizabeth Hall helped with legal issues associated with the manuscript. Dale Cordray of my office kept our books and took care of innumerable administrative details. Thanks, Dale.

Grants were coordinated through the Galveston Bay Conservation and Preservation Association (GBCPA), one of the best activist environmental organizations on the Texas coast. I would like to thank Mary Beth Maher, Ellyn Roof, Katie Chimenti, Nancy Edmonson, Sally Antrobus, Natalie O'Neill, Charlotte Cherry, Charlotte Wells, Larry Tobin, and the other GBCPA board members for allowing me to produce this book under the auspices of GBCPA. There is not a better board of directors anywhere on the Texas coast.

My background growing up in the Rio Grande Valley and spending childhood vacations in central Louisiana and Port Neches is an important part of who I am. I want to acknowledge the men who taught me to love and appreciate the outdoors when I was growing up—the late W. B. Graves, Sr. (Grandpa Graves), William B. Graves, Jr. (Uncle Bun), Charles Blackburn (Uncle Charles), the late L. E. Blackburn (Uncle L. E.), and my father, James Bernard Blackburn, Sr., who passed away before this book was published. I am lucky to have known them. The writing began on a legal pad by my father's bedside as he was recovering from brain surgery in December, 2001. Chapters 2–6 were drafted there, and I completed the manuscript the month after he died in April, 2003. There is a linkage between his passing and its emergence.

This is a book about the heroes of the Texas coast, the people who have fought for it, whom I respect and from whom I have learned. I thank all of them, and others not mentioned, for standing up for the coast. They are presented throughout, but I want to acknowledge them now—Laurence Armour, Tobin Armstrong, John Bartos, U.S. Senator Lloyd Bentsen, Ray Berry, Ron Bisbee, Janie and Wesley Blevins, George Bolin, Mary Lou Campbell, Mary Carter, H. C. Clark, Victor Emanuel, Ted Eubanks, Merriwood Ferguson, Johnny French, Steve Frishman, Al Garrison, Phil Glass, the late John Grimes, Henry Hamman, Richard Harrell, Stuart Henry, Myron Hess, John Jacob, Andy Jones, Bill Jones, Mary Kelly, Walt Kittleberger, Tio Kleberg, Edward Lambright, Mike Lange, County Judge Richard LeBlanc, Ilan Levin, Andy Loranger, Rick Lowerre, John Martin, Bob McFarlane, Bob Moore, Dick Morrison and his son Richard, the Reverend Terri Morgan, Joe Moseley, Joe and Doris Nelson, Ben and Jerri Nelson, Joe Nguyen, Brent Ortego, the people of the D. M. O'Connor Ranches, Erma Patton, Susan Rieff, Andy Sansom, K. J. and Bessie Richardson, former state senator Babe Schwartz, Carter Smith, Sharron Stewart, Bill Stransky, Charles Tapley, Bill Templeton, Muriel and Roy Tipps, former state senator Carlos Truan, Johnny Valentino, Jon Vanden Bosch, George Ward, Diane and Tom Wassenich, Joe Whitehead, Evangeline Whorton

and Lalise Whorton Mason, Donna Sue Williams, and Diane Wilson. I have tried to present correctly the facts of the fights in which they have participated.

I would also like to acknowledge the public officials charged with conservation of coastal resources. Larry McKinney and others from the Texas Parks and Wildlife Department helped in the calculation of the economic value of San Antonio Bay in chapter 17. Many of the staff at the department's Austin and coastal field offices and the U.S. Fish and Wildlife Service field offices are among the best professionals in the business of resource protection.

Members of the federal judiciary of the Eastern and Southern districts of Texas are called upon to referee disputes over resource allocation on the coast. These judges are intelligent, fair, and overworked. Their willingness to weigh the merits of disputes, and their effort to understand often complicated situations and apply the law as written, supply the most effective legal protection we have for the Texas coast. Lawsuits of the past and present notwithstanding, I want to recognize the personnel of the Galveston District of the U.S. Army Corps of Engineers. We may disagree, but without their frontline role, the coast would be in very severe trouble indeed.

This book is also about friendship, camaraderie, and adventures. I want to tip my Team 11 hat to the other members of the team—John Chapman, John Fenoglio, and Jack Schwaller—and to the owners of Team 11, our wives Garland Kerr, Princie Chapman, Sally Fenoglio, and Sue Schwaller. Besides all those already mentioned, I am grateful for the companionship of the late Walter Duson, Don and Caro Jackson, Ann Hamilton, Al, Shelly, and Lee Kaufman, Liz Kerr, Jack Matson, Lynn Randolph, Peter Rowe, and Kerry Tate. We have had great times on the coast. Here's a toast to many more.

Finally, I want to acknowledge the wonder and the magnificence of the Texas coast, and my relationship with it—the brown pelican that is Walter Duson, the white pelican that looks back at me and bids me forward, the caracara that is my totem bird, the wispy blue tail of the feeding redfish, the governing spirit with which I am connected. This relationship was the force that caused this book to be written. I had little will in the matter. It simply had to be.

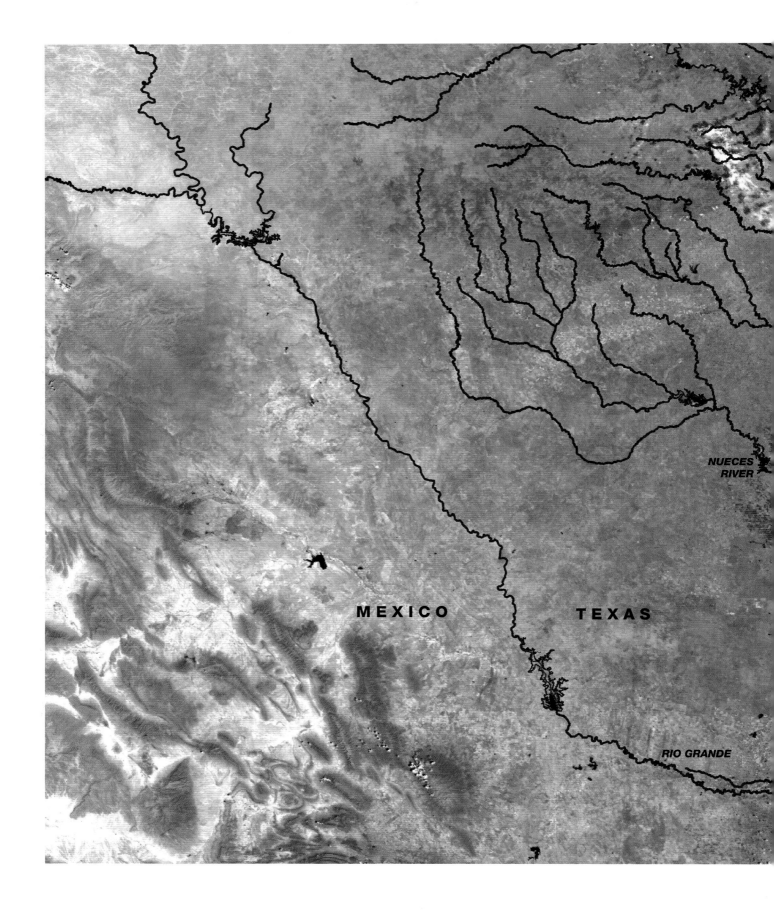

NUECES
RIVER

MEXICO

TEXAS

RIO GRANDE

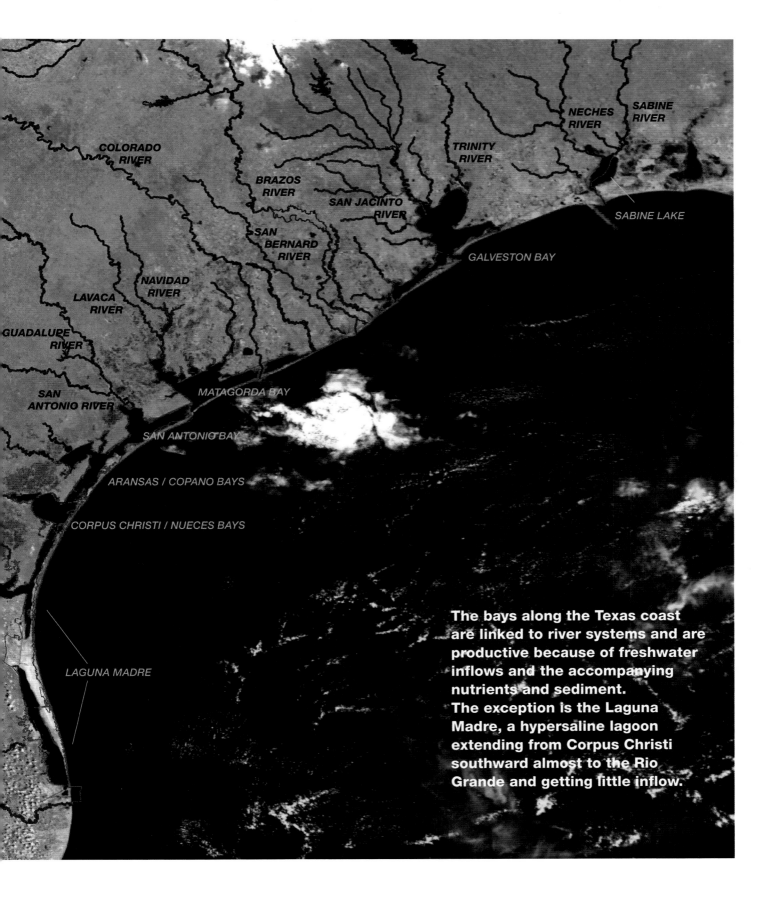

COLORADO RIVER

NECHES RIVER

SABINE RIVER

TRINITY RIVER

BRAZOS RIVER

SAN JACINTO RIVER

SABINE LAKE

SAN BERNARD RIVER

NAVIDAD RIVER

GALVESTON BAY

LAVACA RIVER

GUADALUPE RIVER

SAN ANTONIO RIVER

MATAGORDA BAY

SAN ANTONIO BAY

ARANSAS / COPANO BAYS

CORPUS CHRISTI / NUECES BAYS

LAGUNA MADRE

The bays along the Texas coast are linked to river systems and are productive because of freshwater inflows and the accompanying nutrients and sediment.
The exception is the Laguna Madre, a hypersaline lagoon extending from Corpus Christi southward almost to the Rio Grande and getting little inflow.

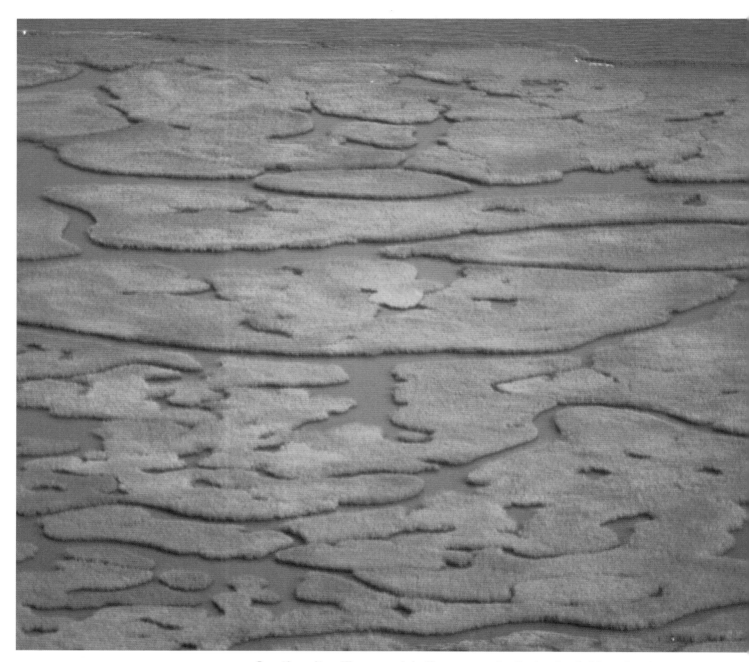

Spartina alterniflora marsh in the Galveston Bay system is extensive. But more than 50,000 acres of it have been lost, mainly due to withdrawal of groundwater and the sinking of the land surface. As the land subsides, the plants are drowned by rising water levels and die. Photograph by Jim Blackburn

Spirit of the Mud

During the growing season, the lush green landscape of the Texas coast is revealed. The *Spartina alterniflora* marsh grass grows adjacent to the open water of the estuary, flanked on the landward side by the rice fields that dot the prairie from Sabine Lake to the Matagorda Bay system.

My place, the Texas coast, is a plain that gently emerges from the Gulf of Mexico, a mud platform ascending slowly from the ocean's grip. Rainwater joins with the mud and establishes the base of life on the coast. No rocks, no mountains—just mud and water.

Over the years, I have developed a spiritual connection with the coast and I act to protect it. Place is where you are, your anthropological, ecological, and geological center. If we understand place, we are more likely to care for it. Place may be the most important concept in environmental protection today. I am an environmental lawyer, and my sense of connection to this coast has proven a driving force in my career. The muddy coastal plain is not obviously a world-class habitat or scenic splendor; yet the more closely I have looked, the more convinced I am. My aim in this book is to share what I have seen.

The coastal plain was formed over the ages by the erosive action of rainfall working on the higher ground far to the west. The rivers that course through the plain—the Sabine, Neches, Trinity, and San Jacinto, the Brazos, San Bernard, Colorado, Lavaca, Guadalupe, Nueces, and the Rio Grande—have banks and beds that carry their normal flow. But these incised channels cannot contain the larger storms that overflow the banks and spread out into the secondary river channels, the floodplain. Over the centuries, these rivers have changed courses through the mud many times, leaving behind lakes and meander scars and depressions that dot the landscape, mute testament to the geological forces still shaping the coast.

Our legal system pretends that the essence of these waterways is limited to their beds and banks, but the pretense is altogether misleading. Instead, part of the natural cycle of these rivers, creeks, and bayous is to flow over the adjacent land, often for days or weeks, leaving behind the sediment that elevates the land surface and provides the base for floodplain forests offering visual relief within the flat

coastal plain. These same floods provide the topsoil that supports lush farmlands as well as native grasslands.

We get rain on the Texas coastal plain—bucketfuls of rain. The moisture often comes in from the Gulf, the water evaporated by the sun, the river flow recycled. These rains are sometimes generated by the counterclockwise rotation of low-pressure systems that we name and fear: Allison, Beulah, Carla, Frances, Alicia, Claudette, Brett. The storm clouds unleash torrents of rain that reestablish our region's water meadows and saturate the prairies and marshes and their water-loving plant life—lush, alive, literally teeming with primal energy.

The Texas coast is a green place, full of plants and the habitat provided by these plants, forming distinct ecological systems. On the upper to mid-Texas coast, salt and brackish marshes are found adjacent to the bays. These marshes are filled with plants growing from two to five feet high and are wet almost year-round. They are flanked by prairie systems that are flat and hold large amounts of water in wet times, classic seasonal wetlands. Today, large areas of these prairies are farmed for rice and soybeans. Along the rivers, forested wetlands and floodplain forests grow in the lush topsoil deposited by the receding floods.

The term *wetland* is a general term that includes several different systems. Marshes are tallgrass wetlands that are saturated year-round, and swamps are forested wetlands that are also saturated year-round. Additionally, there are numerous depressed areas all across the coastal plain, some adjacent to the rivers but most within the flat, poorly drained prairies. These depressions are sometimes called potholes, or flats, and they are usually flooded seasonally, as opposed to year-round. Together, all these areas are referred to as wetlands, and they are green and lush and productive.

As one moves farther south on the coast, the rainfall diminishes, dropping from nearly sixty inches per year near the Louisiana border to less than twenty-six inches along the Mexican border. The lower coast is geologically different from the upper and midcoast, less defined by rivers and flood flows. This is the country of sand dunes and thorn brush, of clear bays and seagrasses and large ranches.

The bays of the Texas coast represent ecological resources of the first order. Our coastal bays are water fingers, drowned river channels carved when the Gulf was several hundred feet lower in elevation. When the sea level rose over five thousand years ago, these river channels were filled with Gulf water, creating places where riverine inflow combined with salt water, creating areas of immense natural productivity called estuaries.

Estuaries are places of high energy, where natural forces combine to create conditions that nurture living things. Here one finds shrimp, crabs, oysters, juvenile and adult finfish, the predatory redfish, flounder, and speckled trout, and the microscopic plants and animals upon which the whole system depends—abundant, teeming life.

Rice fields provide excellent habitat for wintering waterfowl. The lines are levees that follow slight differences in elevation, allowing water to be held within the paddies.

Since the settlement of Texas began, our bays and estuaries have been primarily considered in the context of commerce: places to float boats, to bring in trade, to debark immigrants, to refine and trade in oil and chemicals. Today we live on a coast that has abundant natural resources, yet our historic focus on commerce has prevented the full value of these natural resources from being appreciated and has led to their not being protected to any great extent by the Texas legal system.

My life as an environmental lawyer and activist has been dedicated to trying to understand the coast, its values, and its heritage. I have had the privilege of knowing some of the true heroes of the Texas coast as well as some of the villains.

Over the years, my relationship with the coast changed from student to partner. I now am a part of this place. I have a relationship with this place. I smile when I think of the beautiful birds and the lush greenery, and of paddling among them in my lime green kayak with one yellow hatch cover. For me, the coast in its natural state is like the metaphorical Garden of Eden, a place of abundance, of peace, of contentedness.

From the tallgrass marshes of the Sabine to the mangroves of South Bay, the Texas coast is a rich heritage, but it is being attacked. We could easily lose it to the greed and avarice of those who fail to take account of the value of these bays. It falls upon the people living on the coast to set the standard for stewardship and to insist that this standard be followed.

We need to be clear about where we have been and where we aim to go, what we have overcome and what is yet to be overcome. Many hogs are feeding at the trough of our natural resources. While a few snouts have been pushed aside, there is plenty of work to be done to fuse economic, environmental, and spiritual concerns. Welcome to my place.

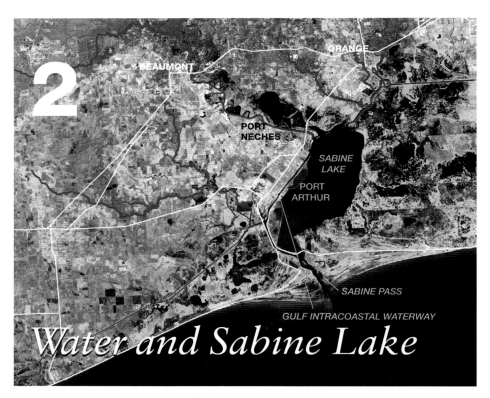

2

Water and Sabine Lake

Texas shares Sabine Lake with Louisiana, seen on the right side of the satellite image. The Sabine Neches waterway allows deepwater ships to enter the system at Sabine Pass. This waterway has one branch extending up the Neches River to Beaumont and another extending north to the Sabine River and Orange, Texas. The Gulf Intracoastal Waterway, the inland barge transportation system, connects the Sabine-Neches waterway with Houston and points south and with Lake Charles, Louisiana, and points east.

I remember when I recommitted myself to fighting for the Texas coast instead of just trying to protect it. I had been hired as a consultant regarding a proposed diversion of water from the Sabine Lake watershed to the Houston area.

The project was simple enough. The Sabine River Authority and Texas Water Development Board wanted to know if the citizens of the Sabine Lake watershed would object to selling water stored in Toledo Bend Reservoir to the City of Houston. Toledo Bend had been built on the Sabine River in the 1960s. The Sabine River Authority owned the water in Toledo Bend and was interested in getting money back on their investment. Few if any water buyers existed in the watershed, but there was substantial interest to the west.

My job was to listen to "stakeholders" in the Sabine watershed to determine what they thought about the idea of selling water to Houston. As an environmental lawyer who represented environmental interests, I was truly interested in what these people thought. And I got an earful.

At that point in my career, I was going through a phase of believing that many of our environmental problems could be resolved through negotiation. I had negotiated the end to several serious environmental conflicts and was enamored

with alternative dispute resolution concepts. I was fond of describing the legal process as being similar to a medieval jousting contest—mediation, I thought, was preferable to donning armor and trying to knock the other side off its horse. And while I still think there is a role for dispute resolution through mediation and arbitration, my experience at Sabine Lake and other venues caused me to dedicate myself to fighting by whatever means for the Texas coast, because without the fight, there is no incentive to negotiate.

Sabine Lake sits in far East Texas astride the border with Louisiana. Unlike much of Texas, the Sabine Lake watershed is wet, really wet. The Sabine River rises in North Texas and forms the Texas-Louisiana border for much of its length, flowing into Sabine Lake from the north. The Angelina River merges with the Neches River to create the inflow into the northwestern portion of Sabine Lake, coming out of the marvelous hardwood forest of the Big Thicket and through Beaumont, the town that the original Texas oil boom built.

Sabine Lake is shared by Louisiana and Texas and is surrounded by lush wetland systems. On the northern portions of the lake, cypress and tupelo gum swamps extend into its tidal edge, forming a maze of bayous and backwaters. To the east is a marsh system that connects Sabine Lake with Calcasieu Lake south of Lake Charles—a continuous stretch of canals and wetland grasses. To the west, the Texas marshes surround Keith Lake and extend northward up to Taylor Bayou and westward to East Bay in the Galveston Bay system. No area of Texas has the water and wetland wealth of the Sabine Lake watershed.

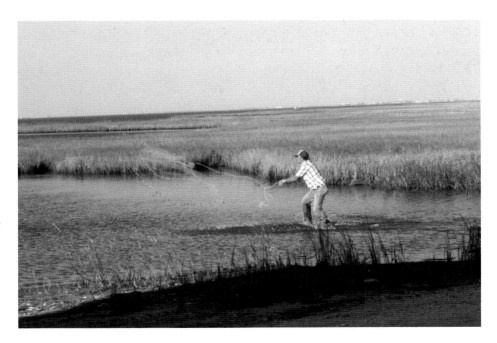

A cast net is efficient for catching live bait. The net is attached to the arm by a rope that draws the lead surrounding the bottom of net under small bait fish, trapping them. If we are to keep the productivity of the Sabine estuary, the flow of fresh water from the river systems into the marshes and estuaries must be protected.

Sabine Lake is the smallest of the Texas bays, just over 60,000 acres in size. Neighboring Galveston Bay comes in at 350,000 acres and Matagorda, the next one south, at about 270,000 acres. San Antonio Bay and the Aransas–Copano and Nueces–Corpus Christi bay systems are the midsized systems of the Texas coast (fig. 1).[1]

But don't be misled by size. The water wealth and wetlands of the Sabine Lake watershed are the envy of the remainder of the state. Houston had its eye on Sabine water, as did Dallas, San Antonio, and perhaps even Corpus Christi. That was why I was paid to talk with the Sabine watershed stakeholders. All of the discussions were noteworthy, but some left lasting impressions. I will never forget a gentleman from South Louisiana. We were talking at a public meeting about the role of fresh water from the Sabine River in giving life to the marshes of South Louisiana. Due to the construction of a deepwater navigation channel to Lake Charles, there is a substantial infusion of salt water into the Louisiana portion of the Sabine marsh. The man explained that the Sabine River's inflow into Sabine Lake was keeping the marsh alive by sending fresh water into it from the west down canals that had been dug for oil and gas exploration.

He explained further that this fabulous marsh system is a fresh to brackish system rather than a salt marsh. Over the years, salt water had become a greater and greater threat to the vegetation, which needs fresh water to live. As salt water entered the marsh system, the grass was killed. Clumps of soil and dead grass fell into the water, and areas that had been covered by grasses became open water instead. Marsh bottoms previously lined with plants that ducks covet were no longer vegetated. In this fresh to brackish system, salt water was the enemy.

He was polite but firm. If fresh water were diverted away from the Sabine River system, he was concerned that the marsh he loved would be killed. And he made it very clear that he would do everything in his power to keep that from happening.

I recall County Judge Richard LeBlanc of Jefferson County, Texas. Judge LeBlanc also was very clear. In his mind, there was nothing positive about diverting water of the Sabine River to points west in Texas. LeBlanc believed that development should come to the water, not the other way around. If the citizens of the Sabine watershed could manage to hold onto their water, their economic future would be guaranteed, he thought. The development might not come in his lifetime, but it would come.

I also heard from representatives of the State of Louisiana about their position on the potential westward transfer of water from the Sabine. That discussion revealed that Texas and Lousiana did not talk much about water policy, that Texas had not spoken to officials of the neighboring state about the diversion, and that the State of Louisiana was concerned about the impact of any diversion on the surrounding wetlands. I discovered that the government of Louisiana had much

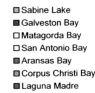

**Figure 1.
Size of Texas Bays**

more official understanding about the value and role of wetlands than did the government of Texas.

It became clear that the science regarding the impact of water diversion from Sabine Lake had not been collected, if it in fact existed. As part of our work, we decided to hold a conference regarding Sabine Lake in an attempt to pull together what was known about the watershed and about how Sabine Lake might be affected by diverting its water. We assembled a planning team from both Texas and Louisiana, and we attempted to get the best people we could to make presentations on their areas of expertise.

The Sabine Lake Conference was a great success from my viewpoint. This conference convinced me that there was a large amount of information about certain specific issues but that there was no overall grasp of how a diversion would affect this important resource. Perhaps more significant, I concluded that there was no entity that had a full understanding of this estuarine ecosystem and how it functioned. I listened to a presentation about how the white shrimp production in Sabine Lake had crashed at about the same time that the two big reservoirs— Toledo Bend and Sam Rayburn—were constructed. Was the crash due to declining inflows? Was the crash due to altered release patterns associated with power production? No one seemed to know.

I learned how the circulation pattern of Sabine Lake had been changed by the navigation canals that ringed it. The Sabine-Neches waterway is a deepwater channel that comes in through Sabine Pass, the outlet to the Gulf of Mexico, and comes north through Port Arthur and Beaumont, today ending at Orange, Texas, on the Sabine River. In the past, that same channel had extended eastward past Orange to Lake Charles before that community got its own deepwater channel up through Calcasieu Lake. That old navigation channel is now part of the Gulf Intracoastal Waterway (GIWW) that connects the Sabine-Neches waterway to points west and east. I learned that there were higher salinity readings on the north end of Sabine Lake than in the middle, a total transformation of the natural pattern of gradation from fresh water to salt water going from north to south.

And I learned about the wonderful resources of the Sabine National Wildlife Refuge, the 124,000-acre refuge spanning an area between Sabine Lake and Calcasieu Lake in Louisiana. Ducks of all kinds flock to this wildlife refuge— widgeon, mallards, gray ducks, mottled ducks, green- and blue-winged teal, ruddy ducks, and bluebills: ducks that travel thousands of miles from prairies in Canada and the northern United States to winter in abundance, ducks that delight hunters as they fly in formation with eyes watching for anything amiss, ducks that delight birdwatchers as they tip to feed, heads below the water, tails pointing skyward.

As I listened to what the experts were saying about the extent of our knowledge of water diversion and the health of Sabine Lake and the adjacent marshes, I realized that we did not know enough to make a serious decision about the pro-

posed diversion. However, what struck me most was that the financial resources of those wishing to protect the ecosystem were totally overwhelmed by the financial resources of those wishing to divert.

The experience of talking to people about moving this water, of reviewing the data and assembling the Sabine Lake Conference, galvanized my commitment to fight for the Texas coast. That moment of clarity occurred in my office the week after the conference. I saw that I was an environmental lawyer for a reason, and that I was uniquely trained to attempt to prevent the Texas coast from being destroyed. This coast should not be lost because of unequal financial resources. I realized that it was not enough to talk about protecting the coast, only to watch as the money interests staked out their position. If the coast were to be protected, then people like me had to fight to make it happen.

The Sabine Lake Conference was about habitat, ecology, and stewardship. Some organizers thought it might convince the residents that enough was known to allow the diversion. Instead, it focused me. I realized that there were many people willing to mediate a solution but very few who were willing to fight for a solution. In Texas, if you are willing to fight, you will suffer financially. Yet without a fight, the coast would be lost. It was that clear. It was that simple. Luckily, the City of Houston decided not to go after the Sabine River water as of early 2003. But they or someone else will be back later in the twenty-first century.

I came by my concern about Sabine Lake honestly—the lake and the adjacent marshes are part of my heritage. When I was a boy, my father and I hunted with Uncle Bun (Bill Graves) in the marshes of southeast Texas, walking for miles into the saturated prairies, carrying duck decoys and shotguns. We would come to the edge of a marsh pond and throw out the decoys and make a blind out of the marsh hay that was lying about. I remember a late morning flight of pintails coming over in formation, the drakes sleek with their dark brown heads, white bodies, and black pointed tails. I can still see the flight turning and coming back toward us, wings set, feet down—a wonderful boyhood memory—my daddy and Uncle Bun and me together in the marsh.

Just after getting married in 1950, Uncle Bun and Aunt Bobbye moved to Port Neches, between Beaumont and Port Arthur on the Sabine-Neches waterway. Jobs in Port Neches were paying twice what one could earn in central Louisiana, and Uncle Bun got on right away with U.S. Rubber, where he worked until he retired in 1987. Uncle Jeff worked at the nearby Texaco Refinery and Uncle Harold worked at the Gulf Refinery, both in Port Arthur within a mile of each other. I would often spend a week or two during the summer with them, going fishing, going to the beach, having fun.

Uncle Bun and Aunt Bobbye's first house was within walking distance of the rubber plant because no one in postwar Port Neches had two cars. Even their later houses were within sight of the tall, tubular, industrial towers, a residential pat-

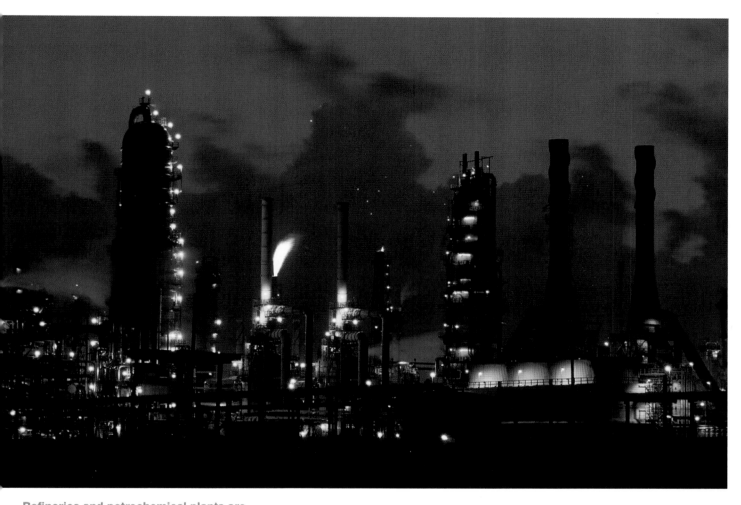

Refineries and petrochemical plants are a reality of the Texas coast. For years, the water quality was severely degraded in coastal areas near such plants, but it has improved dramatically due to the passage of the Clean Water Act and the action of the federal government.

tern that characterizes the region today. Aunt Bobbye died from stomach cancer in 1995, arguably related to chemicals such as butadiene that she and other residents of the area breathed for all those decades.

Uncle Bun and I have been fishing together since I was a boy. He taught me to cast a Zebco spinning reel in the backyard of my grandfather's house in central Louisiana. I was taught to cast left-handed so that my right hand was free to turn the crank on a bass that struck the first instant the lure hit the water, subtlety instilling an optimism about fishing that still exists in me. Although I was raised in the Rio Grande Valley of South Texas, my mother maintained a colonial mentality throughout her stay there. Every vacation we would return to the Baptist side of the Cocodrie Swamp south of Alexandria, Louisiana, where I fished and hunted with my father Bernard and his brothers L. E. and Charles, my mother's father

A school of mullet moves along the surface, creating a pattern of movement distinct from the surrounding pattern generated by wind action on the water surface.

Grandpa Graves, and her brother, Uncle Bun. These men taught me to love the outdoors and to respect nature, to be a sportsman, to eat what we took. They taught me to care about the natural system.

In early 2001, my Uncle Bun and I fished together on the Sabine-Neches waterway. Uncle Bun gave me the wheel of the small boat as he grabbed the cast net and moved to the bow. We were moving slowly down a small canal lined with wetland grasses and rimmed by trees. A green heron slumped on a half-submerged limb in the shadows, watching and waiting. On the opposite side, a great egret crouched motionless, yellow beak jutting out, eyes almost popping out of its head, searching the grass for small fish that shuttled nervously from stem to stem, ever mindful of the predatory beak.

"Now, keep us near the bank and go slow. There—see the ripples ahead of us? Steady. Steady."

Ahead, a pattern on the water surface differentiated a school of shad from the wind ripples, pattern within pattern, the motion of a hundred small fish generating an energy field that stood out against the wind. Uncle Bun drew his arms back and sent the net out into the rising sun, nylon glistening, the net opening into a lead-lined circle, drawn by gravity down over the school and toward the shallow bottom.

Water splashed on all sides as the shad fled the motion that fell upon them, several trapped within the enveloping circle pulled together by the rope tied to Uncle Bun's wrist. With a couple of jerks the net was collected, bringing up a dozen wriggling spotted shad, today's bait for speckled trout along the Sabine-Neches waterway.

"You know what we used to call this channel, don't you?" asked Uncle Bun. "This was Stink Ditch. Nothing was alive in this channel when I first moved over here. This channel used to take the paint off the bottom of your boat. This was one nasty place."

By the time of our 2001 visit, the channel was full of living things. Wading birds of all types lined the edges, each working its own plot of coastal real estate. The birds were there because the fish were there, and the fish were there because the pollution that once killed every living thing had abated, controlled by the Congress of the United States through legislation enacted for precisely this purpose. I am thankful for this gift—the restoration of our natural heritage—and for the ability of the natural system to recover.

The improvement in water quality after the passage of the federal Water Pollution Control Act is one of the great environmental success stories of the late twentieth century. Congress passed Public Law 92-500 in 1972, overriding President Richard Nixon's veto. PL 92-500 was the first law to establish federal permitting to control pollution, rather than leaving matters to the states. Most states, like Texas, had failed miserably to control pollution, necessitating the federal government's intervention on this issue.

Under the statute, now called the Clean Water Act, a unique permit program called the National Pollutant Discharge Elimination System was created. This was not a program designed simply to control water pollution; this was a program designed to eliminate it. And while we have not eliminated all water pollution, we have made tremendous progress in cleaning up industry-lined channels such as the Sabine-Neches waterway.

The terms and conditions of the permit process were set under federal law, and states were allowed to take over the permit program if they were willing to comply with federal standards. For more than twenty years, Texas refused to pass strong state legislation, so the federal Environmental Protection Agency (EPA) set up a pollution control program for Texas, one that cleaned up most sections of the Texas coast.

The Beaumont–Port Arthur refineries predate World War II, but the associated chemical industry expanded greatly during and after the war. Pollution control was not a priority, and as these complexes expanded, the volume of pollution grew substantially. Pollution reached its height in the late 1960s, when the Sabine-Neches waterway was the second most polluted waterway in Texas, second only to the Houston Ship Channel. These dredged channels provide deepwater access for tankers and barges loading refined products and importing crude oil from the Middle East, Africa, and South America as Texas fields began to dry up. These channels also were the "back doors" into which all the waste products were dumped.

According to Richard Harrel of the Biology Department at Lamar University in Beaumont, the Sabine-Neches waterway was virtually dead before the EPA came along and oversaw a great reduction in the volume of pollution. Today, looking at all of these living things in the water, it is hard to believe that the waterway was devoid of life until it was transformed by federal law. The federal permit program was not voluntary. It was direct and clear federal regulation forcing companies to do what the State of Texas refused to do—compel the powerful industries to quit polluting, or at least stop the worst practices.

This is not to suggest that there is no industrial pollution today along the Texas coast. Despite the goal in the Clean Water Act of zero discharge of water pollution, that goal has never been realized, although it is certainly viable in many instances. Both the success of the Clean Water Act in restoring fish life to these industrial channels and the high cost of additional controls have been barriers to even more stringent implementation. We can and will do better on eliminating toxic water pollution. Meanwhile, Uncle Bun and I can enjoy the benefits of the cleanup that has occurred to date.

What Uncle Bun referred to as Stink Ditch is officially known as the Star Lake Canal, a branch of Molasses Bayou. Over the years, Harrel has conducted samplings of the benthos, the community of organisms that live in the muddy bottom. Benthic organisms are excellent indicators of the extent of pollution, because they cannot move. Whereas fish swim away from pollution, the bottom dwellers remain and either survive or perish. During the early 1970s, most of the bottom-dwelling organisms had perished in the Star Lake Canal and in the Sabine-Neches waterway. In 1971–72, Harrel found no living organisms in the Star Lake Canal, whereas he found at least ten species in 1984–85, after the federal cleanup. The number of species he found in the waterway adjacent to the Star Lake Canal increased from ten in the 1971–72 to forty-three in 1984–85.[2]

Harrel's data documented the power of the federal cleanup. Today, he says the major remaining problems are associated with depressed dissolved oxygen levels and "legacy" pollutants. Legacy pollutants are long-lasting pollutants that do not biodegrade. Metals such as lead from gasoline additives and chromium from cooling towers can still be found in the Star Lake Canal and the Mobil Canal,

legacies from past practices. Many of these pollutants have been dredged from the Sabine-Neches channel, but they still remain along the sides and in tributaries.

When Uncle Bun and I fished on this waterway in 2001, we pulled up to a shoal along the eastern edge of the channel, with tankers and barges passing on one side and tall marsh grass flanking us on the other. The sights and sounds of petrochemical production were everywhere. There was a slight taste to the air. The ever-present towers were visible in both directions along the west side of the waterway, and the drone of diesel engines came and went as tugs did their work, pushing and pulling commerce along the deepwater channel. The good news was that the water quality at the start of the millennium was clean enough to support speckled sea trout and redfish and the smaller fish upon which they feed.

Sabine Lake and the Sabine-Neches waterway have been given a reprieve from the pollution that destroyed so much marine life. While the industrial pattern will likely remain for decades, its threat to Sabine Lake has been reduced. Instead, the biggest threat to the future of Sabine Lake is related to freshwater inflows. The key to protecting the lake and its adjacent marshes is protecting freshwater inflow, a tricky topic in twenty-first-century Texas.

The federal government may wind up providing a reprieve for Sabine Lake again. Due to the lake being shared by Texas and Louisiana and the interstate impacts associated with any diversion, the federal government could be drawn in once more. But I am troubled by having to have the federal cavalry come to the rescue. Why can't we in Texas come to an understanding that we have to take the natural system into account when we develop these grandiose plans? Florida is currently trying—at a cost of billions of dollars—to undo the damage done to the Everglades.[3] Why can't we learn from these past mistakes?

I wonder about our Texas heritage and question how smart we really are. Most of Texas is water short, and that means there is not enough water to pretend that water and its conservation are not important. Yet we Texans pretend. Every Texas city wants to grow, and water is needed to fuel growth. We never question the growth or the culture of water use; we only question where we will get more water. I am amazed that we have managed not to kill the Sabine ecosystem to date with all the pollution, with all the channel digging and river damming that we have done. Sabine Lake has survived until my time on earth. The question of the moment is: will it survive my generation?

My generation is the one that grew up under fear of nuclear attack and global annihilation. My generation is the first that was educated after we understood the principles of ecology, after Aldo Leopold and *Sand County Almanac*, after Eugene Odom had written his classic ecology text, after Rachel Carson had written *Silent Spring*. My generation is the one that held the first Earth Day in 1969. It is also my generation that has often failed to act to protect important natural resources, even when we think we should, because we are afraid—afraid

of losing money, of bucking the system, of being blacklisted, of changing the status quo.

Statewide, there is much money dependent on water for future growth. The situation parallels the water pollution in the Sabine-Neches waterway. The industries would never have cleaned up if they had not been forced to do so. I am convinced that the state of Texas will never voluntarily protect the bays and marshes when big money is on the table. Texas will do so only if pressure exists and is maintained.

That was the realization that came over me when I was listening to the residents of the Sabine watershed. I understood that I was in a unique position to attempt to apply pressure against those wishing to divert fresh water; that was what I needed to be doing. If we want these bays and marshes, we are going to have to fight to keep them.

A little blue heron fishes along a marsh shoreline, eyes intent on the water.

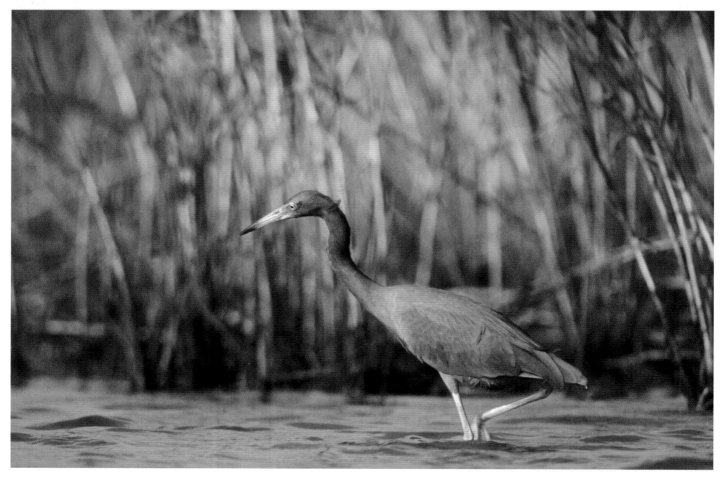

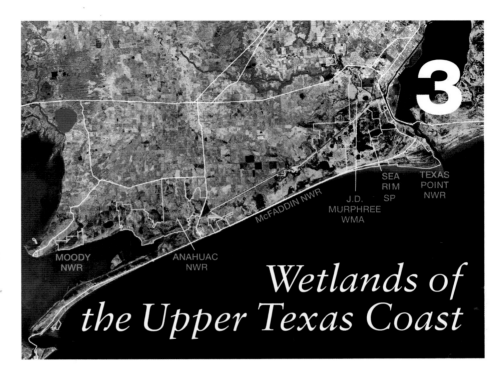

MOODY NWR
ANAHUAC NWR
McFADDIN NWR
J.D. MURPHREE WMA
SEA RIM SP
TEXAS POINT NWR

3

Wetlands of the Upper Texas Coast

Extensive areas of marshland connect the Sabine Lake system with the Galveston Bay system. Much of this land has been purchased by the federal and state government and is preserved as a network of national wildlife refuges and state wildlife management areas.

I prefer to experience the wetlands of the Texas coast in my kayak. That way I can glide quietly along the marsh edge, almost touching the *Spartina* grass as it rises from the life-giving mud of the bay bottom, passing the wading birds as they probe the mud with their varied beaks, searching for food. I share the marsh with the fish and the birds and the crabs and the snails and I am enlightened and uplifted by the experience. For me, to be in the marsh in my kayak is the highest experience on the upper Texas coast.

Yet all wetlands are not marshes. On the upper coast we have gradations of wetlands, from those inundated by tides to those flooded by stormwater and riverine flow year-round to those that are wet only during certain times of the year. Each of these kinds of wetlands is important to various life forms and to coastal ecology, and no area is more blessed with wetlands than is the upper Texas coast. Yet at the start of the twenty-first century, we are in danger of losing a substantial portion of these wetlands.

One morning in February, 2003, I found myself driving along a road on the upper Texas coast with Doug Jehl, the environmental writer for the *New York Times,* and John Jacob, a Texas coastal wetland expert. At one point as we drove along, John and I both yelled out simultaneously, "There's one." Jehl laughed as we explained that we had just spotted what he had come down to see, a wetland

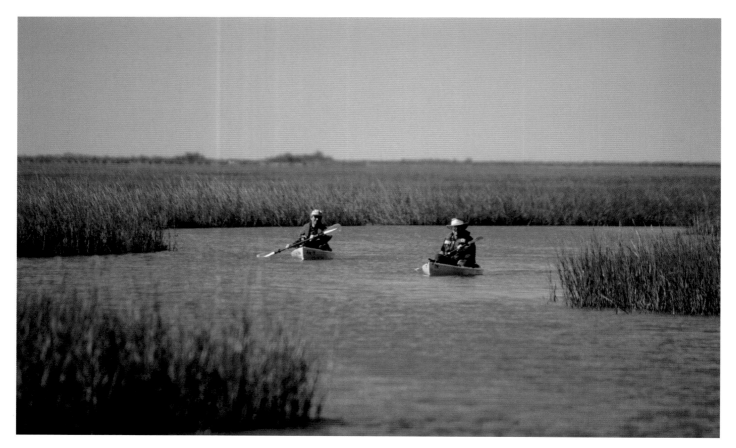

that was no longer protected after the Supreme Court decision in the case of *Solid Waste Agency of Northern Cook County vs. United States Army Corps of Engineers* —known as the SWANCC ("swank") decision.[1]

Jehl had called my office a few days earlier and said he wanted to come down and view firsthand how the SWANCC decision had altered wetland protection on the coast. I told him he was coming to the right place, that wetland protection on the Texas coast had been vastly altered by that Supreme Count decision. Now John and I had found exactly the type of wetland affected by SWANCC. We were looking into the Bayport project on Galveston Bay, a project in which the acreage of jurisdictional wetlands had shrunk from well over a hundred acres before the SWANCC decision to less than twenty acres after SWANCC. This situation was mirrored in several locations up and down the coast.

The upper Texas coast is blessed with hundreds of thousands of acres of wetlands of various types, forms, and shapes. We have the low salt marsh that is inundated daily by the tide, where waving *Spartina alterniflora* marshgrass grows along the edges of bays. On the upper coast, the high marsh is dominated by *Spartina patens* (saltmeadow cordgrass), grading into vegetation types more compatible with fresh water, such as *Panicum hemitomum* (maiden cane) and *Juncus effusus* (salt-stem rush). In some areas, we also have forested wetlands called swamps, and we have bottomlands that may or may not be wetlands, depending

upon how long the water stays in the area, among other things. And we have wetlands that are contained within the prairies—saturated water meadows mixed in with other types of prairie vegetation.[2] These are the so-called potholes or isolated wetlands that were affected by the SWANCC decision.

Figure 2 shows the acreage of marshes adjoining the seven main bays on the Texas coast. A stunning 280,000 acres of marshes surround the Sabine Lake complex. Heading south, marsh acreage around the bays decreases. Corpus Christi Bay has much less marsh than Sabine Lake. Most of the marsh acreage indicated in figure 2 was not affected by the SWANCC decision because virtually all of these wetlands are adjacent to the bays and estuaries of the Texas coast and are thus still regulated by the Corps of Engineers.[3]

The wetlands that were affected by the SWANCC decision were the prairie wetlands not inundated by coastal flood tides or flooding rivers. There is no question that these saturated prairie potholes are biological wetlands. The question is: are they regulatory wetlands subject to permit protection by the U.S. Army Corps of Engineers under Section 404 of the Clean Water Act? Or has this protection been lost as a result of the SWANCC decision?

It is difficult to quantify the acreage affected, but Jacob has estimated that because of this decision, several hundred thousand acres of wetlands on the Texas coast may no longer enjoy federal protection. This is particularly important because Texas as a state has no other wetland protection program. None. *Nada.* The State of Texas does not protect wetlands under its own law. That is why the SWANCC decision was so important.

It came to pass that a story about the fate of wetlands after SWANCC appeared on the front page of the *New York Times,* and there, pictured on the jump page, was a Texas wetland that was no longer protected but should have been. Thank you, Doug Jehl, for taking the time to bring a Texas tragedy to national attention.

Because it has a history of altering and draining wetlands, the U.S. Army Corps of Engineers is a strange entity to be in charge of coastal wetland protection. As the story goes, when the federal Water Pollution Control Act was passed in 1972, creating under Section 404 of the law a federal permit program to regulate dredging and filling, Congress was reluctant to place administration of this permit program into the hands of the then rather new U.S. Environmental Protection Agency. Instead, the Section 404 permit program was placed in the hands of an old friend of Congress that was a known commodity—the Corps of Engineers.

From its inception, this Section 404 permit program has been controversial. Initially, the Corps restricted the geographic coverage of this program to wetlands adjacent to bays and major rivers, only to be ordered in 1975 by the District Court of the District of Columbia to extend the program as written by Congress to its full reach, including prairie wetlands. This expansion was upheld when the Clean Water Act was reauthorized in 1977, surviving by a 50-49 vote in the Senate.

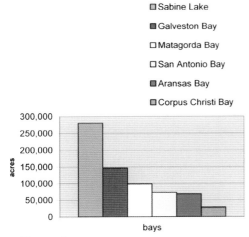

Figure 2.
Marsh coverage in Texas bays—the clear pattern is a decline from north to south.

In 1978, I started teaching environmental law for the U.S. Army Corps of Engineers under contract to the University of Alabama in Huntsville. I taught how the Corps' jurisdiction was upheld and expanded by court decisions in Louisiana and the Fifth Circuit, decisions ruling that the floodplains of Avoyelles Parish, which were inundated only some of the time, were indeed wetlands. A South Texas case extended the jurisdiction to areas away from rivers and streams that were saturated with water, that had water-loving vegetation, and that had wet soils. I taught the theories by which the federal jurisdiction was expanded to include wetland areas that were quite far away from rivers and streams but nevertheless important for waterfowl.

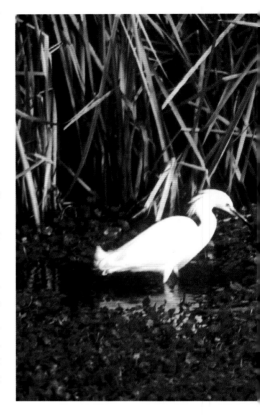

I taught the 1985 U.S. Supreme Court decision upholding the regulation of wetlands and the Corps' 1986 regulations, which extended Corps jurisdiction to include isolated wetland areas far removed from traditional navigable waters. That expansion triggered a series of challenges to federal jurisdiction. One of them—the SWANCC challenge—landed at the door of a conservative U.S. Supreme Court.

The SWANCC decision involved an old gravel pit that had filled with water. It was not adjacent to a traditional navigable waterway, and it was not a tributary of one. Flow did not proceed from this pond to other waters. Federal jurisdiction was established by the fact that ducks and other waterfowl used these waters in their migration, providing a connection to interstate commerce. These were what were referred to as "duck waters" in the trade. If a duck got its butt wet when it landed, federal jurisdiction followed.

The SWANCC decision shot down duck waters and perhaps a lot more. The Supreme Court was clear: its decision held that the Corps regulations as applied to the SWANCC site "exceed[ed] the authority" granted to the Corps under Section 404(a) of the Clean Water Act. With those words, thousands of acres of wetlands on the upper Texas coast may have lost the federal protection that precluded them from being filled for subdivisions and other development.

The SWANCC decision affected the poorly drained prairies and water meadows that are not directly connected to a river or stream. These potholes, these depressional wetlands, occur all through the upper Texas coastal prairie, providing excellent feeding grounds for ducks and geese and other waterfowl. They are part of the wintering grounds along the Central Flyway, an important piece of the Texas coastal ecosystem. While they do not hold water all the time, their soils are considered wetland soils, and the plants they support are wetland plants. They hold stormwater runoff, cleansing it of pollutants prior to it being released to flow overland into coastal waters. I believe these are the kind of waters that the Clean Water Act sought to protect in its desire to restore and maintain the physical, chemical, and biological integrity of the nation's waters, and there are hundreds of thousand of acres of them on the Texas coastal plain.

While the prairie wetlands of the Texas coast are very different from the

A snowy egret fishes in a freshwater marsh. Regulation of the filling of wetlands along the Texas coast is left to the Corps of Engineers because the State of Texas does not have an independent wetland protection statute. The U.S. Supreme Court decision in the SWANCC case limited the extent of wetland regulation by the Corps and left hundreds of thousands of freshwater wetlands unprotected. Photograph by Jim Blackburn

isolated gravel pit considered in the SWANCC decision, at the time of writing the Galveston District of the Corps of Engineers is not asserting regulatory jurisdiction over these wetlands because of their interpretation of the SWANCC decision. This is what Doug Jehl had come to the coast from New York to see—the extent of the damage to overall wetland protection caused by this Supreme Court decision.

Since that decision, knowledgeable developers have been rushing to fill areas that were previously identified as being regulated wetlands. If they fill during this period, they will not face prosecution if the jurisdiction is reextended in the future. This is a grim wetland game played by teams of lawyers and professional consultants who make their living helping people circumvent regulation and destroy wetlands.

Essentially, a squeeze play is occurring on the Texas coast that may threaten all of our coastal wetlands, regulated and unregulated. The first part of the squeeze is the absence of protective regulation for those wetlands that are on the upland side of our marshes. The second part of the squeeze on coastal wetlands is coming from the Gulf of Mexico from sea level rise. To understand this issue, consider the national wildlife refuges that stretch along on the upper Texas coast.

The swath of land from the Louisiana border to Galveston Bay is particularly blessed with wetland resources, a continuation of the wetlands that extend across southern Louisiana. A system of bayous and depressions and abundant rainfall historically provided more than enough fresh water to create a gradient of fresh to brackish and salt marshes from Sabine Lake westward to the north shoreline of East Bay in the Galveston Bay complex. This is the area known as the coastal chenier plain, and it is substantially preserved today due to the efforts of the U.S. Fish and Wildlife Service and its national wildlife refuge system.

A coastal chenier is a historic beach ridge that runs along the shoreline of the Gulf of Mexico. The orientation of the chenier is uniformly east-west and the sand chenier is higher than the high tides, protecting the marshes to the north from the Gulf waters to the south. The chenier extends from within Louisiana to Sabine Pass and then along the beachfront to High Island, continuing down the Bolivar Peninsula until cut off by Bolivar Roads, the pass that connects Galveston Bay with the Gulf of Mexico. The marshes along the north shoreline of East Galveston Bay are also part of the coastal chenier plain.[4]

Andy Loranger is the manager of the Texas Chenier Plain National Wildlife Refuge Complex. This is the collective administrative title for the 103,000 acres of lands making up four refuges stretching from Louisiana to Galveston Bay: the 7,900-acre Texas Point National Wildlife Refuge at Sabine Pass, obtained in 1979; the 56,000-acre McFaddin refuge acquired in 1980, reaching westward along the coastline to High Island; the 34,000-acre Anahuac refuge obtained in 1963, with major additions extending it in the 1980s and 1990s; and a 3,500-acre conservation easement on lands owned by the Moody Foundation near Smith Point.

In addition to this refuge complex, three other substantial conserved areas in

the vicinity are Sea Rim State Park and the J. D. Murphree Wildlife Management Area, both owned by the Texas Parks and Wildlife Department, and the 135,000-acre Sabine National Wildlife Refuge in Louisiana. These large landholdings together represent major conservation resources, a virtual horn of plenty from an ecological and nature tourism perspective. However, without money from the federal government, most of these lands would not have been saved for future generations, because inheritance taxes and tempting offers would surely have caused large tracts to be broken into smaller parcels that would ultimately have been drained and developed, first for agriculture, then for more intensive uses.

In a landowner's rights state such as Texas, the preferred manner of protecting wetlands is for these areas to be purchased on a willing buyer, willing seller basis, and that is what the U.S. Fish and Wildlife Service has been doing. Over the years its representatives have managed to buy large acreages of wetlands, and they want to do more.

In his role as steward over some of these lands, Andy worries about many things. But the huge problem, the one that keeps Andy up at night, is the rise of sea level. According to an EPA report on global warming, sea level is anticipated to rise at least twenty-five inches over the next century, with some forecasts predicting as much as a three-foot rise. This rise is caused by global climate change, also known as global warming.[5]

Discussion of global warming is not socially acceptable in certain circles in Texas because much of the wealth and political power in Texas is derived from oil and gas. The carbon dioxide emissions from fossil fuel combustion are, of course, the principal cause of global warming. So many of our attitudes on the Texas coast are influenced by the oil and gas industries and their offshoots, refining and petrochemical manufacturing, all prime suspects in the study of global warming.

The classic Texas response to global warming has been similar to that of a lawyer representing a man whose dog is accused of biting someone. First, he denies that his client has a dog. Then he argues that the client has a dog, but it doesn't bite. Then he says the bite marks on the victim's leg do not match the teeth of his client's dog. Those living off oil and gas will go down fighting those in the world who claim that alternative energy sources should be pursued. The oil and gas interests fight hard, and they control the state government and have considerable influence in the federal government as well. They are entrenched and hunkered down for the battle.

From what I have gleaned from conversations, speeches, and informal surveying, few Texans have seriously considered global warming as an issue, a position reflected in the actions of the Texas government. Almost no one living in Texas is aware that the contribution of the Texas economy to the release of greenhouse gases is astounding, and no one seems willing to discuss seriously the damage that our economic engine is causing.

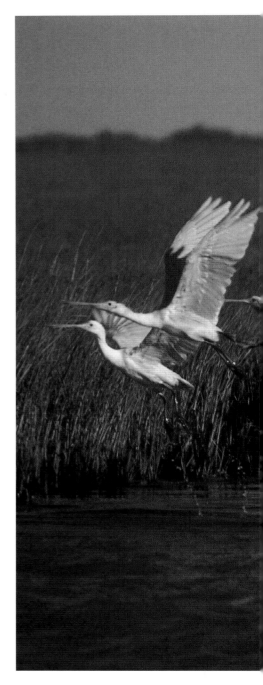

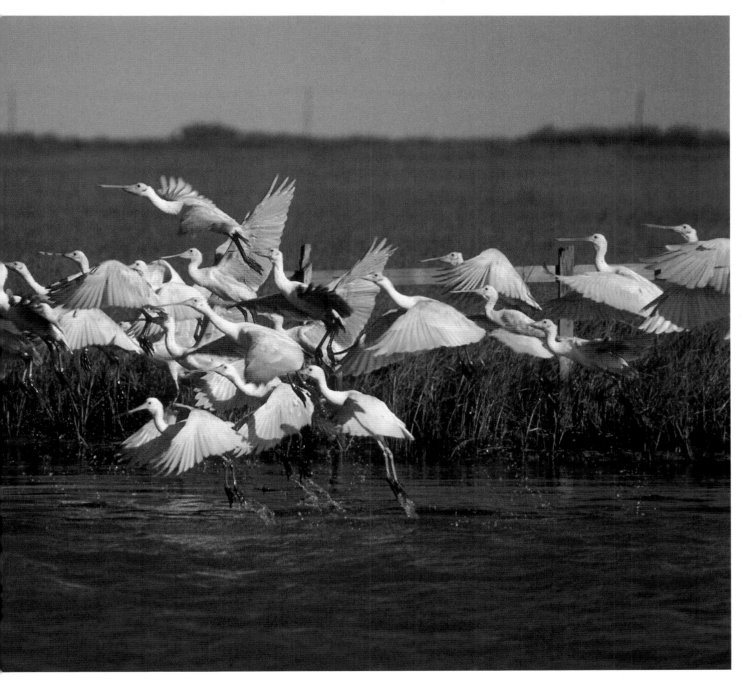

Roseate spoonbills rise from a marsh pond lined with *Spartina alterniflora* wetlands. Sea level is projected to rise from global warming over the next decade, bringing more salt water into the coastal marshes. The brackish marshes of the upper coast are at risk from this intrusion because the vegetation is not adapted for daily inundation with salt water.

Consider the following facts. The U.S. Department of Energy reported in 1999 that Texas released about 10 percent of the U.S. total of 1,800 million metric tons of carbon equivalents, a measure of greenhouse gas emissions.[6] The Carbon Dioxide Information Analysis Center shows that global totals from fossil fuels in 1998 were approximately 6,600 million metric tons of carbon dioxide.[7] Based on these numbers, Texas releases almost 3 percent of the greenhouse gas emissions of the world, an incredible percentage. Although it may not be immediately clear that 3 percent is a high number, consider that one nation, the United States, is responsible for almost 30 percent of the world's greenhouse gas emissions, and Texas alone is the source of a tenth of our nation's total. We on the Texas coast live in the center of these emissions. Most of us really don't think about them at all.

When I talked to him, Andy Loranger was not trying to convince anyone in Texas about the wisdom or necessity of Texans getting serious about controlling greenhouse gases. Instead, his focus was much more practical. As the steward of more than a hundred thousand acres of wetlands adjacent to the Gulf of Mexico, the questions he is concerned with are what sea level rise means to these wetlands and what, if anything, can we do about it. In England, Andy told me, conservation managers are already purchasing property adjacent to the marshes, anticipating that the marshes will be inundated and will have to be reestablished on nearby lands that are uplands today but that will be subject to tidal action after the sea level rises.

"Virtually no one has predicted the impacts of sea level rise on the Texas coast," he said. "It could cause serious damage to our marshes. We would lose substantial land acreage to open water. People have joked about the marshes of the McFaddin refuge becoming the open waters of McFaddin Bay, but to me it is a potential reality. I don't think that McFaddin Bay will form all at once, but I do think the potential is there, over many decades, for much more open water to develop within the refuge, caused by brackish and fresh marsh grass being killed by salt water and sloughing off. The potential is also there for a tidal inlet from the Gulf. That is one thing I am worried about."

Given the prospect of drastic changes to the terrain under his care, it is no surprise that Andy Loranger is concerned about the increase in sea level projected in association with global climate change. We on the Texas coast ought to take his lead and pay more attention to this issue—both to the harm global warming may do and to our responsibility to address the damage provoked by our industry and our SUVs.

The crown jewel of the system Andy administers, the Anahuac National Wildlife Refuge, lies in the western segment of the coastal chenier. Adjacent to the East Bay portion of the Galveston Bay system, it is also endangered by sea level rise. The Anahuac refuge is the most visitor-friendly reserve in the complex. Visitors are afforded access to thousands of acres to observe and photograph spectacular concentrations of migratory birds and other wildlife, to fish, and to hunt

waterfowl. School children from throughout the region use the refuge as a living outdoor classroom. Like all of these investments by the federal government, Anahuac is a treasure that has yet to be discovered by our local promoters, who do not recognize natural capital as being valuable, at least not yet. But they will.

We Texans owe a great debt to the federal government for preserving these coastal wetlands that we would not have preserved on our own. On both sides of Sabine Lake, almost 250,000 acres have been set aside for wildlife protection through the efforts of the federal government, helping to preserve these fabulous natural resources—this ecological capital—for us and those who come after us.

The wetland system of the upper Texas coast has been dealt a difficult hand of cards. Although they are under regulatory protection, the marshes adjacent to the bays may yet be lost to sea level rise. Meanwhile, the SWANCC decision has removed regulatory protection from the nearby coastal prairie wetlands. We stand to lose one set to sea level rise and may lose another set to development, potentially leaving us with few remaining wetlands in thirty to fifty years. We need to understand these forces and anticipate their impacts. We need to act now to preserve the wetlands, both by ensuring protection of prairie wetlands and by providing the room for the landward expansion of the coastal marshes as sea level rises. That is our coastal reality.

Driving along FM 1985, which parallels East Bay through Chambers County near the Anahuac refuge, one commonly sees thousands of snow geese in the rice fields and the prairie potholes adjacent to the road. The geese prefer these flooded prairies, precisely the water meadows that are no longer protected after the SWANCC decision.

When you come upon a flock of snows after they first arrive in the fall, you know it. Some migrating birds are quiet and stealthy, but others are riotous and cacophonous, as if celebrating their migratory success. The snow goose exemplifies the latter category. Geese come south behind the cold fronts of late October, lined up in V-formation, periodically switching leaders as they push southward. The changing leadership is highly practical as the lead bird works harder, breaking the force of the wind and cutting a path for the others to follow, a process known as slipstreaming.

Unlike most people living on the Texas coast, the geese know the rivers and use them for navigation, following them down to the coastal prairies and then dispersing, some going east, some west, some returning to gather in large concentrations on ponds and flooded fields. The flocks seem to get more excited as more birds arrive, the snows with their white bodies and black wingtips, and the blues—the eagle-headed blue morphs—with dark bodies and white heads.

Aar-rik, aar-rik, aar-rik—the high-pitched calls seemingly emanate from all directions at once. Flocks are coming in, circling in a funnel cloud that extends up into the blue sky, gathering on the flooded flat, white on green, stark and clear.

The incoming flights arrive in waves, wings cupped, feet down into the wind. Some of the birds in the higher flocks inexplicably "tumble" downward, literally folding their wings and dropping several hundred feet with a to-and-fro motion, opening their wings only at the last second to catch the air and land carefully next to their neighbors: quick, efficient, graceful. The sight and sound of snow geese heralds the coming of cool weather on the Texas coast. For me, fall has not arrived until I see my first flock of snow geese, the hallmark of my rebirth after another scorching summer.

I grew up hunting geese in the Rio Grande Valley of the South Texas coast. The first waterfowl I killed was a snow, and I can see it still. It stays with me. I am not haunted by it; in fact the opposite is true—I feel that by taking its life, I inherited it. Today I no longer hunt, but I am forever linked to the snows that I hunted for many years. The marshes and prairies of the Texas coast are their winter home. These wetlands are part of their life cycle, part of the genetic code that brings them south from their breeding grounds in James Bay, Canada—paired ecosystems, the marshes of Canada and Texas. When I see the arriving birds, I am part of a living system and I feel it.

I await the fall with anticipation, expectant for the first flight of snow geese. I look forward to that high-pitched call that touches the core of my being, a call that informs me the birds have made the return trip to the Texas coast once more. For another year, fall comes to the Texas coast, and I will see it with my partners the snow geese, the wetlands, and the prairies.

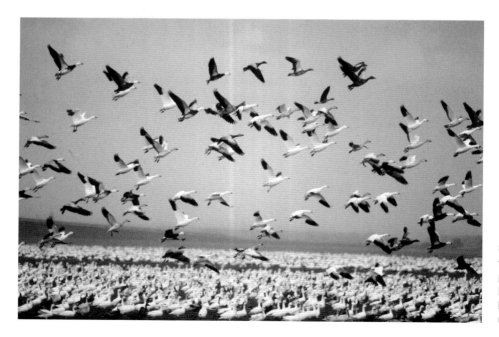

Snow geese feed in rice fields and the associated prairies, wetland potholes, and coastal marshes. During the fall and winter, they can be found in great numbers on the upper and middle Texas coast.

Smith Point juts out into Galveston Bay from the east, separating East Bay from Trinity Bay. East Bay is ringed by wildlife preserves, starting at Smith Point (1) with the Candy Abshier Wildlife Management Area (2) and including the Moody National Wildlife Refuge (3), Anahuac National Wildlife Refuge (4), and McFaddin National Wildlife Refuge (5) on the far right. The Houston Aububon Society operates a sanctuary at High Island (6-where Highways 87 and 124 intersect) and another at Bolivar Flats (7-bottom center on the map) adjacent to the Houston Ship Channel jetty. The Nature Conservancy's Texas City Prairie Preserve can be seen at the lower left, across Galveston Bay from Smith Point.

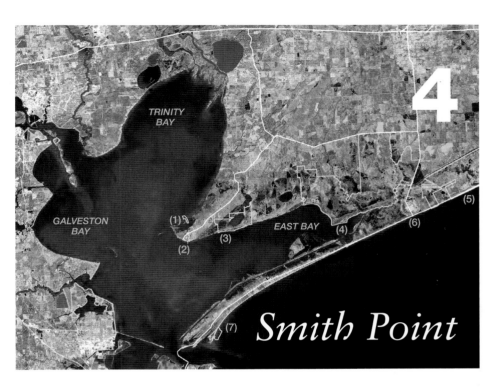

As one of the world's leaders in ecotourism, Victor Emanuel can go wherever he wants to watch birds: to Africa for the southern carmine bee-eater; to Antarctica for albatrosses, petrels, and shearwaters; to Brazil, where his tour leaders regularly spot more than a thousand species on an eight-day trip. But near the end of April, those who admire Emanuel as much as they admire any rare bird will spot him at High Island, initiating inexperienced birdwatchers into the delights of spring migration on the Texas coast.

High Island got its name from the underlying salt dome that pushes a crown of trees up above the surrounding marshes. It is not strictly an island but an elevated and wooded stretch of mainland at the point where the first bridge east of the Galveston Bay mouth crosses the Gulf Intracoastal Waterway to the Bolivar Peninsula. In the spring, when the Neotropical songbirds are flying across the Gulf of Mexico and looking for place to spend the night, High Island is a haven at the end of a long journey. During spring migration, from late March until the end of May, several thousand birdwatchers—not just from Texas but from all over the world—descend on three preserves maintained by the Houston Audubon Society. Although together amounting to only 173 acres in size, the preserves constitute one of the most famous birdwatching locales anywhere, known both for the variety of birds and for the ease of observation.

One of the reasons Victor is considered such a premier birding guide is that he has lost none of his enthusiasm for seeing birds and teaching others about them even though he has been leading professional tours for more than twenty-five years. He is as likely to exclaim over the pure whiteness of a great egret as he is to delight in the subtle coloration of a difficult-to-identify sandpiper. If the painter Roger Tory Peterson can be credited for giving birdwatching its great boost with his field guides of the late 1930s, Victor Emanuel must be credited for turning bird-watching into an international touring attraction. Each year, Victor Emanuel Nature Tours visits every major region of the world, and at this writing the company grosses more than $3 million a year.

The viewing stand in front of Purkey's Pond is an ideal place for a newcomer to begin birdwatching at High Island. The bleachers can hold as many as fifty people on wooden benches; good binoculars over old field clothes are the norm. The migrants need a drink, and they use the pond to wash off six hundred miles of salt air from the trip across the Gulf of Mexico. High Island is also a place where they can eat. Neotropical birds—those native to the tropics of Central and South America—need a forest with a thick understory loaded with insects and fruit. It is the need for such food, which becomes scarce during the North American winter, that sends the birds south each year.

New birdwatchers should not be intimidated. Most experienced visitors are helpful to anyone struggling to identify the pond's birds. Most important, keep quiet. This is not a place for general conversation. However, a noticeable murmur erupts from the stands when a new bird, one not previously seen that day, drops in for a drink—perhaps a redstart, or a painted bunting, or a summer tanager. And then someone points up, indicating another new arrival, and so it goes.

Victor's group, having spent the morning in the marshes of Anahuac and the shallow Bolivar Flats looking at shorebirds, devoted the afternoon to the migrants at Purkey's Pond. An ovenbird, a plump warbler with an olive back and white breast striped with black, poked around the mud at the edge of the viewing area. It would not stay long in Texas but would head north to familiar summer grounds in Canada, the Midwest, and the Northeast. Others came in: a Tennessee warbler identified by its buff breast, a Canada warbler with bright yellow breast and "spectacles"—an eye ring and eye stripe. Both were headed for Canada, but a Kentucky warbler that came in was headed for the South and Northeast.

All afternoon, Victor sorted them out, showing his party the difference between a veery and a wood thrush. Some birds are easy, of course, such as the brilliant red male summer tanager. But the female is harder; she is a dull yellow green, not nearly as bright as the painting in the bird book. It helps to have a live person as a guide. One can easily get lost searching on one's own for a match in the field guide. The small migrant flycatchers are difficult even for experts to identify, but Victor does not need a second glance.[1]

Birdwatchers come from around the world to visit High Island, the Anahuac National Wildlife Refuge, and the Bolivar Flats. Scanning the Anahuac marshes in winter is a reliable way to see numerous kinds of waterfowl.

The trees of the Boy Scout Woods at High Island are renowned for sightings of a wide range of songbird species, especially during spring migration. From mid-March to late May the woodland canopy at this Houston Audubon Society sanctuary is alive with migrants pausing to rest and feed.

High Island is one small part of the vast ecological capital of the Texas coast. When landscape architect Charles Tapley and I were teaching together at Rice University, we became intrigued by the abundance of ecological resources that existed in and around the Houston area. We developed the map in figure 3, which shows that Houston is surrounded by fabulous ecological systems, systems that bring world-class birdwatchers such as Victor Emanuel back time and again.[2] To the east of Houston are Sabine Lake and the coastal chenier prairies and marshes of the refuge complex managed by the U.S. Fish and Wildlife Service. South of Houston are Galveston Bay and the marsh systems that surround it as well as the barrier islands with their beaches and flats where millions of shorebirds gather. The Columbia bottomlands, a great coastal floodplain forest, lie along the Brazos and San Bernard rivers and extend northward into the prairies west of Houston and along the coastal plain. To the north of Houston pine forests and extensive floodplain forests line the San Jacinto and Trinity River systems. Even the biologically unique Big Thicket is within an hour and a half of Houston.

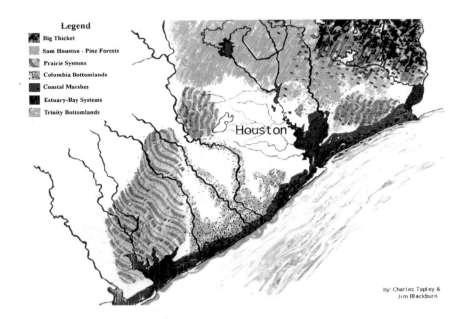

by: Charles Tapley &
Jim Blackburn

Figure 3.
The Houston region is surrounded by an amazing variety of ecological systems, as depicted on this map by architect Charles Tapley. This ecological capital provides excellent outdoor recreational opportunities that are not as yet widely recognized or appreciated.

We on the Texas coast live in a natural paradise and do not know it. Charles and I prepared this map because a similar one did not exist. These assets are scarcely recognized or utilized. Houston has the kind of capital—ecological capital—that most progressive areas of the United States covet; yet we do not appreciate it. To some extent, I think this is a function of our heritage; when the economy is based on extraction, people avoid becoming attached to what might be destroyed. And our dismissive attitude is also partly a function of our harsh summers and our aversion to sweating when virtually every home has air conditioning. Most residents of the Texas coast live a life detached from the natural setting, though it is one of our greatest attributes.

We live in a time when money and value are synonymous, when corporations, which exist only to make money, rule Texas if not the country. My instinct is to search for and discover values that are not monetary, to argue for the incorporation of knowledge and ethics into our view of value, especially of the Texas coast. Yet I know that if we could generate money from our ecological capital, preservation arguments would be heard better and sooner. So what is the money-making potential of this capital?

A group of friends and I decided to explore the ecotourism potential of one of the more obscure coastal jewels, Smith Point. Jutting out into the Galveston Bay complex from the east, Smith Point separates Trinity Bay from East Bay. It is the end of the road—to get there, you have to mean to be going there.

There is no better place for oysters in the United States than Smith Point. The Galveston Bay system produces about two thirds of the Texas oyster harvest

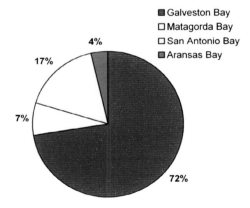

Figure 4.
Percentage of the Texas oyster harvest from each bay system. Galveston Bay far outstrips the others. The four bays represented account for all but a very slight percentage.

Sacks of oysters ready for shipment. The Texas oyster industry sends much of its production to the East Coast of the United States to supplement diminishing production there.

(fig. 4), and the waters off Smith Point are the most productive in this system.[3] Two of the men who know most about these waters and the oysters they produce are Joe and Ben Nelson. The Nelsons are third-generation oystermen whose grand-father came to Smith Point in the early 1900s. Their father opened an oyster house in 1924 and taught Joe and Ben how to work the bay. The boys started in the business when they were seven or eight years old, selling oysters to their teachers. Now the family oyster business runs eight boats over sixty-seven acres of prime oyster reef leased from the state through the General Land Office.

I first met Joe Nelson at a hearing on the widening and deepening of the Houston Ship Channel in the mid-1980s. I was opposed to it, as were many others. All of a sudden, a voice boomed across the room from the microphone. I turned and saw a man with a red, chiseled face and swept-back hair, speaking eloquently about the importance of the bay and what would happen to the oysters of Galveston Bay if the ship channel were widened and deepened and if the dredge spoil were dumped into the open bay, as was proposed by the U.S. Army Corps of Engineers.

As a major oyster producer, Galveston Bay serves as a backup for its more famous cousin, Chesapeake Bay. But Chesapeake Bay production has fallen in recent years due to the many environmental problems there, and now Joe and Ben send refrigerator trucks of oysters to Maryland, the state famous for its oysters. "Maryland and Virginia are fished out by November to December," Joe says. "Now, as many as 40 percent of the oysters eaten on the East Coast come from the Gulf states: Texas, Louisiana, Alabama, and Mississippi." It seems almost a miracle that not twenty miles downstream from the world's largest petrochemical complex, not far from the nation's third busiest port, oysters are thriving and healthy. Yet they are.

The harvest for Texas in 2000 was over 6 million pounds of oyster meat valued at over $14 million.[4] Smith Point hosts eight major oyster shippers and produces some 250,000 sacks a year, three hundred oysters per sack. The dockside value of a sack of oysters is twenty-five dollars. But consumers will ultimately pay a lot more in restaurants when they buy a dozen on the half shell or fried for ten to fifteen dollars.

The oyster reefs off Smith Point extend across the bay to Eagle Point on the populated western shoreline. Before the Houston Ship Channel was cut through the mass of shell that separates upper Galveston Bay and Trinity Bay from the lower bay, cattlemen used to drive their stock to the other side of the bay through the shallow waters over the reefs. Those days are long past, of course, and now as we contemplated how to use the oysters and their reefs, my friends and I wondered if they could be turned into an ecotourism attraction.

Late on an April afternoon, Ben Nelson's oyster boat pulled up at the dock in front of his Spoonbill Lodge and R.V. Park. This was a working oyster dredge, one that had been hauling up oysters for sale only hours earlier. Ben had cleaned it up

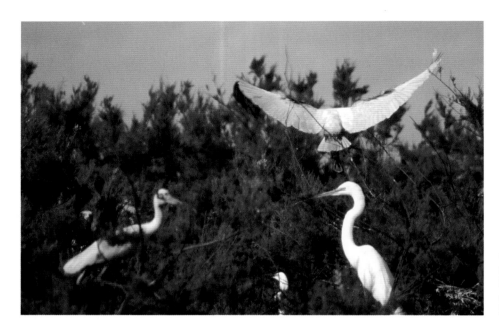

A great egret looks up as a roseate spoonbill lands behind it on Smith Point Island. Note the green eye patch of the egret and the gold on the spoonbill tail. Photograph by Jim Blackburn

and had placed a few plastic chairs on the deck. This was what we had requested— we wanted to experience oyster dredging.

Our band of ecotourists piled aboard the plank-railed boat, some claiming the chairs, some standing along the rails. We listened to Sammy Ray, professor emeritus at Texas A&M Galveston, talk about the oyster, the organism he has spent his life studying and never tires of discussing. Sammy is an excellent speaker and kept us chuckling with his description of oyster sexuality. Oysters are able to change sex during their lifetime, and they produce a tremendous quantity of eggs. The oyster is nothing if not a prodigious breeder. But then again, it has to be. Life is tough for an animal stuck in one spot, and the oyster cannot move once its larva has settled and starts building its shell.

Ben gave the order to slow down and bring up some oysters. We stood clear of the chains as the metal rods and chain-link basket went over the side about halfway between the bow and the captain's cabin. The chains let the basket down into the water, and the boat pivoted as the dredge engaged the bottom and the oysters. After dragging the basket for a minute or two, Ben ordered it brought up.

Two strong deck hands winched the basket up and emptied about fifty oysters onto the sorting table. Ben sent the basket over the side a second time, and another fifty spilled out onto the table.

As we motored over to a bird rookery, the next stop on our tour, Ben and Sammy pulled on their gloves, got out their oyster knives, put the red sauce and crackers on the table among the oysters, and started shucking. Sammy lectured

and shucked and Ben smiled and joked as their skillful knives opened shell after shell and we lined up to send raw oysters down our gullets. Sammy had assured us that while oysters can make people with liver or immune system problems sick, only about fifteen people are affected each year. He believes them to be basically safe.

Sammy is the state's leading expert on the most serious disease that faces the oyster, an infection known as dermo, which has been his life's work. After building up a marine biology program at Texas A&M at Galveston, Ray retired at age seventy, only to continue working at his lab late into the night. His latest project is "Dermowatch," a web site that tracks the condition of six public reefs and three oyster leases in Galveston Bay.[5] Each month, Texas Parks and Wildlife agents bring oysters to Sammy's lab, where he examines specimens under a microscope for the tiny black dots indicating that dermo has infected the oyster. Heavily infected specimens are dense with the black dots.

By carefully monitoring the degree of infection and the salinity of the bay water, Sammy can calculate how many days he believes are left before the oyster reef will succumb to dermo. In the spring of 2000, in the third year of a drought, almost every oyster reef in Galveston Bay had a life expectancy of zero. The problem was lack of fresh water.

Oysters need a mix of fresh and salt water. Too much fresh water can inhibit their ability to feed, but too much salt makes them vulnerable, not only to dermo but to the southern oyster drill, a predatory snail commonly called a conch. Conches are scarce when salinity is low but thrive in more saline waters. Conches devour the oyster after drilling a hole into the shell and they may deposit tough, fibrous egg casings on the shell. "I look at salt water as a skull and crossbones," says Ray. "We need a damned good flood occasionally to flush out the parasites and predators. The key to the future of oysters on the Texas coast is freshwater inflow."

As the rush on the oyster table died down somewhat, a rush to the railing began amid gasps and exclamations of joy and wonder. We had arrived at the rookery on Smith Point Island. A rookery is a place where birds nest and congregate each day, and the Texas coast has many fish-eating bird rookeries. This one was on an island formed by dredge spoil disposal and the action of the currents. The bare sand on the eastern end was dotted with brown pelicans, terns, and gulls. The island widens toward the middle and is covered with salt cedars.

As we neared the salt cedars, long necks rose up to see what was coming. There were white and reddish brown heads of the egrets, black heads of the cormorants, purple and blue heads of the herons, black and white heads of the night herons, and the large pink heads of the spoonbills with their long flattened bills giving them a quizzical look.

The birds were nesting, and they were packed into the rookery, wingtip to wingtip. A roseate spoonbill flew, exposing the gold band across its tail. The brilliance of the gold tail against the pink feathers literally glowed in the soft afternoon

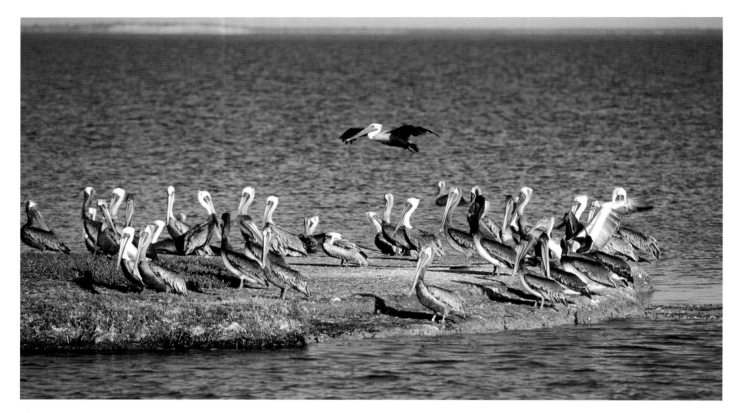

Brown pelicans use islands in Galveston Bay for nesting and resting.

sun. A great egret turned to one side, showing off the green patch around its bill and eye. Great puffs of white feathers fanned out from a displaying snowy egret. A white plume extended back at a jaunty angle from the purple head of a tricolored heron. Birds in their breeding outfits and behaviors are spectacular, and they were putting on quite a show—not intended for our benefit, but we felt lucky to be watching.

The protection of these breeding islands falls to Joe Whitehead, a big man, with large hands and thick fingers, and bowlegged from years of minding cattle on horseback. Joe is an almost-retired veterinarian who first worked as a warden for the National Audubon Society when he was in college. He still performs this task at the island we were viewing as well as two others at Smith Point and another near Rollover Pass across East Bay.

Whitehead says he no longer has as many problems with people disturbing the nesting birds as he once did. For the most part, the signs he posts declaring the nesting islands "No Trespassing Zones" seem to work. But there was a time when people took the eggs for food and baited crab traps with the helpless chicks.

Smith Point Island, where we viewed the birds, is the biggest of the islands under his care. It is only fifteen to twenty acres, much of it covered with salt cedar about four to five feet high. There have been as many as 4,500 ibis in this little spot. Fully 3,000 pairs of Sandwich and Forster's terns have nested here. The island is too far offshore for raccoons and coyotes to reach it, making it ideal for the nesting birds. Once in a while though, a dog swims out and wreaks havoc, and that is where Joe Whitehead comes in, protecting the birds.

Another island Whitehead tends is home to 250 pairs of skimmers, birds that simply make shallow scrapes in the sand or shell and sit on their "nests" until their young are fledged. Near Rollover Pass, a good thirty miles away, he has an island of two to three acres favored by fifty pairs of pelicans that come in early and claim the best pieces of scrub. That tiny spot will harbor 300 pairs of great egrets, 250 snowy egrets, and 200 pairs of spoonbills. The rookery islands are in great demand during breeding season.

In the fall, starting in late September, thousands of migrating hawks pass over Smith Point, funneling down to the last tip of land before striking out over the water. Back in the 1960s, Whitehead recalls migrations of thirty and forty thousand birds. He has seen monarch butterflies passing through, three thousand in an hour, during their fall migration to Mexico. And he has watched a flock of two to three hundred blue jays set out in the fall across the bay, only to reconsider and come back.

On the spring afternoon when we enjoyed the fruits of Joe Whitehead's labor, it was hard to imagine a better place to be than relaxing on Ben's oyster boat with Ben and Sammy shucking oysters and all these birds right off the bow. We moved slowly down alongside the island, with nesting birds constantly offering new and beautiful views of their antics. As the salt cedars ended, the sand continued. Two oystercatchers sat peacefully on the sandbar. A herring gull brooded over our intrusion. More than a hundred white pelicans rose off of the western end of the island, black wingtips and white bodies washed in the light of the setting sun, peaceful and calm, putting a little space between us.

A pair of oystercatchers loaf on an oyster reef.

That night after a dinner of fried oysters, oyster soup, and baked fish, we went out to gaze at the stars. Five planets were lining up. Lee Kaufman, the high school–aged son of two members of our party, set up a telescope and showed us the rings of Saturn, which I had never seen.

The next morning we studied the ecology of the bay. Our guide was Terrie Ling, the Chambers and Jefferson County marine agent. Terrie works with Joan Walker and the Waterborne Education Center, which had provided the boat based in Anahuac and had put our program together.

Terrie pulled out a seine, and she and I carried it out into the shallow water beside the dock at the lodge. Ben Nelson's twenty-room lodge, with its home-cooked meals and great hospitality, sits on a channel that the oyster boats use to

go to and from the oyster reefs. There are marshes nearby, but the area that Terrie and I were seining was featureless shallow water with a mud bottom.

A seine is a net suspended from two poles. The net has floats on the top and lead on the bottom. The idea is to pull the lead-weighted net along the muddy bottom, scooping up the organisms there, while also capturing swimming organisms below the floats. I took the swing end and walked out beyond Terrie, then back toward shore. As we approached the shoreline, Terrie and I pushed the leaded bottom in front of the float and pulled the net out of the water.

It was amazing what was in the net. Shrimp were everywhere, three different types—brown, grass, and pistol. There were baby flounder, anchovies and mullet, and tiny blue crabs. There were nonstinging jellies. The net was full of living things, yet we could see almost no evidence of life looking into the water from shore.

We pulled the seine again, this time next to the marsh grass, and again we captured hundreds of baby shrimp and anchovies. We also caught a larger crab. Terrie lectured for several minutes about crabs and how they molt, or lose their shells, as they grow. She talked about how they can regenerate a claw in three molts, sometimes in as little as three weeks with good conditions. She had our full attention, except when we were swatting mosquitoes. Then we boarded the Waterborne Education Center boat.

The Chambers-Liberty Navigation District bought two former coast guard buoy tenders to be converted into floating classrooms. In turn, these boats were leased by the Waterborne Education Center to take out school children and teach them about the bay. Terrie put on her headset to amplify her voice and started talking about the bay as we motored out. She told us she might talk to us like she did to the fifth graders she usually had on board. We assured her this was probably the right level for her presentation.

One goal of the boat trip was to pull a trawl. The Trinity River had been at flood stage the previous week and the bay was fresh. We measured the salinity off of Smith Point at two parts per thousand where it is usually fifteen. The Gulf of Mexico has an average salinity of about thirty-two parts per thousand. We dropped the trawl into the water and pulled it up ten minutes later. There was virtually nothing there, a disappointing four croakers.

And then we put out the plankton net, a much smaller net with very fine mesh. This time our goal was to collect the tiny organisms that make up the base of the bay food chain. Microscopic plants called phytoplankton take sunlight that is unusable to humans or finfish or shellfish and transform it into plant material that can then be eaten by other organisms.

Most of us have no idea how much plant material is created within the bay system. An estuary like Trinity Bay produces as much plant material as a rain forest, as do marshes and algal beds and reefs.[6] This production of plant material occurs through photosynthesis, the basic building block of ecosystems.

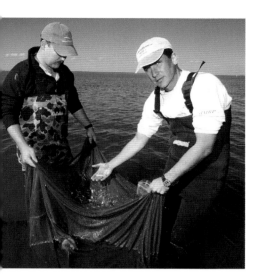

Two seiners reveal their catch. A seine is an excellent way to understand the nursery function of an estuary. By dragging this net in the shallow waters of a bay or marsh, educators reveal to class members the great variety of juvenile fish and shellfish to be found in our nursery during much of the year.

Perhaps most important, whereas all of this plant material is stored in trees in a rain forest, the plant material created in the bays is used immediately. It moves up the food chain, eaten by zooplankton, oysters, mullet, anchovies, and baby shrimp. That is what creates life in the estuary.

Of all of the facts about bays and estuaries, this is probably the most important and the least well known. Estuaries take carbon dioxide out of the air and create plant material in the bay waters. These floating microscopic plants then provide the food that supports the chain of life within the bays of the Texas coast. Without these microscopic plants, there would not be as many mullet, shrimp, crabs, menhaden, and anchovies. Without these smaller organisms, there would be many fewer gamefish than we currently have.

If we lose these small organisms, we will also lose the flounder, the trout, and the redfish. The food chain is like a pyramid. It takes a large base to support a small tip. The trout and redfish and flounder are near the tip; the plankton is the base. Without the base, the tip will fall, a reality of food chain ecology.

Our plankton net had been out for just a few minutes when we brought it in. Terrie directed us to wash it into a large jar. As the bottom of the net was untied, hundreds of baby fish fell into the tub. Most of these were bay anchovies with a scattering of other species. The jar looked like gumbo, and there was more to it than baby fish. There were all types of plankton, turning the water cloudy. The cloudiness was not pollution or sediment—it was life.

As we wound down our ecotourism weekend and prepared to leave Smith Point, we asked everyone for some feedback on the experience. Almost every person on the trip already had some knowledge of the bays, yet we all learned a good deal from the guides who took us out. All participants indicated that they would be willing to pay for an experience like this. The question was how much, and would this be enough to support a tourism industry on Smith Point?

I am a firm believer that anyone interested in learning about the Texas coast should pay someone for an introduction to the ecology and the special places. Fishermen and hunters have long recognized the value and benefits of paying guides to take them out, but it is a new concept to pay a guide for birdwatching or kayaking or bay study. A guide will have a seine for introducing people to tiny animals, for example, and will know the seasons of the birds' nesting activities and which times serve best to beat the heat or keep mosquito encounters at a minimum. If we are going to have a thriving ecotourism business on the Texas coast, we need to pay for it.

As we were coming in from the boat trip, my teaching partner Charles Tapley came over and put his arm around my shoulder to talk about the wonder of the bay. He talked about how he—a man who knows much about the coast—had learned new things and how he wished that everyone who lives here could have the same kind of experience. I share his grand hope that all of us on the coast can find ways to enjoy it, to know more of its riches and majesty and intricacy.

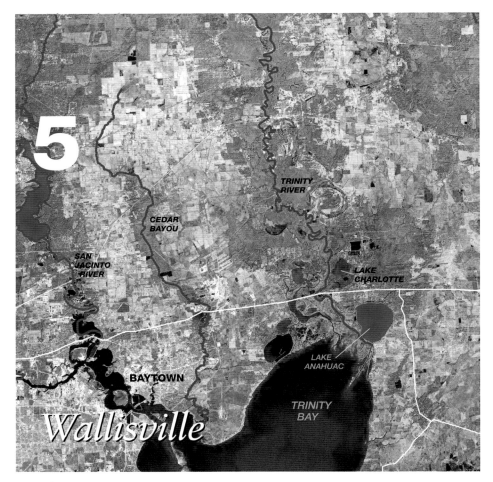

5

TRINITY
RIVER

CEDAR
BAYOU

SAN
JACINTO
RIVER

LAKE
CHARLOTTE

BAYTOWN

Wallisville

LAKE
ANAHUAC

TRINITY
BAY

Interstate 10 bisects the Trinity delta. The large lake south of I-10 on the right is Lake Anahuac, a freshwater reservoir that was part of the bay system before being converted into a water supply facility. Lake Charlotte and much of the area that would have been inundated by the Wallisville Reservoir is immediately north of I-10. On the far left of the image are Lake Houston, a major water supply source for the City of Houston; the San Jacinto River; and the lower end of the Houston Ship Channel industrial complex.

For a little town that saw its heyday a century ago, Wallisville is a place with a lot of resonance among Houston environmentalists. The fight over the Wallisville Reservoir was one of the longest, most serious environmental disputes on the Texas coast. The original proposal was to construct a dam where the Trinity River runs into Trinity Bay, the northernmost lobe of the Galveston Bay system. Wallisville was and remains prime habitat. Wallisville was a fight over swamps and marshes and freshwater inflow. But it was also a fight to change the way things were done on the Texas coast, the first of a number of actions that would make this coast a better place for people and other living things.

I got involved in the Wallisville controversy in the mid-1980s, sitting second chair to Ray Berry, the attorney for the environmental petitioners against the creation of this reservoir to provide water for the City of Houston. This was the first time I had ever been into a judge's chambers and witnessed the dialogue that occurs behind closed doors, when the lawyers turn on each other. I watched Sharon Mattox, an excellent attorney with the Houston law firm Vinson and Elkins, firing verbal arrows into Ray and me faster than any human being I had ever met

before. I did not know then that Sharon and I would face off over and over again for two decades.

By the time I got involved, the Wallisville Reservoir project and the litigation surrounding it had changed considerably from the early 1970s, when the litigation was filed. At that time, it was the first important case on the Texas coast filed under the National Environmental Policy Act (NEPA), the law that Congress passed in 1969 to require the federal government of the United States and all of its many agencies to consider the impacts of their actions on the environment before they decided whether to proceed with a project. The act was intended to add environmental protection to the mandate of the agencies but not to make it the dominant issue. This was an act that required balancing, and it specified the procedures to be followed in trying to achieve a balanced outcome for a range of interested parties.

NEPA requires that an environmental impact statement (EIS) be prepared for all federal actions significantly affecting the environment. In accord with this law, the Corps of Engineers prepared an EIS on the Wallisville Reservoir in 1970, even though the project had already been approved and construction had begun prior to the passage of NEPA. The Corps had been working on this reservoir for years at the request of the Trinity River Authority, a state-created watershed agency, and the City of Houston, the entity needing water. The city and the river authority had worked together in the late 1950s to construct Lake Livingston on the Trinity River to provide water for Houston's future growth. The Wallisville Reservoir was designed as a companion project to Lake Livingston, to increase the yield of urban water supply. Wallisville was the next step in the implementation of the plan to provide water for the booming metropolis.

In 1971, the Sierra Club, Environmental Defense Fund, Houston Sportsmen's Club, Houston Audubon Society, and Texas Shrimp Association combined forces to file suit against the Corps of Engineers, alleging that the EIS on the Wallisville Reservoir was inadequate. This was a historic alignment in which commercial fishermen, recreational fishermen, and environmental groups joined together to act for the benefit of the bay system. The lawsuit alleged that the Corps was not telling the truth about Wallisville's impacts and that the project was actually part of a much larger scheme, the Trinity Barge Canal, intended to bring barge traffic inland to the Dallas–Fort Worth area.

The Wallisville case was important for several reasons. It was the first to raise the matter of how reservoirs interfere with freshwater inflow into our bays and estuaries. Until NEPA and its EIS procedure, there was no mechanism under Texas law to get this important issue heard. Scientists had known for a long time that the problem was important, but the court system, based as it is upon precedent, is poor at addressing new concerns unless specific legislation is passed. Had it not been for Congress and NEPA, this issue could not have been raised.

The Wallisville case also involved habitat that was related to the health of the bay. For the most part, the wetlands of the Texas coast are grass meadows, low and thick. However, in the river deltas and on the upper coast, there are extensive areas of forested wetlands that are flooded for most or all of the year. These forested wetlands are called swamps. Wallisville was a place of water, forests, *and* grass meadows, a place where they came together.

The acreage of swamps and bottomlands along the Texas coast is substantial (fig. 5). Sabine Lake has an incredible 82,000 acres of swamps. The next highest amount is found in the Galveston Bay system, which has about 36,000 acres, much of it concentrated in the vast cypress swamps around Wallisville on the Trinity River. Farther south, the swamps are rare and the floodplain bottomlands predominate. Matagorda Bay has 16,000 acres of bottomlands spread around several of its smaller tributaries, and San Antonio Bay has approximately 6,400 acres, primarily at the Guadalupe Delta Wildlife Management Area. Aransas and Corpus Christi bays and Laguna Madre barely register floodplain bottomlands.[1]

The photosynthesis within these swamps and floodplain bottomlands surrounding our bays is another source of carbon—the basic building block of life—for the bay system. The Wallisville Reservoir was to be built where the cypress and tupelo gum swamp met the coastal marshes and Trinity Bay—the westernmost cypress swamp in Texas. The area where the reservoir was to be located was a prime nursery for shrimp, crabs, and baby finfish. Ecologically, it was a unique place worth fighting for.

At the time that the reservoir was proposed, ecological characteristics were not considered in the equation of where and how federal projects were constructed. That was why NEPA was so important—it forced the federal agencies and the courts to consider these concerns. And by the trickle-down effect, it made the good old boys who ran the river authorities and their engineers and contractors consider these characteristics too.

Distinctive ecological systems are a form of capital—they have value, for today and particularly for tomorrow. They are the key to the future of the Houston region, in my opinion. Our economy is changing. Employers can choose among many different locales. They are not bound to oil fields or waterborne commerce. And employers are all looking for attributes in a locale to attract and keep high quality workers. The Texas coast can compete with any place in the United States in terms of resources and outdoor opportunities, but we have to recognize this capital and value it. The fight over Wallisville Reservoir was a fight to start valuing local ecological capital.

In 1973, Judge Bue, a Houston federal judge, wrote a massive legal opinion of more than a hundred pages regarding the Wallisville project. He tore into virtually every aspect of the "full disclosure" document prepared by the Corps and stopped the project by issuing an injunction against continued construction. At

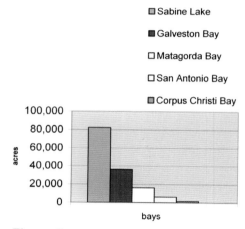

Figure 5.
Swamps and flooded bottomlands surrounding five Texas bays. Sabine Lake has more than twice the swamp acreage of any other bay.

The cypress swamp at Wallisville in the Trinity River delta was a focal point in one of the most important environmental fights on the Texas coast. This swamp and associated *Spartina* wetlands adjacent to the bay were saved by a combined effort of environmental groups and recreational and commercial fishermen in a dispute that lasted more than twenty years.

that time, the reservoir project was 72 percent complete; the land had been condemned and a levee was almost built. The Fifth Circuit Court of Appeals later modified portions of Judge Bue's decision but left the injunction in place.

It is difficult to understand the power of a federal judge until you see one in action. With Wallisville, one day construction was proceeding on a major dam project that would kill over 19,000 acres of swamps and wetlands and nursery. The next day all work was stopped, and men who had sworn that no one would stop them were very confused. Things would never be the same again on the Texas coast.

A victory under the National Environmental Policy Act does not guarantee that a project will not be built. All that is required under NEPA is for the agency concerned to evaluate the impact of the project fully and fairly, to disclose its impacts in the EIS, and to consider alternative ways of completing the project with less environmental impact. The agency is not required under NEPA to adopt the least environmentally damaging alternative, but Congress clearly intended that agencies look for ways to avoid or minimize environmental harm if this could be accomplished while still meeting a project's goals.

An aerial view shows the Trinity River at flood stage, crossing the marshes just south of the now-defunct Wallisville Reservoir and pouring into Trinity Bay. Freshwater inflow is critical to the health of our bays. The maintenance of these inflows represents one of the primary conservation priorities on the Texas coast. The larger water body at the top left is Lake Anahuac, a freshwater reservoir. The town of Anahuac is on the dry side of Lake Anahuac.

Thus while NEPA can lead government officials to water, it cannot make them drink. However, an enlightened official can take the information from an EIS and use it in the decision-making process. The hope and promise of NEPA is that we will have decision makers trying to make the best use of this information.

As fate would have it, an excellent district commander of the Galveston District of the Corps of Engineers, Colonel Jon Vanden Bosch, came along during the period when the Corps was trying to meet the requirements of Judge Bue's decision. District commanders also have tremendous power; a good one can make vast improvements, while a bad one can hurt the coast for decades into the future. Jon Vanden Bosch was a good one.

Colonel Vanden Bosch fully understood the basic message of NEPA that environmental impacts were to be avoided if possible and that alternatives must be considered. The central issue that he examined was the hydrologic function of the Wallisville Reservoir. Why was it being proposed?

When one starts studying this question, it becomes clear that the major function of the Wallisville Reservoir was not to provide water from the reservoir itself but to stop salt water from flowing up the Trinity River. In turn, Wallisville

was directly related to the operation of Lake Livingston, which had been constructed during the late 1950s and early 1960s. The key issue arose from Texas water law. When a dam is permitted and creates new water rights, downstream holders of water rights must be protected. When Lake Livingston was constructed, it impounded much fresh water that would previously have flowed down the river to the bay. By restricting the flow, Lake Livingston was taking out of the river some of the water that had prevented salt water from coming up from the bay during times of low flow, endangering water rights holders below the dam.

The interim solution was to release water from Lake Livingston to force the salt water back into the bay during low flow times. While this solution worked, it reduced the amount of water that could be relied upon from Lake Livingston. By constructing the Wallisville Reservoir downstream of Lake Livingston near Trinity Bay, the movement of salt water up the river could be stopped without releasing additional water from Lake Livingston, thereby increasing the lake's yield.

Vanden Bosch recognized that the size of Wallisville Reservoir was relatively unimportant and that the most important issue was to stop the saltwater movement up the Trinity River. Vanden Bosch also knew the seriousness of the environmental dispute, and he wanted to find a fit between the project and the environment. By 1979, when the new draft EIS was issued, Wallisville was a different project. Instead of a 19,600-acre reservoir, Wallisville was now proposed as a 5,600-acre reservoir. Rather than flooding the marshes and forests on both sides of the Trinity River, this new proposal would flood the forests only on the east side of the river, a major change for the better.

The compromise Vanden Bosch was suggesting did not solve the environmental dispute. Cypress trees cannot reproduce when they are covered with several feet of standing water year-round. These trees need periods of low water, as in the natural fluctuations of river levels, in order for young trees to establish themselves so that the forest persists over time. The 5,600-acre Wallisville Reservoir would still trap carbon and sediment behind the dam, an important negative impact to the bay. What Vanden Bosch did, however, was to admit that a 19,700-acre reservoir was not necessary to provide the City of Houston with its full allocation of water from the Trinity. Environmentalists and fishermen criticized him for not going far enough, but he certainly took a bold first step, one that countered the prevailing mind-set among the engineers and water providers along the coast.

The project proponents were not sure that the revised plan and EIS would be approved by the court. As a result, they went to Congress to try to exempt Wallisville from the NEPA process, in an effort to ensure that the environmental groups would lose. In fact, Congress passed legislation putting a stamp of approval on a document called the Supplemental Information to the Post Authorization Change Report, which came to be known as the SIPACR (pronounced "cypacker")—a document prepared by the Corps after Colonel Vanden Bosch

moved on. Congressional action on the SIPACR essentially reauthorized Wallisville and stated that Congress had seen and approved the environmental documentation, arguably ending review under NEPA.

The environmental community was furious over this turn of events, and by 1986 the Wallisville project was back in federal court. The Corps was petitioning Judge Bue to lift the federal injunction, and environmentalists were complaining that the impacts of the smaller reservoir on the swamps and wetlands and the loss of freshwater inflow to the bay had not been fully or fairly reported. It was at this point that I joined the legal team of the environmentalists. In retrospect, I don't think I helped Ray much, but I sure learned a lot. Ray was an excellent trial lawyer who put on a strong case, and Judge Bue was extremely concerned over the congressional end run on NEPA.

Judge Bue refused to lift the injunction, stating his continuing concern about the project's impacts and about the procedures followed by the Corps, the Trinity River Authority, and the City of Houston in getting congressional reauthorization of the project. In his written opinion, Judge Bue stated that a higher court would have to sanction the behind-the-scenes maneuvers of these agencies, because he had doubts about their legality. In 1987, the Fifth Circuit Court of Appeals sanctioned what Judge Bue would not and lifted the injunction against the Wallisville project.

There are highs and lows in litigation. There is no deeper low than to have fought for years to preserve a resource and failed. But in this case, we lost due to the political power of the lobbyists for the Trinity River Authority and the City of Houston. Someone had gotten a congressman and a senator to "fix" things, and it hurt.

Then the bald eagles came onto the scene—a magnificent pair discovered nesting at Lake Charlotte, in the heart of the 5,600-acre project area. By this time, I was the lead attorney on Wallisville, following Ray, who was burned out after years of hard work and little pay, fighting against the government lawyers and Vinson and Elkins, powerful adversaries who were excellent legal practitioners and well connected politically. But even big-time politics would not be sufficient to overcome an endangered species.

In retrospect, it felt as if some higher power were working to protect the swamp and the bay. As word of the nesting eagles spread, a collective moan went up from the supporters of Wallisville. The Fifth Circuit had approved the 5,600-acre lake for construction, but no document had considered the impact of the lake construction on the eagles and their nesting site. Everyone involved knew that the lake could no longer be constructed as planned.

Once again Wallisville was changed. The Corps determined that an even smaller lake would suffice, one that was 2,000 acres in size rather than 5,600. But by this time, the central question became: why was a lake necessary at all? It had become clear that the water supply yield was not coming from the impoundment itself, with the lake changing from 19,600 to 5,600 to 2,000 acres. Instead, the

benefits were from the lake's interference with salt water moving up the river, preventing the need for releases from Lake Livingston. Why couldn't the Corps simply construct a saltwater barrier and block the flow of salt water up the river?

Ultimately, the Wallisville Reservoir project changed again, this time to include only gates that would close to stop the inflow of salt water. The net impact of these gates when closed was estimated to be a one-foot rise in the elevation of the river, and it appeared that negative impacts to the cypress trees could be avoided. Not all environmentalists were happy with this solution. Some wanted no structure at all and the continued release of water, some worried that reproduction would still be harmed, but from my perspective, it was a victory—the habitat had been protected.

Unfortunately, the Wallisville fight had revealed a much larger problem, one that was implicit in the role of the saltwater barrier. While we made great headway in protecting habitat, the issue of freshwater inflows for Trinity Bay was looking bleak, because the major impacts to Trinity Bay were most likely to come from the full operation of Lake Livingston rather than from Wallisville. Lake Livingston had already been constructed and was full at the time the Wallisville fight began. The most important issue, in my mind, was trying to gain some protection for Trinity Bay, not from the operation of Wallisville (which we had addressed) but from the operation of Lake Livingston.

Lake Livingston is a sleeping giant from an impact standpoint. Lakes are built long before they are needed. The City of Houston has used only a small fraction of the water in Lake Livingston. Even in the early part of the twenty-first century, extensive use of Lake Livingston water has not yet occurred. When Lake Livingston is pulled down as water is used, the lake will absorb floods as it fills up again, and that water will not get to Trinity and Galveston bays, where it is needed.

Historically, the Galveston Bay system has received a tremendous amount of freshwater inflow, with the largest amount of this inflow from the Trinity River going into Trinity Bay. Sabine Lake receives an average of over 12 million acre-feet, while the Galveston Bay system receives over 10 million acre-feet per year (fig. 6). The drop-off in inflow as one moves down the coast is substantial, with Matagorda and San Antonio Bays receiving on the order of 2 million acre feet per year.[2]

What the Wallisville fight demonstrated to me was that there was no system in place in Texas that was looking at these inflows and making sure that we were providing sufficient inflows for the future. Bays and estuaries have not been granted water rights under the existing Texas water law system, although that could change in the future if enough citizens came forward asking for this protection—when we finally act upon the realization that these freshwater inflows are vital to the long-term health of our bays and estuaries.

An estuary is a place where fresh and salt water come together, and it simply will not function without sufficient freshwater inflow. Fresh water brings nutrients and sediments that underpin the entire system, fueling the phytoplankton that we

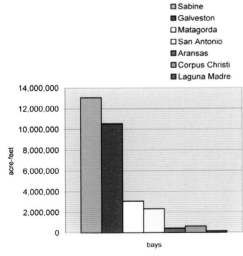

Figure 6.
Annual average freshwater inflow to the bays, based on Texas Water Development Board hydrology data.

caught off of Smith Point. In the ecological systems along our Texas coast, freshwater inflow is a defining element. Remove it, and we will lose the rest.

By the time the Wallisville Reservoir fight became a fight over a saltwater barrier, it was clear to me that some type of process was necessary to address the whole idea of freshwater inflows. Conventional wisdom held that we did not need to be concerned about the volume of inflows during times of plenty but that we needed to concentrate on the inflows during drought times. I agree with this position to an extent, but I also believe that big floods are an important and defining aspect of our estuaries. We should manage water in a manner that respects the rhythms of the coast and tries to emulate them.

Toward this end, we have moved from a focus on yearly flows to monthly flows, which is a real improvement because inflows to our bays vary considerably at different times of the year, as seen in figure 7.[3] The bays of the upper, middle, and lower coasts not only have distinct levels of inflow but also show a sequence of peaks and troughs representing times of relative flood and drought in a dependable annual pattern. I am not sure that we understand the estuarine ecology well enough to make the right decisions about how much or how little inflow each bay will get in the future. Yet, if we fail to try, I believe the results of inaction would be worse.

This philosophy shaped the final settlement on Wallisville, a written agreement between the City of Houston and the Galveston Bay Foundation, a private nonprofit group dedicated to protecting Galveston Bay for all uses. In this agreement, the City of Houston recognized the right of Galveston Bay to receive freshwater inflows from the Trinity River and agreed to study and recommend actions to ensure that freshwater inflows for Galveston Bay would be sufficient to support marine productivity.

After the 1996 Wallisville settlement, a group called the Galveston Bay Freshwater Inflows Group, or GBFIG (pronounced "gibfig") was formed. It meets every month to discuss the health and future of the bay. This group of about forty people includes environmentalists, natural resource agency personnel, water development authorities from Austin, the City of Houston, and even officials from the Dallas–Fort Worth area, all trying to understand the need for and ramifications of dedicating fresh water to Galveston Bay. In the past, water was considered wasted if it went into the bays, but that is no longer the case.

Under its mission statement, GBFIG's four main tasks were to establish itself; to obtain the necessary background information; to conduct analyses to determine the requirements and inadequacies of various levels of inflows (Brown and Root conducted these studies for the group); and to assess the feasibility of various management strategies. The group addresses not just the needs of the bay system but also the socioeconomic and institutional constraints on inflows and is discussing how to handle the inevitable periods of shortage. GBFIG may or may not ultimately be a solution for Galveston Bay. It has, however, created a dialogue

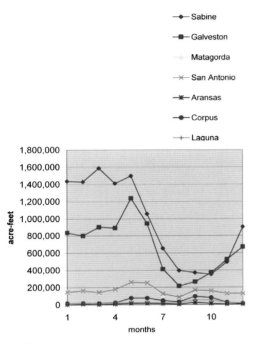

**Figure 7.
Freshwater inflow to the bays by
month.**

and has succeeded over a period of years in maintaining a focus on freshwater inflow. There is no question that freshwater inflow for the bay is now an issue that must be addressed.

We are fortunate in the Galveston Bay system. There is a lot of inflow from our various river systems. We are not at a critical point yet, although we must understand the impact of Lake Livingston and take it fully into account in our water planning. From that perspective, GBFIG and the settlement coming out of Wallisville can be viewed positively, as an important first step in the dialogue on inflows. But it is not the end of the discussion, only the beginning.

What we need on the Texas coast is a philosophy that places water for the bays at the same level of significance as water for development, and our concept of development should incorporate maintenance of our coastal resources, or coastal life. The Wallisville story is a case study in the philosophy of the alternative, an approach to decision making that embraces the impartial identification and evaluation of alternative ways of meeting project goals and purposes. Wallisville did not have to be a reservoir, and in the end it was not a reservoir—a triumph of reason over simplicity and complicity. While Wallisville may not be a perfect project, it is surely better than almost any other similar project on the Texas coast.

Litigation is not the ideal method of decision making. On the one hand, it could not address the problems created by Lake Livingston but only those at Wallisville. On the other hand, it saved the habitat of the Trinity Delta and left the system functioning as before. Today, a saltwater barrier crosses the Trinity River just south of Interstate 10. It is a simple gate structure that closes to prevent salt water from moving up the river. The dam partially constructed in the 1960s is being dismantled. The land condemned for the proposed 19,600-acre reservoir is now a public recreational area, managed by the Corps of Engineers.

I like to take my kayak and put in on the Trinity River just under the I-10 bridge. I paddle upstream about a quarter of a mile and turn into the cut-off that takes me to Lake Charlotte, the site of the bald eagles' nest that doomed the Wallisville Reservoir. As I move away from the river, the swamp closes in around me. When the spring floods have retreated, the land is just visible above the water, covered with small green plants and vines that live below the towering cypress and tupelo. Up ahead, a night heron may rise lazily, moving to a pond within the emerging land, stealthily tracking crawfish in the backwaters. I may catch a glimpse of a small yellow bird flitting in the trees above, the bird my father saw in Louisiana and called the swamp canary, the prothonotary warbler.

The cypress trees in Lake Charlotte are magnificent, their buttressed trunks merging into the water, their feathery green leaves fluttering in summer breezes. I feel privileged to be able to go there, floating through places that were once given a death sentence, an ecosystem that I fought to protect, an ecosystem that remains to greet future generations. On our planet of life, one small battle has been won.

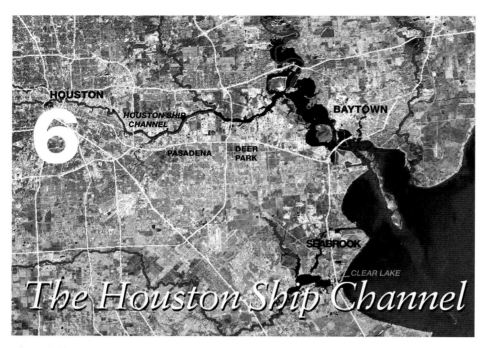

6

The Houston Ship Channel

The Houston Ship Channel complex extends from near downtown Houston eastward. Buffalo Bayou and the San Jacinto River were dredged to allow deep-draft navigation up the channel to service the refining and petrochemical complex that is now virtually continuous between Interstate 10 to the north and State Highway 225 to the south. Reaching for a distance of approximately twenty miles, this is one of the largest industrial complexes in the world. The Houston Ship Channel empties into Galveston Bay.

The Reverend Carla Valentine Pryne (then Carla V.

Berkedal) gaped silently as we slowed to a crawl above the Houston Ship Channel late one night, inching over the Beltway 8 Bridge connecting Channelview to the north with Deer Park to the south, east of downtown Houston. On a clear night such as this, the lights of the petrochemical plants stretch endlessly in both directions, punctuated by the fire-breathing towers that send flames into the air sporadically, sometimes in pulses, sometimes like an eruption, bearing witness to the chemical reactions occurring in the lighted towers and columns.

"This looks somewhat like what hell might," said the Reverend Mrs. Pryne with a twinkle in her eye. "I would sure hate to live down there."

"Down there" was the Houston Ship Channel petrochemical complex, one of the largest in the world. The landlocked portion of the channel extends from the center of Houston eastward down Buffalo Bayou and the San Jacinto River to Baytown, where it enters Galveston Bay and connects with the Gulf of Mexico and oil exporting countries around the world. Shell, Lyondell, DuPont, Atofina, Dow, and ExxonMobil are here, some of the more prominent names among the several hundred chemical plants and refineries that line the channel dredged nearly to downtown Houston. It is an exhibition of technology—raw modernity revealed from the Beltway 8 Bridge.

The Reverend Carla Pryne was in town for the DeLange-Woodlands Conference on sustainable development at Rice University and had spoken earlier in the day about spirituality and the environment, about Christian theology and environmental protection, how the two are one and the same. She had stunned the audience of technical types with her clear and coherent message and her intensity. For an Episcopalian, she presented a lot like a Baptist.

Her message had been about stewardship, about the need to protect the Creation and all of us within it. Creation theology is based upon the biblical statement that God created the earth and "it was good." It begs the question: who are we to change this earth? Pointing out that this same God ordered Noah to save the species, Creation theology focuses upon stewardship, a concept of care and concern for our common dwelling place, keeping in mind those who come after us. She had spoken of freedom from pollution and other scars upon the Creation. Her message included concern about false idols, about worship at the altar of materialism. And she was good.

Sustainable development will emerge as one of the most important ideas of the twenty-first century, combining economics and ecology and social concerns into a coherent blueprint for the relationship between humans and the environment as well as our relationship with one another. Another speaker at the conference, the economist Herman Daly, has written of "empty world" and "full world" thinking, about the fact that we are today living in a world that is rapidly filling up with people and human impacts, yet we are living by a set of principles and theories that were developed when the earth was relatively empty of people and their impacts.[1] The most critical issue now facing us is making this transition to full world thinking. Sustainable development is the concept that can build a bridge between the empty and full worlds, and the spirituality of which Carla Pryne spoke is an important buttress to that bridge.

Looking down upon the ship channel complex sprawling for ten miles in each direction, she was as dumbstruck as the audience who had heard her earlier that day. From our vantage point, the concept of sustainable development—the integration of economics and ecology for a healthy relationship with our planet—seemed a distant dream. When you can taste the air, when your eyes tear from the pollution, the incorporation of stewardship in a meaningful fashion into day-to-day life in Houston seems far away.

Oil is the basic raw material that fuels these complexes. The Houston Ship Channel complex traces its origin to the Humble and East Texas oil fields. Pipelines later linked West Texas fields with the coast. Over time, artificially dredged deepwater channels allowed deep-draft tankers to bring foreign crude to the Texas coast. Refineries built in the 1920s, '30s, and '40s for Texas crude are now being supplied by Kuwait, Saudi Arabia, Venezuela, and others. Without the dredged channels, deepwater vessels would be unable to enter Texas coastal waters, which naturally average about ten feet in depth.

Oil refining is a dominant presence on the Texas coast. Texas coastal refineries represent 4.5 percent of the world's refining capacity.[2] A strip of land approximately three hundred miles long and thirty miles deep produces almost 5 percent of the world's gasoline, diesel, fuel oil, and other refinery products (fig. 8). This is more refining capacity than exists in the entire continent of Africa and just slightly less than the refining capacity of the Middle East or of Central and South America combined. That is a lot of refining capacity in a relatively small area. And it represents a lot of political power in a state such as Texas.

This production is spread up and down the coast, as shown in figure 9, with refineries often in towns out of sight of the national eye—Sweeney in Brazoria County; Pasadena, Deer Park, Channelview, and Baytown in Harris County on the Houston Ship Channel; Texas City in Galveston County; and Beaumont and Port Arthur in Jefferson County. The regional production is noteworthy: the Beaumont–Port Arthur area represents 1.1 percent of global refining capacity, the Houston–Galveston area 2.3 percent of global production, and the Corpus Christi area 0.7 percent of global production.[3] But this immense capacity comes with a price, and part of that price is the disturbing expanse of metal, fire, and smoke along the ship channels, aided and abetted by the associated chemical production.

The growth of refining on the coast was followed by the growth of petroleum-related chemical production. Refineries produce gasoline and many other petroleum by-products, such as naphtha. Olefin plants use naphtha or ethane to produce ethylene, from which polyethylene is made, as well as propylene. Polyethylene is the world's most common plastic, used to make products as diverse as garment bags, trash bags, container lids, housewares, stretch wraps, waste containers, disposable diapers, shipping racks, pails, toys, bottles, food packaging, and merchandise bags.

Ethylene and propylene are the basic building blocks of the modern petrochemical complex, and the Texas coast has 17.4 percent of the world's production of ethylene (fig. 10). Most of this coastal capacity is centered in the Houston area, where over 11 percent of the world's ethylene is produced, much of it in plants visible from the Beltway 8 Bridge. The distribution of production capacity for propylene is similar but with an even more pronounced local concentration (fig. 11). The Texas coast represents 24 percent of the world's production of propylene, with the three-county area around Houston producing 17 percent.[4] Much of this production is also visible from the Beltway 8 Bridge.

The Houston-area petrochemical complex, however, is built on more than ethylene and propylene. The Texas coast hosts 21 percent of global production of butadiene and 24 percent of global production of acrylonitrile, two other important building blocks for chemical processes. Again, the Houston area in particular remains at the center of this production, representing more than half of the total coastal production of these two chemicals.

What does it mean to live in a relatively small area where a significant portion of the world's chemical production and refining occurs? For one thing, it means money. Acrylonitrile production alone is worth over $340 million per year and butadiene production rings up at $625 million. Ethylene production is worth $4.8 billion per year, while propylene production yields $2.8 billion. These numbers do not incorporate the value of any derivative products. This is just the spot market value as of April 4, 2001, of these four chemicals produced in Harris, Galveston, and Brazoria counties.[5] Within the entire petrochemical complex, there are perhaps a hundred or more major products manufactured. The plants represent a lot of money, jobs, and immense political power: industrial capacity larger than that of many industrialized countries and even entire continents. This power is often focused on the Texas Legislature.

Chemical and refining industry also means pollution. In 2000, over 22 million pounds of toxic air pollution were reported as released in Harris County, which consistently ranks among the top counties in the United States for toxic air releases.[6] All these releases were legal, but a City of Houston study in 1999 revealed that fine particle air pollution in Houston was at dangerous levels. The study concluded that approximately 435 people die prematurely each year from this kind of pollution.[7]

■ N. America w/o TX Coast
□ Africa

□ Central, S. America

■ Eastern Europe, Former USSR
■ Far East, Oceania

■ Middle East

□ Western Europe

Figure 8.
World refining capacity, 2000.

And these chemical complexes affect the water as well as the air. Like the Sabine-Neches waterway, the Houston Ship Channel and Galveston Bay were heavily polluted by the late 1960s. David Zwick and Marcy Benstock, writing in 1971, had this to say: "In addition to being the most polluted waterway in the U.S. and probably in the world, the [Houston] Ship Channel may also be the most talked about. Cabinet Secretaries and their assistants, Presidential commissions and local politicians vie with one another in lamenting the sorry state of the water. To date, however, no one has seen fit to apply the sanctions necessary to clean it up."[8]

State control of water pollution in Texas dates back to 1961, when the legislature authorized the first wastewater permits. One of the senior environmental lawyers in Houston chuckles as he remembers this permit system. He described the system as "a true permit to pollute." The industries simply had to identify what they were currently discharging and submit that information to the state, and a permit was issued allowing that amount. The lawyer told of handling one of the first enforcement cases for a client who had miscalculated his pollution and exceeded his own estimates. The company could have asked for more and gotten it. They just didn't.

The fight over the cleanup of the Houston Ship Channel and Galveston Bay in the early 1970s was vicious, with the new federal agency, the EPA, lined up against the industries, the City of Houston, and the state agency then called the Texas Water Quality Board (TWQB). In two early enforcement cases, the TWQB intervened on the side of industry, against the EPA. A 1971 study of Galveston Bay found that the Texas Water Quality Board's "performance during its years of operation has been marked by overweening concern for the health and welfare of the commercial and industrial interests. The background and associations of the

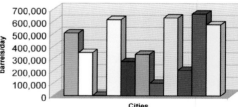

Figure 9. Refining capacity of Texas cities, 2000.

Figure 10. World ethylene manufacturing capacity, 2000.

Figure 11. World propylene manufacturing capacity, 2000.

lay members may be one reason. The Board has never had a member who could be identified with a special interest in conservation or the environment. Of the five appointed by the Governor since 1967, nearly all have been associated with business and industry."[9]

The Galveston Bay Enforcement Conference of 1971 was actually the first big fight to save the bay. At the time more than half of the bay was closed to shellfishing, and the EPA charged that the state was being less than forthright about the rest. The EPA called the conference to put an end to pollution in Galveston Bay, and their bottom line position was that there had to be a limit set on the pounds of waste that could be dumped in the bay. As reported in the *Houston Post*, Hugh Yantis, the executive director of the TWQB, told the EPA: "You're simply standing in the way of Texas' progress." Murray Stein of the EPA responded: "I don't think anyone has tried to do that since Santa Anna."[10]

The conference adjourned in June and did not reconvene until November, when an eleven-point cleanup plan was presented and ratified. Among other things, this plan set a limit on the amount of degradable organic waste (oxygen-consuming pollutants deriving mainly from inadequately treated sewage and called "biochemical oxygen demand," or BOD) that could be discharged into the Houston Ship Channel. The limit was set at thirty-five thousand pounds, substantially less than the several hundred thousand pounds that were then being discharged into the system.

The discharges of toxic materials directly from industrial sources into the bays remain enormous. Over 16 million pounds per year have been going into the Gulf of Mexico off Brazoria County. Discharges from Harris County into the ship channel and Galveston Bay have been the second highest at more than 6.8 million pounds, followed by Jefferson, Nueces, and Galveston counties, each with over a million pounds per year in 2001.[11]

In addition to the direct industrial discharges, over 50 million pounds of industrial pollutants were sent to publicly owned treatment works for treatment and discharge into coastal waters, mostly into Galveston Bay. Permits allow a certain number of pounds per day of toxic discharge from these plants. Collectively, these direct and indirect discharges of toxics into Galveston Bay could approach 10 million pounds per year.

Existing and past discharges have taken their toll. The 2002 List of Impaired Waters registered PCBs and pesticides in fish tissues in the Houston Ship Channel. Dioxins were also found in fish and crab tissues, and portions of the upper bay where it meets the channel are closed to crabbing and oyster harvesting due to dioxin contamination, mainly from paper and vinyl chloride production. Heavy metals are found in sediments above Morgan's Point.[12] Patrick Bayou in the heart of the channel was designated as a Superfund site in 2002, becoming the second estuarine Superfund site on the Texas coast. Lavaca Bay on the midcoast was the first.

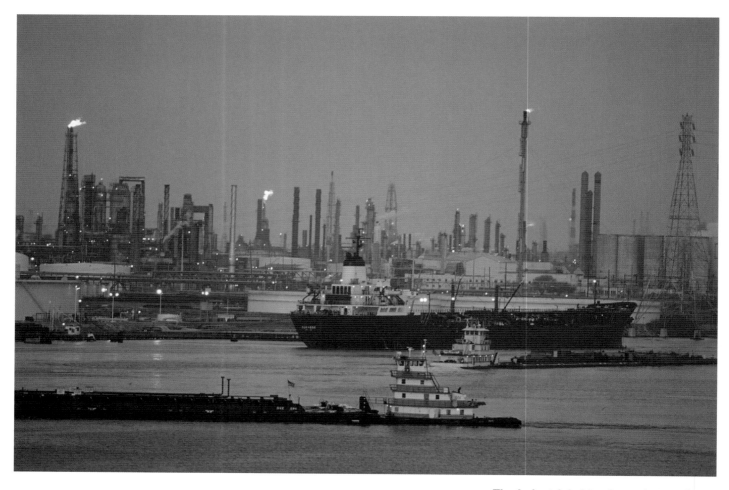

The industrial ship channel at work. Although emissions of plant wastewater into Galveston Bay have declined significantly due to federal intervention, large quantities of toxic pollution are still released into the bay—as much as 10 million pounds a year, most of it in Harris County along the Houston Ship Channel.

All of these chemicals represent health hazards to people who consume them in seafood, and the areas affected take in much of the upper portion of Galveston Bay, including Black Duck and Burnett bays and the Bayport channel. So although we have gone a long way in reducing the worst of the impacts, there are still considerable volumes of toxic pollutants that continue to enter the Galveston Bay system.

In looking back at the heavy pollution of the 1960s and 1970s, a reasonable question arises: how did the bay survive? Certainly many areas were lifeless, such as the landlocked portions of the Houston Ship Channel. However, the resiliency of our coastal bays is amazing, and much of Galveston Bay survived because it is shallow, and in winter our strong north winds can literally blow the water out of the bay, removing up to 50 percent of its volume. This, along with major infusions of fresh water in the spring and early summer, provide excellent circulation, flushing the dangerous chemicals into the Gulf through the pass between Galveston

Island and the Bolivar Peninsula. The physical form of Galveston Bay and our climate helped preserve it until the federal government mandated the cleanup.

Yet that physical form created problems of a different sort. As already noted, like most Texas bays, Galveston Bay is shallow, with an average depth of less than ten feet. Starting after the Civil War, the Houston promoters pushed for construction of a navigation channel to connect Buffalo Bayou, which runs through downtown, with the Port of Galveston and the Gulf of Mexico. A twenty-five-foot-deep channel was opened around 1915, and by the late 1920s oil and chemicals had replaced cotton as the primary product moved through this channel. The channel was subsequently expanded to forty feet deep and four hundred feet wide, a cut extending more than twenty miles up the Galveston Bay system.

In the late 1980s, a major fight erupted over plans to widen and deepen the Houston Ship Channel. At the urging of the Port of Houston Authority, the U.S. Army Corps of Engineers, the federal sponsor of the ship channel, proposed to deepen it from forty to fifty feet and widen it to six hundred feet. This modification would have more than doubled the cross-sectional area of the channel cut, due to slope at the sides. In turn, this larger cross-sectional area would have allowed much more salt water to come into the bay from the Gulf, increasing the level of salinity along its path.

A coalition of interests formed to oppose this project, including recreational fishermen, commercial fishermen, environmental groups, yachters, and business people who loved the bay. After a series of meetings at Rice University, this group incorporated as the Galveston Bay Foundation with the goal of "protecting the bay for all of its uses." The Galveston Bay Foundation worked hand in glove with members of the Texas Parks and Wildlife Commission, including the commissioners at the time, George Bolin, Dick Morrison, Ed Cox, and Bill Wheless, to oppose the project.

The fight over the widening and deepening of the channel ended in a compromise, a major victory for the bay. Rather than a 50-by-600-foot channel, the compromise mandated a channel 45 feet deep by 530 feet wide, which extensive analysis by computer models had determined to be acceptable because it cut the cross-sectional area of the channel in half. Rather than covering 10,000 acres of the bay with eight feet of discarded dredged material called spoil, the Corps agreed to find beneficial uses for this material, placing it in contained areas, planting more than 5,000 acres of salt marsh, and creating nesting islands for fish-eating birds.

The combined efforts of the Galveston Bay Foundation and the Texas Parks and Wildlife Commission, as well as other state and federal agencies, caused the Corps of Engineers and the Port of Houston Authority to negotiate, to compromise. It would not have happened without opposition, without a willingness to fight. It would not have occurred if individuals such as George Bolin and Dick Morrison had not been willing to take on the power structure within the Houston community.

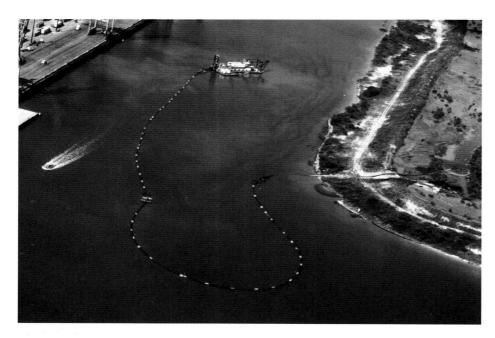

Maintenance dredging of the Houston Ship Channel is virtually constant. The barge contains the mechanical equipment that powers underwater cutting and suction systems. "Spoil" material from the bottom is pumped into a contained disposal area (at right). The deepwater channels along the Texas coast fill in with silt and require maintenance dredging to remain open. In many areas along the coast, significant disputes exist over the dumping of the dredged material into our bays. Photograph by Jim Blackburn

The concern about the widening and deepening of the ship channel had been based on problems involving salinity and dredge spoil disposal. The disposal issue is easy, although not inexpensive, to solve. However, the salinity issue was merely addressed for the short term and certainly not resolved. Indeed, the principal reason that the widening and deepening to 45 feet by 530 feet was acceptable was that there is currently sufficient fresh water coming into the bay to offset the resulting increase in salinity. If these freshwater inflows do not continue, then all the models and the assumptions on which they were based become invalid.

So we come full circle. Salinity and freshwater inflow and the depth of the channels that connect the bays to the Gulf are all related. They need to be considered together in a holistic manner. New proposals are forthcoming for yet another round of deepening of the channels to accommodate larger container ships. Yet more water is being taken from the Trinity River upstream, in Dallas and Fort Worth, even as we discuss what to do. Texas has not evolved a system of management that protects our coastal resources. The federal government saved our Texas bays in 1972 with the Clean Water Act but does not appear to be inclined to step in to mandate a comprehensive management system for our bays. The cavalry is not coming to save the fort.

We Texans are on a path whereby the full costs of our projects—our water supply, our shipping channels, our water pollutants—are not being paid today. Instead, the costs imposed today will be paid by the citizens of the future, much as we are now bailing out Florida with restoration of the Everglades and Arizona

and California on Colorado River diversion projects. Such an approach is hardly fair to future generations, passing our unpaid bills on to them, yet we seem unwilling to address these issues in a substantive manner today. Our most pressing need is to find a different way of thinking about economics and ecology, one that is serious about protecting life on our living planet, one that provides for an accounting of the full cost of our current activities.

I have been asked many times why we invited an Episcopal priest like Carla Pryne to speak at a conference on sustainable development. Isn't sustainable development about science and economics? Why would we muddy up these technical subjects with spiritual mumbo jumbo? We need hard science, not soft sentiment, suggested some of the people in attendance.

But as a society, we also need a moral compass, some type of ethical and spiritual base to balance our thinking about development and science and economics. If nothing else, we must bring integrity to the decision-making processes, integrity that science and technology alone have not provided. That is why Carla Pryne was invited to speak—because if we look into the future to the changes in thinking that will be necessary, it is difficult to see such changes occurring without a spiritual or religious dimension. Only through spiritual insight of some kind can large numbers of people be moved to think in Herman Daly's full world terms rather than in empty world terms.

In her presentation at Rice University, the Reverend Mrs. Pryne talked about Christian revisionist thinking, about humans and our relationship to the natural system. Catholics and Baptists, Methodists, Presbyterians, and Episcopalians—all of these denominations and many others representing about 90 percent of Christians now explicitly recognize environmental and ecological concerns in their theology.[13] Reverence for life and living things is a key principle of this emerging theology. This is different than the Baptist tradition in which I was raised and from which I fled.

Carla Pryne talked about stewardship, the concept that people have been given the role of trustee over the earth and all within it, of care and concern for one another as well as for nonhuman living things. Stewardship requires a commitment to principles and values—to ethics. Humans are trustees over important gifts: our communities and our earth. Environmental justice is part of this emerging theology, making the case that all sectors of the community should be equally free of pollution. It is an attempt to ensure that the weak, the politically disenfranchised, do not receive more pollution, or more floodwaters, because they lack the power to defend themselves in the political process.

These and many more elements are being developed in the new Christian theology. However, for the most part, the ecotheology and environmental justice messages are missing from the pulpits and sanctuaries and churches of Houston. That is why Carla had been invited to speak.

In addition to continuing cleanup of water pollution and legacy pollutants left in the sediments, the stewardship issue of the future will be management of the salinity, the most insidious coastal pollutant. It combines concern for maintenance of freshwater inflow and minimizing salt water coming in from the Gulf through our deepwater shipping channels. Salinity is a hard issue. Our bays are estuaries, places where salt and fresh water come together and mingle; they represent a balance between the two. And where a balance exists in nature, humans have great potential to cause harm.

To protect this balance, we Texans need guidance. The Reverend Carla Pryne and the emerging ecotheology offer one type of guidance. Given that large numbers of our coastal population are card-carrying Christians, the potential for change implicit in this new theology cannot be overlooked or overstated. I welcome this voice. I hope it is heard, for we are in dire need of responsible stewards.

Young sailors enjoy competing on Galveston Bay. The Clear Lake area on the west side of the bay is home to one of the largest fleets of sailing boats in the United States.

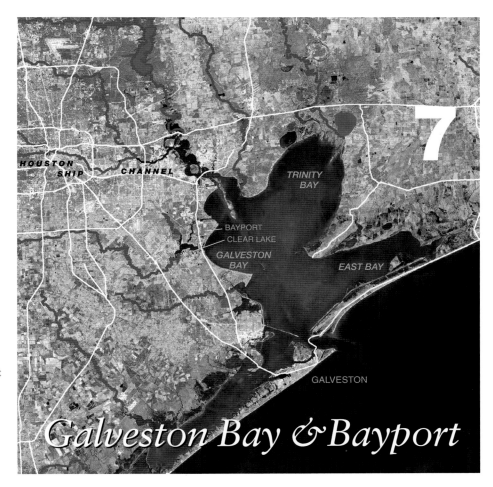

Galveston Bay & Bayport

The Galveston Bay system has about 3.5 million people surrounding it, primarily on the west side. State Highway 146 runs along the west shoreline from Baytown at the top right to Texas City at the bottom center. The Houston Ship Channel was dredged from the Gulf of Mexico through the pass separating Galveston Island and the Bolivar Peninsula (called Bolivar Roads) and then northward through the bay to near downtown Houston.

Skimming along in a large sailboat always got my attention. It is exhilarating, even scary. I like the idea of being powered by the wind; I like the freedom of independence from fossil fuel. Above all, I like the quiet.

Walter Duson taught several of us about sailing. He grew up in El Campo and spent much of his youth on Matagorda Bay and its tributary Carancua Bay, where his family had a house at El Campo Beach. Like many others, he moved to Houston for work, in his case as an architect. And like many others in Houston, he looked to Galveston Bay for recreation, for quality time. For Walter, sailing was it.

The Clear Lake area is the sailing and recreational center of Galveston Bay. Formed where Clear Creek, Armand Bayou, and Taylor Bayou come together, Clear Lake is a protected secondary bay off Galveston Bay proper and is an excellent anchorage for recreational vessels. Today the Clear Lake area ranks near the top in the United States in terms of number of sailboats. It is a recreational paradise right next door to NASA's Johnson Space Center.

Walter kept his boat at Watergate Yachting Center on the south side of Clear Lake. We would motor down the Kemah channel, cross beneath the old drawbridge that once spanned the channel where State Highway 146 now boasts a

high-level bridge, and pass the commercial shrimp boats and restaurants of Seabrook and Kemah. Today the south side of the Kemah channel has been transformed into a carnival, with a Ferris wheel and other glitter entreating visitors to visit the Kemah Boardwalk and eat at Joe's Crab Shack or Landry's or other restaurants owned by Tilman Fertitta. When we sailed with Walter, the place was much simpler and, to my mind, better than it is today.

Walter married my wife's sister Liz, about the time that we moved to Houston and I entered graduate school at Rice University in the early 1970s. We had no money, but we did have Walter, and he would take Liz, my wife Garland Kerr, and me sailing any time we wanted to go. This was my introduction to Galveston Bay, how I first came to know these waters, sailing with Walter and Liz and Garland.

A magical moment comes when you enter the bay and unfurl the sails. The main is pulled straight up along the mast and the jib is pulled up a guy wire extending from the bow to the top of the mast. The motor is cut; silence envelops the boat. You hear the wind, first playing with the sails, and then the sails tighten and fill, white wedges against the water and sky. You feel the wind taking over, powering the boat forward. Walter would take the wheel, immediately seeking the edge, the line where the boat and the wind were most efficient, smiling the devilish smile of a man happier than the law allows.

Sailing hinges upon the art of the practical. The wind is in control—it is your power source and your director. You can sail downwind, but you cannot sail directly into the wind, and that is what makes sailing interesting. You must often glide away from your destination in order to reach it by coming about, rearranging yourself in relation to the wind so that it will push or pull you to where you wish to be.

Sailing with Walter was about friendship and a shared enjoyment of the outdoors. It was about watching birds, fish, and fishermen as well as learning the force of the wind and water. Once Walter took us sailing out of the bay and down the coast. We started out in Galveston Bay and ended up at Port Isabel on Laguna Madre. The first leg was from Galveston Bay to Freeport along the Gulf Intracoastal Waterway, also called the intracoastal canal. We had sailed out of Galveston Bay around the Texas City Dike and into West Bay and were heading south when the sky before us turned black. Before we knew it, a thunderstorm had caught us in the open waters of West Bay, and seventy-mile-per-hour winds ripped at the sails, which we lowered as quickly as humanly possible. Walter turned the boat downwind and put out a sea anchor, and we came to rest at the edge of the channel, scared out of our wits. Later we motored down the intracoastal canal to the marshes outside Freeport to spend the night, watching black skimmers dipping their beaks in the calm water of the marsh at sunset. We escaped belowdecks from the swarms of mosquitoes that closed in after dark.

After the interruption of a week's work, we returned to Freeport by car to resume our boat journey, heading south through Matagorda and Espiritu Santo

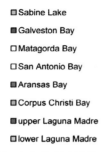

☐ Sabine Lake

■ Galveston Bay

☐ Matagorda Bay

☐ San Antonio Bay

■ Aransas Bay

☐ Corpus Christi Bay

■ upper Laguna Madre

☐ lower Laguna Madre

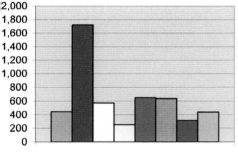

Figure 12.
Fishing pressure on the bays by recreational anglers, in man-hours per year. Galveston Bay far outstrips the others because of its large human population. The total for all the bays is more than 5 million man-hours.

Nothing makes a fishing trip like catching a nice redfish. The Galveston Bay system is the recreational fishing capital of the Texas coast. Surrounded by more than 3.5 million people, it provides excellent fishing, year in and year out.

bays. We sailed past the Aransas National Wildlife Refuge to Port Aransas on the barrier island, where we docked and were joined by more friends for the sail south through Laguna Madre on the Intracoastal Waterway. We swam in the hypersaline waters of Baffin Bay, so buoyant that we floated with ease. We watched coyotes fish in the shallow water of the Land Cut between the King Ranch and Padre Island, leaping and grasping, paws and snout working together for a meal. Sailing with Walter was my first intimate experience with these Texas coastal bays, and it made a lifelong impression. It was one of the events that led me to settle in Houston and become concerned about aspects of the local bays.

Galveston Bay is the recreational center of the Texas coast. Surrounded by over 3.5 million people, it is heavily used by residents of every type and description. Recreational fishing is not evenly distributed along the coast. As one might expect, the highest fishing pressure is adjacent to the largest population center. This pressure can be measured in man-hours, the number of hours people report spending on the bay for the purpose of fishing. Galveston Bay leads all bays in fishing usage, with over 1.5 million man-hours of fishing pressure per year. Laguna Madre follows, then the Aransas, Corpus Christi, and Matagorda systems. Sabine Lake and San Antonio Bay have the lowest use, as illustrated in figure 12.[1] In this survey, there were over 5 million man-hours spent fishing on the coast.

Interestingly, the success ratios of the anglers are similar, despite differing fish populations and numbers of fishermen. Another measure of bay usage is the "catch per unit effort," which is the number of fish, or number of pounds of fish,

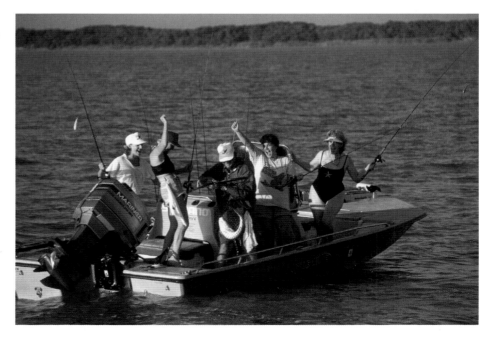

caught for each hour a person spends fishing. Galveston Bay exhibits the highest catch per unit effort, at just over 0.4 fish per man-hour of fishing. Next, in order, are Sabine Lake, Matagorda Bay, Laguna Madre, and Corpus Christi and San Antonio bays. Aransas Bay is lowest at 0.25 fish per man-hour (fig. 13). These data include all fish landings on private boats and do not discriminate on the basis of size of fish, merely number.

A significant economy has developed around recreational usage of Galveston Bay and other estuaries. A study for the Texas Sea Grant Program reveals the tremendous impact of recreation on the bays. Travel expenditures for recreation associated with the bays were over $866 million for the Texas Gulf Coast (fig. 14). The impact of these expenditures sends ripples through the surrounding communities. The total regional economic impact of the expenditures is over $1.5 billion. In addition to economic activity, recreational usage of the bays creates jobs, especially in the service sector. In the Gulf Coast region, over thirty-two thousand jobs are attributed to recreational usage of the bays.[2]

Fishing is a vital recreational activity on the Texas coast and is responsible for 43 percent of the total recreational travel expenditures already identified, or almost half of that $866 million. In addition to spending for fishing trips, gearing up for anglers means acquiring the best lures, rods, and reels that come on the market; many anglers also purchase boats, trailers, and fancy electronic fishing devices. Direct expenditures of this kind by saltwater fishermen in Texas totaled $887 million in 1996—higher than all recreational travel expenditures. The overall economic impact of these direct expenditures for saltwater fishing, again because of the ripple effect, balloons to an amazing sum—over $1.9 billion—in the Texas economy.[3]

In this light, Galveston Bay is clearly a wonderful recreational treasure and resource, something well worth fighting for. And we will have to fight for it year after year. The recreational benefits are dispersed over many small enterprises, everything from bait camps to boat stores, from fishing shops to beer joints. Marina owners such as Johnny Valentino at Eagle Point Marina have had to fight industrial and port-related proposals that never take bay-related recreation into account. In the early 1980s after the ravages of Hurricane Alicia, Johnny and others defeated the proposal by Houston Lighting & Power to abandon their damaged bayfront cooling towers and instead use Galveston Bay as a cooling pond at the Robinson electrical plant south of Kemah. Now Johnny and his neighbors on Galveston Bay have again been forced to act to protect the recreational use—the fishing use—of Galveston Bay.

The evening was cold and dreary as we assembled in front of the George R. Brown Convention Center in downtown Houston for a Corps of Engineers hearing on the proposed Bayport container port. The hearing was in December of 2001. For more than three years a dedicated group of bay residents had been

☐ Sabine Lake
◼ Galveston Bay
☐ Matagorda Bay
☐ San Antonio Bay
◼ Aransas Bay
☐ Corpus Christi Bay
◼ upper Laguna Madre
☐ lower Laguna Madre

Figure 13.
The catch per unit effort by bay system expresses comparative fishing success. Despite significantly higher recreational fishing pressure than on other bays, Galveston Bay has the highest CPUE.

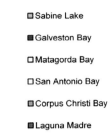

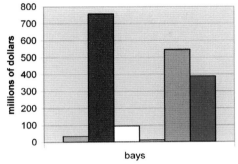

Figure 14.
Regional economic impact of bay-related recreation, 1995. In travel expenditures for recreation associated with the bays, Galveston Bay is far and away the leader.

opposing the Port of Houston Authority's plan for this enormous new port. Containers are metal boxes, approximately ten feet high by ten feet wide by twenty or forty feet long, designed to hold goods of all kinds. Containers can be moved by ship, by rail, and by truck, making them quite efficient for moving products from fabrication point to seaport and then, at the import end, from seaport to distribution to the consumer.

The Bayport container port was proposed by the Port of Houston Authority to be the second major container port on Galveston Bay. The plan involved building it on approximately eleven hundred acres of land along the western shoreline of the bay between the cities of Seabrook and Shoreacres, adjacent to the Bayport Industrial Channel, a spur off the Houston Ship Channel.

Container ports are a relatively new phenomenon, exploding onto the commercial scene with the spread of globalization. Today, the garments made in China and the shoes made in Indonesia, along with multitudes of other items of international commerce, travel the world in steel boxes stacked atop each other on container ships, the stacks standing ten to twenty boxes high and ten to twelve across the beam of each ship. Boxes are delivered to ports, where they are unloaded by immense cranes onto waiting trucks and trains for distribution to commercial outlets throughout the United States. The movement of containers has grown substantially over the last decade, leading to a scramble by U.S. ports to develop sufficient capacity to handle this increased trade.

The growth of container ports is one of the less well known manifestations of globalization and certainly one of the most poorly researched and understood. The needs of these container ports are significantly different from those of historic port usage. Ultimately, container ports depend upon excellent road and rail infrastructure. The goal is to move goods off ships and into the hinterlands as fast as possible. This is not a slow and inefficient process. The goods are already packaged for transport. There is minimal handling, and virtually all of it is automated. This is not a matter of a crew of workers putting a net around a bundle of goods and lifting them onto the docks, moving them into a warehouse, and waiting for someone to pick them up. A container port moves goods in and out at high speed.

As with most important issues on the Texas coast, the Bayport container project was primarily regulated by the U.S. Army Corps of Engineers, not the State of Texas, and we had assembled for the Corps' hearing on the environmental impact of this proposed port on the environment and Galveston Bay. Our band of friends was in front of the main entrance of the George R. Brown Convention Center when the first bus rolled up, an International Longshoremen's Association charter coach full of big men coming to the hearing to speak in favor of the jobs associated with the Bayport container port. Following the first one came bus after bus chartered by the unions, bringing plumbers and electricians to

help their longshoremen colleagues, many stimulated to higher than usual levels of oratory by the alcohol they had to leave behind on the buses. "Hey there, rich bitch," one man yelled at my friend who was handing out pamphlets opposing the Port of Houston Authority. They were clearly aiming to intimidate us.

Another friend, the Reverend Terri Morgan, had come down from Dallas to join our opposition. Terri is an ordained Baptist minister and works for the Baptist General Convention of Texas. She also heads the Christian Environmental Network. For the first time ever, the churches of the bay area had become involved in an environmental issue, due primarily to the work of Terri and her organization.

And then our buses started showing up, bringing bay residents to the hearing being held over thirty miles away from their homes. Residents of Shoreacres, La Porte, El Jardin, Seabrook, Taylor Lake, El Lago, and Clear Lake had come to join with the Houston Yacht Club, a vocal supporter and bay steward, and Johnny Valentino as well as with local and regional environmental groups to denounce the draft EIS prepared by the Corps. The unloading buses brought a clash of cultures but also a common denominator—fear. The union people feared losing jobs; the residents feared losing their bay, their health, and their homes.

Ultimately more than five thousand citizens assembled before Colonel Leonard Waterworth, commanding officer of the Galveston District of the Corps of Engineers. The hearing resembled a high school basketball game, with each side jeering the other, the tone for the evening set by the in-your-face attitude of the chairman of the Port of Houston Authority in his opening remarks.

The evening typified the current state of environmental protection on the Texas coast. Rather than attempting to work with Galveston Bay conservationists, the port authority had made a unilateral decision to locate a new container port on the shore of upper bay amid established residential communities and important ecological resources. Opposition to the proposal was immediate and strong, and it grew. Rather than working with concerned citizens to find a suitable location elsewhere in the bay system, the port authority was trying to force a square peg into the round hole of the Galveston Bay community.

This was a fight that did not need to be. Galveston Bay environmentalists are nothing if not practical. Several alternative sites existed that were acceptable to the environmental community. Some of these were in Harris County, on the Houston Ship Channel. Others were farther down the bay. There was even a private company that had applied to build a port at a better location with private money, in Texas City. Imagine—the Port of Houston Authority wanted to build a port with $1.2 billion of taxpayer dollars while a private company wanted to build the same port with private money, and most local politicians supported the port authority! I have never understood what happened to fiscal conservatism.

This fight was not about jobs. There would be jobs if any of the alternative sites were accepted. The private company, Stevedoring Services of America, is the

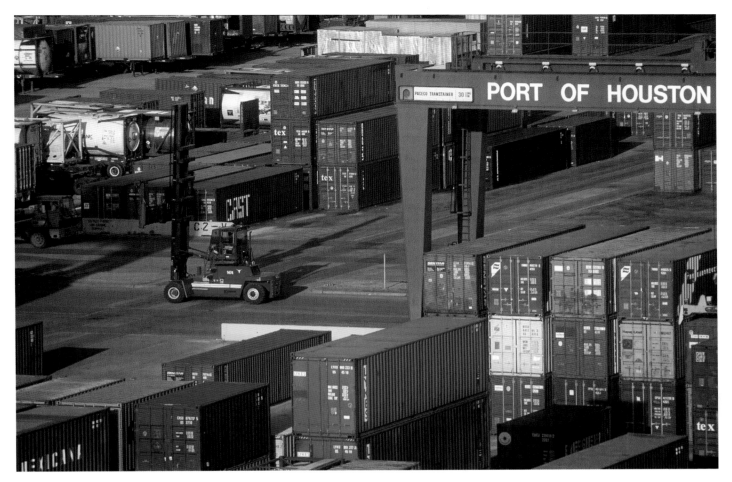

PORT OF HOUSTON

The Port of Houston's container terminal is at Barbour's Cut. Containers are the preferred manner of moving consumer goods from one part of the world to another, a symbol of globalization. One of the largest recent fights on Galveston Bay was over the Port of Houston Authority's proposal to construct a new container port at Bayport, just north of the city of Seabrook.

largest provider of union jobs for the International Longshoremen's Association in the United States. The unions were supplying their political muscle because they had been aroused to action by the port authority. But they were not being told the whole story—that other sites were acceptable to environmentalists and that a compromise would still ensure the jobs.

The battle over Bayport was part of the larger fight for the future of Galveston Bay; it was one of those instances when we could see a decision made today leading inexorably to a predictable outcome tomorrow—the proverbial crossroads. We had just discovered that the Bayport permit application filed by the Port of Houston Authority with the Corps of Engineers asked permission for the wharves to be constructed to a depth of fifty-six feet, even though the existing ship channel is only forty-five feet deep. According to one national official, the major container ports of the future must have access to depths of fifty-three feet for navigation purposes.[4] It seemed clear to us that the port authority was laying the groundwork for later asking the Corps to deepen the channel, bringing more salinity into Galveston Bay, threatening its future.

We had fought hard to win a compromise on the ship channel and salinity in the late 1980s. We were concerned about the port setting up a scenario whereby

they could argue that having sunk $1.2 billion in development costs into the Bayport facility, they needed a deeper channel to keep this investment from being lost. We believed that the time to debate these issues was before the container port permit was issued, before irrevocable financial commitments had occurred. If deeper channels were necessary, then there were alternative locations in the bay system much closer to the salty Gulf of Mexico, where deeper channels could be accommodated without serious environmental impact on overall bay salinity.

Mary Beth Maher and Ellyn Roof live near Galveston Bay and have fought for decades to protect it. They were among the early members of the Galveston Bay Conservation and Preservation Association (GBCPA). Ellyn and GBCPA helped defeat a Corps of Engineers proposal in the early 1970s that would have ringed the upper Galveston Bay shore with a dike. She and Mary Beth lost a fight to stop a chemical plant from being built far too close to residential areas. They had a hand in defeating the power company plan earlier mentioned to abandon the cooling towers at the Robinson electrical plant. They fought the widening and deepening of the ship channel in the late 1980s, they fought and helped defeat a proposed Texas Copper plant in the early 1990s (see chapter 8), and now they were fighting the Bayport container port.

Both were at the George R. Brown Convention Center for the Corps of Engineers' hearing on Bayport. Mary Beth was there because she loves the bay and because she lives less than a mile from the site of this proposed new container port. Her home, which looks out at Galveston Bay, would be immediately down-wind of all the diesel engines that are everywhere in a container port: the ships, the five thousand or more trucks rumbling in and out each day, the trains, cranes, and container movers, all belching small particle matter, the most deadly of our widespread urban air pollutants. Mary Beth's life and the lives of all her neighbors would be forever changed if the port went in; already some were talking of selling their homes and moving.

Ellyn is an accomplished sailor and boat captain; she has taught many young people how to sail. She lives perhaps three miles from Bayport as the crow flies, and she does not like anything about the port proposal, from the arrogance of the Port of Houston Authority to the ultimate need for a fifty-foot or deeper channel. "The Port is going to kill Galveston Bay and we can't let it happen," Ellyn growled, looking up at me, her face beet red with anger. "They tell us that they are not going to go to fifty feet with the deepwater channel, and they submit an application asking for wharves to be allowed to be built to fifty-six feet of depth. Trust us, they say. Well, I'm sure not trusting them. They must think we are idiots."

Peter Brown is a thoughtful architect and land planner who has watched the way Houston has developed. Container ports are relatively new, part of the globalization phenomenon, and there is little information about them in the planning literature. Peter's research shows that at the largest ports, such as Long Beach

and Los Angeles, adjacent neighborhoods are destroyed, elbowed out by the land needs of a container port.[5] At Bayport, this would mean that flourishing residential areas along the bay in Shoreacres, El Jardin, and portions of Seabrook and La Porte would be transformed into industrial and commercial zones over ten to twenty years.

"This container port represents land use impacts of the worst kind," Peter told me. "If Bayport goes in, the five thousand people who live within a mile will be hurt. Their homes will be destroyed—not immediately, but slowly over time. The current owners will sell for less than prior market value, and then the next owners will sell at a loss, a spiral of decay leading to loss of residential viability." In the planning business, the phrase for this is industrial sprawl, the unplanned extension of industrial land use into residential areas; that is what would happen at Bayport.

The hearing at the convention center was supposedly about the draft EIS that the Corps of Engineers had prepared regarding Bayport. However, by busing in the unions, the Port of Houston Authority assured that the hearing would not be about impacts. Instead, it became a jousting match between jobs and the environment—a false division of the issues. Mary Beth and Ellyn and others in the Houston environmental community would support a number of other sites in the Galveston Bay system. They would support a deepwater site at Texas City. They would support expansion of existing container facilities at Barbour's Cut or a new port at neighboring Spillman Island, and there are other possible places in the bay system for it. This fight was not over whether a port could be built but over where it should be built.

Mary Beth and Ellyn and their compatriots Charlotte Cherry, Katie Chimenti, Nancy Edmonson, Larry Tobin, and Sally Antrobus talked to some of the union people who were doing the jeering. One on one, the union men were approachable and open. They did not know the environmental groups would accept another site. Neither did they know that building at Bayport would cause such negative impacts. They had no clear grasp of what the fight over Bayport involved. They had been told that Bayport was about jobs, and they believed the teller.

The source of the union apprehension was the Port of Houston Authority, a political body made up of appointed commissioners, the majority of whom are appointed by Harris County and the City of Houston. These commissioners are not subject to direct control by any state agency once they are appointed, and many people believe that they are out of control. The commissioners get their political power by handing out public contracts to engineers, lawyers, and building contractors. Since Harris County voters had approved a bond proposal for port improvements, the commissioners had $300 million in the bank and authority to issue bonds for another $375 million. They wanted to spend the money, and they wanted to spend it at Bayport.

All that stood between the Port of Houston Authority and its Bayport project was a Corps of Engineers permit and citizens like Mary Beth, Ellyn, Katie, Charlotte, Sally, and Nancy. Many of my male friends told me privately that they were with me, that they thought we were right, but they were afraid to speak out for fear of losing work in this community that blacklists individuals who speak out against the power structure. I myself got fired from a very nice contract doing air pollution consulting with the City of Houston because of my opposition to Bayport. One of the aides to Mayor Lee Brown told me that the mayor did not want one of "his" consultants leading the fight against the Bayport project, which he supported. Mayor Brown's campaign treasurer was the chairman of the port authority. I survived this financial bullying with the help of my wife Garland, but many cannot.

A tremendous burden is placed on the Corps of Engineers in the hearing process. Corps permits cannot be issued without complying with federal environmental laws, such as NEPA (see chapter 5). This legislation requires that the decision maker, the local Corps commander, know the truth about environmental impacts and consider these impacts in his decision making. As the theory and the law go, a good decision cannot be made if the information in the environmental impact statement is bad. The Corps therefore publishes a draft EIS in order for the public and the resource agencies to review the information on environmental impacts and determine if it is right or wrong. As indicated, the reason for the hearing on Bayport was to allow the public to comment on the truthfulness and adequacy of the draft EIS. The hearing should not have been like a sports event, with each side cheering and jeering. It should have been a search for the truth, but sadly, it was not.

We live in a complex world that is pressed to its limits by human impacts. Those of us living on the Texas coast are living under a set of values developed when people lacked the ability to damage the earth to the extent that we can today. As a society, we are faced with the daunting task of attempting to determine which projects will cause so much environmental harm that they should not be allowed to occur or should not be allowed at a particular location. To make informed decisions, we need high quality analysis.

I have a vision of the future in which the assessment of impacts on the environment is one of the most important and respected scientific and technical endeavors in our society, intended to aid decision makers in determining which activities should be permitted and under what terms and conditions. I have a vision of careful deliberation based on excellent analysis; computer models and technology working to help us protect the environment as well as to preserve and create jobs. And I have a vision of decision makers who actually care about the environmental consequences of their decisions on people and on ecosystems.

The Bayport draft EIS was a jumbled mess of omissions, partial truths, and irrelevant facts. The document was over seventeen hundred pages long, but much

of the information was filler. Our major concerns were the integrity of the bay and the impacts of the proposed port on adjacent residents, but there was no information on most of the key issues: the impact of a fifty-foot-plus channel, destruction of onsite wetlands, changing land use from residential to industrial, and effects on human health. We put these omissions in writing and tried again. An environmental fight like the one over Bayport requires patience.

It is easy to get angry with the Corps of Engineers, and they frequently merit both concern and criticism. At the hearing on Bayport, however, I was merely thankful that they and federal environmental law exist. The State of Texas offers no help. No state permit is required for the port because of the structure of our state law. No county permit is required, because Texas counties lack general regulatory authority.

By mid-2003, the complexion of the dispute had begun to change. The Corps of Engineers had not yet made a decision on the Bayport proposal, but they had issued a permit for a container port to be built at Shoal Point in Texas City. This private container facility, better designed and better coordinated with the public and environmental groups, is not facing any opposition and is going ahead. The Bayport proposal was immersed in litigation filed by the Galveston Bay Conservation and Preservation Association, Houston Audubon Society, the commercial fishing group PISCES, Houston Yacht Club, the Texas Committee on Natural Resources, the Gulf Restoration Network, the air pollution group GHASP, and the Galveston Bay Foundation as well as the cities of Shoreacres, Taylor Lake Village, Seabrook, and El Lago.

Then, in January 2004, the Corps of Engineers issued the permit for Bayport. Gradually, every state and federal resource management agency that initially opposed Bayport had dropped their opposition. The U.S. Fish and Wildlife Service had, at an early stage in the proceedings, declared the wetlands on the Bayport site to be unique in the United States, but they relented. The Texas Parks and Wildlife Commission changed its mind shortly before the former chair of the Port of Houston—the one who initially pushed Bayport—was appointed to their board. The U.S. Environmental Protection Agency and the National Marine Fisheries Service backed off their demands that the Corps analyze the impact of the likely future deepening of the Houston Ship Channel. The political pressure was intense. Careers were jeopardized if the "wrong" side was taken.

Again, we filed suit in federal court to stop Bayport. In May 2004, the battle ended. The court made its decision, and we lost.

The Port of Houston is moving forward with construction of the billion dollar Bayport project with Harris County taxpayers' money. The Port and the Corps have promised not to ask for a deeper ship channel anytime soon. They promised that, when they do, they will undertake a full and fair analysis of the impact to Galveston Bay. They promised.

A brown pelican gracefully surveys the bay. The brown pelican population has made a substantial recovery on the Texas coast since the banning of certain pesticides. I often come to the bay to renourish my spirit, and I always find satisfaction in seeing brown pelicans—they offer the hope that sometimes we can repair the damage we do to the environment.

Even though my skin has been toughened over years of fighting and disappointment, this loss was a bad one, one that hurt deep and has stayed with me.

A few days after the decision, I went to the bay, feeling battered and depressed. Staying focused and engaged through this kind of extended contest is precisely the commitment I made after the Sabine Lake Conference, but it is hard and draining. When the tiredness is overwhelming and the load seems too heavy, I come back to the bay to rediscover what I am fighting for.

Paddling my kayak across the bay that spring morning, I saw a brown pelican in front of me, soaring just above the water, searching for fish. Walter Duson died in 1981, about the year the brown pelican began making its comeback along the Texas coast. Walter always said he would like to return as a brown pelican or a dolphin. I smiled and nodded at my friend who taught me to love the bay where I again sought patience and peace.

Interstate 45 connects Galveston Island with the mainland. The Texas City Dike extends far into the bay system, forming a barrier that separates Galveston Bay from West Bay. The dike was constructed to prevent siltation of the Texas City navigation channel just "inside" the dike but also prevents that sediment from being transported to the marshes of West Bay. A number of marsh restoration projects have been undertaken in this portion of Galveston Bay.

Galveston Island

Houston is a town filled with geologists.

The main reason, of course, is the oil business. Many of them expend their professional attention on using modern technology to find hydrocarbon deposits. Others of a more academic turn of mind, like my friend H. C. Clark concern themselves with geologic processes and with how human settlements and the earth's geology coexist.

H.C., fondly referred to by me as "the Doctor," is a professor emeritus in the geology department at Rice University, where he and I first met. Over the years, the Doctor and my law partner Mary Carter and I have been involved in numerous cases in which law and geology came together. H.C. has been my mentor in geology for almost three decades, though I still struggle with some of the concepts. When a geologist starts talking about geologic time, for instance, prepare yourself to slow down quite a bit. Fifty or a hundred years are nothing, and even thousand-year spans are mere moments. A geologist thinks in terms of tens of thousands, hundreds of thousands, or millions of years in the development of the planet.

On the Texas coast, however, some aspects of geology are rather sudden. Although the mud base of the area was laid down over geologic time, deltas and barrier islands can be changed overnight. An island beach can be severely eroded

in a matter of hours by a hurricane. A delta can grow a mile in a day after a major flood. Hurricane Alicia scoured 150 feet of beachfront from Galveston Island in the early 1980s. The delta of the Colorado River expanded more than a mile into Matagorda Bay after the 1991 floods. These represent active geological processes—serious change in the here and now.

The Doctor and I saw something striking on our first field trip together in 1975: a house sitting in the bay, surrounded by water. It was not a house built on stilts, prepared for possible immersion. This was a normal house, part of the Brownwood residential subdivision in Baytown, surrounded by the water of the San Jacinto River estuary in the lower portion of the Houston Ship Channel. It was in an upper-middle-class neighborhood of pleasant homes—homes for plant managers and professionals. This house was not designed to be surrounded by tidal water, but there it was, stranded. Something had clearly gone wrong.

The Doctor strode up to the edge of the bay and talked about the relationship between removal of subsurface water—groundwater—for industrial and municipal usage and the resulting change in the geologic platform of the Houston area. More groundwater had been sucked from the subsurface than was being replenished by recharge rainfall north of Houston, he explained. The water simply could not move fast enough through subsurface sand layers of the aquifer to keep up with the increasing pumpage from water wells. As groundwater was pumped out, the water level in the sands went down, leaving behind clay layers that slowly lost the water within their pores and collapsed. Each time this happened, the geologic platform of the Houston area lost a millimeter or so of elevation.

Cumulative impact is a powerful and important concept in environmental thinking, but it can also be hard to grasp. One water well did not cause that house in the Brownwood subdivision to end up in Burnett Bay; hundreds of wells did. The loss of one millimeter at one location did not cause a disaster; but the continuing draining of the clay layers, day in and day out, over a two-county area, was bound to have serious effects. In this manner, the mud platform of the Houston area began to subside in the late 1950s and continued sinking through the 1960s and into the 1970s. By 1975, almost nine feet of land surface had been lost in some areas of the Houston Ship Channel, and a bowl of subsidence radiated outward in all directions from this epicenter.

The most noticeable impacts occurred at Brownwood. The Doctor and I talked with a landowner who was dumping dirt on his backyard, trying to keep the tides away. He would fail. The land continued to sink. In due course the whole neighborhood had to be abandoned, and the Baytown Nature Center now occupies the remaining uplands and marshes of the doomed subdivision, a sanctuary and a stop on the Great Texas Coastal Birding Trail.

The Doctor is a gentle man with large hands that he uses as he talks of the removal of groundwater, the compaction of the clay, and the resulting geologic

change. He talks of the mud platform of the Texas coast—active, vital, even dangerous—so distinct from the rocky shorelines of the Pacific or New England coasts. The Texas coast is misleading, he says. We tend to think of it as stable, but it cannot recover from overpumping like the Edwards Aquifer in Central Texas can. The aquifer in the Texas Hill Country lies in a limestone system honeycombed with pathways taking rainwater quickly down into a storage vessel that remains intact as water level falls and rises. On the coast, in contrast, the clay layers are relatively impervious to water, and it takes much longer for the rain to filter down. Also since clay is soft, not like the limestone rock, little recovery can take place once the clay has been dewatered and compacted. We have forever changed the Houston area and Galveston Bay by our overuse of groundwater.

In the mid-1970s, the Texas Legislature created the Harris/Galveston Coastal Subsidence District, the first groundwater management district in Texas that meant business. The subsidence district was created to force the citizens and industries of Harris and Galveston counties to do what they were otherwise unwilling to do—limit the use of groundwater. The district has been extremely successful in its effort, virtually halting subsidence along the coast and slowly weaning north and west Harris County off cheap, clean groundwater. Although the subsidence district has done a great job, it was formed only after extensive sinking had already occurred. Areas surrounding Galveston Bay have lost anywhere from a foot of surface elevation around the Anahuac National Wildlife Refuge and West Galveston Island to more than four feet in the Clear Lake area and seven feet near the San Jacinto Monument along the Houston Ship Channel.

The Doctor was the first person to explain to me that the land beneath the bay was also subsiding. So often, our viewpoint stops at the shoreline. The house in the bay was starkly visible, but what about the marsh grasses that grew at the interface of land and bay? Because of subsidence, the water came up and drowned the marsh. But unlike the house that stood as a reminder of permanent loss, the marsh grass simply decomposed and disappeared. Here today, gone tomorrow—with no one ever really seeing the loss of this important component of the bay system.

Lloyd Bentsen was a great supporter of Galveston Bay when he was the U.S. senator from Texas. He was instrumental in the compromise over widening and deepening the ship channel and was also a major force in getting Galveston Bay designated as an estuary of national concern, ultimately resulting in the creation of the Galveston Bay National Estuary Program. GBNEP (now called GBEP) has primarily been engaged in studying the estuary, and one of its findings is extremely important—Galveston Bay has lost more than 50,000 acres of marshland, with much of this loss due to subsidence.[1]

We often have difficulty understanding the impacts of our actions, particularly when it comes to cumulative long-term impacts. Yet here is a case study showing upward of 50,000 acres of marsh lost due to our systematic sucking of

water from beneath the surface of the earth. One might blame the loss on a legal system that allowed landowners to take as much water as they were able to pump, based on an archaic legal concept called the English rule of capture. The same concept allows overpumping of all the aquifers across the state that do not enjoy the protection of a groundwater regulatory district. Texas adopted rules of law developed in a wet country, not suited to our drier climate. Indeed, much about water in this state is not rational, which is why we are now in the process of forming groundwater districts all over the state—to keep from hurting ourselves like we did on Galveston Bay.

The cost of our overdraft of groundwater has been substantial. In addition to subdivisions lost to the bay and increased flooding from high tides associated with tropical storms, those lost marshes represent value, although this value does not figure in the capitalist metric. An environmental economist named Robert Costanza of the University of Vermont has developed a methodology for determining the value of the biological and functional services provided by natural systems. As described in an article in the peer-reviewed journal *Nature*, Costanza and others determined a value of approximately five thousand dollars per acre per year in services that a marsh provides to an ecosystem, including pollutant removal, flood moderation, and nursery functions for the fish and shellfish of the bay.[2] Those 50,000 acres lost to subsidence represent about $250 million per year in services lost to the Galveston Bay system, and indirectly to the users of that ecosystem, because we were sucking out as much groundwater as we could, without regard to the consequences. If the capitalist system had a mechanism to incorporate the cost of lost fishery production into the price of groundwater, perhaps we would not have needed the regulatory system.

Luckily, there are people living on the bay who are committed to doing something about the fact that it has much less marsh than it did fifty years ago. One day I got a call from Evangeline Whorton, asking me to represent Scenic Galveston in court. Evangeline has the determination of a prizefighter, and Scenic Galveston was attempting to overturn a Corps of Engineers permit that had been issued for the filling of a piece of property adjacent to the Interstate 45 approach to the Galveston causeway.

A suit against a Corps of Engineers project on the Texas coast can be filed in the Galveston Division of the Southern District of Texas because the Corps' Galveston office has jurisdiction over the entire Texas coast. The Galveston Division is presided over by Judge Sam Kent, an expert in maritime and environmental law. Judge Kent is a legend among lawyers—he is witty, smart, and totally unpredictable. Neither side has an advantage before Judge Kent on environmental cases, which is just what one would hope for from the federal bench.

Evangeline had a dream of restoring the marshes on either side of I-45 as it approaches Galveston Bay, and the permit in question was to fill a site that had

previously been altered in order to expedite commercial development. The property owner was working with Tiki Island, one of the dredge-and-fill canal subdivisions established along Galveston Bay before modern environmental laws were in place. The canals at Tiki Island had filled with sediment and needed to be dredged out. When dredge material is removed, it must be placed somewhere. The plan was to place the dredge material on the tract between Galveston Bay and Interstate 45, thereby raising the land surface enough for development. But Evangeline was dead set against one more commercial eyesore.

On Evangeline's behalf, Mary Carter and I filed suit to stop this filling activity. Of necessity, the suit was filed against the Corps of Engineers, but both Tiki Island and Joe Tamburine, the gentleman who owned the tract and wanted the fill material, would be affected. As always, Judge Kent was courteous and interested, inviting us into his chambers, where he laid aside his robe and got down to business.

A federal judge has tremendous power, and a good judge wields it wisely. In this situation Judge Kent urged us to try to work out an agreement whereby all parties involved in the litigation could achieve their goals. The permitting entity—the Corps—indicated that they did not have a real stake in this controversy. If we and Tiki and Tamburine could work the matter out, the Corps would certainly cooperate. Ultimately an agreement was reached whereby a smaller volume of dredge material would be deposited on the site, allowing the dredging of the canals at Tiki Island. In exchange, the landowner agreed to sell his property to Scenic Galveston after completion of the disposal, at a fair market value established in the agreement.

Conflicts such as these are never easily resolved. Even after the agreement was signed and the lawsuit concluded, difficulties continued to arise, including Evangeline deciding that she needed to correspond directly with Judge Kent. Kent went ballistic, and my partner Mary Carter almost had a heart attack—I was thankful to have been out of town. After threatening Evangeline with shackles if she ever did anything like that again, Judge Kent cooled down and the crisis passed. In the end Houston trial lawyer John O'Quinn provided the money for Scenic Galveston to purchase the property. John O'Quinn has a deep and abiding commitment to protecting the earth, a commitment based upon his spirituality—a side of this excellent and controversial trial lawyer that many do not know. In early 2000, Scenic Galveston planted cordgrass, *Spartina alterniflora,* on the Tamburine tract as well as several other properties. Scenic Galveston is beautifying Interstate 45 and restoring Galveston Bay.

In *A Sand County Almanac,* Aldo Leopold wrote of different levels of the recreational experience. He wrote of hunting, the active taking of game, as the first level and of photography, the passive taking of game, as the second. He described a third level of outdoor recreation, nature study and observation, which today we call ecotourism. Leopold's fourth level, however, is the most profound and involves

the rehabilitation and repair of the natural system. Think of it—recreation, *re-creation*—seems exactly the right word for a day spent repairing the bay.

Today Lalise Whorton Mason, Evangeline's daughter, leads the repair and rehabilitation efforts of Scenic Galveston. Lalise is a professional landscape designer who has learned how to create marshes through trial and error, research, and common sense. Each project is a hands-on experience, with slope and grading decisions often adjusted on the spot in the field. First the site is prepared, and then the planting begins, all under Lalise's supervision.

Marshes are by definition wet, muddy places. The mud provides the platform for the grass, which is periodically covered with water. On occasion, the marsh can be dry for days, exposed to the elements as the wind blows bay waters out to sea during the passage of a front. The marsh may also be inundated by two feet of water during spring and fall equinox tides. The combination of water, mud, and grass is what make the marsh important; soil, water, and vegetation come together to create habitat where juvenile finfish and shellfish hide from predators and feed upon the detritus and the microscopic organisms inhabiting the marsh.

The process of creating a marsh is slow yet rewarding. The grass is planted by hand, one stem at a time. Stems are spaced several inches apart to allow the rhizome root system to expand outward. Over time, sprigs appear next to the planted stalks, followed by other runners. In about three years a functional marsh will emerge, complete with microorganisms and a community within the mud — a living system.

Members of Scenic Galveston plant *Spartina alterniflora* grass in Galveston Bay. Planting marsh grass is muddy but very rewarding. At the end of the day, volunteers can take pride in having participated in the rehabilitation of the natural system. Today we are beginning to see the difference that weeks, months, and years of volunteer plantings have made at several places in the Galveston Bay system, such as where the I-45 bridge approaches the bay from the north.

Marsh planting is a messy kind of recreation. The re-creators start off in the mud and water and stay there all day. You cup the grass in your hand and you dig out a hole, just as if planting a garden at home, except that all the action is in the water. You have to get the plant far enough into the mud to ensure that it stays upright and also keeps its leaves above the water at high tide. If the plant sloughs into the water, it will decompose.

Lalise is not content with merely planting marsh grass, however; she has a larger vision for this section of Galveston Bay. To the northeast of I-45 as it approaches the causeway lies Virginia Point, the subject of one of the most difficult yet ultimately successful environmental fights on Galveston Bay. In the early 1990s, a company called Texas Copper proposed to build a copper smelter on Virginia Point, a six-story eyesore that would have belched toxic metals into the air and water all around the site.

Various parties opposed Texas Copper, including the Galveston Bay Conservation and Preservation Association (GBCPA), Galveston Bay Foundation (GBF), and several individuals from Galveston Island and Tiki Island. John Grimes of GBCPA and GBF, a leader in the fight against this plant, developed a strategy of passive/aggressive opposition that led to the downfall of Texas Copper. Grimes was a stalwart friend of the bay who was later killed by a container truck at Morgan's Point in upper Galveston Bay.

The Texas Copper fight centered first on the wastewater discharge permit, then on the air pollution permit. From a strategic standpoint, Texas Copper made a critical mistake from the outset. Although wastewater discharge and air pollution discharge permits are both required under Texas and federal law, these permits are not the same. The air permit is a construction permit under Texas law, whereas the wastewater permit is an operational permit. By law, no construction can be initiated on an industrial plant without an air construction permit, whereas both the Texas water pollution control agency and the U.S. EPA allow a plant to start construction without a wastewater discharge permit. The agencies say they are not biased by the fact that millions if not billions of dollars of construction investment have been spent by the time they rule on a wastewater permit, but I don't believe them. In my experience, after the air permit is issued, it is simply a question of terms and conditions for the wastewater permit; denial does not seem to be a viable option to our regulators. It should not be that way, but it is.

In this case, Texas Copper chose to have the wastewater permit hearing before the air permit hearing. In many respects, that hearing over the wastewater permit, which was a heated, high profile trial, was merely a prelude to the fight over the air pollution permit. After the wastewater fight was over and the Texas Water Commission issued the permit, Texas Copper still lacked the critical air permit— and after the wastewater hearing the controversy was growing, not waning. If anything, the public was more committed than ever to killing the copper smelter.

The Japanese owners of Texas Copper were horrified by all this negative attention. Until the permit hearings, they had received a warm welcome from elected officials and their local partner, who gave no indication of the storm of opposition that was brewing. When I met the owner's representative at his home in League City, he was pleasant and totally perplexed by the public hearing process. He expressed shock and dismay at the level of opposition and asked if there were a way to resolve this situation. He agreed to hire Jack Matson, an excellent environmental engineer, to work on better treatment concepts for the wastewater, but I told him we would continue to oppose the air permit. Ultimately, Texas Copper dropped its plan for a Galveston Bay smelter, perhaps because of the continued fight or perhaps due to the global copper market. The owner's representative sent me a Christmas card for several years after the plan for the smelter collapsed. All in all, he was a nice man with a bad plan.

A decade later, Lalise was taking advantage of Texas Copper's demise. Virginia Point was for sale, and Lalise was intent on purchasing the property. The area is laced with wetlands and uplands and can be managed to provide excellent habitat. Perhaps most important, there is a low ridge on the property where trees can grow, a rarity adjacent to Galveston Bay. The potential exists on this property to develop a coastal woodlot where spring and fall migrant Neotropical songbirds can find shelter, food, and water.

Lalise is an architect building communities for the bay's creatures, and she is good at it. This line of work requires money, first for the land and then for the construction; Lalise is also good at raising money. In 2001 she was awarded a $1 million coastal impact grant from the Texas General Land Office to purchase a portion of Virginia Point. In early 2002, she was notified that another $1 million had been approved, giving Scenic Galveston $2 million to purchase and set aside Virginia Point.

Rather than the Texas Copper smelter and its associated air and water pollution, the citizens of Galveston and Houston now have a natural reserve set aside for wetlands and woodlot construction, flanked by marshes both natural and rehabilitated. Lalise and Evangeline have set their sights on removing the topless and the nude bars that are built on fill where wetlands once stood, if they can negotiate a price.

When you come across the causeway that Scenic Galveston is beautifying, you have a choice. You can go straight ahead down Broadway toward the historic part of town and the seawall, or you can cut across at 61st Street to the west end of Galveston Island. Off of 61st Street, my favorite road is Stewart Road because it runs close to the bay. Stewart Road passes swale after swale of freshwater wetlands, geologic artifacts that are packed with waterfowl in the winter, providing some of the best duck viewing anywhere. One of the finest sightings I ever had was of a group of roseate spoonbills and cormorants fishing together in

A cormorant is a fishing machine. As this one demonstrates its dexterity, note the flared tail to give stability for the maneuver.

a line, proceeding as one, driving the fish before them, cormorants swimming, roseates striding alongside, a line of pink and black bodies splashing wildly, pushing inexorably toward the far shore. I watched spellbound for fifteen minutes, and I can pull up that image clear and fresh today; they made a lasting impression.

West Galveston Island is a confusing place. It is lined with million-dollar homes along the beach and the bay, homes that could be completely destroyed by the next hurricane. These are not like the fishing camps to be seen in coastal Louisiana or along the Intracoastal Waterway farther down the Texas coast. These are prime residential units. I don't blame the owners for living there, although I might question their judgment. But I do blame the federal government for underwriting the flood insurance to cover these homes against the rising waters that will surely destroy them one day. Our federal representatives and senators decry our federal spending—yet allow these subsidies for development in high-risk areas. Most of the barrier beaches in Texas, fortunately, are owned either by the federal government or by single landowners not inclined to develop them. Otherwise they would all be developed sooner or later.

Nothing is more devastating than the surge tide of a hurricane, an event of nature that we name and fear, like the proverbial plague of locusts, formidable and metaphysical. A big cyclone spins counterclockwise out in the Gulf and moves onto the continental shelf, the low pressure allowing the water to bulge at the center, the circulation pushing the bulge up on the "dirty" side as the storm moves toward the coast, spinning and growing. The tide starts rising along the coast as much as two days before the strike occurs. In a big storm, the roads on the west end of Galveston Island are predicted to go underwater twelve hours prior to landfall.

And then the storm comes in, covering the entire island. Where the dune system has remained in place, it cuts the power of the water, not holding it back but slowing its fury, protecting what lies behind the dunes. The waves crash into the beach, ripping up sections of it, working on the foundations of the houses, throwing loose boards and pilings like battering rams against standing structures. The world grows still as the storm's eye passes. Then the wind turns to come from the other direction, and the bay moves back over the island, pushed by the other side of the circulation pattern, carving bayous into the landward side of the barrier formed by centuries of storm surge. Afterward, the water retreats and the island is still there. Homes may be gone but the island remains, though rearranged, the sand moved from one place to another. That is a barrier beach, an active geologic process.

Both the beach and bay sides of the barrier island are classically nourished by sand sources, and both are deficient these days. Dams and jetties are capturing much of the sediment that used to supply our beaches with sand. Within Galveston Bay, the Texas City Dike has obstructed the flow that used to move from the main stem of the bay into West Bay and out through San Luis Pass at the south end of Galveston Island. Given the combined effects of the dike, the diminished input of sand and silt coming down the river systems, and land subsidence, the marshes of West Galveston Island are beleaguered.

Phil Glass of the U.S. Fish and Wildlife Service has spent his career observing and evaluating threats to the coastal environment. He has been concerned for a number of years about two important changes on the bay side of Galveston Island: loss of submerged seagrass and loss of the *Spartina* marsh. Both these losses are due to human impacts; both can be repaired and rehabilitated.

Phil told me I needed to go and see the seagrass that was coming back, reestablishing itself behind barriers that the Fish and Wildlife Service had constructed, using money from out of court settlements associated with natural resource damage caused by hazardous chemical and oil spills. The bay shoreline of Galveston Island was vegetated with submerged seagrass until the early 1960s. Then, almost overnight, the seagrass disappeared. Some attribute its demise to sewage from west-end development, the nutrients causing algae to bloom and block out the light that the grass needed to survive. Others blame dredging and

an increase in bay turbidity. Yet others blame subsidence or pollutants from industrial development. Whatever the reasons, the grass died. Until December of 2001, I had never seen seagrass in West Bay.

I launched my kayak behind Galveston Island State Park, one of the quality public access points on West Bay, and paddled out into a meadow of submerged seagrass. I had fished this area several years before and there had been no seagrass here, just mud. Now the water was crystal clear and I saw grass beneath the surface. Even though the water was cold, I put my hand down and touched the grass, not trusting my eyes. What a beautiful sight after decades of absence.

I paddled up to some long dark tubes or mounds that rose four or five feet out of the water. Several mergansers flew up before me, their fishing interrupted, their white wing patches clearly visible in the winter sun. The protective tubes, called geotubes, lie between the seagrass meadow and the open water of West Bay. The tubes act as a breakwater to intercept erosive waves and keep the water between tube and shore relatively calm. In turn, the calm water has less turbidity, allowing the seagrass to grow. Once the grass is established, even less sediment will be resuspended, reaffirming the cyclical nature of environmental problems and solutions.

Phil had suggested I fish this area with my fly rod from the kayak, saying the water was perfect for it, and he was right. Another fly fisherman was drifting across the meadow as I watched, his arm gracefully removing the line from one spot and placing it in another, a deceptively slow motion that generates distance and accuracy in the hands of an experienced fly caster. I didn't fish; I merely drifted lazily with the light breeze, watching the artistry of a good fly fisherman fishing a seagrass meadow on a beautiful winter day.

Galveston Island State Park is one of the places where I first learned to fish from a kayak. My fishing buddies and I had waded the marshes of the state park for years and were pleased to have kayaks liberate us from "death marches" through knee-deep muck. The *Spartina* marshes behind the state park are lush, although there is not nearly as much marsh today as there was when we started fishing there. Areas that used to be marsh are now open water, and Phil Glass is working on that problem as well. Behind other geotubes he is developing new marshes, bringing in sediment and filling in diked areas designed to allow the planted marshes to be subject to the ebb and flow of the tide.

Unlike Lalise's marshes, these plots are being created out of open water—a more difficult task but one that can also lead to success, once the geometry of fill and compaction are fully understood. Phil and others have convinced a development adjacent to the state park also to install geotubes and develop marsh and perhaps seagrass in West Bay, hoping to establish a pattern that all west-end development will follow.

West Galveston Island is a bittersweet place to me because of my involvement with one of the more controversial developments there, Lafitte's Cove, originally

called Pirates Cove section 6. In this case the developer was George Mitchell, an impressive man whom I respect as one of the few businessmen in the Houston area willing to elevate environmental issues to the forefront. My first job after law and graduate school had been working for Mitchell north of Houston in the Woodlands, where I was a member of the team of design professionals attempting to integrate the frequently competing concepts of environmental concern and land development. I was forever changed for the better by that experience.

Mitchell owned a tract of land on West Galveston Island next to the tidal Eckhard's Bayou. Bob Moore, an excellent attorney from Galveston, filed suit against the Corps of Engineers and Mitchell Development on behalf of an adjacent landowner over the plans for this tract alongside Eckhard's Bayou. Bob sued under the National Environmental Policy Act, arguing that the Corps had not properly considered cumulative impacts. He won at both the District Court and Fifth Circuit levels, and Mitchell's development was stopped.

At that time I was teaching part-time, lawyering part-time, and practicing environmental planning part-time, trying to make a living in Houston as a professional committed to environmental protection. My planning firm was in partnership with Peter Rowe, one of the brightest men I have ever known, now on the faculty of the Graduate School of Design at Harvard. Humility was not our stock in trade. I was confident of my ability to design a bayside development. Rowe, the planner, and Blackburn, the lawyer, thought they were really good environmental planners.

Mitchell Development asked Peter and me to evaluate the lawsuit and try to understand the steps necessary to meet the court's order and develop the property of some 250 acres. From the start, it was clear that Mitchell intended to develop the land unless we could find someone willing to purchase it. The same determination that had led him to many successes in the oil business and in the Woodlands was apparent even regarding this small tract.

The Eckhard's Bayou property was ecologically interesting, if not unique. It adjoined a tidal bayou and had both *Spartina* wetlands and freshwater marsh in linear depressions flanked by prairie uplands. It also had a high sand ridge that supported a significant grove of oak trees, making it one of the places on Galveston Island where Neotropical songbirds land in the spring. For several years I had the keys to this property. I learned warblers, I caught speckled trout and redfish in the bayou, and I came to know and love the place.

We tried to find buyers for the tract but could find no entity willing to purchase it. Neither the Nature Conservancy nor the Texas Parks and Wildlife Department wanted to invest in a small tract. According to some of their analysts, the area was not unique—just nice. Failing to find a purchaser, I helped develop a site plan that eventually was permitted, survived a court challenge, and was built.

Our plan was much better than the previous plan that had been stopped by the court. Aspects of it were fine. The plan saved most of the important ecological features at the site, setting aside a fifty-acre preserve that protected the oak trees, the majority of the high quality freshwater wetlands, and the prairie between the oaks and swales. The park established there has a nature trail to observe the birds that use this area. The channel that was cut through the edges of the tract is lined with planted *Spartina* grasses and was designed to have flow-through circulation and aeration if necessary to prevent water quality problems.

Yet today I feel hollow when I think about this experience. I know that Peter and I protected as much of this site as could be protected while still ensuring an economic return. I had imagined a nature reserve surrounded by reasonably sized homes and was stunned to see the first of several huge houses constructed. But what really depressed me were the twin boat stalls constructed for a pair of jet skis. This site and Eckhard's Bayou would never be the same, regardless of all careful planning and fine design.

Humility is a positive trait, useful for other things besides confronting the sudden violent power of hurricanes or the irreversible geological shift of subsidence. Galveston Island is etched in my soul as a place that has had much to teach me. I am humbled by our inability to foresee the harm of our actions at Lafitte's Cove, to foresee the changes that would be irreversible. And I am likewise humbled by the wonders of the natural system and its ability to restore itself and blossom when given a second chance.

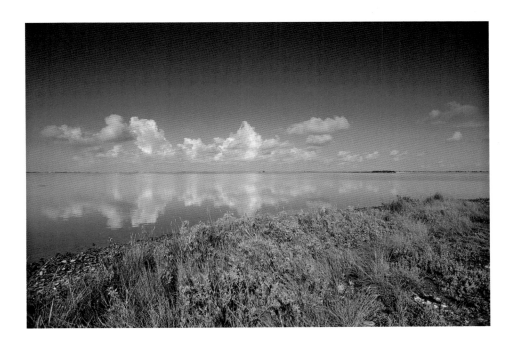

The beauty of a coastal bay is often manifest when the wind dies. Here, Jim Olive captures Christmas Bay at its best.

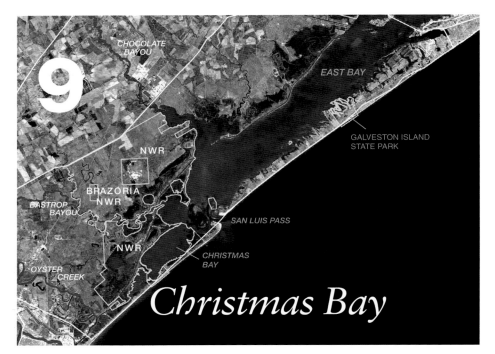

CHOCOLATE
BAYOU

EAST BAY

GALVESTON ISLAND
STATE PARK

NWR

BRAZORIA
NWR

BASTROP
BAYOU

SAN LUIS PASS

NWR

CHRISTMAS
BAY

OYSTER
CREEK

Christmas Bay

San Luis Pass, one of the last natural passes on the Texas coast, separates Galveston Island from Folletts Island. The Christmas Bay Coastal Preserve lies to the north of Folletts Island. Much of the land area adjacent to and north of Christmas Bay is part of the Brazoria National Wildlife Refuge. Galveston Island State Park is shown in the middle of Galveston Island.

West Bay meets the Gulf of Mexico at San Luis Pass, a resort for birds at low tide. The flocks of birds blanket the flats in a patterned fabric of black, white, brown, and gray—avocets and stilts, willets and dowitchers. The tides work the silt into a textured surface, rippled and sparkling in the sun. Tidewater is trapped in depressions within the ripples, patterns within patterns.

The mud is a giver of life in this system. As the flats meet the bay, the mud seems to merge into a liquid phase of undulating, murky water. Most of the water along the upper Texas coast can grow murky with a simple change in the winds or increased inflows from the rivers. But this murk is not pollution; this is a life-giving force that settles in layers. A chocolate brown bay after large rains or on a day when the wind blows from the southwest is part of the natural cycle.

The rhythms of the bays are most noticeable at the passes. It is here that a bay's incoming tide begins and that the low tide ends. The flats behind San Luis Pass are laced with channels, pathways for shrimp and finfish between bay and Gulf.

San Luis Pass separates Galveston Island from Follet's Island in Brazoria County. It connects West Bay with the Gulf of Mexico, and a tributary pass called Cold Pass connects Christmas, Bastrop, and Drum bays with San Luis Pass and the Gulf. San Luis Pass is one of only three natural passes along the Texas coast, the other two being Cedar Bayou on St. Joseph Island, which often silts in, and

Pass Cavallo in the Matagorda Bay system, which is dying due to the deepwater channel nearby. Natural passes are mysterious and dangerous, places where the currents eddy around sandbars and shoals. They are also increasingly rare.

At slack tide they are misleading, seemingly safe during the phase between water movements. Birds loll complacently, sitting at low tide on exposed sand flats, waiting. And then the tide starts in, filling the bay like a bathtub through the spigot of the pass. Over a period of hours, West Bay and Christmas Bay can gain at least a foot of depth, not a large tide by global standards, but an extreme for the shore of San Luis Pass.

I have waited in my kayak in Christmas Bay, trying to perceive the moment when the tide starts in. Once I sat encircled by oyster reefs that were exposed at low tide, the oysters clearly visible. Water would squirt up every now and then, reminding me the oysters were alive rather than the inanimate shells they appeared to be. A pair of oystercatchers loafed on a nearby sand spit, their scarlet-orange beaks and black heads brilliant in the afternoon sun. The tide was slack and nothing was happening.

In a matter of minutes, the situation changed. First a snowy egret flew to the reef, followed shortly by another and then a great egret. Carefully, these fishing birds spaced themselves along the reef, about thirty yards apart. Soon there were birds deployed at fishing stations on all the reefs. The birds had sensed something to which I was not attuned, some force that they could feel and I could not.

Slowly, the tide came in, rising up over the exposed oysters. As the water rose among the shells, small fish moved into the crevices between the oysters' calcium carbonate homes that had been fused together to form the reef. And when the fish moved in, beaks began darting in and out as the fish-eating birds struck paydirt.

The pass brings in the tide and guides it back into the Gulf. The strong current at the mouth grows weaker as the tide moves into the bay, but move it does, slowly, inexorably toward the back of the bay and then out again.

Passes are great for fishing, and San Luis is no exception. In the late spring, the speckled trout become much more active, and a line of anglers can be found along the bay's shoreline behind San Luis Pass and in the surf when conditions are right. San Luis is one of the most easily accessible areas of the upper coast and thus receives extensive use. Fishermen of every type abound —wade fishermen with waders, nets, hats full of lures, and a wading belt with pliers, knife, and fish stringer; bank fishermen with lounge chairs and cold beers at hand, fishing on the bottom with dead bait. All ethnicities and all styles come together at the pass.

San Luis is a dangerous place for swimmers and waders. There are usually one or two drownings a year here and multiple near death experiences. The power of the tide is misleading. It is easy to forget about the tide moving out when the fish are biting or when the water is cool and fun. Suddenly, your feet start to slip off the sandbar and you step forward, only to find that there is no sand under

either of your feet. Suspended, you are easily ripped off the sandbar. The water catches you and pulls you out into a trough before you know what has happened. A strong swimmer may be able to fight the current and rediscover the bar, but a weaker swimmer has no chance. Often the best approach is to go with the flow and allow an eddy current to pull you out. Unfortunately, that approach requires a cool head, something difficult to maintain while fighting the tide.

Several schemes for the development of San Luis Pass have been proposed. One of the last plans had several high-rise hotels on the beach near the pass, probably one of the all-time bad ideas for the place. If a large number of casual tourists were to be in the Gulf at San Luis Pass, the number of drownings would skyrocket. That kind of development would likely also preclude the extensive public usage that now occurs on the Galveston Island side of the pass. A better alternative would be to purchase the land around the pass and set it aside as public property, for continued recreational use by the kind of anglers and boaters who value the special qualities of passes.

As already noted, Cold Pass connects San Luis Pass and the Gulf of Mexico with Christmas Bay, one of the jewels of the Texas coast. Christmas Bay is relatively pristine. It still has extensive acreage of seagrass, which disappeared from most of the Galveston Bay system in the 1950s. Christmas Bay has the highest biological diversity of any of the upper coastal bays, and it gets relatively low usage despite extensive public access from Follet's Island.

The bottom of Christmas Bay, like all the bays of the Texas coast, is owned by the State of Texas. Public ownership of the bay bottoms is one of the great gifts of our Spanish heritage. Spanish civil law had a much stronger view of the role of public access than did British law. Our concept of open beaches also comes from this Spanish heritage. As a result, all our bays are open to everyone living on or visiting the Texas coast. Access to the bays is not always adequate, but the ownership is clear—the bay bottoms are the property of the people of the State of Texas.

Christmas Bay is a unique natural area, perfect for fishing, birding, kayaking, and wading. I have watched a Vietnamese woman walking in the marsh with her pointed hat, gathering periwinkle snails while her little boys collect clams. Crab traps are set out in the bay, and crabbers come every day to check the wire baskets marked by white floats. Wade fishermen walk out from various entry points along the bay, and boats travel carefully as they approach Rattlesnake Point and its oyster reefs.

Rattlesnake Point is a place I go to find peace and solitude. I have never seen a rattlesnake on the point itself, although I saw one swimming in Christmas Bay. (It is amazing how fast a wade fisherman can move away from a swimming rattlesnake.)

At one time in my life I lost my spirit. I was emotionally spent and had no reserves. I was not taking care of myself or the people who were important to me. I was not doing well at all—I was empty, barren, and sad.

A white pelican loafs at low tide at San Luis Pass. This pass between West Bay and the Gulf is natural and full of energy and accessible, one of the best places for birdwatching and fishing. Only three natural passes remain on the Texas coast, and the other two are silting in, making San Luis Pass unique.

My spiritual rehabilitation began when I sought and found the animus—the spirit, the life—in nature, first on the shores of Galveston Bay and then in the great bird migrations of the Texas coast. I remember being in the marsh. It was fall and the first cool norther had come a week before; the summer heat was finally in retreat. The *Spartina alterniflora* grass was flooded with the equinox tide, and the periwinkle snails were visible above the water, gripping the grass stalks. I noticed two white pelicans paddling gracefully ahead of me, taking a channel into the marsh. The second one looked back at me, as if to say, "Follow me." I did. Every so often, a white shrimp would hop out of the water or finger mullet would skitter down the marsh channel. The blue tip of a tailing redfish could be seen as lace rising from the water, lazily flipping to and fro. A flock of teal buzzed low across the marsh grass, and more white pelicans glided across the surface with bills submerged, avian seiners of marsh fish.

It came to me that I was participating in *life*—not just mine but that of other living things as well, nonhuman things: birds, plants, fish, shellfish, even plankton and bacteria. The mud was alive, the water was alive, the plants were alive. This was no artificial construct, no legal abstraction. I was connecting with life and with the ether that differentiates living and nonliving things, something much greater than I.

Since then I have returned to Christmas Bay year after year to be nourished and renewed, to put my place in the world in perspective. Christmas Bay is a sanctuary to me, a cathedral where I come to pray in my own way, raising my thoughts to other living things, to a pervasive power called life on this planet, one that stands out in the solar system (as we know it now) for that very thing—the presence of life.

In this cathedral I observe life and contemplate the similarities of all living things and search for my spiritual essence among them. In the spring, I pray to the migrating songbirds because their return restores my faith for another year. I cheer the orioles, the tanagers, and the warblers because their hopeful journey reinforces my own. And I applaud them when they cross the water onto land and fall to the earth, safe again, both of us.[1]

In the fall, I raise my eyes in tribute to the first flight of blue-winged teal flashing across the surface of the marsh, barely above the top of the grass, a life-affirming sight if there ever were one. I stop and salute a high flight of snow geese, their V formation high above the coastal marsh. I smile at the ibis poking its curved bill among the grass stems. I am alive within a living planet.

Establishment of a spiritual relationship with the coast changed me. I perceive events differently, responding at a visceral as well as an intellectual level. My mind and body have a partner—my spirit—that connects me with other living things. In this cathedral, I am whole.

As I rediscovered my spirit, I became more of civic activist. During one spring migration, I was walking along a road with friends, looking for migrating

During the equinox tides, the marshes are flooded. This woman is gathering periwinkle snails, one of many organisms living within the marsh. The snails have moved within easy reach in their effort to escape the high water.

songbirds. We found a grove of live oaks that had a small wetland area beneath it. As we were watching warblers in the oaks, someone noticed a scarlet tanager sitting on a palmetto frond just above the water. The bird was so tired from its recent flight across the Gulf that it simply sagged onto the leaf and did not move, allowing us to walk by within a few feet. We could see that the exhausted tanager had failed to shake the dust from its side, where it had clearly lain on sandy ground. Watching this fragile bird, I realized that if we continued to destroy nature on the Texas coast, the birds would have no sanctuary, no stand of live oaks with a wetland underneath.

When widening and deepening of the Houston Ship Channel was proposed in 1986, the threat to Galveston Bay galvanized me into action. When the Texas Copper smelter was proposed in the early 1990s, I acted to protect that which had spiritual value to me. I have since been compelled to oppose the Port of Houston Authority once again, this time because its proposed Bayport container port is a threat to the bay. I have found that my spiritual self is affirmed by

activism. Efforts to protect the natural system are a part of the practice of my spirituality. Activism defines me in a positive manner to myself. I feel alive when I am acting in an attempt to protect that which has spiritual value to me.

There is certainly a religious basis for activism. What exhibits activism better than Jesus throwing the money-lenders from the temple in Jerusalem? He was literally tossing greed and avarice from the temple, which had been turned into a "den of robbers." In large measure we have lost this connection between activism and spirituality in our organized religion today—the basis for such activism exists, but for the most part it is not practiced at the institutional level. Ultimately, this form of spirituality is highly personal; it is experienced and felt. My friend Hilmar Moore does not believe in the spiritual world. Instead, he experiences it. He needs no book or preacher or philosophical proof. He has a primary experience, and so do I. This form of spirituality does not require large edifices with early and late services. It is not just open for business on Sunday. It is lived.[2]

I often enter the cathedral of Christmas Bay through fishing. Fishing puts me in touch with other living things while clarifying my role as a predator within that system. I prefer to fish in a kayak, sometimes alone but usually with friends. The kayaks used on the bays for fishing are not the same as river kayaks. In my experience, river kayaks are fully enclosed and relatively easy to turn over. By contrast, fishing kayaks are open at the top, with a molded plastic area for your rear and legs, and they are stable. Used with a modicum of care, these kayaks open up the secret places of the Texas coast.

Camaraderie comes with fishing and fishing partners generally, and kayaking reinforces this because of the unique requirements of the sport. Like most fishing trips, a kayak trip starts before dawn. On one typical trip, four of us gathered at one person's house at 4:00 A.M. We strapped the kayaks to the roof of the SUV and loaded the equipment—paddles, anchors, life vests, wading boots and belts, fishing rods and tackle, and bait buckets for live bait. We were not putting our kayaks on a boat in order to move around on the bay, trying some paddling in this place or that. Instead, we would drive to our selected put-in point and then paddle, definitely limiting our fishing range. If the initial put-in turned out to be without fish, we had no ability to pick up and move twenty miles to a better spot, as you can with a boat. These are consequences of the put-in decision, and debates about the best place contribute to the fun.

Approached by road from Houston, Christmas Bay starts about seven miles northeast of Surfside. It is surrounded by salt marsh and full of oysters, two prime indicators of a healthy estuary. Much of the land along the bay's northern shore is part of the Brazoria National Wildlife Refuge: the bird watching is great, the fishing is dependable, and large sections of this protected shore will never be developed. Surfside was an easy drive. There was virtually no traffic except for other fishermen, most of whom were pulling boats. Going kayak fishing means

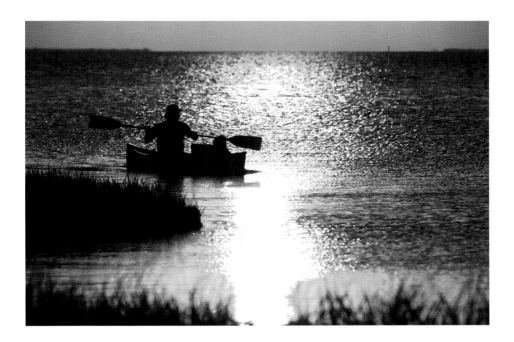

A kayaker takes off into the early morning. To me, going fishing and birdwatching from a kayak is the finest way to enjoy the Texas coast.

no trailer to haul, no flat tire to fix. There is no waiting in line to launch and no embarrassment from failure to back a trailer seamlessly onto the boat ramp.

As usual, we turned on the outdoor show on KILT Radio as we drove south. This radio show is a coastal fishing institution, with bait camp operators and guides from the coast as well as from inland calling to report if anyone is catching fish. Anglers enjoy listening to the lies as much as the occasional truth. Besides being good for weather information and water conditions, the show moves you into the right frame of mind.

There are many places to put in on Christmas Bay. A county park at a bait camp has parking spaces. A major camping and public access point is located at Cold Pass, and numerous sand roads lead to the edge of the bay or to channels running into it. As with any serious outdoor activity, advance planning and scouting of options are necessary for a successful trip. Side roads can be treacherous in wet weather, and roads that are easy to find in daylight can be much more elusive thirty minutes before first light.

We stopped to pick up live shrimp in Freeport. Bait camps are an interesting sight at any time, but before daylight they are at their best. A white flag signals live shrimp, a yellow one live croaker. Cars, trucks, boats, and trailers were parked at all angles. The aerated live wells were pumping water, illuminated by a hundred-watt bulb hanging above. A pride of house cats milled around the edges of the light, dashing furtively to and fro. The attendant was grumpy. The fishermen

were anxious. Live shrimp were scooped out in quart- and pint-sized buckets. "Gotta quart coming out," sang the helper as the next hopeful stepped to the front.

We crossed the Intracoastal Waterway and headed up the Blue Water Highway, a wistful name if ever I heard one. This road connects Surfside with Galveston via a toll bridge across San Luis Pass. We turned off well before the bridge onto a small sand track and drove to the edge of Christmas Bay, arriving just as the first light was visible in the east.

First we checked the water level. The tide was not yet in. In the headlights, the water line was reflected and the saturated beach from the last high tide was clearly visible. The tide charts said the tide would be coming in during the morning, and the weather forecasters opined that it might be slightly higher than normal due to tropical weather in the Bay of Campeche.

Unloading kayaks was easy. The boats were placed in the beam of the headlights, and we set about readying our gear. We attached knee straps and backrests to the sides, rod holders in the rear. The anchor was a key item, as was a life vest. Lunch, a dry bag, and extra gear were stowed in the hatch on each craft. Wading belt, tackle, and fish stringer were secured under the hatch straps. A fishing kayak has holes in the bottom that allow the water to rise into the kayak, which is why this kind of craft is much more stable than those that float above the water. But the holes also mean that the kayaker gets wet. On a hot summer day like this one would be, the water feels good. In fall and winter, however, thermal protection such as a pair of neoprene waders is necessary.

Before full dawn came on, the flotilla was assembled. The four kayaks moved gracefully onto the flat surface of Christmas Bay, one lime green with a yellow hatch cover, two purples, and an aqua. The sun was just visible to the east, an orange orb backlighting the kayak in front, sleek and low in the water, with the rod extending from the rear like an outrigger. The white tips of the paddles flashed up and down, up and down, as we glided toward our favorite fishing spots.

Christmas Bay is a quiet place. By late summer, the breeding season of gulls, herons, and spoonbills is over, and the fledglings are venturing out on their own. The raucous sounds of the rookery, so noticeable in April and May, are absent by August. The only sounds now were those of the gulls passing over and the barges and other craft moving down the intracoastal canal. A kayak fits comfortably into the rippling silence.

Tidal movement is one of the great rhythms of the Texas bays. Away from the passes, the movement is subtle, but the onset of tidal change is well understood by fish. Fish feed best during tidal changes, and we hoped that day would be no different. After paddling for fifteen minutes, we paused next to an oyster reef, catching a disdainful look from a nearby heron. We were fishing near Rattlesnake Point, and the tide here comes in from the south at Freeport, the current clearly visible through the reef channels, meeting the incoming tide from Cold

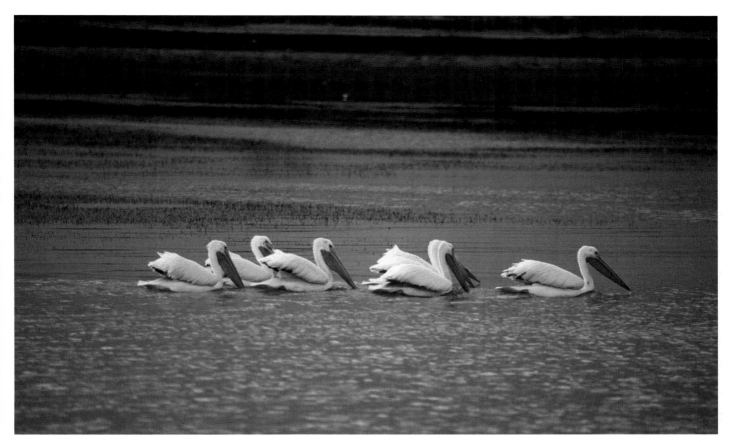

White pelicans often fish together. I once followed a pair of them into the marsh and found myself connecting with other living things in a new way. Since then, I have returned to the marshes and to Christmas Bay for spiritual connection and replenishment.

Pass farther into Christmas Bay. Redfish would be moving in with this tide, into the grasses that line the muddy bayous and the small coves defining the bay-marsh interface. Speckled trout would be waiting where the tide washed through the oyster reefs. The signs were good; we hoped the planets were aligned for successful fishing.

One kayak moved into the open water to fish the current coming through the reef; another moved into the interior of the reef complex to fish the sheltered areas where predators lie in ambush. The third and fourth moved toward the salt marsh. As we split up, a willet flew from the sand spit next to the reef, shrieking its *whee-whee-whee-whee-whee* call, the white of its black and white wing pattern reflecting the pink and orange hues of the morning sun.

The beauty of a kayak is that it can go where most boats cannot. The area where we were fishing had no other boat traffic. If we paddled into the oysters, we could simply back up and find a different pathway through. The bottom of my kayak shows scars from encounters with oysters but no serious damage. It is difficult to paddle fast enough to do any real harm.

John Chapman lighted up a cigar as he took up his station in the bay, fishing the current coming out of the reef. He was anchored on the mud bottom, the tidal current coming toward him. He fished in toward the reef, allowing the bait to flow in his direction with the current. His feet dangled over the side and he was a

happy man, enjoying the morning. An occasional speckled trout or the more likely hardhead catfish pulled him back from reverie.

Jack Schwaller took the middle of the reef. Here, the best tactic is to paddle to a point and anchor, fish, and then pick up and paddle again. It is possible to fish from an unanchored kayak, but the combination of tidal flow and close quarters with the reef, along with handling the paddle and the rod, makes it difficult to coordinate. The key within the reef is to find the ambush points of the predators—the places where they wait for a meal to come by. Corners and pockets are best, and eddy pools are good too. On a moving tide, the speckled trout and perhaps some redfish hide somewhere within the reef.

John Fenoglio and I went to the marsh. The kayaks glided easily over the surface, immune to the soft mud eighteen inches below. It always amazes me that large fish can live in very shallow water. Twenty-to twenty-eight-inch redfish weighing up to eight pounds are common in water less than two feet deep. Large flounder and black drum can also be found in shallow water. The key here is food: the shallow water of the marsh is full of food. This is where the shrimp and finger mullet live, where the juvenile crabs and finfish grow. If the bait is in the marsh, the predators will follow. An incoming tide brings fish into the shallows of the marsh edge. On a high tide, the redfish stay against the shoreline. Nothing is prettier to a marsh fisherman than the splash of a large redfish chasing bait on the shoreline.

The early morning quiet was broken by the sound of a striking redfish; ripples moved across the small protected cove. As Fenoglio paddled toward the splash site, fish moved before him. The kayak came almost on top of the mullet before they bolted wildly to either side. Larger fish left Vs of wake as they pushed off away from the kayak. As John looked up to scan for any sign of the fish he had just heard, a pair of roseate spoonbills flew low across the marsh, glorious pink in contrast to the green-gold tint of the *Spartina* grass in the early sun.

Fishing the marsh for me is about its relationship to the bay. The birdwatching is excellent. Looking for fish at the shoreline, you may see movement in the grass at the water's edge. A small chickenlike bird steps stealthily along the exposed shoreline, then dashes around the clay ledge and ducks back into the marsh on the other side—a rail of some type. White ibis with their scimitar beaks are my companions, probing into the mud for worms and crustaceans. We are together.

Because the wind angle was not quite right, I decided to get out of the kayak and wade, tying the kayak to my wading belt. Fenoglio, fishing two hundred yards away, made the same decision. After a half hour and some success near the reef, Jack and Chapman paddled closer to us. We motioned that there were fish around, and they settled in nearby.

As the sun rose, the wind increased and the water clarity—not good to begin with—diminished. The Texas coast is a "wind coast" more than a tide

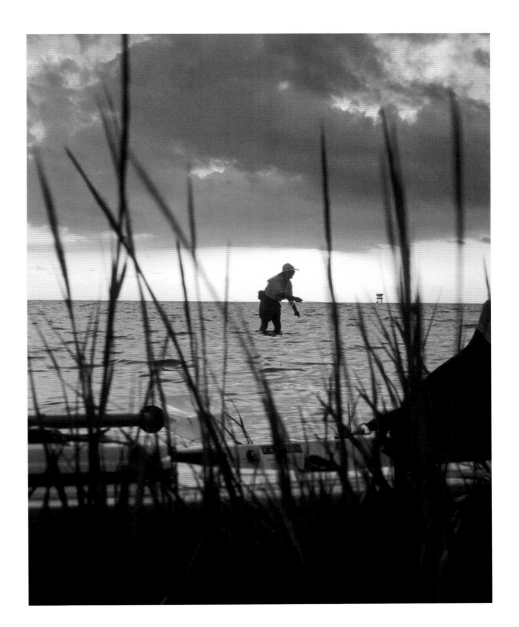

A wade fisherman on the Christmas Bay shoreline has used his kayak to reach the fishing ground and then beached the craft, choosing to wade after redfish and speckled trout.

coast: the wind can have a more pronounced effect on conditions than does the tide. This is particularly so during the winter, when northers can blow half the volume of the bay out into the Gulf.[3] The area we were fishing would not have enough water to float a kayak after a big norther had blown through.

We decided to paddle around the point and find a cove sheltered from the wind. We each had a red and a trout or two, good for the pan, but we were not yet finished. The sun was much higher now, hot and burning. It was time to roll down the long sleeves and slide on the long pants. We pulled up on the shell beach of Rattlesnake Point for adjustments and a quick brunch. For now, the fish could feed without risk of hooks. Shorebirds inspected us briefly but then resumed foraging for their own brunch. No sandwich ever tasted better than that simple one on the shore of Christmas Bay with friends, both human and not.

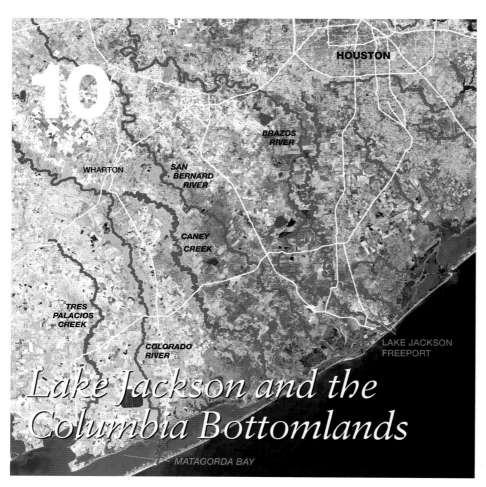

HOUSTON

BRAZOS RIVER

WHARTON

SAN BERNARD RIVER

CANEY CREEK

TRES PALACIOS CREEK

COLORADO RIVER

LAKE JACKSON FREEPORT

Lake Jackson and the Columbia Bottomlands

MATAGORDA BAY

The Columbia Bottomlands are forests growing in the floodplains of the Brazos, San Bernard, and Colorado rivers as well as those of a number of smaller creeks and bayous. This area extends from U.S. Highway 59—the Southwest Freeway—southward to Christmas Bay to the east and Matagorda Bay to the south. Several refuges exist along the coast, including the Brazoria National Wildlife Refuge, Peach Point Wildlife Management Area, San Bernard and Big Boggy national wildlife refuges, Mad Island Wildlife Management Area, and the Texas Nature Conservancy's Clive Runnells Family Mad Island Marsh Preserve.

"Hello again, Mr. Blackburn," said Sam Kent, federal district judge in Galveston. "Welcome to my court. What can I do for you today?"

We were present for a status conference. I explained that I had filed suit against the U.S. Army Corps of Engineers on behalf of Sharron Stewart of Lake Jackson, the Houston Audubon Society, and the Sierra Club to protect the Columbia Bottomlands along the Brazos and San Bernard rivers where they reach the coast. Our suit was against the federal government for issuing a permit to the City of Lake Jackson to fill wetlands for a golf course. Our primary concern was to protect this coastal forested area that was used by millions of migrating Neotropical birds. The year was 1996, and controversy surrounded the Columbia Bottomlands.

The forest of the Columbia Bottomlands has grown for centuries in an area crisscrossed by rivers that have changed courses over geologic time. Today two of the major rivers, the Brazos and the San Bernard, flow directly into the Gulf. However, during flood stage, these rivers flow for miles to either side of their beds and banks, spilling into the adjacent bays and marshes that line the coast from Christmas Bay to East Matagorda Bay, providing critical freshwater inflow, nutrients, and flushing as well as the fertility to grow the bottomland forest.

The bottomlands extend from the Gulf of Mexico up to sixty miles inland, occupying the area between Christmas and Bastrop bays to the east of Freeport and Matagorda Bay to the west. As you move inland along Bastrop Bayou, the Brazos River, Jones Creek, the San Bernard River, Caney Creek, and the Colorado River, forests line the floodplains, dotted with wetlands and ash flats. The forests are double canopy, with an overstory of oak, sweetgum, hackberry, green ash, elm, and hickory and an understory of holly, beautyberry, yaupon, and palmetto. Over the years, the forest has been fragmented, with swaths cut out for cropland, rangeland, timber, and development. The proposed Lake Jackson golf course would break up one of the last remaining segments of contiguous, uncut, old-growth forest, more than twelve hundred acres of it, an action bound to have profound effects on the wildlife.

At the invitation of Judge Kent, both sides offered summaries of their positions and then were invited into the judge's chambers. Judge Kent removed his robe and sat at the head of the conference table, clearly in charge of the meeting. Justice Department attorneys from Washington, D.C., were defending the Corps, and the City of Lake Jackson was represented as well.

I had been in Judge Kent's chambers before and knew he often focused on getting the parties to see the wisdom of settlement. One earlier case had involved the channelization and clearing of Caney Creek, a tributary of East Matagorda Bay near Sargent. The East Matagorda Bay Foundation had sued the local drainage district, seeking to force the district to obtain a federal permit prior to stripping this estuary of all vegetation—habitat important to the fish and shellfish that migrate into the creeks and bayous and use them as nurseries. To a drainage district, this vegetation was a problem, an obstruction to flow.

Judge Kent is not without humor. His initial comment on that case was that he was glad to know there was something happening in Sargent besides marijuana smuggling, a typical criminal case on the docket of the Galveston federal court. Judge Kent never had to rule on or even hear the case involving the clearing of Caney Creek. The simple act of our filing suit and the judge convening a status conference in his chambers led to the drainage district deciding to halt construction and to protect the remaining habitat. I continue to be amazed at the power of the federal court system.

Hence Judge Kent's opening remarks at the conference table on the Lake Jackson case were no surprise. He started by making humorous yet biting comments about both birdwatchers and golfers. In his own inimitable manner, Judge Kent was simply stating that he was unbiased in the litigation. He promptly urged us to settle this case and sent us off to negotiate.

Part of the reason for litigating this case was that the Galveston District of the Corps of Engineers had not found many acres of wetlands on this proposed golf course site, despite the fact that it was covered with water for months at a time and was full of wetland vegetation. The problem was the soil. The definition of a wetland is highly technical, and one requirement is that the soils exhibit historical saturation, that they are "hydric soils." In the Columbia Bottomlands, the soil is so dense that water tends not to penetrate into the subsurface, and so the chemical characteristics of the soil do not fit the typical definition of a wetland.

An almost immediate result of the Lake Jackson litigation was that the Corps of Engineers reviewed the way they evaluated wetland soils and changed their position, adding thousands of acres in the bottomlands to those classified as wetlands. Today, the Corps would have found many more acres of wetlands on the site, even after the SWANCC decision discussed in chapter 3. Yet wetlands were only part of what the litigation was about.

Half an hour to forty-five minutes after sunset in Nicaragua, in the Yucatan, or in Tamaulipas in southeast Mexico, warblers push off into the darkness. They have been waiting for the surface of the earth to cool and for the tall columns of turbulent air to dissipate. They want a clear starry night with a tail wind on which to begin their spring migration over the Gulf of Mexico. As in the fall, when north winds help carry them south for the winter, they use the prevailing southeast winds to help them cross four to six hundred miles of open water to the coasts of Texas and Louisiana.

There are more than thirty species of wood warblers, all small, nervous, and flitty, birds that are the bane of beginning birdwatchers' identification skills. With them, orioles and tanagers, grosbeaks and catbirds, thrushes and buntings all cross or parallel the Gulf of Mexico during the annual spring migration.

This is an incredible journey of faith and endurance, the migratory message passed down through DNA and experience. Ruby-throated hummingbirds no bigger than one's finger make the trip. So do the outrageously gorgeous painted buntings that the Spaniards called *las mariposas pintadas*, painted butterflies, for their red breasts, lime green backs, and heads of indigo blue with scarlet eye rings. I have seen these migrants arrive across the Gulf, buffeted by the squall lines associated with late spring cold fronts. The birds arrive so tired that they literally collapse on the marsh grass of the barrier island, wings splayed out, eyes wide open, immobile.

Warblers ordinarily weigh a little less than half an ounce, but to prepare for migration they double their weight, fattening up on insects. Ornithologists can

feel the tumorlike fat deposits with their fingers when they handle the birds during banding. The timing of takeoff is governed by a number of factors, with the length of the day being one of the most crucial. Birds also seem to detect changing weather patterns, perhaps through hearing low frequency sounds or registering changes in barometric pressure. When these birds lift off and cross the Gulf in March and April, usually in flocks of 100 to 150 birds of mixed species, they are so numerous that they can be followed on weather radar. Scientists call it an exodus. Altogether, about 29 million birds make the dangerous flight across the Gulf to come to the Columbia Bottomlands.

How do they know where to go? Migration routes seem to be partly inborn and instinctual and partly learned. Experiments with releasing birds in a planetarium have convinced scientists that some birds, such as buntings, navigate by the heavens, telling north from south by the rotation of the stars around the North Star. Others, like humans, navigate by the changing position of the sun. Recently scientists have come to believe that birds use more than one method of navigation, depending on conditions. However they do it, it works, and they have been doing it for tens of thousands of years, most likely since the last ice age, when the receding glaciers provided new ecological niches.[1]

With a tail wind of ten or fifteen miles an hour and flying at altitudes from fifteen hundred to five thousand feet, warblers can hold an airspeed of thirty-five or forty miles an hour, hitting the Texas coast by mid- to late morning after an eighteen-hour flight. Sometimes if the tail wind persists and they have not exhausted their stores of fat, they skip on into the interior of Texas and disperse. But if things go badly—if a thunderstorm comes up, or worse, a late norther blows in and enters the Gulf—they may not arrive until after dark or may not arrive at all. A sudden spring norther can exhaust the birds and cause what birdwatchers call a "fall-out."

In a fall-out, some birds arrive so weary that they "fall out" onto the sandy beaches of the barrier island. Others perch on boats and offshore drilling rigs until they can recover their strength. Many drop into the ocean and wash up as brightly colored corpses in the surf. Birds that survive the head wind arrive thirsty, depleted, their fat deposits burned away, their wings and bodies sprayed with salt. They are looking for the first good place to land, with food, fresh water, and shelter. Along the Texas coast, they are looking for the one feature that stands out from the low green marshes and bays—trees. On a journey such as this, the Columbia Bottomlands area is a five-star rest stop. It has everything: trees, food, water, and shelter. For most birds, it is a place to stop over and rest; for some it is the final destination—the nesting area.[2]

The full extent of use of the Columbia Bottomlands by migrating songbirds is still being realized. Experienced birdwatchers like Victor Emanuel have long known that migrating birds arrive at the bottomlands in the morning and after-

The summer tanager is one of many varieties of Neotropical songbirds that rely on the Columbia Bottomlands as part of their migration pathway between North American breeding grounds and wintering grounds in Mexico and Central and South America. Litigation over the Columbia Bottomlands was an attempt to protect this important habitat for the migrants.

noon and rest, feed, and recover, but until a few years ago no birder had seen what the birds were doing at night.

During the early 1990s, ornithologist Sidney Gauthreaux of Clemson University studied the bottomlands with Doppler weather radar, stationed in nearby Dickinson. Thirty to forty minutes after sunset, he found, the rested birds arose in flocks large enough to register on radar and flew northeast for 150 miles and more. Gauthreaux's counts showed that millions of birds were using the bottomlands before moving east. These forests were a critical port of entry for a huge percentage of the songbirds of the northeastern United States.[3]

Sharron Stewart is passionate about these birds and protecting this habitat. For decades, the extensive usage of the Columbia Bottomlands by birds was not well known beyond select birdwatching circles. A lifelong environmentalist, Sharron has joined with the U.S. Fish and Wildlife Service and Texas Parks and Wildlife Department to help preserve these important bottomlands. Because of the uniqueness and significance of the tract where the golf course was proposed, she filed suit to protect forested wetlands and to cause a detailed environmental impact study to be done before the Corps of Engineers issued a permit allowing destruction of the forest.

Sharron's 1996 lawsuit generated strong and visceral responses. Lake Jackson is a small town, a company town dominated by Dow Chemical. Most of the citizens of Lake Jackson work for Dow either directly or indirectly. Although the

Hummingbirds exemplify the miracle of bird migration—such beauty and long-distance power in such a small package.

Houston Audubon Society and the Sierra Club were also plaintiffs in the litigation, Sharron took the brunt of abuse as the named plaintiff and the local resident. "What people do here when they don't agree with you is to demonize you," she told me. "It doesn't matter the merits of your argument. You represent something that they fear. And they ostracize you—leave you out of things. You feel really alone." It happened when she fought Dow on air and water pollution in the 1970s, and it happened again when she went to federal court over the golf course.

For their part, the U.S. Fish and Wildlife Service and Texas Parks and Wildlife had tried to purchase as much of the bottomlands as they could, as fast as they could. Mike Lange of USFWS knew from the beginning that he had his work cut out for him in protecting the Columbia Bottomlands. In 1995, he and his agency, working with Texas Parks and Wildlife and the Nature Conservancy as well as other organizations and individuals, published a document showing the boundaries of the historical forested area that might be purchased and protected. The habitat was being fragmented, chipped to pieces for small developments, pipeline and utility paths, grazing, and logging, and it was threatened as a functional habitat.

According to the draft environmental assessment by the USFWS, in 1900 the Columbia Bottomlands contained 700,000 acres of hardwood forests. Of this, only 177,000 acres remained, or about 25 percent of the original acreage, and much of this was both highly fragmented and threatened.[4] In support of the concept of establishing a national wildlife refuge, the study concluded:

The Service proposes to acquire up to 28,000 acres of bottomland hard-wood forests and associated swamps, ponds, lakes, and sloughs along the lower Brazos, San Bernard and Colorado Rivers in Brazoria, Matagorda, Wharton and Fort Bend counties, Texas. This acquisition would be either in the usual form of fee title ownership or a less-than-fee title arrangement known as a conservation easement. These lands would become part of the National Wildlife Refuge system and would be known as the Columbia Bottomlands National Wildlife Refuge, a unit of the Brazoria National Wildlife Refuge Complex.

The executive director of the Texas Parks and Wildlife Department at the time, Andrew Sansom, concurred. This forest type dominated by big, old oaks and pecans was unique. Sansom had grown up among such woodlands in Brazoria County, and he concluded: "We'll be real sorry if we don't deal with a major commitment to preserve it in our generation."

The USFWS proposal seemed like a good plan. Willing sellers such as the owners of Osceola Plantation, a 7,000-acre tract with nesting bald eagles and unique vegetation, would be met by willing buyers. No one's property would be condemned, and what would be preserved would be a rapidly fragmenting habitat of importance not just to Texas but also to the United States and Central and South America. Then came the proposal by the City of Lake Jackson to develop one of the last large contiguous tracts for a golf course. Sharron and others filed suit after the permit was issued by the Corps, and all hell broke loose in Brazoria County.

So many millions of migrants use the wooded bottomlands as a rest stop that their exodus to points north can be observed on radar. In the image, the intense green is the center of a mass of migrating birds moving northward from the Columbia Bottomlands. Illustration provided by Jim Blackburn

A map included in the USFWS plan identified virtually all forested areas within the four counties as potential sites for inclusion in the refuge. Local landowners, fearing that their land would be taken against their will, misunderstood the map. The plan was immediately blasted by Brazoria County commissioners, State Senator Buster Brown of Lake Jackson, and U.S. Representative Tom DeLay of Sugar Land, who denounced the project as a federal takeover that would stop development in Brazoria County. DeLay, newly elected House majority whip during the 1994 congressional elections that gave Republicans their first majority since the 1950s, placed in the federal budget a rider declaring that the USFWS could take no action against the Lake Jackson golf course. Later, he stopped funding for the bottomlands purchase.

The purchase was put on hold. Texas Parks and Wildlife distanced itself from the proposal and allowed the Texas Senate to initiate a complete review of the property rights, interagency cooperation, habitat management, and community participation issues to determine the fate of the bottomlands purchase.

In order to gather information, the Senate Natural Resources Interim Subcommittee conducted a series of public hearings. After hearing from more than fifty-eight speakers, Senator Brown met with the county judges from Brazoria, Matagorda, Fort Bend, and Wharton counties and established a Four-County Task Force chaired by the four county judges and composed of local residents with different points of view. Observers such as Sharron were worried that the Four-County Task Force would simply be used by Senator Brown to put forth a predetermined answer, yet that did not happen. In fact, the results of this Four-County Task Force were rather amazing.

One major study committee included Laurence Armour, an heir to the estate of Shanghai Pierce (see chapter 13). The Pierce Ranch once extended two counties deep, from the Wharton and El Campo area along U.S. Highway 59 to the coast along the Colorado River to Matagorda Bay, and it still exists as a large contiguous land holding. From the beginning, conservationists such as Mike Lange and Sharron worked with Laurence's study committee, trying to assuage fears and provide assurance that preservation of these bottomlands was compatible with the needs of private landowners and with political goals for the area. Sharron worked to ensure that the voices of landowners wanting this refuge were heard, and they ultimately were.

Laurence's study committee became focused on the economic potential of the birds and of conserved areas such as San Bernard, Brazoria, and Big Boggy national wildlife refuges and the newly proposed Columbia Bottomlands refuge. Carefully constructed, a plan could be developed to allow ecotourism to combine ecological preservation and economic development. The committee looked at figures from the State Task Force on Texas Nature Tourism, which had reported that in 1991, 4 million Texans spent over $1.3 billion traveling to and observing,

feeding, or photographing wildlife. Also, nature tourism had averaged a 30 percent annual increase each year since 1987.[5]

Laurence's committee's work reflected a new attitude toward the environment, now beginning to gain traction among landowners. His family had lived for decades off oil, rice, and cattle. The oil was running out, and the rice market was flagging. Laurence was one of a number of landowners who believed that environmental protection and property rights interests could support each other. He worked to develop ecotourism on the Pierce Ranch, which includes a portion of the Columbia Bottomlands. As part of the subcommittee work, the group developed a position on the value of the bottomlands for birding and their long-term potential for tourism. Buyers for land at market value are hard to find, and many of the landowners want to sell their land to the federal government for a fair price.

The release of the work by Laurence's committee in September of 1996 marked a turning point in the fight for the bottomlands. Laurence's group managed to forge a consensus based upon the philosophical concept of land stewardship and the practical concept of ecotourism. Despite all the preceding and surrounding conflict, the report highlighted the extensive usage of the Columbia Bottomlands by migrating Neotropical songbirds (fig. 15), validating the area's key role and international importance.[6]

The report also identified how local, state, and federal interests could work together in partnership for environmental conservation, and it emphasized that landowners have rights as well as responsibilities as stewards of the land to protect this habitat. The co-chairmen declared themselves in favor of a community-based conservation framework for the protection of these coastal woodlands through such less intrusive means as conservation easements, wildlife management cooperatives, or technical assistance for habitat management, rather than through outright acquisition by a government agency.

To the amazement of virtually everyone, the Four-County Task Force put the landowner controversy aside and forged a consensus. The conveyance letter to Lieutenant Governor Bob Bullock from Senator Buster Brown, chair of the Senate Natural Resources Interim Subcommittee, said it all: "The Senate Natural Resources Interim Subcommittee respectfully submits to the Members of the 75th Legislature its report on the U.S. Fish and Wildlife Service's decision to enact the Columbia Bottomlands Protection Plan, which would create a habitat for migratory birds in Brazoria, Matagorda, Fort Bend and Wharton Counties. The members of the subcommittee are pleased to report that the affected communities were able to establish a structure for the resolution of this matter."[7]

In response to this, the U.S. Fish and Wildlife Service issued their final proposal for Austin's Woods conservation in April of 1997 (they renamed the refuge Austin's Woods because the bottomlands were settled by Stephen F. Austin's original three hundred settlers). USFWS adopted the committee's recommendations wholesale.

They explained that all bottomlands would not receive "refuge designation," so that property values would not be affected, alleviating the major concern of the previously opposed residents. Because of this decision, USFWS predicted a mosaic of land blocks that would unite with local conservation efforts to preserve ecosystem structure and function. They concluded that the acquisition of land for the new refuge would depend on willing sellers and donors, the quality of the habitat, and the availability of funds. These newly protected federal lands would combine with the state's more than 4,000 acres in Brazos Bend State Park and over 150,000 acres of private lands with habitat management initiatives to present a truly united effort on behalf of these forests, which the various interest groups all eventually concluded were a source of local pride, a part of their heritage, and of inherent value.[8]

As the debate on nature tourism and the merits of the refuge continued, Sharron's federal lawsuit moved ahead before Judge Kent. We were called back into chambers to discuss the status of our settlement discussions. Environmental settlements are difficult in the best of situations, and while we had tried to meet each other on some issues, neither side was willing to settle. We told this to Judge Kent, who looked at me and said that he was going to go ahead and rule and that I might not like the result.

Months later I was amazed when the case of *Stewart vs. Potts* (the colonel of the Corps) came out, and we won. Judge Kent agreed that the Corps had failed to consider the cumulative impacts prior to issuing this permit and ordered the permit remanded to the Corps of Engineers. His action did not stop the golf course forever, but it did prevent the forest yielding to fairways in the next year or two.

A remand such as this is a powerful legal remedy. It stopped one party—in this case the City of Lake Jackson—from going forward with its planned golf course because it lacked the necessary permit. This remedy provided time for circumstances to change, time for different points of view to emerge. Sharron and I had no illusion of absolute victory. Under Judge Kent's order, the Corps had to go back and restudy the situation. Then they could issue the permit again if they had done the right studies.

During all this time, Mike Lange was busy. Mike has analyzed the bottomlands from the Gulf of Mexico inland to U.S. 59. He knows every major woodland tract and streamside woodlot. He knows how Bastrop Bayou runs into Bastrop and Christmas bays. He knows how the tide runs up Oyster Creek, the Brazos and San Bernard rivers, and Caney and Jones creeks. He knows how the coastal marshes interact with these woodlands, how the runoff brings nutrients into the bays, how the freshwater is distributed horizontally through the floodplain north to Bastrop, Christmas, and Drum bays, southward into Cedar Lakes and East Matagorda Bay. And he knows every piece of land with ecological value in the four-county area as well as which tracts have owners who are ready to sell.

Season Category	Number of Species	Annual Population
Annual Residents	72	1 – 2,500.000
Migrant Breeders	27	1,000,000
Winter Residents	81	1 – 1,700,000
Migrants	57	24,000,000
TOTAL	237	27 – 29,000,000

Figure 15.
Findings on bird usage of the Columbia Bottomlands, as reported by the (Texas) Senate Natural Resources Interim Subcommittee.

Mike is part scientist, part traveling preacher, making his rounds, working the deals. He coordinated with Sharron, who knew some of the critical landowners. Mike lined up private money for purchasing land, to take up the slack left by DeLay's impoundment of federal funds. At the state level, Texas Parks and Wildlife offered technical assistance, providing interested landowners with the latest in wildlife and habitat enhancement information.

Many landowners lined up to sell their land. Mike Lange found the seven-hundred-acre Dance Bayou tract, a beautiful stretch of marsh, old-growth woods, and wetlands near the San Bernard River. The land was purchased by Houston trial lawyer John O'Quinn, who once again came through for coastal conservation needs. He deeded the land to the U.S. Fish and Wildlife Service, and it became the first tract of the Columbia Bottomlands National Wildlife Refuge.

By 2001, Mike Lange was a happy man. The prohibition on federal spending had been lifted. He had recently purchased several smaller tracts and was working on a few larger purchases. As of January, 2003, USFWS had a total of 12,500 acres saved and was almost halfway to its goal of conserving 28,000 acres for Austin's Woods. Ron Bisbee, Mike's supervisor, is working on assembling the Texas Mid-Coast National Wildlife Refuge, which will protect some of the most important coastal habitat in the state. In association with Texas Parks and Wildlife, the USFWS is establishing a series of land tracts that will ultimately protect West Galveston Bay, Christmas, Drum, and Bastrop bays, the marshes between the Brazos and San Bernard rivers, the Cedar Lakes salt marshes, and East Matagorda Bay. To stimulate private landowners' participation in the federally orchestrated protection of the Columbia Bottomlands, USFWS is offering access to matching funds for conservation-oriented improvements.

All of us in Texas owe a debt of gratitude to the federal government for this effort; and to Sharron Stewart, Houston Audubon, and the Sierra Club for fighting for these bottomlands; to Laurence Armour for standing tall in the face of good old boy politics; and to John O'Quinn for putting money where the earth needs it.

Through all of this action, the lawsuit continued. The Corps redid their analysis of the environmental impacts of the golf course and noted that it was only 200 acres out of 177,000—totally missing the point of the analysis of cumulative impacts and fragmentation—and the permit was reissued. From an ecological standpoint, the question remained: how much habitat can be lost before serious impacts occur to migrating Neotropical songbirds? How many acres of bottomlands near the Gulf can be lost without substantially harming bird populations?

The Senate Interim report, drawing heavily on USFWS and Texas Parks and Wildlife documents, states that the numbers of these birds are declining, especially the following species: the yellow-billed cuckoo, wood thrush, Swainson's warbler, prothonotary warbler, painted bunting, eastern wood-peewee, Kentucky warbler, indigo bunting, and orchard oriole. The Corps' own documents note that

several of the species using the bottomlands for migration are declining to the point of heading toward the endangered species list. Is the loss of these bottomlands critical in the life cycle of these birds? The Corps never answered these questions in their analysis but merely reported that the construction of the golf course represented the loss of less than 0.06 percent of the remaining forested habitat.

But can the birds survive on the amount that is left? That is the important issue. How much forest is enough? If the amount remaining is inadequate, every acre lost is significant to the future of the beautiful songbirds that sparkle like Christmas tree ornaments in the green spring leaves of trees in the Texas coastal forest. The Freeport Christmas Bird Count has frequently reported the largest number of species in the country; it would be especially tragic to allow this cycle of habitat degradation and loss of species diversity to rob the area of this source of pride and acclaim.

In late 2000, Judge Kent ruled against Sharron Stewart and the Sierra Club and Audubon, finding that the Corps' reanalysis, while not perfect, was not so bad that he as a federal judge would intervene in their decision-making process; instead he deferred to the scientific expertise and analyses of the Corps of Engineers. Sharron and others appealed this ruling to the Fifth Circuit Court of Appeals in New Orleans, which upheld that decision, and we decided not to appeal to the U.S. Supreme Court. Two days after the plaintiffs opted not to file with the Supreme Court, the Lake Jackson City Council sold the golf course bonds.

In a fight such as the one for the Columbia Bottomlands, the lawsuit was part of a series of events that led to a consensus that these bottomlands were important and that efforts to preserve these bottomlands were both necessary and useful to the community. The golf course tract was lost, but the larger point was made that these bottomlands were worth fighting over.

It is important to recognize the strength of will required by Sharron Stewart, who stood up and took on her neighbors, trying to change public opinion. It is important to recognize the difference that a responsible steward such as Laurence Armour can make. And it is important to note the perseverance and dedication of government employees such as Mike Lange. We should also recognize the philanthropy of persons such as John O'Quinn. People can and do make a difference. And the birds will be better off for all of their efforts.

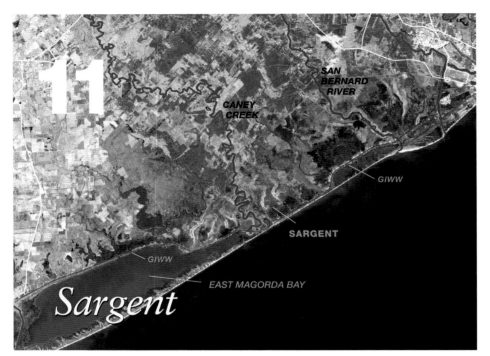

Sargent

SAN BERNARD RIVER

CANEY CREEK

GIWW

SARGENT

GIWW

EAST MAGORDA BAY

The community of Sargent lies where Caney Creek enters East Matagorda Bay. East Matagorda Bay reaches westward from there, and to the east lie the Cedar Lakes and the San Bernard River. The Gulf Intracoastal Waterway is clearly visible on this map, running along the northern shoreline of East Matagorda Bay, dipping almost to the Gulf of Mexico at Sargent, and then following the north shoreline of Cedar Lakes.

The people who called me were Muriel and Roy Tipps, commercial fishermen who own a bait camp and shrimping business in Sargent on the north end of East Matagorda Bay. The U.S. Army Corps of Engineers was dumping fill into East Matagorda Bay, and the shrimpers couldn't shrimp and the recreational fishermen couldn't fish. "Mr. Blackburn, they're killing our bay! The people of Sargent want to do something about this," vowed Muriel, "We don't have much money, but we'll do what we can to raise enough to go to court."

Muriel and Roy's concern was due to the disposal of dredged material resulting from the maintenance dredging of the Gulf Intracoastal Waterway, commonly called the intracoastal canal. The canal runs from the Mexican border to Florida, a twelve-foot-deep artificial channel that cuts across bays and marshes and grasslands. Through Texas, the waterway lies behind the barrier islands, protected from the Gulf of Mexico. This artificial channel and the tugs and barges that it supports are constants along the Texas coast. From Corpus Christi northward, barges of petrochemicals, diesel, gravel, and sand move like ghosts—disturbing presences on the edge of consciousness, pushed by powerful diesel tugs issuing plumes of black smoke visible for miles on the flat coastal plains.

The canal's origin dates back to U.S. Secretary of the Treasury Albert Gallatin's 1808 study entitled *Public Roads and Canals,* in which he formulated

a plan for federal promotion of inland transportation and established the principles that have guided the federal government's view of coastal canals. As is the case with many public works concepts, the implementation fell to the U.S. Army Corps of Engineers.

Although the idea originated two hundred years ago, its realization was slow. By 1895, only a three-foot-deep canal existed from Sabine Pass to Christmas Bay. Frustrated by the slow progress, Victoria banker Clarence Holland formed the Intracoastal Canal Association in 1909 to lobby Congress to speed up work on the canal.

In 1923, the canal association commissioned General George Goethals, famous for his work on the Panama Canal, to undertake a study of the economic potential and justification for a continuous waterway along the Texas coast. The River and Harbor Act of 1925 included the Louisiana-Texas portion of the canal, and the New Orleans to Galveston segment was opened in 1934. By 1949, the canal had been dredged all the way to Brownsville.[1]

There are two parts to the life of a canal: construction and maintenance. Because the intracoastal canal crosses numerous rivers and smaller tributaries, every flood event brings silt into the waterway. In many cases, the canal has become a primary or secondary circulation pathway, meaning it is deeper than surrounding outlets and bay areas. Over time, the canal fills in.

A canal filled with sediment is no longer functional and has to be reopened, which the Corps of Engineers terms "maintenance." The Corps is responsible for maintenance dredging, a process that involves bringing into the canal a floating platform full of diesel-powered compressors and pumps. At one end, a cutter chops into the accumulated silt, releasing it so that it can be sucked into a large pipe, pumped to a remote location, and discharged.

The description may sound antiseptic, but the process is not. The discharge pipe disgorges a black plume of watery mud laced with the remains of fish and shellfish. Gulls hover around the discharge, looking for a free meal. The black muck flows like lava across the land surface and oozes into the bay, slowly expanding outward, covering the bottom, suffocating the oysters. From the air, it looks like an oil spill.

Muriel and Roy Tipps had called me because the Corps, in their maintenance dredging of the canal south of Sargent, had been dumping the dredge spoil directly into East Matagorda Bay, silting in shrimping and recreational fishing areas and oyster reefs. Some portions of the bay that had previously been navigable had been silted over, and boats could no longer pass. When we began to press for a remedy, the Corps called a public meeting to discuss these concerns with the locals.

There were not many places to hold a public meeting in the little town of Sargent in 1984. Only one marina, the Don Juan Marina, was large enough. The

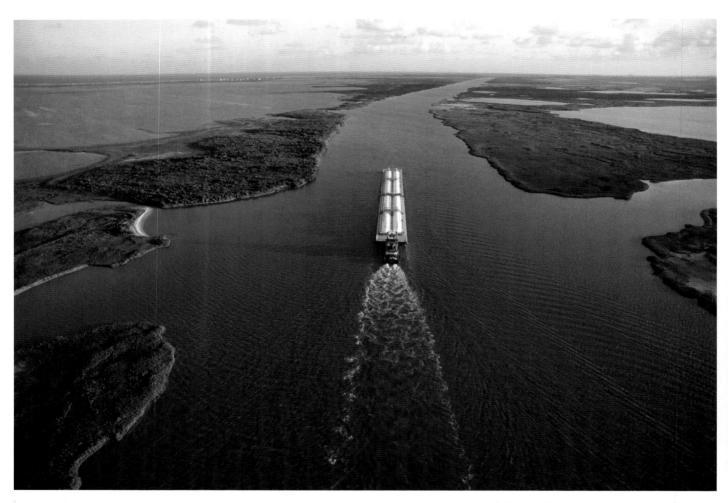

A tug pushes a barge loaded with petrochemical products down the Gulf Intracoastal Waterway. The waterway was cut through the bay and marsh systems of the Texas coast during the 1930s and '40s. Many of the environmental disputes up and down the coast have arisen over the disposal of silt that settles on the bottom and must be removed by dredging to keep the canal open.

Corps talked with the marina owner and arrangements were made. But when the Corps representatives walked into the Don Juan Marina on the appointed day, they knew immediately that they had made a mistake. The owner had been serving up beer to recreational and commercial fishermen for an hour or two in advance of the public meeting. The white rubber boots of the commercial fishermen mingled with the loafers and tennis shoes of the recreational fishermen. All present were unified in their anger about the dredge disposal practices of the Corps.

As public hearings go, this one was truly memorable. The crowd was unruly from the beginning, with new buckets of beer being purchased throughout the hearing. Rick Medina and Herbie Mauer, who would later become high-ranking officials in the Galveston District of the Corps, were in the trenches that day. Rick was using a pointer, trying to focus on a map, but the crowd was not impressed.

When it was time for the public to speak, Roy Tipps strode up to the front of the room with two buckets in his hands. He picked up the first bucket and took from it a couple of blue crabs, a handful of nice large shrimp, and a few fish. He talked about these being the resources of the bay as he placed them on a table.

Roy then picked up the second bucket, which was full of dredge mud, and dumped it all over the neat pile of shrimp and crabs. "This is what you are doing to our bay," he yelled, and the meeting began to fall apart. Shouts and jeers came from around the room as more beer was inhaled. The atmosphere was growing hostile, and the Corps representatives were nervous.

Muriel cannot remember which of the Corps of Engineers team pulled her aside, but the message was clear. They needed help getting out of the room. If they were not quite afraid for their lives, they were certainly edgy about the tenor of the crowd. Muriel sneaked them out at the back of the Don Juan Marina as the crowd rumbled on about the problems in the bay. It was a meeting neither side would soon forget.

As a result of the meeting, the Corps agreed to dredge access channels through the silt, connecting the waterway and East Matagorda Bay through the area that had become blocked due to the open bay spoil disposal. But that was not enough to satisfy Sargent's residents, who decided they needed to go to court to put a stop to the maintenance dredging.

At this stage, the Texas Parks and Wildlife Commission also got involved. The commissioners of this state agency are political appointees, and Governor

This photograph was taken for the litigation brought by Texas Parks and Wildlife and Muriel and Roy Tipps of Sargent. The black plume of spoil material was being discharged into East Matagorda Bay, blocking access to the bay and suffocating oyster reefs. As a result of the litigation, disposal practices in the upper Texas coast were altered.
Photograph from Jim Blackburn

From the air, the open water discharge of spoil material appears as a muddy pancake spreading into the bay, generating turbidity and suffocating the bottom-dwelling organisms.

Mark White had recently appointed a new commissioner, a trial lawyer named Dick Morrison. Among other responsibilities, Dick was given the job of coordinating with commercial fishing interests, and he too was concerned about the impact of dredging on these fisheries. Texas Parks and Wildlife resolved to go to court, and Dick started the legal action at the state level by asking Judge Neil Caldwell of Brazoria County to issue a temporary restraining order, stopping the Corps from dredging the canal until an adequate disposal plan was developed. Judge Caldwell approved it, and Dick had a Texas game warden serve the restraining order to the captain of the dredge boat, which then had to shut down.

Obtaining a restraining order in state court was relatively easy, but the Corps transferred the legal action to federal court, where the battle was joined. Jack Carter of the Texas Attorney General's office represented Texas Parks and Wildlife, while I represented Muriel and Roy Tipps and the commercial and recreational fishing interests of Sargent. After a full day of hearing evidence, Judge Hugh Gibson of the Galveston Division of the Southern District of Texas decided that the dredging could continue, but only after changes were made by the Corps.

At the hearing, the Corps claimed that they would conduct their maintenance dredging differently in the future. They agreed to try to protect oyster reefs that would otherwise be smothered by the plume of mud. They agreed to try to contain as much of the dredge spoil as possible within diked disposal areas. They had heard the concerns and were willing to attempt to address them.

In retrospect, this fight over dredge disposal in Sargent had a much greater impact than the result would indicate. Several years later the Corps agreed to a beneficial use plan for Galveston Bay in association with the settlement on the Houston Ship Channel, a plan specifically designed to use dredge spoil in a positive manner, building marshes and bird nesting islands with material that under the old system would simply have been dumped in the bay waters. Roy and Muriel's challenge changed the way the Corps disposed of dredge material on the Texas coast.

The relationship between coastal residents and the Corps of Engineers is interesting and complicated. The Corps is a permanent fixture on the coast of Texas and in all other coastal states. They have a unique role as the public works agency for the United States government in waterborne transportation. They are also a major regulatory force on the coast, exercising jurisdiction over the issuance of permits for construction and activities that affect U.S. waters.

The entirety of the Texas coast falls under the jurisdiction of the Galveston District of the Corps. A colonel commands each district, serving a two- or three-year tour of duty. A successful turn as a district commander is a key to being promoted to general. Most do not make it and end up as consultants or employees of government institutions or the corporations that they previously regulated.

Colonels come and go, but the civilian staff of the Corps is relatively constant. Most are engineers, hydrologists, or biologists who attempt to enforce the regula-

tions that define the standards, principles, and procedures guiding Corps decision making. The Corps has a strong and direct relationship with Congress and implements the programs that Congress requires. They cannot lobby Congress for funds or particular programs and can only implement those mandated by the U.S. legislative branch. They do, however, manage to communicate very well with key members.

On the one hand, the Corps is the construction and maintenance agency for numerous public works projects intended to benefit the economy. Detractors consider many of the projects to be congressional pork barrel projects. In addition to the canal, the Corps has constructed numerous deepwater navigation channels along the Texas coast as well as flood control levees, reservoirs, and channelization and water development projects. Due to the nature of these projects, the Corps is often associated with causing substantial environmental damage.

On the other hand, the Corps is a regulatory agency. Under Section 10 of the River and Harbor Act of 1899, the Corps must issue a permit before any project can be constructed in or affecting navigable waters of the United States. These are rivers and channels that are accessible to boats when waters are up to the mean high tide line. This broad permit program applies to almost every project on the Texas coast that affects the bays.

The Corps also has responsibility for permitting under Section 404 of the Clean Water Act. As discussed in chapter 3, the scope of the coverage of this program has changed over the years. Suffice it to say that the Section 404 permit program confers federal jurisdiction over more water than does the Section 10 permit program, and it overlaps with the Section 10 program.

With both permit programs under its control, the Corps regulates all actions that physically alter the bays and also regulates the discharge of dredge and fill material into thousands of square miles along the Texas coast. The Corps is the only agency with permitting jurisdiction over bays and wetlands on the Texas coast. No independent permit process for wetland protection exists in Texas. Permission is required to place any structure on the bay bottoms, which are owned by the State of Texas. However, the Texas Legislature has chosen to leave to the federal government the protection of our coastal waters and wetlands from dredging, filling, and development. There is oversight of these federal permits under the Texas Coastal Management Program and the rules of the Coastal Coordination Council. However, if the federal permits were to go away, no state program exists that could replace these Corps permit programs.

Frequently, the Corps gets blasted by coastal landowners and legislators for its regulatory programs. Time after time, politicians bemoan the restrictive policies of the Corps of Engineers and the difficulties it causes developers as a result of its regulatory program. In fact, without the regulatory program of the Corps of Engineers, the Texas coast would have very little protection indeed from the discharge related to dredging and construction along our tidal bays, estuaries, and rivers.

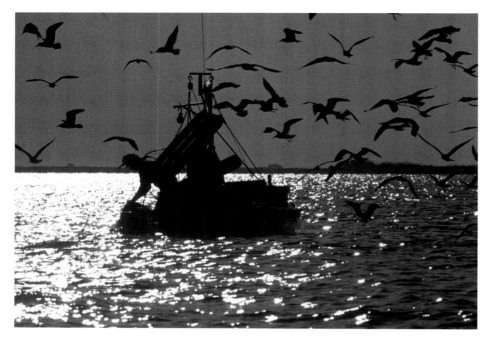

A bay shrimper pulls in his catch as laughing gulls hover for an easy meal. Commercial fishing interests have played a major role in protecting our bays from damaging disposal actions and pollution. Over the last few decades, commercial fishermen have been willing to be plaintiffs in environmental litigation such as that along the intracoastal canal on East Matagorda Bay near Sargent.

The Corps thus has a distinctly split personality, at once enabling development through public works projects yet also regulating development through the permit process. The Corps wants to keep Congress happy by pushing forward economic development, yet the law forces them to regulate that same development. It is enough to cause any agency something of an identity crisis.

Dredging and the Corps are not the only problems found in the Sargent area. Sargent lies on Caney Creek, which flows from Wharton County down through Matagorda County to the bay. Caney Creek is a meandering coastal waterway, with numerous tributaries such as Linville Bayou. Linville Bayou is a beautiful little stream that passes through the forests of the Columbia Bottomlands. It is also polluted.

Bessie Richardson and her now deceased husband K.J. lived near Linville Bayou, just south of State Highway 35, the "coast road," as it is known. K.J. was concerned about the wastewater from the Phillips 66 Sweeney Refinery, which was just upstream. Linville Bayou was covered with foam. It looked like a college student's prank, throwing soap in the fountain. But it was no joke, and the perpetrators were not college students. It was the result of industrial discharge. K.J. was also concerned about a hazardous waste "land-farm" operated by Phillips 66 just across the road from his home. K.J. asked for help preventing Phillips from obtaining permits for both the land-farm and the wastewater discharge into Linville Bayou.

I had never seen an industrial hazardous waste land-farm prior to the visit arranged as part of the legal discovery process. The concept justifying a land-farm is that the toxic chemicals are degraded by microbes in the soil. But a land-farm allows chemicals to evaporate into the atmosphere. Spreading the chemicals on the land and then plowing the ground allows a relatively large percentage of the hazardous chemicals to evaporate, particularly during our hot Texas summers. K.J. had described the odors he and his neighbors were experiencing, and they were bad. They were also dangerous. Phillips provided us with rubber boots and gasmasks for a site visit attended by me and my expert, "the Doctor." I have a picture of myself in a gas mask on the wall of my office, reminding me daily of the bad projects that get permitted in Texas.

Ultimately, Phillips shut down the land-farm because Congress passed the Hazardous and Solid Waste Amendments of 1984, which phased out most forms of land disposal of hazardous waste by 1990. K.J. and his neighbors continued to fight over the wastewater discharge, arguing that the chemicals being dumped into Linville Bayou were causing damage to both Linville and Caney creeks. Biologist Robert McFarlane of Houston was brought in as a consultant to work with us in the fight over the wastewater. McFarlane's fieldwork indicated that Linville Bayou had been severely harmed by the industrial discharge. There was little marine life in the bayou itself, and the mud was contaminated with heavy metals.

Phillips was working to improve its wastewater treatment system. Davis Ford, an environmental engineer from Austin, designed an advanced treatment system that removed both organic materials and metals, and the problem regarding the continuing discharge was addressed, leaving only the issue of the past contamination along Linville Bayou.

K.J. and his neighbors had filed suit in state court over the pollution, and we agreed to mediate our dispute. The solution that emerged, in addition to a damage award, was to create a technical arbitration panel to evaluate the data regarding the pollution remaining on Linville Creek after the discharge had been cleaned up and to determine what should be done to remediate the situation. McFarlane represented the citizens along Linville Bayou, Ford represented Phillips, and the two groups selected Neil Armstrong of the University of Texas Marine Science Institute in Port Aransas as the third panel member.

The logistics were fairly straightforward. Data would be collected regarding the contamination levels, and remediation alternatives would be identified. Then the panel would make a determination as to which alternatives, if any, should be selected. Both parties agreed to be bound by the findings of the technical advisory panel.

At the conclusion of the process, the technical advisory panel determined to leave the contamination in place. Although measurable levels of various heavy metals were present, the panel determined that the risk of contamination from

remediation was significantly higher than the risks associated with leaving the contamination where it sat. The concern was that if heavy equipment were used to dig out the sediment, substantial amounts of contaminants would be resuspended in the water and would flow downstream into Caney Creek and East Matagorda Bay. The pollutants that were on the stream bottom were covered with sediment and were not available for uptake by fish at that time. The bad discharge had been corrected. The people living there were not in any danger from these older pollutants. From the perspective of relative risk, it was better to leave the contaminants where they were.

As far as I was concerned, the conclusions of the panel were correct. What is not correct is the philosophy that allowed these pollutants to be discharged in the first place—a regulatory philosophy more concerned about not upsetting industry than about protecting people and public waters, a belief that less regulation is better and that industry will do the right thing without regulation. That philosophy continues to be present in Texas, even after numerous examples of its shortcomings.

After thirty years of working on the Texas coast, I remain convinced that industry will not voluntarily act in the public interest. Industries are run by corporations, and corporations exist to make a profit. As investors have become more and more focused on short-term earnings, long-term commitments by corporations seem to be a thing of the past. If it does not generate a short-term profit, an otherwise admirable long-term project will most likely be rejected or abandoned.

Pollution control is one of the activities compromised when short-term profits prevail over long-term benefits. Often, higher capital investments on the front end can result in lower costs to the company over the long term. However, a high initial investment will be deferred if the regulatory authorities permit an older alternative to be used, even if operational costs may be higher than with new equipment. Experience has shown this to be true, as in the case of grandfathered facilities, even if the result is more costly over a longer period or if the less expensive alternative poses a significant future risk of litigation. Nowhere in the calculations of the short-term money manager is the long-term harm to waterways, to the public, and to wildlife. That is why we need strong regulations.

The East Matagorda Bay Foundation was founded in the late 1980s, following in the footsteps of the Galveston Bay Foundation. Continuing concerns about the water quality of Caney Creek and Linville Bayou and about maintenance dredging by the Corps of Engineers were among the focal points of the new foundation. Another concern was the fringe of big beautiful trees lining the banks of Caney Creek—trees with limbs and leaves that went into the water, providing excellent aquatic habitat in this brackish stream.

One day I got a call from Bill Templeton, the head of the East Matagorda Bay Foundation. The Matagorda County Drainage District was cutting down trees along Caney Creek. On the foundation's behalf we sent Bob McFarlane out

to investigate, and McFarlane corroborated Bill's account, adding that he thought there was a substantial amount of silt being discharged into the water as the trees were being cut down.

Silt spilling into the water could qualify as a discharge of fill material, and if a discharge of fill material were occurring, then a permit was required from the U.S. Army Corps of Engineers. Since the Clean Water Act contains a provision allowing citizens to enforce federal requirements, we had a place to start.

A few phone calls to the Corps revealed that the drainage district had not obtained any permits from the Corps of Engineers before beginning these clearing activities. We contacted the district and asked them to stop, and then we went to federal court in Galveston. The case was assigned to Judge Kent who, as always, was interested and interesting.

I was representing the East Matagorda Bay Foundation, and Carol Dinkins and Sharon Mattox of the Houston law firm Vinson and Elkins were representing the drainage district. We were invited into chambers, where Judge Kent relaxed and asked us about the case. The district argued that the drainage work was necessary to prepare the drainage system for hurricane season. Judge Kent was clearly concerned about this and did not want to issue an injunction that would prevent a local community's effort to protect itself from storms. The foundation's position was that it should be possible to improve drainage capacity without totally eliminating all trees from the banks.

In the end, without admitting any past violations, the district agreed that it could not and would not discharge any dredge or fill material into Caney or other creeks without first obtaining a Corps permit. At least for a while, the trees and the habitat along Caney Creek were protected.

By being willing to go before the federal court, the residents of Sargent had again acted to save their coastal resources. Muriel and Roy mobilized Sargent in the 1980s, and dredging practices along the coast have not been the same since. K. J. and Bessie and their neighbors caused Phillips 66 to change its ways. And the East Matagorda Bay Foundation halted the destruction of Caney Creek. These people are not resource biologists or professional activists. They belong to a community of modest size and limited means, but when they saw the damage resulting from inadequate regulation along the Texas coast, they jumped in to tackle it. Between them they have shown that a community committed to acting on its own behalf can defend itself, in the process creating worthy precedents for other communities to follow.

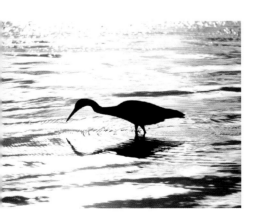

A wader fishes in the late afternoon sunlight.

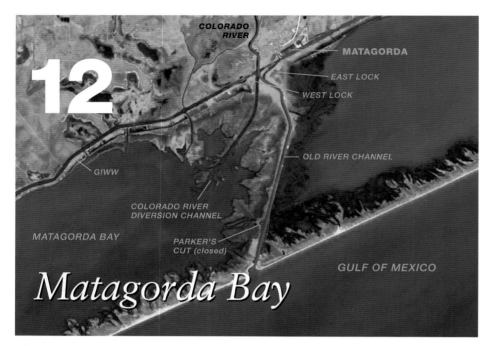

COLORADO
RIVER

MATAGORDA

EAST LOCK

WEST LOCK

GIWW

OLD RIVER CHANNEL

COLORADO RIVER
DIVERSION CHANNEL

MATAGORDA BAY

PARKER'S
CUT (closed)

GULF OF MEXICO

Matagorda Bay

12

The mouth of the Colorado River is an area that has been extensively altered by human activity. In the past, a channel was dug that allowed the Colorado River to flow directly into the Gulf of Mexico. More recently, that channel was dammed at the Gulf Intracoastal Waterway, and a new channel, called the diversion channel, was constructed into Matagorda Bay in order to divert fresh water into the bay and to create the marshy delta that can be seen on the map. On the Intracoastal Waterway on either side of the Colorado River are locks to prevent floodwaters from entering the waterway.

Al Garrison oriented the boat carefully as we approached the locks on the Gulf Intracoastal Waterway. We were on the east side of the Colorado River near the community of Matagorda. A barge loaded with benzene was approaching from the other direction, requiring careful maneuvering at close quarters. Pushed by a tall diesel-powered tug, the looming barge crept forward, pushing a wave out to either side.

"It's a miracle no one has been killed in these locks," Al marveled. "All the fishing boats going to Matagorda Bay have to come through these locks. Many weekend boaters don't know how to maneuver in close quarters with these powerful tugs."

The tug pulled up even with us as we idled near the bank, the water boiling up behind it as the tug labored to push the benzene up the intracoastal canal to points north. "You have to position your boat so that the thrust of the diesel doesn't throw you into the bank," Al cautioned. "You have to watch it. You take some guy who doesn't get on the water much and has a couple of beers—he could get thrown into the sidewall and get hurt, like that doctor who broke his shoulder blade."

The barge and tug passed, and we entered the lock. The gates were open that day, but they are often closed to keep down the currents caused by a new diversion channel the Corps of Engineers cut in 1990. To take the long view, modifications are nothing new to Matagorda Bay, which is in many ways the most heavily modified of all our coastal bays.

The Colorado River is one of the state's major rivers and a major provider of inflow to the Matagorda Bay system. The average inflow into the system is just over 2 million acre-feet, distributed unequally over the year. Both Matagorda and San Antonio bays have double peaks for inflows, with definite highs in May–June and again in September–October and corresponding decreases in the summer and winter (fig. 16).[1]

The inflows to Matagorda and San Antonio bays contrast with those received by the three South Texas bays: Aransas and Corpus Christi bays and Laguna Madre. Both the Aransas Bay and Laguna Madre systems have small riverine inflows that exhibit only a single peak in the fall. Corpus Christi Bay receives fresh water from the Nueces River, which has several tributaries that drain the Hill Country south and west of San Antonio. While Corpus Christi Bay shows a double peak, its highest inflows are in the fall, a key difference from the bays to the north. This seasonality represents an annual rhythm in the bays, differing from north to south.

Prior to 1930, the Colorado River emptied into Matagorda Bay after curving around the town of Matagorda. However, there was not much flow because a huge logjam north of the town of Wharton acted like a dam, trapping sediment and slowing flow. In the 1930s the Corps of Engineers blew up the logjam, releasing sediment that flowed downstream to form a delta where the Colorado River entered Matagorda Bay.

The delta expanded into the bay, propelled by river flow split into several channels that constantly changed course and sometimes even disappeared. Due to the lack of a single well-defined channel, storm waters piled up where the river entered the bay, causing flooding at Matagorda and farther upriver.

To fix the flooding problem, a channel was dug to funnel the flow of the Colorado River through Matagorda Bay and directly to the Gulf. The material dredged out to make the channel was piled on either side, creating uplands adjacent to the new river channel (now called the "old" channel). Over the years, local residents built fishing shacks and eventually nice homes; bait camps also flourished on these artificial banks.

As knowledge about and interest in freshwater inflows increased, several agencies began focusing attention on the fact that the fresh water from the Colorado River was no longer flowing into the bay but rather out into the Gulf. The National Marine Fisheries Service, U.S. Fish and Wildlife Service, and Texas Parks and Wildlife Department developed a proposal to divert the Colorado River back into the bay, and they convinced the Corps to agree to this plan.

In 1990, the Galveston District of the Corps undertook their first-ever environmental enhancement project by changing the course of the Colorado River. The Corps constructed a channel that now carries the flow into Matagorda Bay, and they built an earthen plug dam just south of the intracoastal canal to stop the

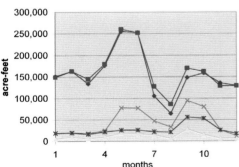

Figure 16.
Freshwater inflow to bays on the middle and lower coast, by month, showing similar seasonality for Matagorda and San Antonio bays. Data from the Texas Water Development Board.

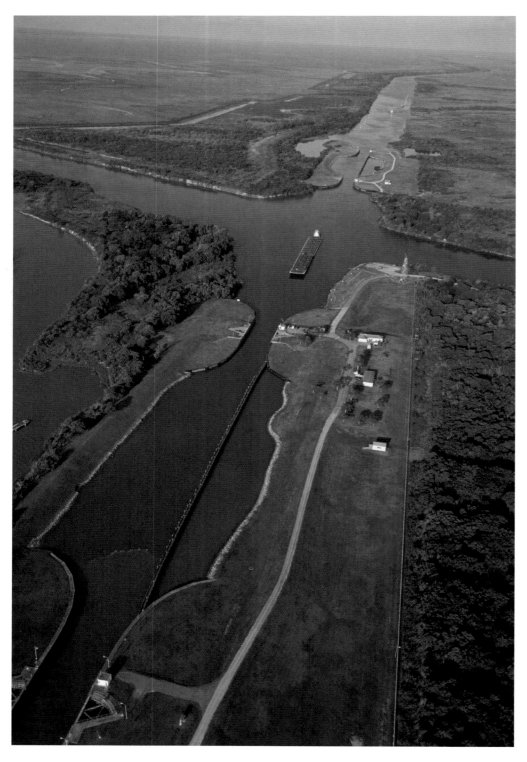

A loaded barge moves through the locks along the Gulf Intracoastal Waterway at Matagorda. The Colorado River flows across the canal and into a new diversion channel constructed to take fresh water into Matagorda Bay. As a result of this diversion, a new delta is being created in Matagorda Bay, along with a number of problems for barge transportation, local boaters, and the bay.

After the diversion channel was constructed, direct access from the old river channel into Matagorda Bay was no longer possible, requiring all boaters heading in that direction to pass through the Colorado River locks, getting up close and personal with tugs and their loaded tows.

flow directly to the Gulf. In order to provide access for the homeowners and marinas along the portions of the old river course now cut off, a new boat channel was cut to connect the intracoastal canal with the old river channel isolated below the dam. This boat channel entered the intracoastal canal between the swing bridge and the lock on the east side of the Colorado River (see map opening this chapter).

I applauded the Corps for undertaking an environmental enhancement project, and I applauded the agencies for thinking positively about coastal planning. Unfortunately, this project has been plagued with problems. The first negative result affected the barge industry. The new channels caused major steering problems on the canal, especially for tugs attempting to cross the diverted Colorado River. Due to currents created by the new diversion and boat channels, the tugs could no longer push two barges through this bottleneck, and they often ran into the structural supports of the lock system while pushing just a single barge. Perhaps more important, the industry was horrified at the possibility of a collision with the swing bridge that lets cars onto and off of the isthmus.

Then there were the fish kills. This problem has plagued the old river channel—the section of the Colorado River between the dam and the Gulf of Mexico—and is related to the operation of the locks originally constructed to protect the canal from floodwaters on the Colorado. The Corps operates these locks and

now uses them to attempt to control the currents created by the diversion, aiming to prevent trouble for the barges. The locks are often partially or totally closed, and little circulation occurs in this old river section. In late summer, the dissolved oxygen levels in the water can fall below those necessary to maintain fish life. Without circulation, these low oxygen levels occur over a fairly wide area, and at least two major fish kills have resulted.

Al and I motored through the locks and entered the Colorado River. The dam shutting off the river was to our left, south of the intracoastal canal, and the diversion channel stretched south before us. Al pointed behind us to broken timbers on the lock, evidence of the destructive power of a loaded barge.

"The barges tear up these timbers every other week. They have to replace them on a monthly basis," Al warned.

Al should know. He is a commercial fishing guide who goes through these locks several times a week during most weeks of the year. He has watched the Corps' project develop, and he is not happy with the result.

Since the diversion channel was built, he says, problems have cropped up that did not exist before. "If the Corps would just open up Parker's Cut, it would make all the difference," was his conclusion.

Parker's Cut, also known as Tiger Island Cut, is an artificial channel cut by the Parker dredging company in the 1950s. It connected Matagorda Bay with the old Colorado River course about a mile above the river's confluence with the Gulf. This channel provided a physical connection between Matagorda Bay and the Gulf for the migrant fish and shellfish populations as well as for recreational and commercial fishermen. It also assisted water circulation.

Parker's Cut was closed in 1991 as part of the Colorado River diversion project. The cut was closed because it provided an opening back into the old channel and the Gulf of Mexico. The agencies wanted the fresh water from the river to flow into the bay and create a gradient down the bay from fresher water at the new mouth of the river to saltier water in the deepwater channel at the Port O'Connor jetties. They believed Parker's Cut would have worked against that plan, and they closed it.

George Ward, a coastal geohydrologist with the University of Texas Water Resources Center in Austin, participated in the early studies regarding the water diversion and found himself at odds with the Corps and the agencies.

"We had concerns about whether or not to go forward with the diversion of the river into the bay, due to data indicating that the Colorado River water was lacking nutrients and would not perform as anticipated," said George when I consulted him in 2000. "But if they did go forward, it was our recommendation to keep Parker's Cut open. Parker's Cut was the most important fish pass on the Matagorda Bay system. I never thought it should have been closed, and I certainly think it should be reopened."[2]

One of George's concerns is fish migration into the Matagorda Bay system, the second largest on the Texas coast. Matagorda Bay extends from the town of Matagorda south for approximately forty miles to Pass Cavallo, the natural connection between Matagorda Bay and the Gulf. Today, Pass Cavallo is silting in, inexorably altered by the deepwater channel constructed at Port O'Connor to allow deep-draft vessels to reach Point Comfort fifteen miles inland.

Passes are part of the architecture of the bay system. They are places where the water moves into and out of the bay systems with daily tides. They sustain the rhythm of the bay, and they are maintained by the gravitational pull of moon and sun. Passes form during storms, and most silt in within a year. There is usually only enough energy in each bay system to keep one pass open at a time. When the deepwater channel was constructed at Port O'Connor, the tidal energy became focused there, leaving Pass Cavallo, the natural pass, to die.

Problems have plagued the Colorado River diversion project since its inception in 1990, including fish kills such as the one shown here. In late summer, the amount of dissolved oxygen in the water drops to dangerously low levels because of poor circulation in the old river segment leading to the Gulf. These menhaden are floating out of the river into the Gulf on the outgoing tide. Photograph by Jim Blackburn

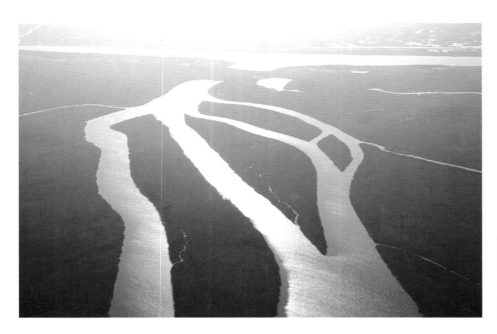

Parker's Cut used to connect the old river channel with Matagorda Bay. The cut was filled in as part of the Colorado River diversion project and no longer connects the old river channel with the bay.

As Pass Cavallo fills with sand and silt, the deepwater channel grows, and all the agencies concerned are in agreement: the deepwater channel at the Port O'Connor jetties is out of control. It was originally dredged to forty feet, but scouring—the action of the fast-moving water on the sand sides of the channel— has created depths of over a hundred feet at the jetties. The water velocities moving through this pass are substantial, much greater than those of the natural currents along the Texas coast. In turn, the strong current produced by the deep channel can disrupt the pattern of fish and shellfish migration on the coast.

The main problem with the scouring is its effect on the life cycles of organisms moving between bay and Gulf, such as shrimp and crabs. These two species rely on the currents to help them migrate from the Gulf, where they are born as tiny free-floating organisms, into the bays, where they later feed and grow. In the beginning, they lack the strength for self-propulsion. Instead, they depend on the tides, which in nature are governed primarily by the moon. They ride the incoming tide to its apex and then drop to the bottom, fastening to the sand while the tide moves out. When the tide changes again, they float back to the surface and continue their trip into the bay and up into the marshes and fresher portions of the estuary.[3] Now that the deepwater channel has changed the flow of the currents, this migration becomes vastly more difficult.

The critical point in the migration comes at the pass connecting the bay and the Gulf, and the changes in the bay system concern George Ward. "With the deep

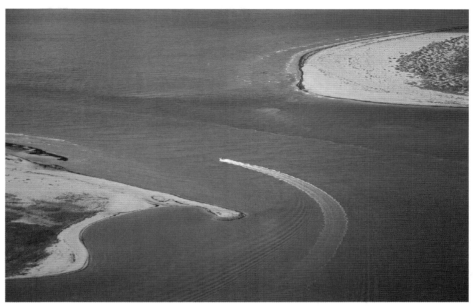

A boater races through Pass Cavallo at the lower end of Matagorda Bay. Due to the construction of the deepwater channel at the Port O'Connor jetties, Pass Cavallo—one of only three remaining natural passes on the Texas coast—is dying, slowly silting in. Most of our bays do not have enough tidal energy to maintain two openings; at the south end of Matagorda Bay the energy has been diverted to the Port O'Connor jetties.

scoured channel at the jetties, it is difficult for these planktonic shrimp and other life forms to move from the Gulf to the bay. So far, Pass Cavallo—the natural pass—has remained open and provides the primary pathway. But with the continued siltation, we will lose Pass Cavallo. When that happens, the fishery in Matagorda Bay will be in bad shape, unless Parker's Cut is reopened."

Al and I proceeded down the diversion channel, surrounded by one of the prettiest saltgrass marshes on the Texas coast. This marsh predates the diversion channel constructed to allow the river to flow into the bay. As we continued down the channel, we began to see the logs that have come to rest at the sides of the channel, each lodged in the sediments of the new delta that is forming at the end of the diversion channel.

This is an active geological process, the river filling the bay with sediment and debris from major flood events. Mud flats extend for a mile or so on either side of the channel, dotted with wading birds of every description. This is a graveyard for fallen trees, torn from the banks upstream by angry storm waters pushing toward the sea. The trees lie prone, the root balls fanning upward from one end and limbs extending from the other. Some of those we saw were old, remnants of the two huge floods in 1991, which expanded the delta much faster than predicted. Some were new, green leaves still spreading from their unbroken limbs.

The major beneficiaries of these trees are the bay birds. One tree trunk was lined with brown pelicans, loafing between fishing trips. Another tree was bright

A natural pass like Pass Cavallo has an elegant architecture, connecting the bay islands and their submerged grass flats behind Port O'Connor with the Gulf of Mexico, smoothly bisecting the barrier island.

with pink, the roseate spoonbills colored by the shellfish on which they feed. Every so often, an osprey may be seen, with a mullet or small trout pinned to the topmost branch by the talon that allows the bird to rip away at the flesh. Egrets, herons, terns, and gulls abound in this haven for fishing birds.

The mud flats of the delta are wonderful for birds, but treacherous to humans. Once my wife Garland and I were kayaking these flats when a front blew in. Before we could retreat, the water level began falling rapidly, the combination of a north wind and an ebbing tide. We had gone far out on a flat, looking for ducks, and then the water disappeared, becoming only a thin film over the delta muck.

I decided to try walking the kayaks out of the delta. I have walked in some extremely boggy places on the coast, but this was the worst I have ever encountered. There was no firm bottom. I quickly gave up and got back in the kayak.

Garland tied hers to mine and we pushed and pulled the pair through the viscous mud, cutting a path as we literally inched forward with each thrust of our paddles. We eventually made it back to the diversion channel, and I now have a much greater respect for this new delta. It is not a place for large bipeds.

We can draw some conclusions from the experiences surrounding the diversion. First and foremost, major unforeseen problems have resulted from this project. Small boat access is a huge problem at present. Recreational fishermen have to enter Matagorda Bay through the locks, getting intimate with loaded barges in the very stretch that already provides the greatest navigation problems for the barges. Circulation difficulties are clearly occurring, and the Matagorda Bay fishery will suffer as Pass Cavallo continues to silt in. If not already in trouble, the Matagorda Bay fishery is certainly headed in that direction unless something is done to change the present conditions.

Reopening Parker's Cut seems a reasonable action, and discussion of this option has been ongoing for several years. The Port of Bay City has joined in the request by Matagorda residents to open Parker's Cut. Yet the Corps of Engineers, the project sponsor, has been slow to respond. Clearly, some serious politics are at work here, and I have looked carefully at the freshwater inflow issue and the role of the Lower Colorado River Authority (LCRA) in this regard. This river authority created under Texas law has jurisdiction over the lower half of the Colorado River, including counties within the watershed. The agency has responsibility for the management of several large lakes in Central Texas and holds water rights used by rice farmers and municipalities in the watershed.

River authorities were formed to make sure that water did not limit development, a difficult task in a state where water is often scarce. The river authorities are often characterized as "water hustlers," along with the Texas Water Development Board, their philosophical if not legal leader. In late 2000 the Matagorda Bay Foundation, a group formed by Al, Henry Hamman, and me, joined forces with the LCRA to do some modeling of the impacts of opening Parker's Cut. Although LCRA is not an agency with statewide jurisdiction, they do have authorization from Texas Parks and Wildlife to undertake the "official" modeling of bay and estuarine impacts for the State of Texas. The results of this effort showed that reopening Parker's Cut would increase salinity in the bay, particularly during critical low-flow periods. If this happened, LCRA might be asked to release more fresh water into the bay system—and LCRA is concerned about any additional water releases because these may impinge upon proposed diversion of fresh water to the City of San Antonio.

The LCRA is one of two river authorities developing plans to provide San Antonio with water to meet current and future needs, in addition to providing water for the Austin area and farmers farther down the river. San Antonio is not in the watershed of the Colorado River. If the LCRA were to provide water to San

Antonio, an interbasin transfer would take place, meaning that the water would be physically transported from one river basin to another. The wastewater would be discharged into another system and would not be returned to the Colorado River or ultimately to Matagorda Bay, even though the LCRA says it would be "leasing" the water to San Antonio and would eventually get it back. I submit that once municipalities use it, that water is never coming back.

Such a transfer represents a serious dilemma in two important ways. The first is cost—how much will San Antonio pay? And the second is the key from a scientific and legal perspective—what will be the impact of the diversion on Matagorda Bay?

The Corps diverted the Colorado River to add fresh water to the bay. The purpose of the project was to reduce salinity. Now, the LCRA is proposing to move water to San Antonio, water that is currently flowing into Matagorda Bay. Less fresh water means increasing salinity for the bay, and Parker's Cut, if reopened, will also increase bay salinity to some extent. And just like that, Matagorda Bay becomes a participant in the twenty-first-century water war in Texas.

Right now the pending water conflict looks more like a calf scramble than like a war. In a rodeo calf scramble, forty or so young men and women chase after twenty or so calves. The goal is to put a rope around a calf and bring it to the judging station. If you catch it, it's yours. This is a wonderfully chaotic event, with calves eluding pursuers and pursuers falling all over themselves trying to catch the calves. Welcome to the Texas water scramble, where the race to provide San Antonio with water is the number one attraction.

The LCRA's first step in developing their proposal is to seek control over all of the remaining water rights in the Colorado River, and it has applied to the State of Texas for a permit for over 800,000 acre-feet of floodwater on the Colorado River. This is a lot of water and would provide the foundation for the transfer of water to San Antonio.

The San Antonio diversion project typifies "new" water development thinking. Rather than placing a dam on the river to capture flood flows, the LCRA is proposing a series of pumps to transport flood flows into off-channel reservoirs. That way no dam would impede the flow of the river during low-flow periods or collect sediment behind it.

Pumping water to off-channel reservoirs reduces the impacts compared to dams across the main channel of the river but by no means eliminates them.

The LCRA's plan to divert water to San Antonio will be analyzed extensively as the final proposal is developed. Two environmental groups, the National Wildlife Federation and the Matagorda Bay Foundation, have requested a contested case hearing over the first step in this transfer, the issuance of the permit for 800,000 acre-feet. This initial permit may establish the terms and conditions of all other aspects of the transfer, even though the full plan may not be developed for several years.

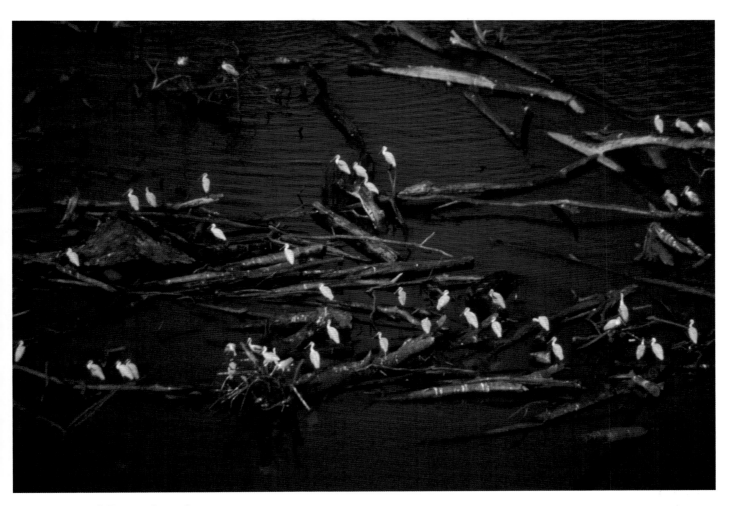

Roseate spoonbills perch on the trees brought into Matagorda Bay by floods on the Colorado River. The deposition of these trees along with tons of silt is building a delta out into Matagorda Bay, an active geological process and a treacherous area for bipeds foolish enough to try to walk through it.

Susan Rieff was in charge of resource protection at Texas Parks and Wildlife back when Dick Morrison was a commissioner. At that time, the agency was a major force engaging the Corps of Engineers to protect the resources of the Texas coast, and Susan was in the center of the action. She provided the technical support and know-how to back up the commissioners' passion for the coast—a passion not reliably present in all subsequent commissioners.

Susan played a key role in the National Wildlife Federation (NWF) taking a strong position regarding the LCRA diversion plan as well as the Guadalupe-Blanco River Authority's proposal to divert the Guadalupe River down the coast. She knows environmental issues in Texas, and she and NWF's fine water lawyer Myron Hess have squarely targeted water diversions and the resulting impacts on rivers

and bays as one of the most important environmental challenges facing Texans. Working alongside the Matagorda Bay Foundation, NWF brings a national presence. Together the two groups hope to ensure that the permitting agency in this case, the Texas Commission on Environmental Quality, pays attention to science and economics as well as politics.

A bay is a commons. To reiterate some ideas already explored, in Texas, the bay bottom is owned by the state and shared by all of us. In addition bays provide economic services, although we have not traditionally thought of them this way. Bays remove waste products. Microscopic plants in the water remove carbon dioxide from the air and nitrogen and phosphorus from the water. This plant life fuels the production of other living things, including crabs, shrimp, and oysters— shellfish with commercial value. The bays provide a venue for recreational fishing and ecotourism.

As we saw in Galveston Bay, these services have a dollar value beyond their worth in the intrinsic beauty of the bay. In their calculations of the value of various ecological systems, environmental economist Robert Costanza and his colleagues found that an estuary like Matagorda Bay is the most valuable of all systems, providing services with a price tag of almost $11,000 per acre per year. This surpasses the contributions of the runners-up—the seagrasses, tidal flats, swamps, and floodplains. Tropical rain forests account for less than $1,000 per acre per year by these calculations (fig. 17).[4]

The Matagorda Bay system is slightly over 270,000 acres in size. Multiplying 270,000 acres by $11,000 per acre per year produces a value of almost $3 billion per year. If the diversion of water to San Antonio causes the ecological functions of the bay to decrease, then there is a loss of dollar value associated with the water transfer. In turn, this dollar cost should be added to the cost paid by the group benefiting from the water, in this case San Antonio. Perhaps more important, if concern over the need for and amount of freshwater inflows keeps Parker's Cut from being reopened, then migratory pathways to the bay for marine life could be cut off when Pass Cavallo silts in. It would be a real tragedy if the connection between the Gulf and the bay were functionally removed from a marine productivity standpoint, yet that is what is at stake.

In public presentations on this project, LCRA has presented the discussion of bay and estuarine inflows as a trade-off between fisheries productivity and rice farming.[5] Their analysis showed that the "optimal" combination of rice production and fishery productivity exists when the bay receives inflows of 500,000 acre-feet. But that level of inflow would result in a 30 percent decline of the bay's productivity with 1 million acre-feet of inflow. Their analysis also shows that when inflows are around 1 million acre-feet, rice farming acreage declines substantially, particularly with regard to the season's second crop. Today there is an average of 2 million acre-feet coming into the whole bay system, with the bulk

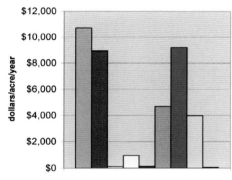

Figure 17.
Average value of annual ecosystem services provided by different kinds of ecological systems, based on calculations by Robert Costanza and colleagues. Values are extremely high for estuaries and their components—for seagrasses, swamps, and tidal marshes.

coming down the Colorado. LCRA is not proposing to continue that level of inflow. With either 500,000 or 1 million acre-feet, inflow will be reduced. It is just a matter of how much and who gets hurt.

The clear message here is that other users of Colorado River water are being preferred over both rice farming and bay productivity. As posited by LCRA's plans for diverting water to San Antonio, water would also be held back in the Highland Lakes of Central Texas, which would keep a constant water level next to the boat docks of the homes on Lakes Travis, LBJ, and Buchanan. Politically, water for San Antonio and for boat docks on the Highland Lakes is more important in Texas than rice farming and bay inflows. In turn, rice farmers and bay advocates are looking askance at one another, distrustingly, as if the other were the enemy.

There should be no fight between the rice farmers and the bays. For decades, the two have coexisted comfortably. A group called the Texas Rice Industry Coalition for the Environment (Texas R.I.C.E.) was formed to celebrate and support the ties between environmental interests and rice farming. The bays benefit from the return flows, and the waterfowl benefit from the rice. But both the rice farmers and the bays are politically weak. By setting up the water discussion as a trade-off between rice and the bays, the LCRA is reflecting the current political reality that San Antonio and the residents of the Highland Lakes are to be taken care of first. That kind of priority says a lot about Texas thinking today. Advocates for development in San Antonio and the Highland Lakes are much more successful than are the advocates for the bays. If we who love the coast do not get organized and create a political presence, we will lose our estuaries.

Al pulled the boat near a sandbar guarding the mouth of a small bayou. The sun was still high, but the light had a special quality. The marsh seemed to glow, bathed by a warm and soothing sun that highlighted the green of the water, the gold of marsh grass, and the blue of the sky. I cast toward a school of bait, reflecting on the need to transform coastal politics, to bring forward the protection of the bays as an endeavor just as important as any other priority. My brow creased with awareness that the change needs to happen soon—the time for protection of our magnificent bays to be on a par with providing parking lots for the boats on the Highland Lakes is now.

Holding the rod and watching the sun go down, I looked out over the wonder of the coast and found a hopeful thought about the future. I know that if we could just get more people exposed to the coast, to understand it, to have their eyes opened by Al and others who know the bays, we could transform the politics. Alternatives exist for providing water where it is needed without depleting coastal abundance. Al Garrison helped open my eyes. He taught me about the bays, how to read the water, how to feel comfortable in this aquatic system. And for this, I will always be thankful.

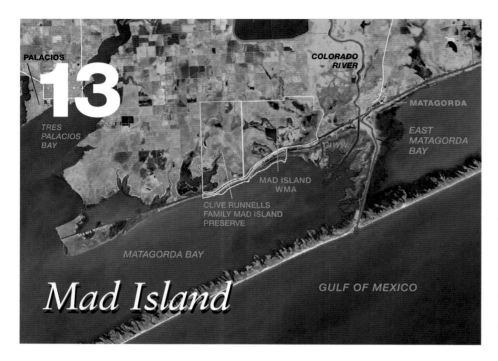

PALACIOS

COLORADO
RIVER

MATAGORDA

TRES
PALACIOS
BAY

EAST
MATAGORDA
BAY

GIWW

MAD ISLAND
WMA

CLIVE RUNNELLS
FAMILY MAD ISLAND
PRESERVE

MATAGORDA BAY

GULF OF MEXICO

Mad Island

The Mad Island Wildlife Management Area and the Texas Nature Conservancy's Clive Runnells Family Mad Island Marsh Preserve sit side by side on the north shore of Matagorda Bay. Along the southern edge of both preserves runs the Intracoastal Waterway. The barrier island separating Matagorda Bay and Mad Island from the Gulf of Mexico is the Matagorda Peninsula.

Clive Runnells sat across from me at the conference table in his Houston office as he talked about Mad Island, a tract of coastal marsh that he inherited from Shanghai Pierce and eventually conveyed to the Texas Parks and Wildlife Department and the Nature Conservancy. Runnells was not raised on the Texas coast but moved here in the early 1950s, when the Pierce Ranch was still contiguous from Highway 59 southward across Wharton County and Matagorda County to Matagorda Bay.

He laughed about Mad Island, about how it got its name. There are many stories about the source of the name, but the one Clive Runnells likes best came from an event among the Indians who wintered in the Mad Island marsh. These Indians lived on a point extending into a brackish lake, collecting clams and oysters and leaving the shells piled in mounds that can still be found today.

As the story goes, the Indians traveled with many dogs. One year, when they departed, several of the dogs were left behind on the point in the marsh. After a while, the dogs went mad, hence Mad Island. Runnells does not attest to the accuracy of the story—only that it was told to him. I told him that my favorite version was about mosquitoes, about how they drove the cattle mad. Again he laughed, saying that after spending time in Mad Island, he finds the mosquitoes no longer bother him.

The Mad Island marsh is a magnificent part of the Texas coast, far enough north to receive abundant rainfall but far enough south for the vegetation to be

transitioning into South Texas brush on the higher land. This tract was once part of the Pierce Ranch, the landholding amassed by Shanghai Pierce, one of the truly notable Texas characters. I always thought Pierce received his nickname because he shanghaied workers, but that was wrong; it came from friends in his native Rhode Island who thought he resembled a Shanghai rooster.[1] Like much about cattle baron Abel Head Pierce, the stories get better with retelling.

Shanghai Pierce was a big man, standing about six feet, four inches. He was larger than life, wearing a big hat and fancy clothes. He was known for his wit, for his style. He built his own town as well as his own church (which he described as belonging to him, rather than his belonging to it). He built his gravesite statue years before he died, enjoying it while he was living. There was once a cow branded "AHP is a SOB," which amused rather than angered Pierce, who let that cow range for life because it was a good advertisement.[2] You can sense some of Pierce's wit and style when speaking with Runnells.

Runnells came well after the heyday of Shanghai Pierce, as did Laurence Armour, another Pierce heir, who emerged as a key player in the Columbia Bottomlands (chapter 10). When the Pierce Ranch was divided up in the late 1950s, Runnells became the owner of the Mad Island tracts, among others. As he described it, there used to be no fences for tens of miles except around rice fields; the cattle had traditionally wintered along the coast at Mad Island. After the ranch was fenced off, Runnells became a steward of the land, walking every inch of it that could be walked, knowing every aspect.

But to hear him tell it, the work to maintain a ranch on the coast was exhausting. Because of the Gulf Intracoastal Waterway to the south, poachers could gain access to the south shoreline of the ranch. Being an absentee landlord was difficult. There were always fences to mend, erosion problems to stop. In the mid-1980s, Runnells was approached by Texas Parks and Wildlife Commissioner George Bolin, who talked about preserving this marshland for future generations. Runnells was looking for a ranch in South Texas, and a land swap was suggested with the Texas Nature Conservancy, which owned title to an appealing tract. In this manner, 5,600 acres of Mad Island marsh came into the hands of the Nature Conservancy, which then made a deal with the Texas Parks and Wildlife Department, creating the Mad Island Wildlife Management Area (WMA).

In 1989, the Clive Runnells family donated to the Texas Nature Conservancy another 3,148 acres of land, creating the Clive Runnells Family Mad Island Marsh Preserve. The Nature Conservancy later augmented it through funds from the North American Wetlands Conservation Council and a small donation from Dow Chemical, expanding the preserve to more than 7,000 acres. The Nature Conservancy's goal is to restore the marsh habitat to its original condition. The Mad Island WMA and the Nature Conservancy's Clive Runnells Family Mad Island Marsh Preserve stand beside each other, protecting the marsh along the north shoreline of Matagorda Bay.

Together, the two refuges include unique coastal wetlands and upland prairies that host more than three hundred species of birds, all types of commercially important fish and shellfish, marsh nursery habitats, and native Texan fauna such as bobcats, armadillos, coyotes, and deer. The wetlands, however, like many along the coast, had been damaged by saltwater intrusion, decreased freshwater inflows, and channelization.

In 1990, working with many partners—government agencies, private foundations, and corporations—the Nature Conservancy began an ambitious program of conservation research, habitat enhancement, and public education to restore the preserve to something like its original landscape. These enhancements consisted of improving the preserve's rice fields as a source of food and habitat for the thousands of waterfowl that use Mad Island as one of their migration stops on the Central Flyway. Other efforts involved restoring freshwater wetlands that had been lost to drainage projects and embarking on a controlled grazing and burning program to restore the coastal prairies and create winter foraging areas for migrating ducks, geese, and cranes. Within two years, almost a thousand acres of wetlands and prairies had been restored, and habitat quality had been enhanced on more than half the preserve.[3]

Research there is focused on managing rice fields more effectively, for both the farmers' profit and wildlife habitat, and on controlling or eradicating exotic species like the feral hogs so detrimental to native plants and animals. These great black pigs are everywhere, non-native and destructive. Often they can be seen walking through the marsh, forever digging, ripping the land apart in their incessant search for food. They can be quite dangerous and are much larger than the collared peccary or javelina of the South Texas brush; annual hunts for the hogs are conducted on the Mad Island WMA property. Clearly it takes much more work to reconstruct nature's arrangements than to preserve their balance and interconnections, and the results are always only approximate.

In the case of the coastal prairie, says former WMA manager Brent Ortego, its demise was due primarily to the fact that it was "too farmable." Water was easily brought in through irrigation ditches, buffalo that roamed and grazed the region were killed, and lightning-sparked fires were suppressed. Now the managers at the preserve and WMA prescribe burns every three or four years and bring in cows to graze in rotation, to try to simulate the two classic defining features of the bluestem and Gulf cordgrass prairie. To illustrate the fate of land left untended and devoid of its natural constraints, Texas Parks and Wildlife left several sample plots on the WMA ungrazed and unburned. These rapidly became overgrown with baccharis, a woody shrub, and no longer support the geese and other waterfowl that frequent the rest of the prairie.

At a charity function, I once purchased a weekend's usage of the Nature Conservancy's Mad Island preserve. The greatest pleasure of this retreat was sit-

ting in the observation tower watching sandhill cranes fly in to roost on Mad Island Lake and the adjacent water bodies. The two-story structure stands above the prairie grasses, a testament to the changing times on the Texas coast. Once used to host the employees and guests of a private corporation at one of the better duck hunting leases on the coast, this building is today the headquarters of the preserve. Its past was cattle and hunting. Its future is wildlife conservation.

Another powerful force, however, continues to modify the form of the coastal marshes of the Mad Island Marsh Preserve and WMA. The Gulf Intracoastal Waterway was cut through the marshes on the north shoreline of Matagorda Bay in the 1940s. It allows salt water to reach into the marshes north of the waterway much farther than it did before, turning the productive fresher marsh more saline and causing loss of vegetation and an overall decline in ecosystem diversity. Both the preserve and the WMA border the intracoastal canal. During the 1930s and 1940s private property was either purchased or condemned for the canal. The intracoastal is bounded on one or both sides by private property along much of its length, except where it crosses open water, and erosion of property into the canal is a major problem for these landowners.

The relationship between the canal and its neighbors is always tenuous and sometimes testy. Barges move up and down the waterway, propelled by huge diesel-powered tugs. The tugs rise three or four stories above the water, looking from a distance like UFOs hovering above the marsh grass. Black smoke from the diesel engines snakes across the sky, marking the path. The power generated by these barges is phenomenal. Water boils up behind the tugs, twin screws churning to propel the barge forward, pushing the water up and out.

The barges are usually filled with petrochemicals from DuPont or Dow or Koch Petroleum or any of a number of petrochemical plants south of Mad Island. Only a few feet of a full barge show above water; the rest of it moves below the water line, submerged, unseen except for the water being displaced. Regulation size for these rectangular barges is 35 feet wide, 190 feet long, and 12 feet deep, and they are pushed forward at five miles per hour. Moving through liquid space, the barge sends before it a wave that runs outward toward the shore. One barge per hour, twenty-four hours a day, seven days a week, fifty-two weeks a year, year after year for almost six decades, the barges have moved past Mad Island. Each day the impact of these waves removes a small piece of the adjacent shoreline.

The shoreline removal is very different from barrier islands being transformed by hurricanes. It is a slow process, a few grains of sand at a time. But slow does not mean benign. One barge at a time, grain by grain, the shoreline adjacent to the waterway is being eroded away. Moreover, once the canal was built, waves created by daily winds could augment the damage caused by barge erosion.

Erosion is a big problem for the reserve and has been for at least the past seven years, according to James Shuler of the Mad Island Marsh Preserve

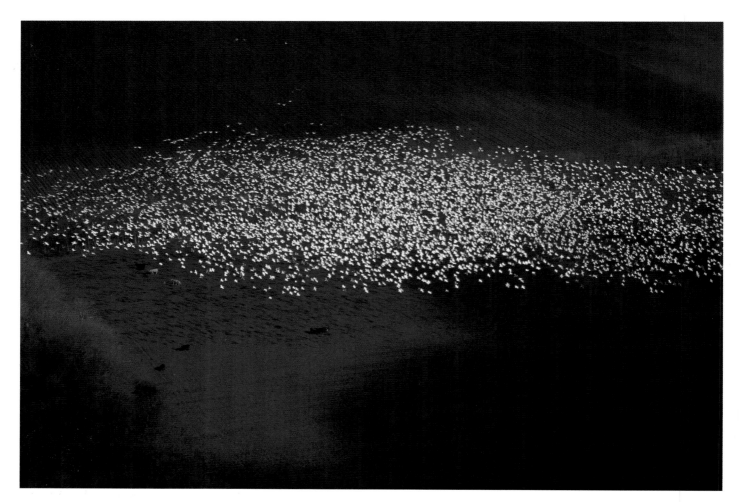

headquarters. Managers are using everything from plastic fencing to hay bales to try to catch the sediment and slow the erosion. "The canal is supposed to be two hundred feet across," says Shuler. "Now it varies, but at many points, it's well over three hundred feet." Loss of shoreline has the potential to cause substantial ecological harm. The shoreline soil supports saltgrass marsh. Once enough soil is lost beneath a plant, it slips into the canal. Plant by plant, the coastal marsh is slipping away.[4]

Other effects loom also. The preserve has a high brush ridge called the Paleo Beach Ridge paralleling the waterway. The higher land protruding above the surrounding marsh is dense with Tamaulipan scrub—low shrubs like lime prickly ash, elbow bush, mountain laurel, Texas persimmon, yucca, and coral bean. The foliage provides cover for deer and bobcat, raccoons and quail. Immediately north of this ridgeline is one of the most beautiful freshwater marshes on the middle

Snow geese concentrate in large numbers on the rice fields and pastures on and around the Mad Island Marsh Preserve, owned by the Nature Conservancy, and at the Texas Parks and Wildlife Department's Mad Island Wildlife Management Area. These two coastal plain reserves were made possible by the stewardship of Clive Runnells, a descendant of the Texas cattle baron Shanghai Pierce.

coast; workers at the preserve call the area Shell Lakes. Freshwater marshes decrease as one moves south down the coast. In the cold months this Mad Island freshwater marsh is full of wintering widgeon, teal, and pintails; mottled ducks nest there during the summer. If the sand ridge between the canal and the freshwater marsh erodes, the fresh marsh will be destroyed by saltwater intrusion.

Fighting erosion is a major activity at the preserve. At one point a series of wooden fences have been constructed, extending outward from the shore into the canal at an angle. The goal is to calm the water and allow silt to settle out between the fence and the shoreline. Where the silt has settled, *Spartina* grass has been planted to hold the soil in place. Small marsh patches thus exist in places along the waterway.

At another location, more substantial erosion protection is necessary. Concrete blocks with holes in the centers, called Gobi mats, are laid along and secured to the eroding shoreline. The block mats provide structural protection yet allow the energy of the wave action to be dissipated through the holes. Controlling wave energy is neither easy nor straightforward. Hard edges can be destroyed in big storms, and energy can be transferred down a hard edge like a steel piling, so that at the end of a wall the water digs into the exposed soil with even greater force. The ideal erosion control device has both strength and give, a combination of soft and hard. The best way to control erosion is to stabilize the most exposed surfaces and attempt to replant and refill the more protected surfaces. Against all of these measures, the barges wage incessant war, each hour pushing a new wall of water into the shoreline and sucking loosened grains into the vortex behind the tug, where gulls and terns gather to feed on fish and shellfish that pass too near the screws and are tossed to the surface for the birds' next meal.

Educational efforts at the Mad Island preserve are focused on increasing the awareness in surrounding communities of the valuable resource the marsh represents and of the need to protect the coastal environment. The benefits of ecotourism are emphasized. Here is a sustainable way of improving local economies while also protecting the wildlife and habitat crucial for the future of both the animals relying on the preserve and the communities surrounding it. The success of the Christmas Bird Count is a clear example of how the resources protected at Mad Island can benefit the sometimes skeptical locals.

In the nineteenth century, annual Christmas hunts used to occur where teams competed to see who could kill the most birds of all kinds. In 1900 ornithologist Frank Chapman proposed an alternative: an outing on which teams would count rather than shoot the birds. Twenty-five counts were held that first year, according to P. D. Hulce, former president of the Houston Audubon Society. "Now we have almost 1,800 counts in United States, Canada and Central America with 50,000 participants. It is the largest bird data base in the world."[5]

The distinguished ecotourism operator Victor Emanuel did not start the Christmas Bird Count in Texas, but he greatly added to the prestige of Texas

birding with his success in the Freeport counts back in the late 1950s, when he was a teenager. For years the Freeport annual count tallied the greatest number of bird species anywhere in the nation. I went on several of these Freeport counts as the guest of David Marrack, who taught me much about birding. But in 1997, the Mad Island count soared to the top. It would be the leader in Christmas Bird Counts for six years in a row, breaking records in the process (fig. 18).[6]

The rules of the count require that it take place within a circle of fifteen-mile diameter. The circle may extend over public and private lands, and the challenge is to include as many different types of habitat as possible within it, because diversity of habitat means diversity of species. As real estate goes, Mad Island definitely has the three prime characteristics of location, location, and location. Brent Ortego put it this way: "Location in that Mad Island is at the edge of the range of eastern, western, and southern fauna; location in that it has a forested river extending all of the way to the Gulf; and location in that the landowners have retained extensive areas of native habitat." Now that Mad Island has the top-ranked count, more than a hundred birders come each year from all over the United States, and even from as far away as England, and pay their five-dollar registration fees to be part of the team that sees the most kinds of birds in a single day.

The goal of the counts is twofold: to identify as many species of birds as possible and to estimate the number of individuals present of each species. Each count has a leader and a team; the team can split up to cover as much ground as possible in a twenty-four-hour period. Hard-core birders start at midnight—Brent included—rising in the dark to listen for owls and draw them out with tape-recorded calls. Still in the predawn dark, he heads over to Brandt Lake, a cooling pond adjacent to the South Texas nuclear power plant, home to thousands of ducks, ibis, and spoonbills. At the pond he plays calls to the rails, the most elusive of birds.

Brent began managing the Mad Island WMA for Texas Parks and Wildlife in 1992. He and Jim Bergan of the Nature Conservancy started the Mad Island count in 1993. Brent wanted something to showcase the diverse natural resources of southern Matagorda County, so he teamed up with the Bay City and Golden Crescent Nature Clubs to recruit birders from all over the state to attend. Ortego has since moved on to helping ranchers in the surrounding counties manage their hardwood bottomlands and coastal prairies for wildlife, but his initiative has proven durable, and the results have been gratifying for everyone.

The year that the Mad Island count set a national record with 235 species of birds in one day, one of the team leaders was Hulce, who works by night as the Houston Ballet's head lighting technician and works by day, particularly during the days around Christmas and spring migration, on identifying as many birds as possible. Ortego says the Mad Island preserve has 208 core species, birds one can usually bank on finding there on any given day during the count period. Lingering migrants boost the total, and then there are the rarities that spice up the day

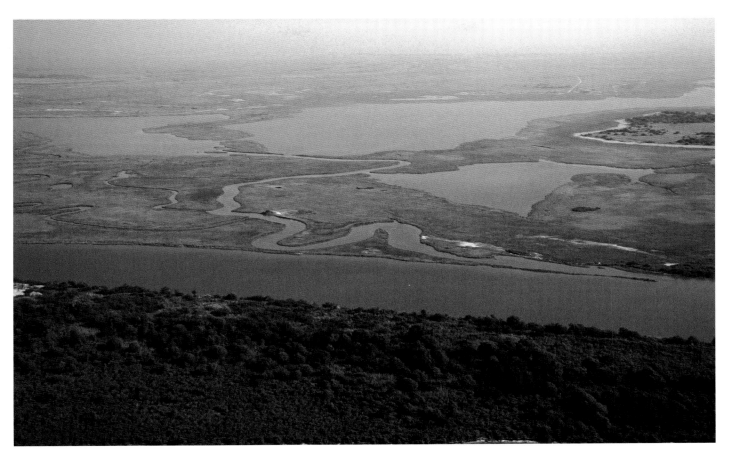

Mad Island Slough connects Mad Island Lake (upper center) with the intracoastal waterway, which is bounded on the south by vegetated spoil islands. Erosion threatens the marshes of Mad Island because daily barge traffic generates large wakes that cause soil and plant life to slough off into the canal, slowly but surely expanding the waterway into adjacent private and public lands.

and add the excitement of the unexpected. The nominees for "best bird" one year included the Cassin's vireo, the chestnut-sided warbler, and the green kingfisher; in the end the vireo won the vote.

The count circle drawn for the Mad Island count is half water and has the well-forested Columbia Bottomlands of the Colorado River running through its center, often sheltering lingering migrants. The delta attracts shorebirds of every description and hosts ospreys on the stark limbs of dead trees. Even in the face of a gusty norther, Ortego knows how to interpret the landscape and anticipate which birds will be found where. Scanning telephone wires, he spots shrikes and kestrels. In the agricultural lands, he watches for Harris's hawks and groove-billed anis. He hopes for a longspur, a sparrow that the sharp eye of an informed observer may find in the plowed fields or upland grasses.

One of the nicest aspects of the Mad Island count is the cooperation shown by local businesses, industries, and residents. While the heart of the count is within

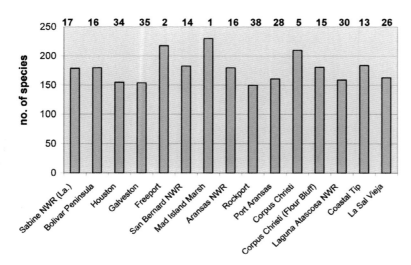

**Figure 18.
Christmas Bird Counts in Texas,
showing number of species noted
and national ranking.**

the Mad Island Marsh Preserve and WMA, the surrounding landowners who grant permission for birders to enter their property and count the birds in their woodlands, prairies, or marshes are likewise key to the success of the count. Local industries like the Equistar chemical plant and the nuclear power plant donate meeting rooms so that the weary and often wet team members can regroup, compare notes, and enjoy a banquet at the end of the day.

Another leader for the count has been Mark Dumesnil, a senior land steward with the Nature Conservancy. He says he has heard several versions of how the preserve got its name, but the one he favors has to do with a typographical error. Several hillocks of high ground are called islands along this part of the coast, although not really islands. Years ago, according to Dumesnil, some of the maps showed this area as Mud Island, and later someone changed the letter *u* to an *a*, making it mad instead of mud. Whatever the reason, the place now has a name as colorful as the birds that flock to its rich habitats, or as the sunsets that tint the gleaming waters of Matagorda Bay, visible at the southern edge of the preserve.

One of Mad Island's most impressive visitors is the sandhill crane, standing three and a half feet tall and with a wingspan six feet across. Nearly the whole population of lesser sandhill cranes gathers along the Platte River in Nebraska during their spring migration from Texas and the Southwest to Canada, Alaska, and Siberia in the north. Their annual migratory journey can be a round trip of fourteen thousand miles, with the Platte River as an extended refueling stop. Sandhill crane fossils found in Nebraska date back more than six million years, making these cranes the oldest of bird species still among us. The fact that these cranes are more numerous than the rest is due largely to the protection and restoration of their wetland habitats.

Cranes are long-lived; pairs mate for life, raising only one or two chicks per year. The cranes have however proven adaptable, nesting in smaller territories

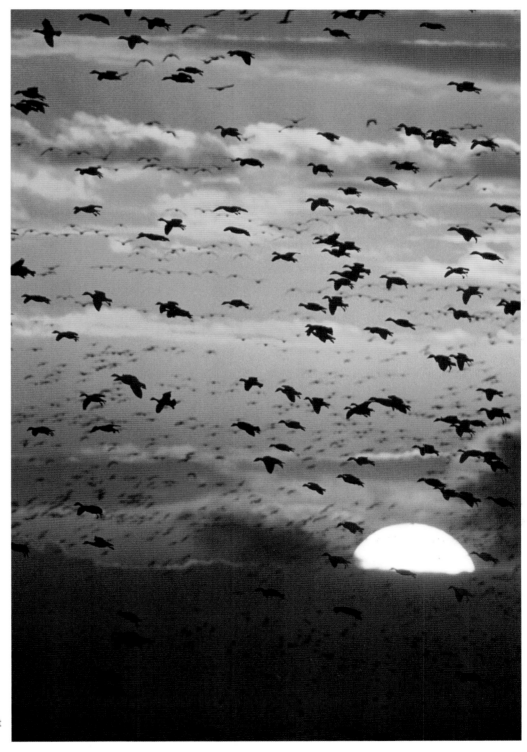

Geese coming in to roost in the late afternoon are a magnificent sight on a cold winter day.

and learning to feed off the waste grain and small animals associated with the farm fields that replaced so much natural habitat along their migration routes. About 450,000 cranes winter in West Texas and another 100,000 winter on the coast.

Today, the greatest threat to sandhill cranes is continuing loss of habitat at the stops along their migratory path, especially on the Platte River. Nearly 70 percent of the river's flow in Nebraska has been drained or diverted for agricultural and urban uses, diminishing the number of sandbars available to the cranes for safe roosting. During their few weeks of rest and refueling on the Platte, cranes can gain as much as 15 percent of their body weight before continuing to their breeding grounds farther north. Texas is an important wintering area for midcontinent sandhill cranes, says Jim Ray of Texas Parks and Wildlife, and some of the important places in Texas for the sandhills are the Mad Island Marsh Preserve and WMA.[7]

The cranes are social birds, feeding and roosting together in communal groups. When they migrate, they wait for clear, sunny skies and then take off together in great circling columns as they ascend the rising warm air. High overhead they form up into the distinctive V in which they travel as much as 350 miles a day.[8] The crane's powerful and unmistakable call is amplified by an unusual loop in its windpipe behind the breastbone, creating the resonance and haunting character of its voice. They call to one another during migration to help stay together and coordinate the flock's movements.

In *A Sand Country Almanac*, Aldo Leopold expresses the awe and reverence that many have felt when hearing or seeing the great migrations of the cranes:

High horns, low horns, silence, and finally a pandemonium of trumpets, rattles, croaks, and cries that almost shakes the bog with its nearness, but without yet disclosing whence it comes. At last a glint of sun reveals the approach of a great echelon of birds. On motionless wing they emerge from the lifting mists, sweep a final arc of sky, and settle in clangorous descending spirals to their feeding grounds. A new day has begun on the crane marsh.... Our ability to perceive quality in nature begins, as in art, with the pretty. It expands through successive stages of the beautiful to values as yet uncaptured by language. The quality of cranes lies, I think, in this higher gamut, as yet beyond the reach of words.[9]

Mad Island is a stop among more than three hundred along the Great Texas Coastal Birding Trail, the brainchild of ecotourism guru Ted Eubanks and Madge Lindsay of Texas Parks and Wildlife. In 1993, they began to develop the idea of a trail running from the Mexican border to Louisiana, marking stops of interest to birdwatchers, nature photographers, and wildlife observers of all levels of expertise and interest. The concept took effect in stages and was completed in April of 2000. So successful has it been that other states are now seeking to copy it and provide similar attractions to draw in visitors and their tourist dollars. Texas

Parks and Wildlife itself has authorized the development of three more trails, through Central Texas, the high plains, and the piney woods. These will complement the coastal trail, served by a system of maps and guides to natural sites and collectively called the Great Texas Wildlife Trails.

Since its inception, the coastal trail network has been a cooperative effort, with Texas Parks and Wildlife backed up by the Department of Transportation using highway enhancement funds to pay for improvements and signage at each site. Working with these government agencies are a host of citizens, conservation groups, and businesses all banding together to create this unique opportunity to improve public access to the state's stunning abundance of birds and other wildlife.

Texas is the state with the greatest number of bird species, more than six hundred, and 75 percent of these have been seen along the coast, making it an obvious draw for those interested in bird life.[10] In 2001, the Great Texas Coastal Birding Trail received international recognition for its contribution to socially responsible tourism when it earned the British Airways Tourism for Tomorrow

Sandhill cranes roost on the Mad Island preserve and WMA and nearby marshes, fanning out by day to feed in the adjacent prairies and fields.

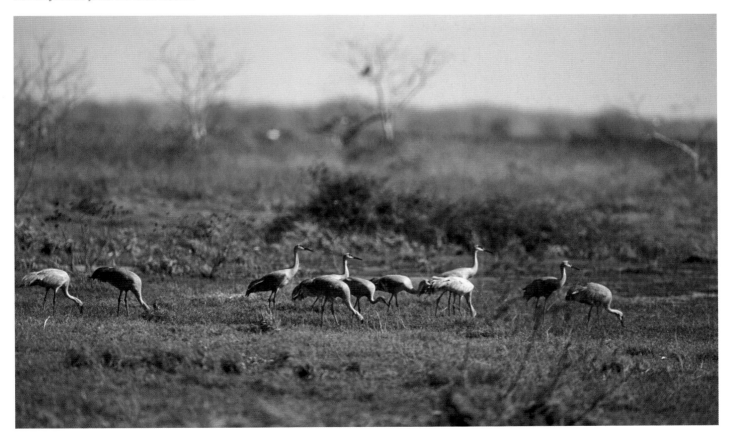

Award. This designation is a prestigious award recognizing projects that promote sustainable activities within the tourism industry. As the plans for other trails indicate, Texas has learned from this project about the possibilities—both economic and ecological—in the development of similar initiatives. One hopes this experience will translate into other activities along the Texas coast.

Al Garrison and I fished Mad Island Slough early one winter afternoon, just in from the intracoastal canal near the mouth of Mad Island Lake. The afternoon was cold and clear. A norther had blown much of the water out of Mad Island Lake, evicting the juvenile shrimp, crabs, and fish from the marsh nursery along with the predators. The air was still and crystalline; the only sounds were the peeps of shorebirds and the *whish* of air flowing through their wings when they passed overhead, coming in to forage on the lake's exposed mud flats. As the late sun turned the sky yellow and red, the sandhill cranes returned to their roost sites in and around Mad Island Lake. Their graceful formations came at us from the distance, individuals gaining size and resolution as they neared the marsh.

The eerie trumpeting call of the wintering cranes punctuated the quiet coastal evening, connecting us with far places and times. They were doubtless to be heard there when Shanghai Pierce founded his cattle empire and for millennia before that. In their great age as a species, the cranes are a continuity in a world of disjunction.

Pierce may have joked about owning the church, but his actions nonetheless bespeak a sense of community responsibility. In his era, that meant establishing a town, a station, churches. His heirs continue the civic tradition with a deeper kind of commitment: helping to preserve and restore a rich natural heritage of marshes and waterfowl and long-distance migrants, in a place that outstrips every other in the nation with its birds.

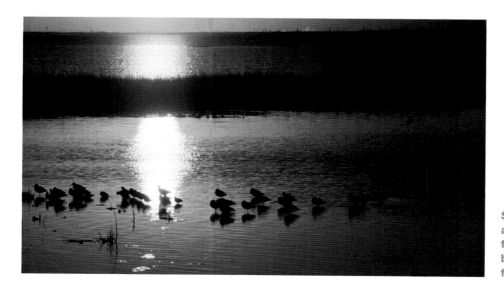

Small waders gather in the late afternoon sun, feeding on the mud flats exposed when the north winds blow significant amounts of water from the bays and adjacent marshes.

The Matagorda Bay system extends from the mouth of the Colorado to the west and south, connecting with the Gulf of Mexico through the ship channel at the Port O'Connor jetties and Pass Cavallo. The town of Palacios, at upper right, is a major shrimping center on Tres Palacios Bay. Several preserves exist in this area, including the Mad Island reserves to the east; Aransas National Wildlife Refuge adjacent to Powderhorn Lake near Port O'Connor; Matagorda Island Wildlife Management Area; the Welder Flats Wildlife Management Area; and the Guadalupe Delta Wildlife Management Area on the northern edge of San Antonio Bay.

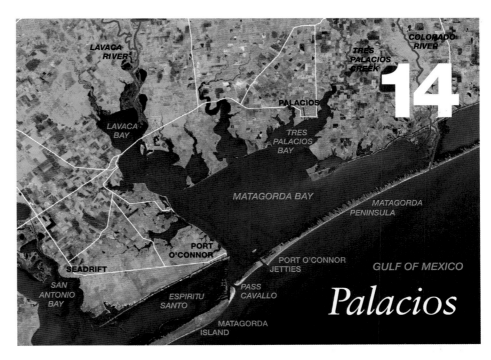

Palacios

Joe Nguyen called our office in June of 2000, asking for help concerning the new shrimping regulations proposed by the Texas Parks and Wildlife Department. He and the other shrimpers along the coast were concerned that these regulations would put them out of business, and their fears seemed well placed.

Earlier that year an interview with Hal Osborne, head of the fisheries section of Texas Parks and Wildlife, had appeared on the website of the Coastal Conservation Association (CCA). Osborne said in the interview: "You can make regulations that make basically, you know, time and area closures, that make the shrimper himself so inefficient . . . You can regulate them out of business."[1] These were strong words coming from the head of the state agency responsible for fisheries, and the bay shrimpers had no doubt that the intent of the proposed regulations was indeed to put them out of business.

Shrimping occurs both in the Texas bays and out in the Gulf of Mexico, including state and federal waters. Until the legislature acted in 1975, shrimping was regulated by each coastal county, and the regulations were varied and often unenforced. Since the publication of that first management plan in 1989, the Texas shrimp fishery has come under more and more scrutiny and regulation. Regulation is necessary to protect the bays and estuaries but can also be unfair and can force good, hardworking people out of business. The key is balance, and I believed Joe and the other shrimpers deserved a balanced outcome.

Shrimp swim in a tank at a bait camp. The regulation of the shrimp fishery is a heated issue that has bay shrimpers worried about their future. Shrimpers can be relied upon to fight for the protection of the bays. If we force the shrimpers from the water, we will lose an important voice fighting for the bays. Recreational fishermen must be willing to move forward to take up the slack. Otherwise, there may be no parties with the legal standing to seek protection of our bays in agency proceedings and in court.

When shrimper Diane Wilson and I were fighting Alcoa over mercury-containing wastewater going into Lavaca and Matagorda bays in the 1990s (see next chapter), Joe and the Vietnamese shrimpers stood with us in administrative proceedings and court actions intended to prevent Alcoa from worsening the mercury contamination in Lavaca Bay. When he called, I resolved to do what I could to see that the shrimpers were treated fairly in the regulations being proposed by Texas Parks and Wildlife.

I guess I am biased to some extent on behalf of the shrimpers. It is hard to find partners to fight against big industry on the coast. The courts and regulatory agencies require a group to have "standing" in order for the group to be able to object to permits and participate in administrative law hearings. Standing means that a group has a more specific interest in the proceeding than is held generally by the public. Economic interests are the easiest to demonstrate, although use of an area for recreational fishing, birdwatching activities, and guided hikes often suffices. Many environmental groups lack members with standing when an issue involves some of the more remote areas of the Texas coast—and some groups that do have standing have chosen not to be involved in many of the fights against industry. The bay shrimpers are almost always willing to fight when something threatens the bay, and they do not care about stepping on political toes.

The shrimping industry has not excelled at public relations. The shrimpers' long effort to resist equipping their nets with turtle excluder devices, or TEDs, cost them dearly in public perception. The TED is a thirty-inch hole in the net designed to allow sea turtles to escape. It also allows some shrimp to escape. However, sea turtles are endangered, and shrimpers must protect them. Today they do. But they were slow to accept these changes, and it hurt them in the court of public opinion.

After our partnership in the Alcoa fight, Joe and I had worked together on the shrimp regulations in 1995, when as in 2000, the bay shrimpers believed that the proposed regulations were aimed at putting them out of business. Busloads of Vietnamese shrimpers poured into Austin, revealing to the public and to agency officials, perhaps for the first time, the full extent of the Vietnamese presence in the coastal shrimping industry. Some of us have seen Vietnamese shrimpers on the bay, or on the docks in various places, but the scope of their involvement in the industry is not well known to many coastal residents.

The war in Vietnam changed the Texas coast. In the late 1970s and early 1980s, over 150,000 Vietnamese people came to the United States, fleeing the war's destruction and political oppression in their homeland.[2] Many thousands of these immigrants settled in Texas coastal towns; major Vietnamese enclaves currently exist in Port Arthur, the Seabrook-Kemah area, Port Lavaca, Palacios, and Rockport as well as other areas.

The Texas coast offered two things that were familiar to the Vietnamese: climate and shrimping. They often settled in large family groups and lived and

worked together to try and make it in another culture with a different language. Like other immigrants to the United States, the Vietnamese faced racial problems in addition to those related to making a living and learning how to operate successfully in a new culture.

In the late 1970s, racial conflicts erupted in Seadrift on San Antonio Bay and in Kemah as the established Anglo shrimpers clashed with the recent Vietnamese arrivals. One white shrimper was killed in Seadrift, and the Ku Klux Klan arrived to burn boats and intimidate the immigrants. Oddly enough, the Grand Dragon of the KKK, Gene Fisher, later listed the concerns of the poor whites whom the Klan supposedly represented as "jobs, maintaining a decent standard of living, and depletion of the shrimp supply that sustained their way of life."[3] This would seem to indicate that they had more in common with their Vietnamese neighbors than not. But the Vietnamese shrimpers used different radio channels and spoke Vietnamese on the water, and the unknown is always unsettling.

Over time, both groups realized that they had more similarities than differences, and the racial tensions have eased, producing in their place a good working relationship between the Vietnamese and their Anglo counterparts. The success of the Vietnamese has been amazing, and they have realized great benefits from their emphasis on savings and education for their children, producing dramatic results in the space of a generation.

The Vietnamese community is now linked with the Anglo shrimping community. Although shrimping does not provide the same economic engine that oil, gas, and petrochemicals do along the Texas coast, the shrimping industry in the Gulf and bays is large. Figure 19 shows landings by port in 2000. The bulk of the harvest from Brownsville–Port Isabel and Freeport is from offshore waters rather than the bays, and the high Port Arthur catch in the figure includes both offshore shrimp and menhaden. What may be surprising to some is the relative ranking of Palacios on Matagorda Bay, where the landings—or commercial catch—are almost exclusively shrimp. Today, Palacios is one of the centers of shrimping on the Texas coast, along with Aransas Pass–Rockport.[4]

Texas is the leading state in the nation for brown shrimp, representing 39 percent of the total United States catch of brown shrimp. Louisiana ranks second, with Alabama a distant third place (fig. 20). Texas is also a major harvester of white shrimp, although it lags far behind Louisiana in the total catch of this delectable crustacean (fig. 21).[5]

The shrimping community's deep ties to the Texas bays and to the fishing life spark strong emotions. Ed Lambright has been working the waters around Port O'Connor for more than forty years. He started working on shrimp boats as a deckhand when he was ten years old back in 1957, earning a penny a pound. He bought his first boat around 1968 and started shrimping for himself so as to spend more time with his children, the youngest of whom grew up on the water

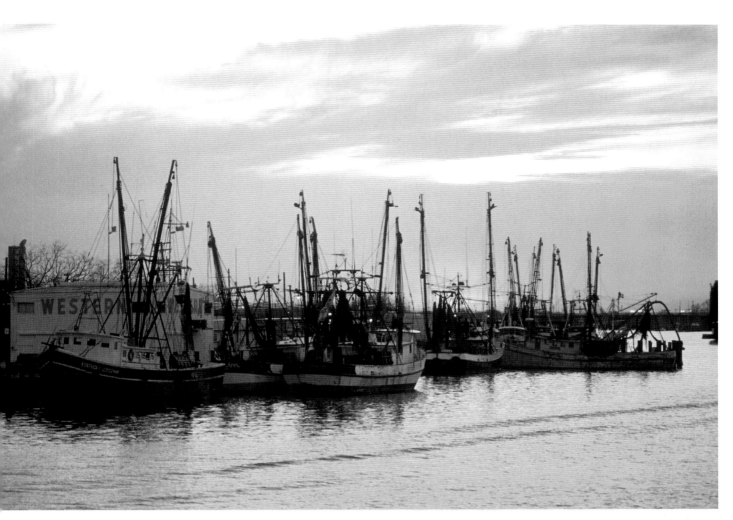

Shrimp boats docked on the Kemah channel in Seabrook.

aboard his father's boat from the time he was in a bassinet. Now Lambright takes his six grandchildren out.

The bay shrimpers thought they had arrived at a long-term agreement with Texas Parks and Wildlife in 1995, when both the Anglos and Vietnamese strongly objected to the regulations as originally proposed. Instead of passing a set of harsh regulations, Texas Parks and Wildlife worked with the shrimpers and adopted a concept that could protect both the fishery and the fishermen. This concept was called limited entry.

There are two types of bay shrimping licenses: bay and bait licenses. Under the limited entry concept, caps were set on both kinds. Essentially, the existing licenses were grandfathered and no more could be issued. Licenses could be bought and sold among shrimpers, and they could also be bought and retired either by the state or by individuals and organizations.

With the immigration of the Vietnamese to the coast had come a large increase in the number of shrimping licenses. The increase peaked in the 1982 to 1984 period but has steadily declined since then (fig. 22).[6] There was a small spike in license sales with the advent of limited entry, but the trend downward has contin-

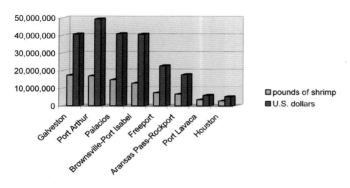

Figure 19. Shrimp landings by Texas ports, 2000.

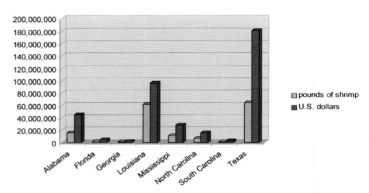

Figure 20. U.S. brown shrimp landings, 2000.

ued since that time. Limited entry is a valid concept; it can and will work. It requires sufficient funding to buy the licenses, however, and neither the state nor the private sector has raised the money to buy out large numbers of licenses.

Although the number of boats in the bays has declined, many recreational fishermen continued to be concerned about shrimping and shrimpers. That concern led to pressure on Texas Parks and Wildlife to reconsider regulations for the shrimping industry, regulations that had been put off in 1995 in exchange for the limited entry program. The renewed impulse for restrictions was what caused Joe Nguyen and Thuy Vu of Palacios to come into my office, followed several days later by Ed Lambright, Janie and Wesley Blevins, Poodle Whittenberg of Seadrift, and others.

To a person, these shrimpers felt they had been double-crossed by Texas Parks and Wildlife when the agency proposed the new regulations in 2000. Texas Parks and Wildlife asserted in the proposed regulations that the shrimp fishery was in bad shape, that it was overfished, and that the future of the fishery was at risk unless serious restrictions were placed on bay shrimping. The same official who said you could regulate the shrimping industry out of existence was the architect of these regulations.

Ed Lambright, speaking on the proposed regulations, said the shrimpers got no support in the media. "It's funny," he said, "the public perceives us as a bunch of outlaws. But I pay my taxes; I volunteer on all kinds of boards. I have been volunteer Fire Chief (of Port O'Connor) for years. I donate to charities. I put two kids through school, but we're outlaws, and they want to marginalize us. But it don't work like that. The shrimp are like my guns, you'll have to pry them from my dying hand if you wanna take that away."[7]

Lambright and others contended that the existing set of regulations was effective and that overall the industry was healthy. Regulations passed in 1989 had established daily pound limits, mesh size requirements for nets, and dates for

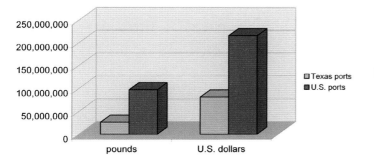

Figure 21. U.S. white shrimp landings, 2000.

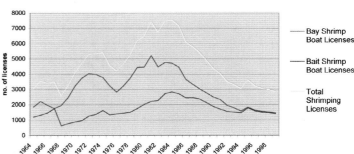

Figure 22. Number of commercial shrimp licenses sold in Texas, 1964–1999.

both brown and white shrimp commercial seasons.[8] Zones amounting to about 12 percent of the acreage of Texas bays had been set aside as nursery areas where shrimping was prohibited, and the shrimpers were now using TEDs to protect endangered sea turtles. All these regulations were in effect in addition to the limited entry program that prevented the industry from expanding and that was designed to have some licenses bought out each year. Yet Texas Parks and Wildlife was proposing more regulations, and the shrimpers felt they were under attack—not due to the health of the shrimp fishery but for other more political reasons.

The first issue in the battle over the regulations proposed in May of 2000 was whether the shrimp fishery was being depleted to the point where its future was in danger. I asked fisheries scientist Robert McFarlane to research this and tell us what he discovered. One needs to know something about the life cycle of shrimp to understand this issue. Shrimp do not live very long, their average life span being little more than a year. Both brown and white shrimp breed in the open waters of the Gulf of Mexico. The larval shrimp are free-floating and move with the tide into the bays, where they migrate to the fresher portions of the estuaries and marshes. Here, they grow to about three to five inches in length and then migrate back into the Gulf to breed and die (fig. 23).[9]

As long as sufficient numbers of adults return to the Gulf and breed, the fishery is in no danger. Once the larval shrimp migrate into the bays and estuaries, they may encounter different environmental situations, such as higher or lower inflows, pollution, or high plankton concentrations. Conditions vary from year to year, and a bay may have excellent shrimp one year and poor numbers the next year, yet they are all dependent upon the parent stock in the Gulf. If enough breeders are laying eggs in the Gulf each year, then the fishery will remain healthy.

In order to assess the claims of Texas Parks and Wildlife, McFarlane first examined the data on the number of breeders that were returning to the Gulf

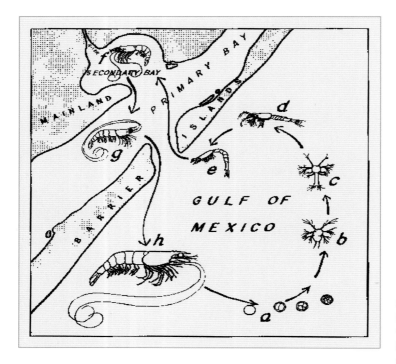

Figure 23.
Shrimp life cycle: Adults breed in the Gulf, and larvae migrate into the bays to feed and grow. Reproduced courtesy of Texas Parks and Wildlife Department.

each year. Data from the National Marine Fisheries Service did not indicate a loss of parent stock in the Gulf of Mexico.[10] Instead, it showed that the breeding stock has steadily increased since 1980 for white shrimp and has stayed about the same for brown shrimp, the two species that comprise the bulk of the commercial harvest (fig. 24). McFarlane then investigated the numbers of juvenile shrimp that entered the breeding population (called recruitment). The National Marine Fisheries Service data again showed that the number actually increased (fig. 25).

These data were presented to Texas Parks and Wildlife in response to the regulations proposed in 2000. "Recruitment overfishing" had been a primary reason listed by Texas Parks and Wildlife for the suggested new regulations, but the data clearly indicated that there was no current evidence of a recruitment problem in the shrimp fishery.

Once it became clear that the fishery was not in imminent danger, the focus of the final regulations changed from recruitment overfishing to a concept called "growth overfishing." Growth overfishing occurs, according to Texas Parks and Wildlife, when either the total yield or the mean size of individuals caught decreases relative to the amount of time spent fishing. Growth overfishing is measured in "catch per unit effort," or CPUE. If shrimpers are working harder and catching less, that might indicate a problem with the fishery—too many boats working longer for less return on their time. And so the focus of the regulations changed, with Texas Parks and Wildlife now asserting that regulations were needed to allow the harvest of larger, more valuable shrimp with less effort.

But did the data support a claim that growth overfishing was occurring? McFarlane investigated this in detail and found that the CPUE trend line for brown shrimp declined during the 1980s, when the shrimp industry expanded. However,

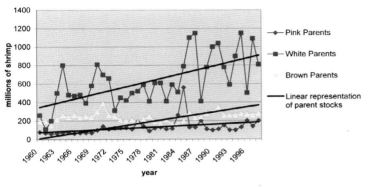

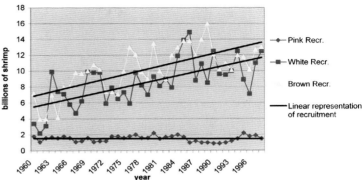

Figure 24.
Annual parent stock estimates for the Gulf of Mexico shrimp fishery, 1999. Parent stock refers to the breeding population found in the Gulf. Data from National Marine Fisheries Service, graph from Robert McFarlane.

Figure 25.
Annual recruitment estimate for the Gulf of Mexico shrimp fishery, 1999. Recruitment estimates measure the reproductive success of the parent stock—that is, young shrimp recruited into the breeding population. Data from National Marine Fisheries Service, graph from Robert McFarlane.

the decline stopped in 1996 and the trend since then has swung upward. A similar decrease in the CPUE occurred for white shrimp, but that trend also turned around, starting in about 1990. The current trend is upward, a greater catch per unit effort, a further indication of the relative improvement that has occurred in the fishery.

Within our bay systems, the CPUE has been rising since the 1980s and has increased substantially since 1987. If anything, the data indicated that the fishery was in good shape, that the parent stock was doing well, and that recruitment of juvenile shrimp was good.

McFarlane concluded that the purpose of the 2000 regulations regarding growth overfishing was based on something other than improving the health of the fishery. The concern over growth overfishing was not about the *number* of shrimp in the breeding population but about the *size* of the shrimp that were harvested. In other words, the concept of growth overfishing was purely economic. If you waited a little longer and the shrimp grew bigger, they would be worth more. McFarlane believed that the advantage of waiting in order to harvest bigger shrimp was offset by the fact that the natural mortality of shrimp is around 27 percent, meaning that after two months, only one half of the saved shrimp would remain alive at the time of harvest."[11]

Because larger shrimp are worth more in the marketplace than are small shrimp, the same number of shrimp will generate more money if caught in the Gulf rather than in the bays. To eliminate growth overfishing, according to McFarlane, it would be necessary to cease fishing the bays entirely. That was what had the bay shrimpers up in arms.

During the period for public comment, the Texas Parks and Wildlife commissioners received more than seven thousand letters and emails with thoughts and suggestions and opinions both for and against the proposed regulations.[12] Originally, the commissioners had proposed additional restrictions on gear and on the size of shrimp that could be caught. In the end only three restrictions were passed that directly affected the bay shrimpers. Additional nursery zones were established; use of bycatch reduction devices (BRDs, pronounced "birds," another hole in the net in addition to the TED, to allow small fish to escape) became mandatory in the bays; and the white shrimp season was shortened by two weeks.

One might think the bay shrimpers would have felt they had dodged another bullet, that the regulations adopted were not as bad as they might have been. But the bay shrimpers did not see it that way. They felt they had not been told the truth. Even though the new requirements were less restrictive than what had originally been proposed, the shrimpers felt that the power of recreational fishermen was behind the intensifying restrictions—that there was no integrity to the regulations.

I am a recreational fisherman. I have a foot in each camp on this one, as a recreational fisherman who also has a warm spot for the bay shrimpers of the Texas coast. What ultimately made me decide that Texas Parks and Wildlife was not telling the whole truth about these regulations was their response to a question the shrimpers raised about red drum, or redfish. The question was simple: the shrimpers asked if the stocking of over 450 million redfish between 1975 and 1990 had had any measurable impact on shrimp populations?

Texas Parks and Wildlife responded that redfish don't eat shrimp.[13] To me, that is a ridiculous statement. Redfish may prefer other food, such as crabs, but they certainly eat shrimp. I have caught too many on shrimp for it to be otherwise. To assert that they don't is like denying that Texans eat hamburgers.

In early 2002, the shrimp industry was again in court against Texas Parks and Wildlife. They may win, or they may not. The present set of regulations may not force them out of business, but if this trend continues, they eventually will be forced from the bays. The bay shrimpers took a stand on principle—that they cannot and should not be regulated under a guise. If the data showed a problem, they would support the regulations. Without the data, they smelled a rat.

Janie and Wesley Blevins hang on to shrimping as a way of life. They are good people who have invested their lives in an industry that increasingly exists at the mercy of Texas Parks and Wildlife and a coastal constituency dominated more and more by recreational rather than commercial fishing. The numbers of commercial licenses are going down, now less than twenty-five hundred. By contrast, coastal recreational fishermen and women now number over 250,000. The lights are not off in the shrimping towns like Palacios, but the partying is over.

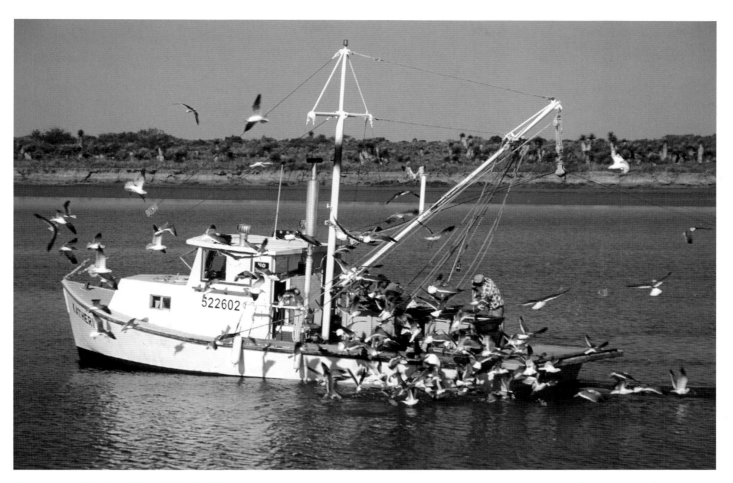

Shrimper in the bay. Wood slats hold the net open when it is pulled behind the boat. The number of shrimpers in the bay system has steadily declined since the mid-1980s.

Commercial shrimp farms are springing up on the Texas coast, coming in without much attention from the regulatory agencies, despite warnings that they could spread viruses to our coastal ecosystem. At first, they were not even required to have permits, and now they get the permits even over strong opposition. To make matters worse, Europe has refused to allow the import of farm-raised shrimp from China due to genetic engineering issues, leading China to dump shrimp on the U.S. market.

If recreational anglers want shrimpers off the bays, the best way forward is to buy out the licenses under the limited entry program. In this manner, those shrimpers who want to get out of the business can at least get some money to help them start again in a new career. It may not be much, but it is fairer than contriving reasons for regulations and simply closing down the industry. And don't tell me that redfish don't eat shrimp.

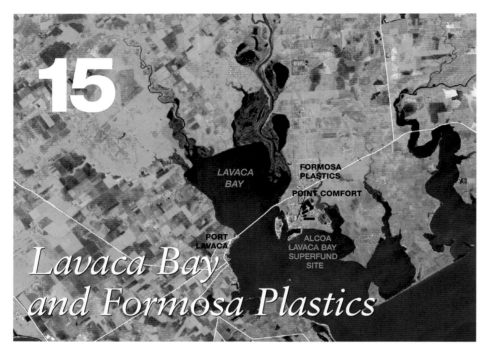

15

Lavaca Bay and Formosa Plastics

LAVACA BAY

FORMOSA PLASTICS

POINT COMFORT

PORT LAVACA

ALCOA LAVACA BAY SUPERFUND SITE

State Highway 35 crosses Lavaca Bay. The Formosa Plastics Point Comfort facility can be seen on the right side of the bay, north of SH 35. Port Lavaca lies on the left side of the bay, along the same highway. The island immediately south of the SH 35 causeway is part of the Alcoa Lavaca Bay Superfund site, an area with extensive mercury contamination. Much of the mercury that was discharged from Alcoa will be left in Lavaca Bay in perpetuity rather than removed.

Diane Wilson is a shrimper from Seadrift, and she is larger than life. I imagine her as a kind of colossus, standing with one foot in San Antonio Bay and the other in Matagorda Bay, rising over the Calhoun County peninsula, arms lifted, fighting off those who would harm these bays.

Diane became an environmental activist because Alcoa had contaminated Lavaca Bay with mercury, closing it to crabbing, and because of the Toxic Release Inventory (TRI) that requires industries to report their emissions of hazardous air, land, and water pollutants. The National Wildlife Federation published the results of the first TRI reports. Newspaper coverage of this NWF report clearly showed Calhoun County as the number one spot in the country for land disposal of hazardous waste, and that caught Diane's attention. She is an amazing woman, and most people have never met someone like her. She is smart, she is outrageous, and she can cause a lot of trouble in a very short time. But perhaps most important, she is committed, with a capital C.

Formosa Plastics was planning to make extensive additions to their polyvinyl chloride plant in Point Comfort on Lavaca Bay at about the same time that Wilson read the NWF report. Wilson and her friend Donna Sue Williams called me to help them fight this expansion, and I agreed to help them out. It is hard to recognize the days that change your life when they are happening; at the time, I had no idea what was coming.

Diane, Donna Sue, and I challenged the first round of permits for a $2 billion expansion of Formosa Plastics and were content to try to tighten up permit conditions and obtain some studies of health effects on the Point Comfort community of about fifteen hundred people. Then we found out that Formosa had not told us about the full extent of their expansion plans, despite their claim that we already knew everything. It was then that we decided to fight them with everything we had.

The first round of the fight was to force an environmental impact statement (EIS) for the expansion. A federal permit was required for the planned wastewater discharge, and the National Environmental Policy Act applied. The U.S. Environmental Protection Agency was not planning to require an EIS, but we felt it was essential that Formosa make a complete disclosure of the extent of the expansion and that the health and safety impacts be revealed.

We filed all the necessary legal documents and were promptly told no— there would be no EIS. Texas was emerging from the real estate and oil bust of the mid-1980s, and the politicians were giddy over this Formosa expansion, with its five thousand construction jobs and more than a thousand permanent jobs. Formosa did not want to file an EIS, and the state and federal governments supported them.

The EPA's refusal to consider an EIS caused Diane to go on the first of two hunger strikes against Formosa. She felt strong ties to the teachings of Gandhi and decided that if his methods worked against the British, they ought to work against the United States too. From the outset, I hated her hunger strike. By its end, she was wan and weak, thoroughly transformed from the robust figure we knew, strong from hard physical work on fishing boats. My job as her friend as much as her lawyer was to negotiate an honorable end to this hunger strike, and we eventually convinced the EPA to prepare an EIS. Essentially, she did through a hunger strike what I could not do through the court system.

After that EIS encounter, Wilson and I concentrated on fighting the air pollution construction permit allowing the expansion that Formosa had failed to disclose to us. Wilson went to the files of the Texas Air Control Board in Corpus Christi and spent weeks poring over permit documents and enforcement records. The picture that emerged from this research was a poor one; Formosa was a company that had not done a good job of meeting its environmental obligations, not only in Texas but in Delaware as well.

We publicized this information, and we took it into the administrative hearing process of the Texas Air Control Board. Formosa became notorious in Texas and around the country for its poor compliance record. (To this day, I am convinced that Formosa's competitors in the chemical business assisted us behind the scenes, without our knowledge, in this negative publicity.) But ultimately, the construction permits were nevertheless issued by the state air agency.

By this time, construction was under way and Wilson was becoming more and more concerned that a disaster was going to occur in Lavaca Bay, where the wastewater discharge was proposed to occur. Although Formosa had its air pollution construction permit and had started construction, it still did not have its federal wastewater discharge permit, and the EIS was not yet complete. This process was totally backwards from a practical and a legal standpoint, but the EPA and Formosa both maintained the fiction that they would dismantle the plant if the EIS came out against its construction, insisting that Formosa was proceeding at its own risk.

Wilson seized this moment for her second hunger strike against Formosa. This time, she focused on the company's compliance record and the harm that would likely come to the community and to the bay. More fundamentally, it was a strike against the unfairness of the federal and state permitting system. On this hunger strike Wilson got nationwide support from many organizations, including Greenpeace and the Oil, Chemical, and Atomic Workers Union. She became a popular personality with the media and many environmental groups because she was willing to risk everything to protect the environment. These groups urged Wilson forward, generating publicity, pushing her on, and often taking advantage of her, in my opinion.

I hated Wilson's hunger strikes because they were so absolute. After a couple of weeks, she could not follow a train of thought for long—concentration was a struggle. I couldn't stop her, but I also couldn't bring myself to help her starve herself.

Once again, I helped negotiate an end to the hunger strike, trying to come up with an honorable resolution for my friend. During our legal fight, I had discovered that the State of Delaware had forced Formosa to clean up its plant there, and Formosa had done it. The problem was not that Formosa could not clean up its act; rather, it was that neither the state nor the EPA was requiring the company to do so at Point Comfort.

Formosa's representatives and lawyers met with Wilson and me and a couple of Diane's supporters in my office one Saturday. At the meeting, there was posturing and give and take on both sides, but eventually a conceptual agreement was reached. Formosa, Wilson, and I would sign a legally enforceable contract that established a three-member arbitration committee called the Technical Review Commission (TRC). This three-member commission had the authority to hire auditors to evaluate air quality, hazardous waste, water quality, emergency planning, and worker safety practices and procedures, including management, at the Point Comfort facility. The three members were to be Ken Mounger, the Point Comfort plant manager, environmental engineer Davis Ford from Austin, and myself.

Under the contract, Formosa agreed that they would be bound by the recommendations of the auditors if two of the three TRC members voted for these.

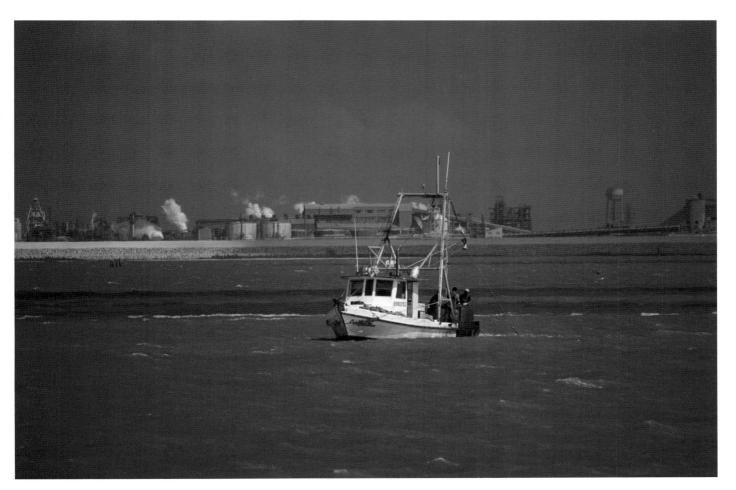

A shrimper in front of the Alcoa plant in Lavaca Bay. Alcoa discharged mercury into Lavaca Bay for many years under a permit issued by the State of Texas. This mercury discharge led to the designation of a Superfund site in Lavaca Bay. The contamination of Lavaca Bay by Alcoa was one of the reasons that Diane Wilson decided to oppose the expansion of Formosa Plastics, which also proposed to discharge into Lavaca Bay.

In other words, Formosa agreed to give control over reform of air quality, water quality, hazardous waste, emergency planning, and worker safety issues within the plant to a review panel on which two of the three members were from outside the corporation. The members of the TRC would be paid by Formosa, as would the costs of all studies.

After hours of wrangling, at the end of a very long afternoon, Diane agreed to the settlement. Her next hard choice was whether to eat a hamburger or Mexican food first. The burger won.

I considered this the best agreement of its type that had ever been negotiated in the United States. We were going to have the opportunity to reform a huge chemical complex, and the company indicated both the willingness and desire to go forward. We had all been in a no-win situation before, but now we had a chance to find ways for each of us to win.

Formosa called the following week to say that two elements in the agreement, one regarding concessions to aid organizing by labor unions and the other the buy-out of homes in Point Comfort, had to be omitted if they were to move forward with the agreement. We all were upset by the change, but I was the only one who felt the agreement could and should be salvaged. Our main concerns had been protection of Lavaca Bay, protection of the citizens of Point Comfort, and worker safety. Those goals had not been compromised by the rejection of the other two points.

Wilson and I worked for days trying to resolve these issues. Finally, I went down to Seadrift and sat with her on folding chairs at the fish house dock, looking out over San Antonio Bay. We talked about Joseph Campbell and the hero's journey, about Jungian psychology and the collective unconscious, about ethics, spirituality, and ecofeminism. We reestablished the partnership that we had had before the last hunger strike; we decided that I would sign the agreement and that she probably would as well.

The agreement signing was set for early morning in the Speaker's conference room in the State Capitol. Formosa wanted to publicize the end of our fight before the state media. Wilson and I had agreed the previous day to meet early in the rotunda of the Capitol. I got there early, but Wilson never showed up. No one had cell phones back then, and Wilson was not home. The signing was postponed for an hour as we waited for her. Then I went ahead and signed the document.

The signing itself was quite a scene. Greenpeace had sent demonstrators to oppose it, staging some guerrilla theater that parodied Governor Ann Richards, Chairman Y. C. Wang of Formosa, and me. I was rendered as "Slick Jim the Lawyer," with dollar bills pasted to my suit. It was one of the worst days I have ever experienced, but I believed then (and still believe) that the approach in the agreements would ultimately benefit Lavaca Bay and the residents of Point Comfort. Wilson subsequently told me that I should go forward but that she simply could not oppose those who had helped her during her strike.

The agreement with Formosa signed in 1992 was an amazing success. I give much of the credit for this success to Ken Mounger, Formosa's Point Comfort plant manager. If he gave you his word, you could bank it, but the greatest testimony to his commitment was that he and his wife and two children moved into the Point Comfort community, less than a mile from the plant. If the citizens of Point Comfort were to be negatively affected by Formosa, Ken and his family would be too. If all plant managers on the coast lived next to their plants, I guarantee we would have cleaner operations. I think Ken was grateful to have our agreement. It gave him more leverage than he might otherwise have had in protecting the community during this period of change within Formosa.

From 1992 to 1996, the audit process and a good corporate attitude transformed Formosa Plastics operations at Point Comfort. The auditors were selected by the Technical Review Commission, Mounger and I and Davis Ford, our "third-

party neutral." The initial audit covered the existing facility and identified 187 specific recommendations for improvement regarding management systems, pollution prevention, industrial hygiene, water quality, air quality, solid and hazardous waste, and emergency and spill prevention. Formosa accepted the recommendations, and these subjects would be revisited in the subsequent audits. In addition, the ongoing construction was reviewed on a one-time basis for mechanical integrity, process safety management, and fire safety programs. These one-time audits generated 283 recommendations that were accepted and acted upon.

The second round of audits identified 71 specific findings, mostly regarding air quality. The third round of audits, completed in 1996, included the new plants that had become operational with the completed expansion. In this round, 264 audit findings were agreed to by Formosa. In total, 805 recommendations were accepted by Formosa and implemented at a cost of several million dollars over a five-year period.[1]

The improvements resulting from these audits were evident and rapid. After 1994, environmental noncompliance virtually disappeared at the Point Comfort facility. The "reportable quantity" releases—unpermitted, accidental releases of hazardous substance that had to be reported—went down even though the plant expanded substantially. In the important area of worker safety, the number of accidents dropped from well over the industry average at the start of the audits to below the average for the Texas chemical industry by the end, a dramatic improvement. By any metric, the audit agreement was a success (fig. 26).

In 1994 Wilson decided she wanted to sign her own agreement with Formosa Plastics. From 1992 to 1994, she had continued to fight the wastewater discharge permit with the assistance of the Sierra Club. What she really wanted was suspension of discharge into Lavaca Bay, and there was no way that such a result could be achieved through either the EPA or the state agency, then called the Texas Natural Resource Conservation Commission (TNRCC; now the Texas Council on Environmental Quality). Although the EPA has zero discharge as a mandate in the Clean Water Act, the agency routinely ignores this requirement.

Wilson asked if I could help her negotiate a wastewater discharge agreement with Formosa, and in 1994 she signed the Wilson-Formosa Zero Discharge Agreement. Under this contract, a mediation process was established that included Wilson, Formosa, Davis Ford, the EPA, the TNRCC, and me. As a result of studies conducted and the mediation process, three waste streams were recycled, removing about 2.6 million gallons a day of discharge from entering Lavaca Bay. This represented about 32 percent of the total discharge, which had been as high as 7.9 million gallons per day.[2]

While this 32 percent reduction in effluent was quite remarkable, it was not zero discharge. One huge stumbling block to achieving zero discharge involved salt. Salt is the raw material from which chlorine is manufactured, and the brine

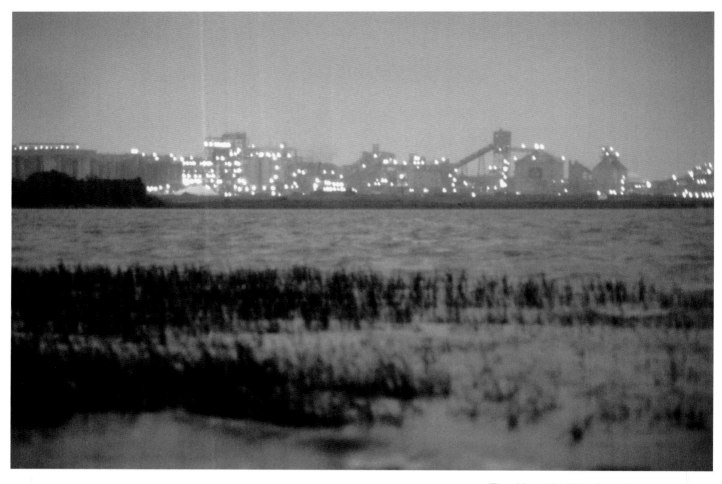

The Alcoa facility viewed across the Lavaca Bay Superfund site.
Photograph by Jim Blackburn

solution that results from the process becomes a wastewater stream. Under the wastewater scheme at Formosa, this brine stream was mixed with the other wastewater streams and was discharged into Lavaca Bay. The problem was that the brine stream is so salty as to kill most living things; it needs to be diluted with other wastewater prior to discharge into the bay. Therefore, only so much wastewater could be recycled before the brine stream became too concentrated for release into the bay. As such, the brine stream was the factor limiting the amount of recycling that could be achieved.

This problem could easily have been addressed when the plant was being constructed by returning the brine stream to the salt dome from which it was extracted, approximately twenty miles away. A line returning the salt to its mine site could have been built at that time for virtually no additional cost. Instead, the brine discharge became the problem that prevented zero discharge work.

I am still hopeful that Formosa can and will address this issue to achieve zero discharge. Formosa Plastics is one of the better performing industries today, and this was not always the case. They deserve credit for working with Wilson and me, and the individuals involved deserve particular credit. Without their persistence, this solution would not have been reached. Credit also goes to our third-party neutral Davis Ford, who worked us through some tight places.

Imagine what life along the Texas coast might be like if all the refineries and chemical plants executed agreements of this kind with citizens or citizen groups to evaluate performance and study the potential for zero discharge. Formosa has set an excellent example. Such agreements can and do work. There is no reason why a zero discharge study should not be required for every plant discharging into the waters of the Texas coast—if not for water quality improvements, then to help reduce the future water needs that will ultimately pose the greatest threat to our bays and estuaries.

Lavaca Bay has never been harmed by the discharge from Formosa, at least as far as can been determined from monitoring to date. Diane opposed Formosa's wastewater discharge because she did not trust industry—because Alcoa and its operation at Point Comfort had ruined a portion of Lavaca Bay. But the same cannot be said for Alcoa and its operations at Point Comfort. Alcoa legally discharged mercury into Lavaca Bay under a permit issued by the State of Texas during the 1960s and into the 1970s. During this time, Alcoa operated a chlor-alkali unit that used a mercury cathode. That process resulted in wastewater containing mercury being discharged to the bay.

Unlike much of the pollution on the Texas coast, this mercury contamination did not get flushed from the bay system. Instead, it settled into the sediments, day after day, year after year, increasing in concentration. Today, a portion of Lavaca Bay is a Superfund site.[3] Superfund sites are designated by the Environmental Protection Agency because they are highly toxic and place a substantial population at risk. These are the most dangerously contaminated sites in the United States, and Lavaca Bay is one of them. An area of the bay is closed to crabbing and fishing because the levels of mercury from tissue samples taken there exceeded Food and Drug Administration standards. Lavaca Bay belongs to all of us, but today a single user has appropriated a portion of the bay, and the rest of us are excluded for safety reasons.

Mercury is not a pollutant to be taken lightly. Mercury causes neural disorders. It is also extremely dangerous because it bioaccumulates up the food chain, meaning that small organisms such as worms and crabs collect this material and pass it up the food chain to those predators that feed upon them. In situations such as this, the food chain works to amplify the effects of the contamination. For example, one unit of pollution in one worm could mean ten units of pollution to the small fish that eats ten worms and a hundred units of pollution to the larger fish

■ Management Systems

□ Pollution Prevention

■ Industrial Hygiene

■ Water Quality

□ Air Quality

□ Solid and Hazardous Waste

■ Emergency and Spill Prevention

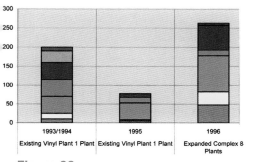

Figure 26.
Audit recommendations accepted by Formosa Plastics by category.

that eats ten smaller fish. And if a human eats ten fish, then the amplification is up to a thousand units. The amplification may not be that exact, but no doubt exists that people who eat a lot of fish from Lavaca or adjacent parts of Matagorda Bay consume more mercury than the rest of us, and the levels could be dangerous to human health.

To make matters worse, the scale of the contamination in Lavaca Bay extends far beyond the closed area, into the nursery portion of that bay and well down into the Matagorda Bay system, three-quarters of the way to Port O'Connor and almost to Palacios (fig. 27).[4] That is a lot of mercury contamination. Alcoa was dumping up to sixty-seven pounds of mercury into the water each day when this discharge was authorized by the State of Texas.

In the last decade, mercury levels for speckled trout, drum, flounder, redfish, and gafftop catfish in Lavaca Bay all measured higher than the 0.5 milligrams per kilogram level recommended by the U.S. Food and Drug Administration (fig. 28).[5] Concentrations of mercury in the redfish are extremely high, due to the large proportion of crabs in their diet. Crabs seem to bioaccumulate much more mercury than do other organisms. On the other hand, shrimp do not seem to bioaccumulate mercury at all, bearing testament to the fact that different biological systems have different responses to disruptions of their natural environment.

Today, Alcoa is trying to mitigate its contamination by building a containment system around the island where mercury-contaminated material was dumped in large quantities. Certain areas are being covered with a clay surface, encapsu-

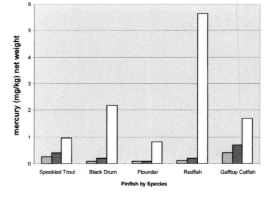

Figure 28.
Mercury contamination of fish: United States, Texas, and Lavaca Bay waters.

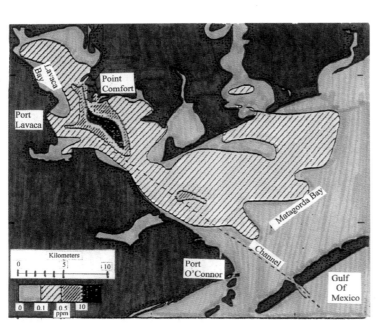

Figure 27.
Coverage of mercury contamination in Lavaca and Matagorda bays.

lated, and left in place. This solution was chosen because of the high risk associated with dredging up this material, and in the process releasing more mercury into the system, although cost also played a role in the decision.[6]

No one in Texas seems overly concerned that Alcoa rendered a portion of one of our bays toxic. I am amazed that there is not a general outcry over this solution and against this company, but there is not.

However, I have heard rumors that mercury contamination may lead to the closure of a portion of Matagorda Bay to recreational fishing. If that were to occur, perhaps the anger at Alcoa would increase. I am saddened that my state did not have the foresight to prevent the mess from occurring in the first place and that the permitting agencies did not do more to keep a portion of one of our nursery bays from being turned into a dumpsite for private industry. Yet this is what has happened.

I wish we could depend upon our state agencies to protect our bays, but it does not seem that we can. Throughout my career, I have spent more time fighting the state government than fighting the corporate and industrial interests that prefer to be able to dump wastes inexpensively, when and where it suits them. That is the reality of a system dominated by certain types of interests. Even when laws and regulations are sound, economic power gives those interests sway over the agencies charged with enforcement. The bottom line is that if we want the bays to be in sound condition, we must watch these agencies like a hawk watches for a mouse moving in the grass, and we must be prepared to strike as quickly. Every time.

Mercury contamination of fish in Lavaca Bay is a major issue. The black drum shown in the photograph is one of several species that accumulates mercury, primarily because it eats crabs and bottom organisms that move mercury up the food chain. The redfish (red drum) from Lavaca Bay show more mercury contamination than any other species.

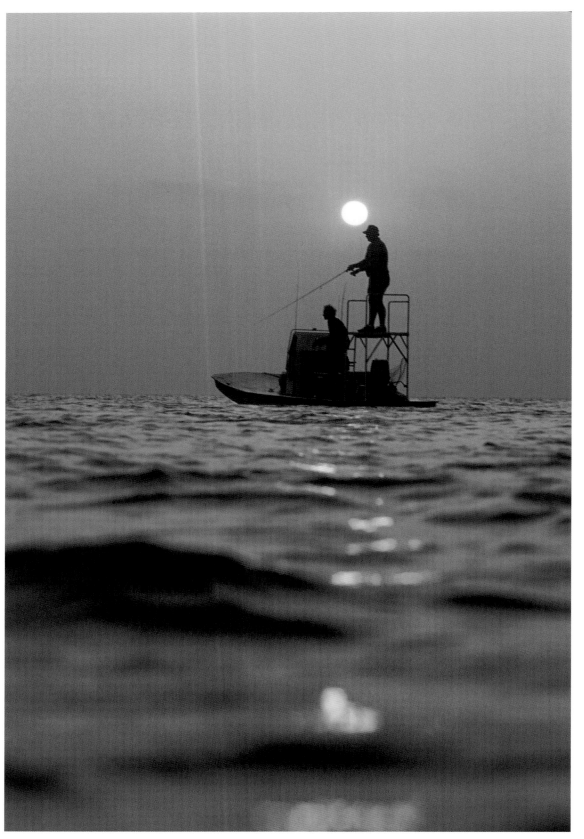

The fishing is excellent at Port O'Connor. The Gulf Coast Conservation Association (now Coastal Conservation Association) was the force behind the elimination of commercial fishing for redfish and speckled trout, but to date, recreational fishermen have not exercised the full extent of their political power for coastal pollution control and stewardship.

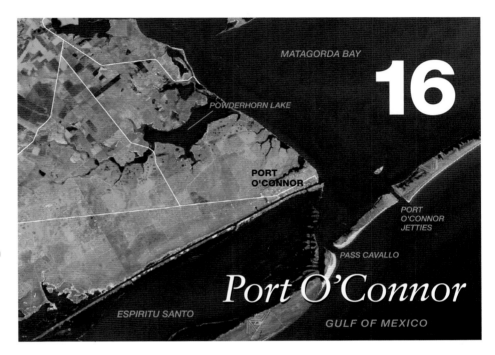

Port O'Connor is adjacent to the Intracoastal Waterway near Pass Cavallo and the constructed navigation channel through the Matagorda Peninsula. Espiritu Santo is the bay immediately south of Port O'Connor, separated from the Gulf by Matagorda Island and from Matagorda Bay by a series of small islands.

Early June: Port O'Connor was abuzz with noise and energy. Boats on trailers were lined up at the boat ramps, thirty or more strung out along the road before dawn, trucks and SUVs with their engines thrumming, waiting to deliver their two-hundred-horse-power tunnel-hulled flat-water fishing boats into the intracoastal canal, where Matagorda Bay meets Espiritu Santo.

This was a testosterone-charged morning. Three fishing tournaments were going on, and the contestants were chomping at the bit. Chunky men in shorts, long-sleeved shirts, and a world-class assortment of hats were moving around the vehicles. Drivers were under mounting pressure to deliver each boat into the launch as quickly as possible, with hoots and jeers greeting slow maneuvers or a botched attempt. In the background, the noise level shot up as another boat powered by two hundred horses charged off against the lightening sky, intent on icing a box of winners. The Port O'Connor ramps were no place for the shy or the sensitive. This was competition fishing time.

Team 11 was in the water, though we were not part of any of the three tournaments. Jack Schwaller had bought a guided fishing trip at a charity event, and he, Chapman, Fenoglio, and I were set for a day of wade fishing in the beautiful waters off Port O'Connor. We were all struck by the number of boats launching and the intensity of their drivers. We generally fish in our kayaks, away from boat launches, and we were amused and disconcerted by what we saw.

We call ourselves Team 11 because that was the number we were assigned in a fishing tournament several years ago. We kayakers took on the horsepower in a little tournament designed to raise money for a medical mission to Guatemala, called Faith in Practice. It was the only tournament in which I have participated, but we always enjoy having an annual date to go down the coast and fish together.

A few days earlier, my friend Henry Hamman and I had been talking about Port O'Connor; he had growled his unease about fishing tournaments. I did not appreciate what he was talking about until I laid eyes on the scene at the marina, and even then it took a while to sink in. We live in the era of the increasingly irrelevant male, but there was no ambiguity here—the biggest one would win.

Port O'Connor is sport fishing territory, the motherland of the Gulf Coast Conservation Association (GCCA). The GCCA was started by a group of recreational fishermen who got tired of catching nothing while commercial fishermen came in loaded down with redfish and speckled trout caught in gill nets and on trot lines. After an encounter between the two camps ended in dueling middle fingers, GCCA was formed to fight for recreational fishing on the Texas coast.

From the word go, GCCA meant business. The redfish wars fought in the late 1970s ended when the Texas Legislature passed House Bill 1000 in 1981.[1] The bill granted gamefish status to speckled trout and redfish, thereby protecting them from commercial fishing. Speckled trout and redfish caught in Texas waters could not be bought or sold and, except for farm-raised redfish, were essentially eliminated from restaurants. Overnight, the commercial finfishing industry was transformed, as were restaurants up and down the coast, which had to take trout and redfish off the menu.

With passage of the Redfish Bill, GCCA was an overnight success, a hero to the growing sport fishing industry and its practitioners. The icon of this success was the coppery gold redfish bumper sticker with GCCA boldly splashed across it, displayed on cars and trucks up and down the coast and as far inland as San Antonio, Austin, and Dallas. More than forty GCCA chapters sprang up along the coast and elsewhere in Texas and then in Alabama, Mississippi, Florida, and Louisiana. When chapters started forming on the Atlantic Coast, GCCA changed its name to the Coastal Conservation Association (CCA).

In addition to eliminating commercial finfishing for trout and redfish, the organization has focused on hatcheries for these species. To date, CCA Texas has produced billions of eggs and released over a quarter billion fingerlings into our coastal waters and is trying to perfect the technology for hatchery reproduction of trout.[2] It currently partners with Central Power and Light on a hatchery at Flour Bluff near Corpus Christi and another with Dow Chemical in Lake Jackson. Annual stocking from the Marine Development Center (CCA and the power company) and Sea Center Texas (CCA, Dow, and the Texas Parks and Wildlife Department) is estimated at 50 million redfish fingerlings.[3] The CCA philosophy is

clearly that more is better when it comes to redfish, even though some ecologists worry that single-species management on coastal bays could create ecological problems and may already be skewing the balance in predator-prey relationships.

But ecology recedes when there is fun to be had. The CCA is the sponsor of the State of Texas Angler's Rodeo or STAR Tournament, a huge event that is a dominant presence throughout the summer on the Texas coast. The coast is divided into three sections—upper, middle, and lower—with four types of fish in the onshore division: speckled trout, flounder, gafftop catfish, and sheepshead. Regional winners receive a boat, motor, and trailer, while runners-up receive gift certificates. There are also cash awards for catching specially tagged and released redfish. In all, almost a million dollars go out in prizes and scholarships in the various divisions and regions.[4]

The STAR Tournament is largely a membership recruitment device. In order to participate in the tournament, you must be a member of CCA. If you catch a huge trout and are not a participant, you cannot enter the trout. If you catch a tagged redfish and are not a member, you cannot collect the prize money. Anyone tempted to pass a prize-winning fish to a buddy who is a member should be warned: all winners may be required to take a polygraph test. In order to win, you must swear that you caught the fish in accordance with the rules.

Today CCA Texas claims over forty thousand members, quite an increase over the fourteen fishermen who started GCCA in Port O'Connor back in 1977.[5] The STAR Tournament scoreboard can be seen in every coastal community, with

The flounder is a prized game fish on the Texas coast.

chalkboards reflecting changes in the leaders and runners-up as the summer progresses, a constant reminder that if you join CCA, you too could be a winner.

CCA has tremendous potential to do good on the Texas coast, to encourage masses of recreational fishermen toward an ethic of stewardship for the whole coast and coastal resources. I know many of the leaders of CCA, and as individuals they subscribe to a stewardship ethic. However, the organizations as a whole has not yet articulated a coastal conservation ethic that extends to protection of diverse aspects of our bays. In the past, CCA has tended to shy away from legal confrontations with polluters, destroyers of wetlands, and bay usurpers, choosing instead to work within the Texas Legislature and the existing power structure.

The time is coming, however, when CCA Texas will be up against some difficult decisions about fighting for the health of the bays. No issue is more important or more difficult than ensuring freshwater inflows to our estuaries. If freshwater inflows stop, bay productivity will be lost, and the bays will be forever changed for the worse. No matter how many redfish fingerlings are stocked, few will survive to be caught if they have nothing to eat. CCA Texas has stated its intent to protect inflows, an important first step, but only the first step.

Ultimately, protecting the bays means protecting the phytoplankton. This is not glamorous, but it is exceedingly important. The stewardship concept of heroic men protecting microscopic plant life lacks a certain something in emotive force, unfortunately, but ecology is like that. But the phytoplankton is what feeds the microscopic animals that feed the tiny shrimp and crabs as they float from the Gulf to the nursery bays, eventually becoming food for the redfish fry. George Ward describes our estuaries as salad bars, and we need to keep the salad bars stocked. The reds feed and grow in the nursery bays, eating the small fare first before moving back out to the Gulf waters when they are ready to spawn, usually at about four years old. Redfish spawn near the mouths of passes, so that when their hundreds of thousands of eggs hatch a few days later, the tide will carry the young toward the sheltering shallows of the wetlands and the salad bar.[6]

As I watched the boats launching in the dawn at Port O'Connor, more than half of the trucks in line sported the CCA redfish sticker. I caught myself dreaming that CCA would recast itself on the side of the phytopklankton and adopt "green" tactics, like fighting permit applications through state and federal administrative agencies and the courts, in an effort to prevent projects that damage the wetlands and the microscopic plants and animals. These are battles that must be fought, and they have to date been fought on the upper and midcoast by the commercial fishermen whom CCA would like to limit as well as by environmental groups. If the commercial fishermen are forced out, someone must take up the slack.

The CCA leadership has publicly stated that ensuring freshwater inflows is their most important conservation issue on the coast and that they are poised to make freshwater inflows their number one conservation issue in the twenty-first

century. If this organization embraces and fights for this issue, we can look forward to a much greater chance of success than would otherwise be the case. With that one decision, CCA Texas could make a huge difference to the future of the Texas coast. Yet the fight in the 2003 legislative session was less than a smashing success.

Cooperation among groups will be the most important aspect of the various water fights ahead of us, and cooperation is difficult. The various groups on the coast need to coordinate actions and reach consensus regarding settlements and deal making. Often, one group decides to make a deal and leaves the others behind. I have been involved in situations like that in the past; I have made mistakes like that. I know now that a lone wolf attitude often works against the long-term interest of the resource. To make our strongest showing to protect the coast in coming decades, we need to be working together. We will fare better as a pack.

Team 11's Port O'Connor trip was already a great success. We had left Houston on Friday morning intent on fishing Powderhorn Lake in our kayaks. None of us had fished Powderhorn before, and it's always a great adventure to fish water for the first time without a guide. Guides are great now and then, but there is something satisfying about figuring out the water, the habitat, the fishin' places on your own. To the extent that I can now do this, I thank Al Garrison.

I had picked up a map of the Matagorda Bay system and located a potential put-in at the old town of Indianola on the north shoreline, but we had no idea what it looked like on the ground. The difference between a map and reality can be substantial. Indianola is a collection of fishing camps and a couple of stores. Initially, it was an unfriendly place. As we came to the water's edge, we encountered "Private Property" and "No Trespassing" signs. We asked an old man sitting on his porch if there was a place we could launch our kayaks; he shook his head in the negative and jerked his thumb up and back, clearly indicating where he wanted us to go. We followed his suggestion and headed back up the road, which led us to an RV park. We paid five dollars to launch, park, and later use their fish-cleaning table. Sometimes you just go where the thumb sends you.

Powderhorn Lake is a beautiful secondary bay between Port Lavaca and Port O'Connor, connected to Matagorda Bay via a series of cuts and marshes. Schwaller, Fenoglio, and I launched together but took off in three directions, checking out the shorelines and reefs in search of redfish. John was in charge of communications—we had walkie-talkies so that we could keep one another posted about where we were and how we were doing. He could not ensure that we would use them correctly, but they were in hand.

I chose to go into a tertiary bay fed by a bayou. I paddled to the back of the small bay and was immediately treated to the sight of hundreds of bait fish scurrying along the edge of the marsh. A white ibis with an immense orange-red curved bill made eye contact with me, checking to see if I warranted concern. After a moment, it decided that I was safe and proceeded to ram its bill back into the soft marsh

mud. Every now and then, an egret would startle or a tricolored heron would take flight, settling down again fifty yards ahead. As I moved down the shoreline, I was herding herons ahead of me, a fine thing to be doing on a Friday afternoon.

I found the redfish under the bait fish, just as they were supposed to be. The tide is the drumbeat that sets the rhythm of a bay; it was moving fine, and the fish moved with the tide. When the tide is slack, fishing is like dancing without music and without a partner—you are working it alone.

Once I had my reds, I set out looking for John and Jack, my communications with the others sporadic and unintelligible, mainly because I was pushing the wrong button. I heard John say he was on the south shoreline and had one red. I heard not a peep from Jack. Paddling the half mile across the absolutely calm lake, I marveled at its beauty. Seldom do you see absolute calm on the coast, and I stopped my kayak to gaze at the south shoreline and the ranch beyond the shore.

From the middle of the lake it was apparent that we were in South Texas. The brush and grasslands are different than at the northern end of Matagorda Bay. There is a change in the land, a change in the vegetation. I usually see a caracara in the South Texas brush, the wonderful white-tipped predatory and carrion-eating bird that is special to me. When I see one, I feel protected. I think of it as my totem bird, a good luck symbol, a kind of guardian.

Suddenly, I saw motion out of the corner of my eye and heard a funny coughing sound, like a hose clearing air pockets. I turned to see a bottlenose dolphin rolling across the smooth surface, its skin shining in the afternoon sun. A dolphin is slippery and smooth and death to fishing. Any fish with any sense would be moving as far away from the dolphin as possible, as did I, one interested in fishing.

I finally caught up with Jack near the put-in and reached John on the radio. We would be cleaning six reds and a trout, a good afternoon's fishing. As we drove into Port O'Connor that Friday evening, we sensed the excitement in the air as trailered boat after trailered boat rolled across Calhoun County to the end of the road.

Jack's charity purchase included a place to stay, and whereas the good guest prefers not to be critical, we were a bit grumpy after finding beds with no sheets and baths with no towels. Jack's under-his-breath "oops" did not give us much satisfaction. Chapman had joined us in Port O'Connor, and the four of us took off in search of motel rooms—which of course were all already rented. Luckily, we thought to ask if one motel would rent us sheets and towels. "Why sure, honey," came the drawled response. "For fifty bucks and a hundred-dollar deposit, we'll fix you right up."

Back at our inn, it was time to eat. Posted on the wall was a message meant for us: "If you want your fish cooked, the best is Josie's Mexican restaurant." We looked at each other as one. We had fish—Josie's was the place for us. Team 11 entered Josie's like kings, sheets and towels behind us, bearing our fillets in an ice chest, ready to be treated to the best fish dinner we had ever eaten. Although it is

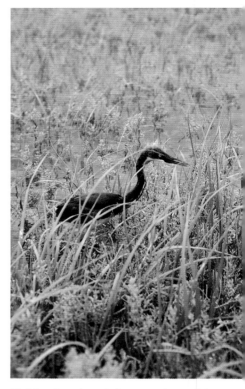

Fishing in a kayak is great fun, with egrets and herons such as this tricolored walking in the marsh in front of you.

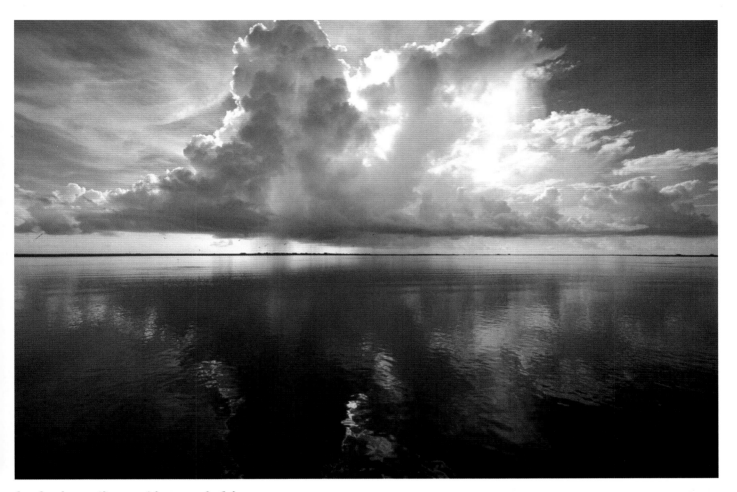

A calm day on the coast is a wonderful time to be in a kayak.

illegal for restaurants to sell coastal trout and redfish, it is legal for them to sell the service of cooking your fish. Make no mistake about it, the broiled redfish smothered in onions, tomatoes, and jalapeños was delicious.

The next morning, we and all those boats set off in search of trout and reds. We would be wade fishing the clear waters between the Calhoun County mainland and Matagorda Island. At every stop, a seemingly endless parade of horsepower revved past us, disrupting the tranquility and, it seemed, the fish. They were scarce on Saturday. We saw a lot of pretty water, complete with submerged seagrass, but we returned to the dock with a meager haul of fish.

The bustle at the dock was the reverse of the morning's proceedings, with everyone moving a bit more slowly. Again large numbers of boats and trailers converged as the boats lined up for mounting onto the trailers and hauling out of the water—one after another after another. Weigh-in for the tournament was not until later, and many anglers were still out on the water, trying for that last fish to push them over the top.

Again I was struck by what could be accomplished if the legions of recreational fishermen on the coast would stand up for the bays—would put their horsepower to work for the lowly phytoplankton and bay ecology as well as for

the redfish and the trout. When this untapped human resource redirects energy to that end, all will be possible. The "all" that I wish for is to pass the rich heritage of the bays down to future generations. We see it as our birthright, but it will not be the birthright of those who come after us unless we push hard for it.

Much has been achieved by activists to date, but there remains much to be done. We need freshwater inflows to the bays. We need to make sure the Corps of Engineers does the right thing on permitting and dredge disposal. Coastal industries must be watched every single day, lest all our bays become Lavaca Bays. As commercial fishing interests are edged out of the bays, we lose the kind of coastal citizens who have been willing to stand up and be counted when it came to fighting Houston Lighting and Power, DuPont, Formosa, and the Corps of Engineers. If we lose these voices, will others emerge in their place?

I believe that recreational fishermen wanting to take over the bays have a responsibility to take up the mantle of stewardship too. We need sporting interests to demonstrate a commitment to protecting the bays, and we are not there yet. There have been abuses in the past by commercial fishing interests, but what about the recreational fishermen who have inherited the spoils of the redfish wars? It is easy for victors to forget why they fought, what principles they were fighting for, and what they hoped to achieve.

Suvs and trucks with empty trailers still lined the main road into town from the boat ramp when we pulled out of Port O'Connor. As the town receded and we drove north across the ranchland south of Powderhorn Lake, a caracara flew across the road in front of our vehicle, white head, white wingtips, white tail, and dark body distinct in the late afternoon sun. I knew my trip home would be a safe one.

A crested caracara rises from a mesquite tree in South Texas.

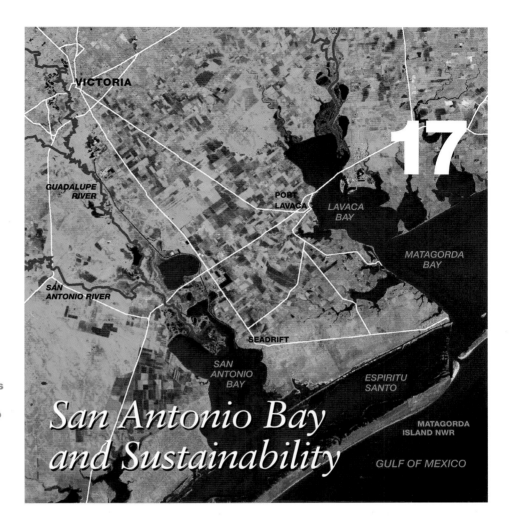

The Guadalupe and San Antonio rivers join together to form the Guadalupe delta and provide freshwater inflow to the San Antonio Bay system. Matagorda Island separates San Antonio Bay from the Gulf of Mexico. To the southwest of San Antonio Bay are the Blackjack Peninsula and Aransas National Wildlife Refuge.

San Antonio Bay and Sustainability

You could feel the tension in the large conference room at One O'Connor Plaza in Victoria. The owners of the D. M. O'Connor Ranches had called a meeting to discuss the diversion of water from the Guadalupe River to the city of San Antonio. The Guadalupe–Blanco River Authority (GBRA), San Antonio River Authority (SARA), and San Antonio Water System (SAWS) had jointly applied to divert water from the Guadalupe River south of Victoria and to transport it to San Antonio via pipeline. Along the way, they were going to purchase groundwater from willing sellers.

The D. M. O'Connor Ranches cover substantial acreage in Goliad, Victoria, and Refugio counties. These ranchers consider themselves stewards of their land and their region, and they were concerned about what the water diversion implied for their ranching operations, for the economic future of Victoria, and for San Antonio Bay. I was working with Mark Rose, a water expert who had previously headed the Lower Colorado River Authority, and Bill Jones, the Victoria-based representative of the O'Connors.

Mark was the key speaker at the meeting and spoke from his years of experience leading a river authority. One of the selling points pushed by GBRA, SARA, and SAWS in public presentations was their promise to send the water back to the Guadalupe basin after it had been used for several decades by San Antonio. On this point, Mark was adamant: there was no way that the water was ever coming back to Victoria. Once residential users were dependent on a water supply, the water would not be taken from them.

The purpose of the meeting was to announce that the D. M. O'Connor Ranches were opposing this diversion to the City of San Antonio. By applying to divert water, GBRA, SARA, and SAWS had fired the first shot in the twenty-first century water war, and the battle was now joined. Understanding this fight requires an understanding of San Antonio's water situation. San Antonio is a town that grew very large on cheap underground water. It was wonderful water—clear and tasty and available where it was needed. Put in a well, and the water was there for your use. But if you put in another, and another, and another, you would reach a limit, and San Antonio did so.

The initial culprit in this story is Texas water law. Texas groundwater law is still controlled by a 1904 Texas Supreme Court decision that described the analysis of groundwater as involving the occult. The case brings forth images of water witches and seances rather than electric logs that describe subsurface sands and clays based on electrical resistance and computer models that are used today to evaluate groundwater quantity. As a result of the 1904 decision and later cases that failed to overrule the English rule of capture and fear of the occult, we in Texas are faced with a situation whereby the groundwater in a particular area can be overpumped, and substantial damage results.

One can find no better example of what economist Herman Daly calls "empty world" thinking.[1] To paraphrase Daly's writings on sustainable development, most of our policies, laws, ethics, and institutions are based upon thinking that evolved when the world was relatively empty of humans and human impacts. Daly believes that sustainable development requires "full world" thinking—a perspective taking into account human impacts and our ability to transform our ecological system. For if we destroy the natural system, there is nothing sustainable about our society.

Empty world thinking related to groundwater extends to surface water as well. In its laws Texas does not recognize the connection between surface water and groundwater. For example, the Edwards Aquifer used by San Antonio feeds the springs at San Marcos and New Braunfels with groundwater, providing a base flow in the Guadalupe River, among others. If the Edwards is overdrafted by groundwater consumption, then the springs will dry up, and the base flow of the river will be diminished if not removed. Rather than address the relationship between groundwater and surface water directly, the Texas courts have failed to

The delta where the Guadalupe River flows into San Antonio Bay. Due to proposed diversions to San Antonio to provide water for future growth, the future of the Guadalupe River is uncertain. In 2002, the Guadalupe River was voted one of the most endangered rivers in the United States by the American Rivers Association.

act, eventually forcing the federal courts to address the Edwards Aquifer overpumping issue under the Endangered Species Act due to the presence of unique species in these springs.

We in Texas have a situation in our rivers where the base flows—the flows that are dependable year in and year out—are already allocated to water users. That is certainly true of the Guadalupe River, which was identified in 2002 by the nonprofit group American Rivers as one of the most endangered rivers in the United States. There is simply no water left in the Guadalupe that is 100 percent dependable in dry years as well as wet. Now that the City of San Antonio is being forced off groundwater because of endangered species, people are looking across Texas for more water. Projections indicate that the San Antonio area needs an additional 200,000 acre-feet per year to accommodate growth projected to the year 2050.[2]

San Antonio has generated a liquid gold rush in Texas. T. Boone Pickens spoke at the 2003 Texas Water Law Conference about his plan to deliver groundwater to San Antonio from North Texas. Lawyers are studying groundwater law as they rush to find clients who want to sell groundwater rights to San Antonio. The Alcoa facility in Rockdale wants to sell groundwater to San Antonio. And the Lower Colorado River Authority and Guadalupe–Blanco River Authority both want to deliver surface water and groundwater via pipeline to San Antonio. These entities are competing to determine which can deliver the most water to San Antonio at the cheapest price. And Corpus Christi, Dallas, Fort Worth, and Houston are watching closely.

Price is the key issue in this liquid gold rush. Economists who study sustainability often refer to "full cost pricing." The Business Council on Sustainable Development in its seminal publication *Changing Course* emphasized the need to "get the price right."[3] There is much discussion about full cost pricing but little action. If there ever was a need for full cost pricing, it is in these San Antonio water supply alternatives.

The proposal of the Guadalupe–Blanco River Authority, San Antonio River Authority, and San Antonio Water System to send water to San Antonio will be the first challenge for Texas in water diversion permitting and sustainability. The flow that these bodies have applied to take from the Guadalupe River is large. Water will be scalped from flood flows and stored in off-channel reservoirs. As noted, GBRA, SARA, and SAWS are also in the market for groundwater and are searching the counties adjacent to Victoria for these rights.

Under their proposal, the cost of water delivered to San Antonio would be in the range of $800 per acre-foot for water rights and construction of the pipeline. However, these costs do not represent the full costs of the transaction. The Guadalupe River flows into San Antonio Bay. If surface water is diverted from the Guadalupe, San Antonio Bay will be harmed. The cost of harm to San Antonio Bay is not included in the currently projected cost of this water, and that is a major sustainability issue.

According to computer models developed by the Texas Water Development Board and the Texas Parks and Wildlife Department, the optimum inflow for marine productivity for San Antonio Bay is 1.15 million acre-feet of freshwater inflow per year.[4] Today, there is insufficient flow to nourish the bay during drought conditions, but the bay can withstand droughts as long as there are also periods of abundance. If, however, we remove the floodwaters, we will tap the lifeblood of the bays and estuaries.

At the time of writing, virtually no water is dedicated to the preservation of San Antonio Bay. All of the base flow of the Guadalupe is allocated, and the application filed by SARA, SAWS, and GBRA seeks to take an additional 289,000 acre-feet of water from this estuary.[5] Essentially, this application will divert about 25

percent of the 1.15 million acre-feet necessary to maintain the productivity of the San Antonio Bay system. According to the state agencies' computer models, a reduction of 289,000 acre-feet off optimum inflow levels results in a 40 percent reduction in productivity.[6] Imagine that—a 40 percent reduction of redfish, speckled trout, shrimp, oysters, the living things that many of us value about San Antonio Bay.

What is the value of a 40 percent reduction in the productivity of San Antonio Bay? How much is that worth? As already set out in figure 17, Robert Costanza and colleagues established the value of the ecosystem services provided by an estuary at $11,000 per acre per year. San Antonio Bay is approximately 130,000 acres in size, making it worth almost $1.4 billion per year in ecosystem services. A 40 percent reduction in value would therefore be worth about $560 million per year in damage. That annual cost totally overwhelms the cost of constructing and operating a pipeline to deliver water to San Antonio.

There are those who doubt Costanza's approach. Critics claim he is practicing voodoo economics—that these ecosystem services are not real economic costs, that no money is changing hands. In this regard, it is instructive to recall that the Texas Supreme Court labeled groundwater analysis as involving the occult in 1904, a concept that is laughable today. Perhaps Costanza's analysis will have a similar fate. And there are other ways to assess the costs of the proposed water diversion.

San Antonio Bay can claim credit for producing about 13 percent of the Texas shrimp harvest, amounting to approximately $30 million per year. It produces 17 percent of the Texas oyster harvest, worth $2 million dockside and $17 million per year on the halfshell. San Antonio Bay produces 20 percent of the crabs commercially caught on the Texas coast, worth about $1 million per year. The bay also sees half a million man-hours of recreational fishing pressure per year, and each of those hours of fishing pleasure has value.[7]

Texas Parks and Wildlife has estimated the hard dollar value of San Antonio Bay at $55 million per year. If this current value were reduced by 40 percent, the region would lose $22 million per year. That amounts to a cost of $3,800 per acre-foot over the fifty-year life of the project. Thus in a full cost scenario, San Antonio—the water user—would pay the $800 per acre-foot for the water and the pipeline and would also pay at least $3,800 per acre-foot for damage to the economy that would be reflected in job loss and lower retail sales in and around Calhoun, Victoria, and Refugio counties, leading to a total cost of $4,600 per acre-foot. Staggering as this cost seems, calculations using the Costanza values would be far higher. Yet Texas Parks and Wildlife is hardly a practitioner of voodoo economics; the projected 40 percent reduction in productivity of San Antonio Bay would mean dramatic losses even under traditional market economics. The point is: whatever way you look at it, water diversion carries enormous costs.

Essentially, this diversion of Guadalupe River water would shut down the coastal economy in Calhoun County and would substantially impact the larger

metropolitan economy of the Victoria area. Perhaps more important, there is currently an abundance of water in the Victoria area, a geographic competitive advantage in a water-short state. Over the next few decades, that competitive advantage will be significant, but it stands to be lost with the transfer.

I knew I was in the middle of the Texas coastal water war after a speech I gave to the Victoria Rotary Club in 2003. I followed to the podium a high school awardee who had spoken of the role God played in her life. I was speaking on behalf of the D. M. O'Connor Ranches, and I laid out my analysis of how Victoria was getting the short end of a deal with the devil. I questioned the idea that this diversion was in the best interests of the Victoria area, and I questioned people's willingness to sacrifice the quality-of-life resource of San Antonio Bay.

Bill Jones, the representative of the D. M. O'Connor Ranches, approached a local elected official on the street in Victoria later that day. Rather than the friendly smile he usually received, Bill found himself facing an angry demeanor and a finger pointed at his nose. "You tell that Houston lawyer of yours," the official blurted, "that I am going to slap the slobber out of him the next time I see him." Bill quickly called me to report that we had certainly raised some feathers with our analysis and our criticism of the local community for its failure to recognize the peril of the proposed transfer.

In fact, we had intended to ruffle some feathers. We were confident that if the cost analysis were redone to include environmental costs, other water supply alternatives would move to the top of the list. For a broader view of the issue to emerge, someone had to challenge the empty world thinking that was failing to consider the environmental cost of the diversion.

Sunset at Seadrift. If proposed reductions in freshwater inflow were to occur, the productivity of San Antonio Bay could decline substantially, perhaps as much as 40 percent under certain scenarios. A 40 percent reduction in bay productivity would reduce yields of oysters, shrimp, and crabs and would represent a loss of some $22 million per year to the economy of towns such as Seadrift that rely on San Antonio Bay productivity for their livelihood.

Take desalinization, for instance. Desalinization has not been chosen as an alternative because it is allegedly too expensive. It costs $700 per acre-foot to desalinate water at a project in Tampa, Florida. This cost would be in addition to the cost projected to build a pipeline, leading to a total cost of $1,500 per acre-foot for the water. Even $1,500 per acre-foot is much less than the $4,600 per acre-foot for Guadalupe River water priced to include the cost of damage to San Antonio Bay. Using this methodology and these metrics, desalinization is viable, even at a higher cost. However, if the price of diverted water is not set appropriately, we will never see this options. We will simply kill our bays. What we need in Texas is a dialogue, not a gold rush.

An arguably easier approach to protecting estuaries would be to have the bays be part of the water rights permitting process. In this manner, inflow needs would be addressed institutionally. Issuing a water rights permit to a bay seems like heresy to some, but applications recently have been filed by several environmental organizations to secure water rights and riverine inflows for three bays.

The San Marcos River Foundation (SMRF, inevitably pronounced "smurf") has applied for such a permit for San Antonio Bay in the amount that the state agencies have identified as being necessary for maximum fishery production. A beneficial use can be permitted under Texas law, and bay and estuarine inflow is listed in the Texas water rules as a beneficial use. If permitted, this water would be put in the Texas water trust for future generations. This water rights application is both a legal and reasonable approach—but remember, we are in Texas.

In the spring of 2003, the lieutenant governor of Texas wrote to the Texas Commission on Environmental Quality asking that the hearing on SMRF's San Antonio Bay water rights application be delayed to give the legislature time to clarify Texas law. The lieutenant governor's press release said he did not believe the legislature had contemplated bay and estuarine inflows as beneficial uses. He said he feared that such permits could interfere with the state's water planning for urban, industrial and agricultural uses. In other words, water for the bays was not one of the lieutenant governor's priorities.

The hearing room at the Texas Commission on Environmental Quality was packed for the decision on whether the SMRF application should proceed to a hearing or be rejected. Diane Wassenich, the bright and energetic leader of the foundation, had rallied a large assortment of water rights advocates to come before the commission. Her able lawyers, Stuart Henry and Ilan Levin of Austin, had charted this innovative legal pathway to save water for flow in the rivers and into the bays. Although the relevant statute did not identify instream flows and freshwater inflows for bays and estuaries as beneficial uses, the rules of the TCEQ did. The question was: would the TCEQ have the fortitude to enforce their own rules in light of substantial political opposition to the issuance of a permit to protect instream flows and bay and estuarine inflow?

The opponents to the SMRF permit application were led by the Texas Water Conservation Association, an interesting name for a group aiming chiefly to provide water for the growth and development of cities. Some of the biggest names in the Texas lobby were against the SMRF application. Their strategy had been to attempt to marginalize the San Marcos River Foundation as a group of river rats, portraying Diane and her allies as radicals only trying to protect tubing in the San Marcos River. This assertion was not true, but it was widely circulated. The D. M. O'Connor Ranches had held a press conference where they and the Coastal Conservation Association both endorsed the SMRF application. These two organizations were clearly not radical, yet the rumor persisted that this application was a radical act.

The action before the TCEQ was anticlimatic. Stuart Henry, the lawyer for SMRF, is a great orator, but he was not allowed to speak. Neither were citizens allowed to speak. Chairman Robert Huston of the TCEQ essentially offered his viewpoint that the legislature had not clearly given the TCEQ the authority to go forward with this permit application. The other two commissioners concurred, and the application was denied by a 3-0 vote. In this manner, the innovative concept was cast aside, and the issue was tossed back to the legislature.

In April of 2003, freshwater inflow for the bays and estuaries was before the Texas legislature, a body that meets every other year for six months. Several bills were filed involving the interbasin transfer of water and setting water aside for the bays and estuaries. Dallas and Houston are concerned about these issues, not out of sympathy for San Antonio but because they are worried about their own long-term ability to divert water.

One bill that was filed concerned the interbasin transfer permit that was required under Texas law to divert water from one river basin to another. That provision had been added in a prior legislative session as a result of concern by residents of the Sabine River basin over their lack of ability to protest the impact of a diversion. At the start of the 78th legislative session, SARA, GBRA, and SAWS wanted a bill passed that would combine the Guadalupe River basin and the San Antonio River basin into a single basin under Texas law. That bill would have allowed Guadalupe River water to be sent to San Antonio without any opportunity for a protest to be lodged by opponents concerned about the impact of the diversion on San Antonio Bay. Fortunately, SARA, GBRA, and SAWS decided that such a consolidation was not their favored course.

After that river basin consolidation issue, the major issue remaining for the legislature to address was whether water rights could be set aside for the bays and estuaries, as proposed in the San Marcos River Foundation application. The SMRF application had struck a major nerve in the water hustlers, who never imagined that water rights could be set aside as beneficial uses for instream flow and bay and estuarine inflow. And as in many situations when nerves are struck, a reaction occurred.

Juvenile speckled trout. Freshwater inflow is essential to keep the estuary functioning so that it can provide the nursery function necessary in the life cycle of many saltwater fish species. These juveniles can escape predators in the fresher, upper portions of the estuary as well as among the marsh grass.

At the legislature, SMRF attempted to preserve the concept of an application for water rights for bays and estuaries. Diane reached out to varied groups—the Coastal Conservation Association, Sierra Club, D. M. O'Connor Ranches, and National Wildlife Federation; the Caddo Lake Institute and its leader, rock singer Don Henley; the Matagorda Bay Foundation, Galveston Bay Foundation, Galveston Bay Conservation and Preservation Association, and others—to establish that preservation of the flow in our rivers and the inflow to our bays is one of the most important issues we have before us.

In the end, the Texas Legislature passed a so-called compromise bill. A study group was formed under Senator Ken Armbrister's Senate Bill 1724, requiring that the issue of freshwater inflows be studied over eighteen months and that the question of water rights for the bays and estuaries be considered in the next legislative session. S.B. 1724 stopped water rights applications for the bays and estuaries, but it did not halt permit applications seeking to obtain large amounts of water rights for cities and urbanizing areas. Thus, while applications like SMRF's have been set aside, S.B. 1724 has not stopped the SARA-SAWS-GBRA application.

The 2003 legislative session was not successful in protecting our bays. At the end of that session, no process existed to set water aside for our bays and estuaries. We had tried to get equality with diverters and had failed. It is humbling to observe power being wielded at the Texas Legislature and before agencies such as the Texas Commission on Environmental Quality. The antidote to this raw power is an ethic of stewardship and a willingness on the part of the citizens of the coast and of Texas who care about the future of the coast to stand up and fight for this valuable resource—and by *fight,* I mean fight as hard as the other side does.

It is not a radical concept to protect the bays and estuaries of the Texas coast. It is not a radical concept to ensure that we do not destroy San Antonio

The key to the protection of San Antonio Bay and other estuaries is the guarantee of freshwater inflow. The Texas Commission on Environmental Quality denied applications by environmental groups such as the San Marcos River Foundation, the Matagorda Bay Foundation, the Galveston Bay Conservation and Preservation Association, and the Galveston Bay Foundation to dedicate unallocated river water to the bays. A study committee was instead assigned to look into this issue and report findings to the legislature prior to the 2005 legislative session.

Bay and other bays rather than fueling growth with unreasonably cheap water. In fact, it seems that the truly radical concept is to encourage growth by promising water that is unreasonably cheap, leaving the costs to be borne by future generations. We know these things, yet we are not wise enough or principled enough to make the hard choices and ensure that we do not destroy our coastal ecological system in our zeal for growth and development.

In *A Sand County Almanac,* Aldo Leopold explored the ethical issues of the relationship between humans and nature. In "The Green Lagoons," he writes about the delta of the Colorado River near Baja California in the early 1920s, about how a mud flat was covered by little wild melons, about how the wildlife was so abundant and wonderful. He notes that he was told that the green lagoons had been converted to raising cantaloupes by the late 1940s, that the abundance was declining. He then laments that humans kill the things that they love and that some say we had to.[8]

Will the green lagoons of the Guadalupe delta suffer the same fate as the green lagoons that no longer exist where the Colorado River runs into the Gulf of California, as described by Aldo Leopold in *A Sand County Almanac*? Can we not learn from the mistakes made in other places?

Leopold clearly thought that we were not predestined to destroy what we love, that we can save that which is important if we can develop an ethic of protection. Leopold called this the land ethic, but what he was referring to was an ethic of stewardship of the natural system, an ethic requiring that the full costs of a transaction or of an alternative be developed and articulated, an ethic requiring that a transaction or alternative be rejected if it does not take into account all of the damage it does.

We Texans are not paying the full costs of our actions. The time has come to admit it and adopt a different way of doing things. As hard as it may be, we must move away from empty world thinking and embrace full world thinking. Part of full world thinking is full cost pricing. But more important, part of full world thinking is the development of an ethical construct ensuring that we do not destroy those things we love, those natural places that cannot be replicated, those places that are home to other living things. It is this ethic that is the antidote to greed. And along the way, we just might have to be willing to get the slobber slapped out of us.

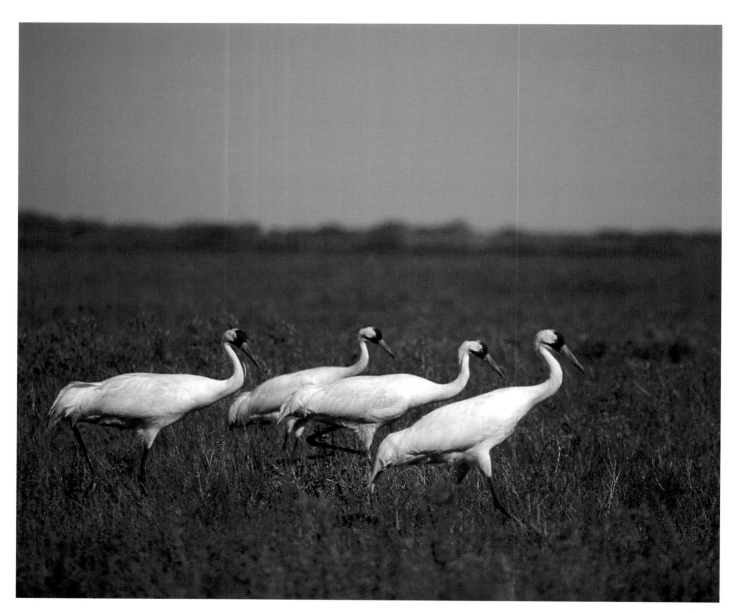

The whooping cranes are the show–stoppers at Rockport. The population of whoopers has slowly but surely grown as habitat preservation increased and hunting pressure decreased.

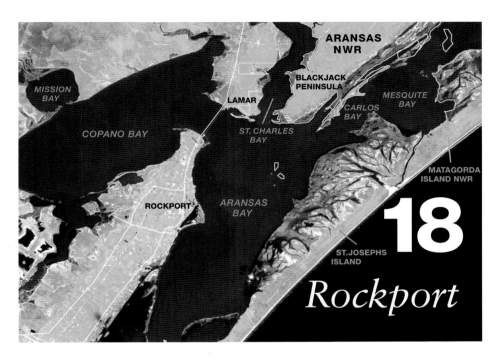

State Highway 35 connects the Lamar Peninsula with Rockport at the point where Copano Bay meets Aransas Bay. St. Josephs Island exhibits a large washover fan from storm connections with the Gulf of Mexico. Cedar Bayou, a pass that is sometimes open, separates St. Josephs Island in the south from Matagorda Island at upper right. The preserved areas include Goose Island State Park on the Lamar Peninsula, Aransas National Wildlife Refuge on the Blackjack Peninsula, and the Matagorda Island National Wildlife Refuge.

Rockport

Aransas and Copano bays are blue-green jewels set in the bend of the Texas coast, where the coastline completes its transition to a north-south alignment. This is where the bays become much clearer, where seagrasses begin to be found in quantity, where the redhead ducks winter.

The town of Rockport is on a peninsula, touching Aransas Bay on the east and Copano Bay on the west, with Goose Island, the Lamar Peninsula, and Aransas National Wildlife Refuge to the north. To me, Rockport means whooping cranes and crabs. One of my first experiences in Rockport was staying with Garland in a historic house at the center of Rockport belonging to the family of our friends, Carol and Tree Craig. Tree woke me up early one morning and said we were going crabbing. The only crabbing I had ever done was putting a piece of meat in a net and waiting for a crab to come. Tree assured me that was not what he had in mind.

We drove south out of town and parked on the side of the highway. Tree pulled out two long poles with nets attached to them and two washbasins with ropes attached. We tied the washbasins to our belts and started wading in the shallow water, poles in hand. We were stalking blue crabs in the clear, shallow grass flats.

The crabs generally stayed motionless, unless we spooked them. After a few misses, the timing became more natural and I started scooping up a five- or six-inch blue crab every so often. When I caught one, I would dump it into the basin

and start the process again. Over a two-hour period, Tree and I caught over a hundred and brought them back for a midday crab boil. Crab meat is delicious, although it takes some work to get the meat out of the shell.

But the whooping cranes are the showstoppers in Rockport. Whooping cranes are large, graceful birds, an endangered species now slowly increasing in number. In 1938, there were just fifteen of the birds in the wild. The numbers rose to about forty by 1960, and by 1980 there were almost eighty birds in the wild population. At the turn of the twenty-first century, the population in the wild was just over 180.[1] The birds seem to be slowly recovering but will not be coming off the endangered species list in the foreseeable future.

Garland and I spent our first wedding anniversary in 1972 in Rockport looking at whooping cranes. We went out in January with Captain Brownie Brown on his whooping crane tour boat. Brownie was the first ecotour guide I met on the Texas coast, although the famous birder Connie Hagar had begun bringing birders to Rockport in the mid-1930s.

Hagar is a true Texas legend, a self-taught birder who became as good as or better than most professionals. In addition to attracting other birders to Rockport, Hagar also raised local awareness about birds. Few people in the area knew much about birds other than the ducks that they hunted. Hagar explained to anyone who would listen that the various warblers were not generic "Mexican canaries" and that the hawks migrating through were broadwings and not chicken-eaters, as they were locally known. During her time in Rockport, she took nationally renowned birders all over the area, putting this part of the Texas coast on the national and international birdwatching map. And she never tired of showing off the whoopers.

Brownie's whooping crane tour was remarkable to me in at least three respects. It was the first time that I ever saw a bird as large as a whooping crane. A whooper stands some six feet tall, a truly striking sight on the flat marshland. Second, I saw my first sea ducks up close on that trip, particularly the beautiful buffleheads with their distinctive white markings. Finally, I was impressed with Hardhead, Brownie's cat, named affectionately after the hardhead catfish of the Texas coast. Hardhead lounged on a ledge in front of Brownie for the entire jaunt, like royalty on the throne.

That anniversary trip was the first of many ecotours that she and I would take together. Garland grew up in Fort Worth with a friend named Caro Jackson. Caro and her husband Don had been coming to Rockport for years. When Don retired from American Airlines in the mid-1990s, he and Caro built a house on the Lamar Peninsula on the north side of Aransas Bay and moved south from Fort Worth. They have never regretted it for a minute.

Don and I are quite different, and it took many years for us to establish our friendship. As we aged, our similarities became more pronounced and our differ-

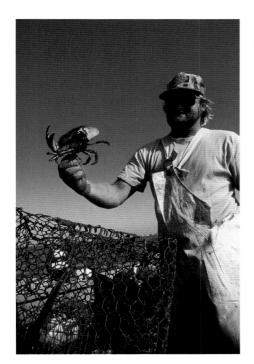

A crab trap has an opening on top and a bait container in the bottom. To get to the bait, the crab climbs down into the wire mesh basket, where it is trapped until collected. In the past, crab traps have been abandoned. Now they must be tagged and maintained or they are subject to removal. The prize in this case is a stone crab.

ences less important. I know few men who enjoy both fishing and birdwatching, and Don is one of them. I enjoy talking with him because he has something to say that interests me. He has been taking birdwatching lessons from a local expert and has become an accomplished birder. He has one of the few confirmed sightings of a greater flamingo on the Texas coast. A lot of people mistake a roseate spoonbill for a flamingo, but it is rare to see a flamingo here.

Don fishes the bays surrounding the Aransas National Wildlife Refuge, the wintering grounds of the whooping cranes. One day we launched his boat at Goose Island State Park on St. Charles Bay on the Lamar Peninsula. The dumpster at the boat launch was filled with crab traps, illegal traps removed from the bays as part of a cleanup effort by Texas Parks and Wildlife.

Crab traps are ingenious devices. The trap is a wire mesh basket that is roughly a three-foot cube. At the center of the bottom, a smaller wire compartment holds the bait, usually cut up fish and offal. The trap sits on the bottom of the bay, keeping the crabs from getting to the bait from the outside. The only way to get to the food is to crawl around the trap until an opening is reached and then enter the trap. The opening is designed so that it is hard to get back out.

Crab traps are marked by floats at the surface connected by a rope to the wire box on the bottom. These days, our bays are full of these floats marking the locations of crab traps. The crabber comes along in an outboard with a forward-mounted platform and a large working deck in the back, hooks the float with a boat hook, hauls up the trap, shakes out the crabs into a holding tank, rebaits the trap, and throws it out again.

Crabbing, like shrimping, is now a limited entry commercial enterprise. Each crab trap is supposed to have a name and identification number on it. Each crabbing license entitles the crabber to no more than two hundred traps. Over time, the expectation is that many of these crabbing licenses, like the shrimp licenses, will be bought up and retired. Crabs are not nearly as abundant on the Texas coast today as they were when Tree and I walked the flats and scooped up enough for a crab boil with no difficulty.

In 2002, all crabbers on the coast were required to remove their traps from the water for a two-week period so that abandoned traps could be located. During this time, any crab trap that was found in the water was illegal and could be confiscated by anyone on the water. The first year Texas Parks and Wildlife organized this activity, thousands of traps were removed; the event was so successful that it will likely become an annual tradition. The traps in the dumpster at Goose Island had been picked up the day before by fishermen and conservationists interested in removing illegal traps from the bay. Don and I hoped to remove a few ourselves.

The Aransas National Wildlife Refuge sits on Blackjack Peninsula. St. Charles Bay extends into the refuge on the west and Aransas Bay forms the southern

boundary. Mesquite Bay and Carlos Bay separate the eastern portion of the peninsula from St. Joseph's and Matagorda islands, and the Intracoastal Waterway runs parallel to the refuge shoreline. San Antonio Bay forms the northern boundary of the refuge.

Don and I turned the corner from Aransas Bay and cruised behind the Blackjack Peninsula, looking for redfish and crab traps. The spring day was South-Texas gorgeous. The clear blue sky seemed to expand to infinity, dotted with white puffs of cloud. The marsh grass was spring green, sparkling in the sunlight. The oaks on the higher ground appeared as a line of darker green behind the marsh grass, horizontal strips magnified by the blue expanse of the sky. The wind was gentle in the early morning, but that would change. The wind blows in South Texas.

We planned on drift fishing, a process that involved positioning the boat upwind from promising water and letting the wind blow us across the fishing area. We were fishing with artificial lures, a gold spoon for me, a soft plastic one for Don. As we motored into position for a drift, we could see three pairs of whooping cranes in the marsh ahead of us as well as one juvenile bird with its dirtlike orange-brown markings. The cranes are territorial, and the pairs were evenly spaced across our view.

The birds appeared huge on the flat coastal landscape. They stood out like white beacons in the green marsh grass and blue water of the marsh lakes. We watched one stride majestically across a lake, one leg slowly moving forward, beak poised, looking for crabs. Every now and then, we saw a head dart down and come up again, the neck muscles moving the unlucky crab up the food chain.

The Aransas National Wildlife Refuge and Canada's Wood Buffalo National Park provide homes for the whoopers, twenty-four hundred miles apart but inextricably linked in the crane life cycle. Wood Buffalo is where the whoopers go each spring to spend the summer and raise their young. The nesting area is so remote that it was not discovered until 1954.[2] From there, each fall, the whoopers migrate down to the Texas coast for the winter. Their wintering ground had been known for decades and was preserved in the late 1930s, when President Franklin Roosevelt authorized the purchase of land that is now the Aransas refuge.

As the crane population increased, the cranes expanded their territories into areas outside the refuge. Portions of St. Joseph and Matagorda islands now have cranes, as do San Antonio Bay, St. Charles Bay, and even Copano Bay on occasion, according to our friend Victoria Lightman, who has a home there. As the cranes push out from the protection of the refuge, their peril increases, such as hunters mistaking one for a snow goose.

Two things that whoopers need to survive are marsh ponds and crabs. The areas that provide these habitat requirements must be kept safe from threats like erosion resulting from traffic on intracoastal and oil and chemical spills from the barges that traverse it. Freshwater inflows are even more important because with-

out them, the estuary will not produce nearly as many blue crabs. Without the crabs, the whoopers will not have sufficient food. Preservation of freshwater inflows becomes key to crane preservation, adding another level of interest and concern to the debate over the diversion of water from the Guadalupe River to San Antonio.

Don and I decided to try to catch a few crab traps. We motored over toward several traps sitting on the bay bottom. These were old traps, some lacking floats, abandoned over the years. As Don pulled us close, I tossed a grappling hook and, after several misses, firmly secured a trap. Don put the boat in neutral and we both tried to pull the trap into the front of Don's boat.

It takes plenty of effort to pull in an old trap that has been mired in bottom muck for a long time. As we lifted it, bottom creatures flowed out with the mud: annelid worms, small crabs, and shrimp. We released several small fish that were stuck inside and let the trap rest on the bottom of the boat, oozing mud, as we moved on to the next trap, making our small contribution to the coastwide effort to remove abandoned traps that continue to trap crabs as well as boat propellers.

On February 23, 2002, the day before we went out, volunteers picked up more than 6,800 abandoned crab traps on the Texas coast. Of these, 2,131 traps were removed from San Antonio Bay and 1,360 traps were removed from Aransas and Corpus Christi bays, the high numbers reflecting the large crab harvest in these bays (fig. 29).[3] Over seven hundred traps were removed from crane habitat areas, but an aerial survey after the event revealed another three hundred or more abandoned traps still in the crane area.[4] Of these, Don and I removed six.

The blue crab is a versatile species, a swimming crab that scavenges for food. Its scientific name, *Callinectes sapidus,* can be literally translated as the beautiful, savory swimmer. As a general rule, blue crabs prefer to swim sideways, although they can swim both forward and backward.[5] These crabs can be found from Cape Cod to Argentina and are widespread in the bays and estuaries of the Gulf Coast.[6]

Blue crabs grow by losing their shell and growing another larger shell in a process called molting. If a claw or other limb is lost, it can be regenerated over a period of several molts, the water temperature and food availability determining how often the crab can molt. Mating occurs only when the female is molting. After mating, the male carries the female until her shell hardens, ensuring passage of his genetic material by protecting her and keeping her from other males.

The larval blue crabs are filter feeders that eat phytoplankton, the fuel of the estuary, and zooplankton (microscopic animals). Adults are omnivorous, devouring almost any type of food they can find. The crab is itself an important food source for other species, including redfish and wading birds as well as whooping cranes.

Blue crabs depend upon estuarine systems for their existence. The females spawn in waters with relatively high salinity, greater than twenty parts per thou-

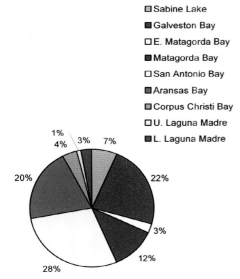

☐ Sabine Lake
■ Galveston Bay
☐ E. Matagorda Bay
■ Matagorda Bay
☐ San Antonio Bay
■ Aransas Bay
☐ Corpus Christi Bay
☐ U. Laguna Madre
■ L. Laguna Madre

Figure 29.
Blue crab harvest by bay.

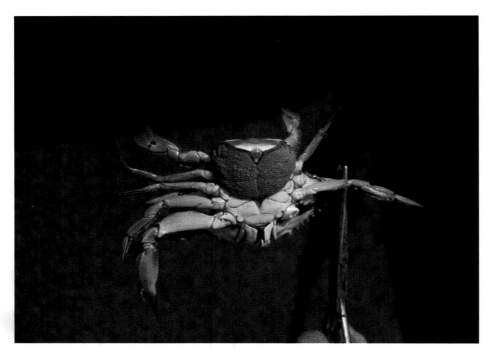

The eggs are clearly visible on this female blue crab. Juvenile blue crabs spend an important part of their life cycle in the fresher upper portions of the bays and are dependent upon freshwater inflows. In turn, whooping cranes are dependent on freshwater inflows to ensure the continuation of their primary food source—the blue crab—around the Aransas National Wildlife Refuge.

sand. Such areas are usually found in the lower estuary and at the edge of the Gulf, where salinity is about thirty-two parts per thousand. The larvae start out microscopic and spend a short time in the Gulf before returning on the tides to the estuary, where they spend much of their life cycle. As a general rule, juvenile crabs are found in the portions of the estuaries with lower salinity, and adults are more widely spread throughout the bay systems.

The importance to crabs of the estuarine environment, a mix of fresh and salt water, cannot be overstated. A crab may not seem like much of a traveler, but it has done a good deal of commuting by the time it reaches a dinner plate. The large juveniles and adult males migrate to the fresher, upper estuaries in the spring. The small juveniles also migrate to the fresher, upper estuaries, making the presence of these fresher waters an essential part of their life cycle. Females that have spawned offshore return to the lower estuary in the summer, and fertilized females migrate back offshore to spawn in the fall. In the late fall, the adult males and the large juveniles move to the lower, more saline sections of the estuary.[7]

If the crabs are to have the varied salinity that they require, fresh water must continue to flow into the bay. For the whoopers to have crabs to eat, the fresh water must continue to arrive. The decisions to be made by the State of Texas regarding inflows of fresh water will determine the fate of the whooping crane as well as of the fisheries up and down the coast.

In the midst of our crab trap removal operations, the whooping crane tour boats arrived. Several tour boats operate out of Rockport, providing the best way to see the cranes as well as many of the sea ducks, herons, and egrets. I wish every citizen of Texas could see these wintering cranes at least once; they are a distinctive part of our natural heritage, so handsome in appearance, so few, so rare, and yet so exposed and readily visible out in the marshes.

When I visit Rockport, I am struck by the foresight that Franklin Roosevelt and others had in preserving the wintering grounds of the whooping crane. This crane is dependent upon us for its continued existence. Had we destroyed this habitat—had we allowed it to be developed—the bird would have disappeared from our earth. In the late nineteenth century, Texans were still fighting the natural system to survive, scarcely realizing that we would soon have the ability to eradicate a species completely; in the case of the whooping crane we very nearly did so. If all continues to go well, it looks as though we should be able to secure the population of these birds, and we know now that we have the power to protect or destroy coastal ecosystems, with their crabs and birds. In just over one hundred years, we have reached a special position of unique power over other living things.

Yet we have gotten to this position without an ethic to control the use of this power. In Herman Daly's empty world, humans did not need to consider the loss of natural habitat, because habitat was abundant. Species were not routinely threatened by human action. Now habitat is being lost at unprecedented rates, and the earth is losing a stunning fifteen to twenty thousand species annually. Three hundred years ago, loss of species is estimated to have been around one species per year. In the middle of the twentieth century, losses were tallied at just over one hundred species per year. The drastic increase to thousands of species lost each year means we are wiping out the other living things on this planet at an unbelievable rate, and many of us do not even know this, much less care about it.

Daly's full world answer to this crisis is to incorporate an ethic of protection of living things into our moral construct. With the theologian John Cobb, Daly has written about the increasing adoption within the religious community of the concept of reverence for life and other living things. This religious view finds its basis in the story of the Creation, that it was good. Who are we to destroy that which the Creator found to be good? Buttressing the view is Noah and the story of the ark, the saving of all of the species of the world from the great flood. If Noah was directed to save these species, who are we to destroy them?[7]

Secular thinkers cast the matter in other ways. From Aldo Leopold we get the land ethic, a concept that the ecological system needs to be understood and conserved, that we have interfered with our ecological systems to our own detriment. From Rachel Carson we get the perspective that humans are destroying other living things without thought and without remorse, that we may lack the

right to call ourselves civilized if we continue with this uncaring and unthinking destruction.

We have made mistakes and will doubtless make more as we strive for an appropriate ethic to find our way in the full world. But along the Texas coast, at least one thing has been done right. The Blackjack Peninsula is a refuge, the marshes are protected, and the whooping cranes have been preserved, at least until our time on earth. Today, it is the decline of freshwater inflows and the risk of a decline in crabs that threaten the crane, rather than loss of habitat. Now we need to focus on maintaining freshwater inflows so as to maintain bay productivity.

The Texas Legislature may not pass laws to protect freshwater inflows. If they do not, then the federal Endangered Species Act may enter into the water rights equation. In the Hill Country, as we have seen, the Endangered Species Act forced the City of San Antonio off groundwater because of threats to endangered species in the springs fed by the Edwards Aquifer. On the coast, if sufficient water rights are not set aside to protect the blue crabs relied upon by the whooping cranes, a federal court may be required to intervene.

Don cranked up the motor, and we returned thr ough the shallow bays behind the refuge. As the beautiful white birds passed before us, I smiled. All was well and right on the coast that day. And topping it off was the realization that the wild card in the fight for freshwater inflows for San Antonio and Aransas bays just may turn out to be the whooping crane and blue crabs.

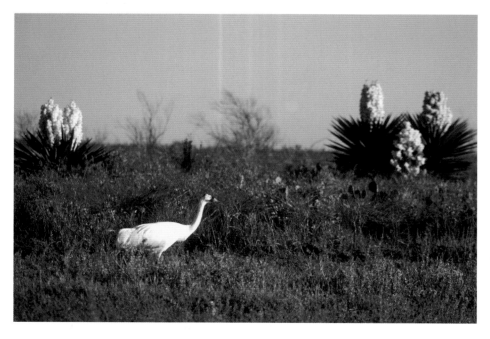

Whooping crane beneath yuccas. If Texas does not take adequate action to ensure freshwater inflows for San Antonio Bay and the Aransas National Wildlife Refuge, the whooping crane could be negatively impacted. Prior to that happening, the federal Endangered Species Act would be triggered, causing federal intervention in Texas water politics, just as occurred in the Edwards Aquifer dispute.

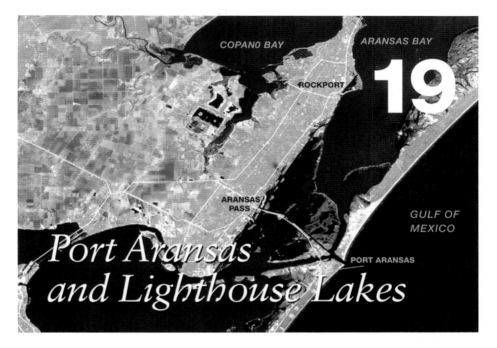

Harbor Island is shown to the right of State Highway 361, which connects Aransas Pass with Port Aransas. The navigation channel through the pass at Port Aransas connects with Corpus Christi Bay and the Port of Corpus Christi to the south and with the Gulf Intracoastal Waterway heading north, separating St. Josephs Island to the north from Mustang Island and Port Aransas to the south.

Off the isthmus between the mainland town of Aransas Pass and the island community of Port Aransas is a place called Harbor Island, site of one of the biggest environmental fights ever to take place on the Texas coast. The people defending the coast won this one, which is why the Lighthouse Lights Paddle Trail now offers access to one side of Harbor Island. We had decided to paddle the trail system and see for ourselves what others had fought to preserve.[1]

A kayak expedition involves at least a week or two of planning calls, full of anticipation and gossip, to coordinate arrivals from Houston and Austin. It means kayak-laden vehicles laboring through Houston's Friday traffic. And it always provides high entertainment.

We arrived at the water on Saturday morning, all enthusiasm. We parked adjacent to the road leading to the Port Aransas ferry, unloading light kayaks on the sand. Launching is an amusing, inevitably disorganized process. We pored over the aerial photograph laying out the trail, picking a path that seemed reasonable for the level of skill and endurance collectively assembled. Where was the Chapstick? Who had the lunches? Where did the trail start? Where was my vest? Was the wind really blowing as hard as I thought it was?

Tired of waiting, two kayaks dashed ahead of the others. The first of our two-person kayaks was launched next, moving forward like a World War I battle cruiser, the occupants destined for a long day of paddling into a stiff wind blowing

from the north on the first day of duck season. Our eight boats and ten occupants were quite a sight: Princie Chapman in the orange boat, Garland Kerr and John Chapman in matching grape boats, Sue Schwaller in the white one, Jack Scwaller and his daughter Ellen in light blue, Al Kaufman in a little green one, Shelly Kaufman and son Lee in the battle cruiser, and me in lime green with a yellow hatch cover. We were a rainbow sherbet flotilla.

Just across a deepwater channel, the Lighthouse Lakes Paddle Trail begins. The trail exists thanks to the efforts of coastal activists who fought and defeated the Port of Corpus Christi's plans to construct a deepwater port, called Deeport or the Harbor Island Superport. Deeport was proposed with an eighty-foot-deep channel leading from the Gulf of Mexico inland to a superport for oil tankers. That superport was to be constructed exactly where the trail is now located, on wetlands, mangroves, and some uplands on the north side of the Port Aransas highway that would have been dredged and filled—that is, destroyed.

Oil was already coming into Corpus. The practice was and is to bring the oil to the Texas coast in supertankers, which are met offshore by smaller tankers that "lighter" the cargo from the mother ship. The smaller tankers make several trips and either remove all the oil or lighten the mother ship sufficiently for it to be able to navigate the forty-foot-deep Corpus Christi Ship Channel. Lightering has been safely undertaken on the Texas coast for years, although the spill potential is ever present. However, for the most part, both oil companies and coastal residents believe lightering to be a workable solution to the problem of importing oil. But there is always someone with big plans, and an unnecessary superport becomes the next great idea for economic development.

I first met Steve Frishman at the end of the Deeport fight. I had just joined the board of directors of the Texas Environmental Coalition, a statewide group that included Sharron Stewart of Lake Jackson. An intense, intelligent man, Steve had the look of someone caught in a war zone. At the time I did not understand what he had been through, and he was not inclined to explain. After more than two decades of similar kinds of clashes, I now know something of what Steve had experienced.

Steve founded the *Port Aransas South Jetty,* an activist newspaper that became the mobilizing force in the fight against Deeport. Lots of great newspapers got their start as a form of protest, informing people about elections, or labor issues, or some other form of injustice. The *Port Aransas South Jetty* is one of those. It began as a six-page biweekly affair dominated by pictures of large marlin and hammerhead sharks alongside community news in the form of bar gossip and personal announcements. It was also a blow-by-blow documentary of the fight to keep a sleepy little tourist and fishing town—Port Aransas—from becoming dominated by oil storage tanks and associated activity.

The Deeport fight began in April of 1972, when the Port of Corpus Christi unveiled its plan for a deepwater port on Harbor Island, across the ship channel

from Port Aransas. The plan as presented to the Corps of Engineers in Galveston had three phases. Phase I was the dredging of a seventy-foot-deep entrance channel from Harbor Island to the Gulf of Mexico, deepening the existing channel by thirty-two feet. Phase I also included the construction of two docks for supertankers and a turning basin half a mile wide. The second and third phases required the deepening to sixty feet the channels extending along the north shore of Corpus Christi Bay and building a railroad causeway from Harbor Island to the mainland.[2]

If an onshore deepwater port were needed on the coast, there is a good reason for Port Aransas to be seriously considered, and that is the cost of dredging. At Port Aransas the continental shelf drops off relatively close to shore, some ten miles out, compared to Galveston, where the shelf extends outward thirty or forty miles. This closer proximity to deep Gulf water means lower dredging costs, although the costs would still be very high. The Corps estimated that it would take three or four boats working continuously for three or four years to complete the dredging at Port Aransas, and all that dredged material would have to be dumped somewhere.

At about the same time as the port commissioners released this plan, Congress had instructed the Corps of Engineers to investigate the most economically and environmentally viable location for a superport along the Gulf Coast. The Corps had already reviewed inshore ports, offshore islands, and offshore "monobuoys," among other things, and had concluded that the monobuoy system was the best option because it represented the least expensive, lowest-risk way to go. A monobuoy is a hose extending to the water surface several miles offshore of the barrier islands; tankers hook up to it, allowing them to connect to a seafloor pipeline that conveys the contents of the tankers to onshore refineries.

A monobuoy is a sensible and environmentally safe superport. It is not, however, the stuff of dreams for promoters of economic development. Few construction jobs are involved. No new channel that may bring in other types of deep-draft vessels is required. There is no dock or port development. Neither is there creation of new land areas from the wetlands and marshes. A monobuoy simply was not what the port had in mind.

Texas ports have a history of fighting each other. Competition, not cooperation, has been the ethic of Texas port development. What one port has, the others want, and matters escalate, as with the pressures for new stadiums for sports teams. The facts regarding economic necessity and environmental harm do not matter much in this process. Instead, the sole goal is to generate jobs and work, whether the initial expenditure makes long-term economic sense or not. In Corpus, the local oil industries expressed some support for the big project but balked at putting up any of their own money—a sure sign that the project was not needed to advance their economic interests.

In 1973, the Nueces County Navigation District released their pre-permit description of the Harbor Island Superport. It required deepening the entrance

channel to eighty feet (the spoil to be dumped in the Gulf); deepening the Corpus Christi Ship Channel across Corpus Christi Bay to seventy-two feet (the spoil to be dumped on or near Harbor Island); and dredging a turning basin 2,300 feet in radius. A bulkhead would be built around the basin with fill to twenty feet above sea level, and the north jetty would be moved a thousand feet north to make room for storage tanks, pumping stations, utilities, and other buildings.[3] All found, the plan represented a huge alteration of the Port Aransas landscape.

On September 20 in Miller Auditorium in Corpus Christi, the Corps of Engineers held the first public hearing on the Harbor Island permit. The outpouring of opposition was thunderous. One hundred and twenty of the more than nine hundred people attending indicated that they wished to make statements. The hearing lasted until 2:30 A.M., when it was adjourned until later that morning, finally closing at 4:30 in the afternoon. An additional 5,600 signed statements by those opposed to the superport were entered into the record.

Three years later, the Navigation District released their revised permit application for Phase I of Harbor Island, which was at that time the largest dredge project ever planned, with the cost estimated at $280 million. Their plans were displayed over three of the eight pages in the now weekly *Port Aransas South Jetty* and included dredging 98 million cubic yards of spoil. They planned to dump two thirds of this in the Gulf and one third on Harbor Island and on Mustang and St. Joseph islands, taking three years to finish the job.

A group of local people opposed to Harbor Island formed an organization called the Citizens for Estuarine Planning, and they put together a presentation for the city council, which convinced the council members to call for a public hearing in Port Aransas, not Corpus Christi. Taxpayer money had already been spent, they claimed, on various studies, and since the residents' money was being spent, they had a right to know why and for what. At that hearing, when asked about the potential harm the Deeport project would have on the environment, the director of the Port of Corpus Christi, Duanne Orr, declared flatly: "You can't have your cake and eat it too."[4]

Some people at the University of Texas Marine Science Institute helped oppose the port project by assisting in the preparation of a two-page spread on the negative environmental consequences of Harbor Island, which Steve Frishman ran right next to the Navigation District's plans in the *Port Aransas South Jetty.*[5] Through various paths, the suppporters of the project then tried to have the funding for the institute reviewed by the politicians. This move was ultimately thwarted, but the stakes in the fight had clearly increased.

The Lighthouse Lakes Paddle Trail is within a mile of the deepwater channel that connects Corpus Christi with the Gulf of Mexico through the jetties at Port Aransas. From the trail, you can see and hear the ferries taking cars to Port Aransas. Offshore fishing boats and tankers are just visible too. But that was not

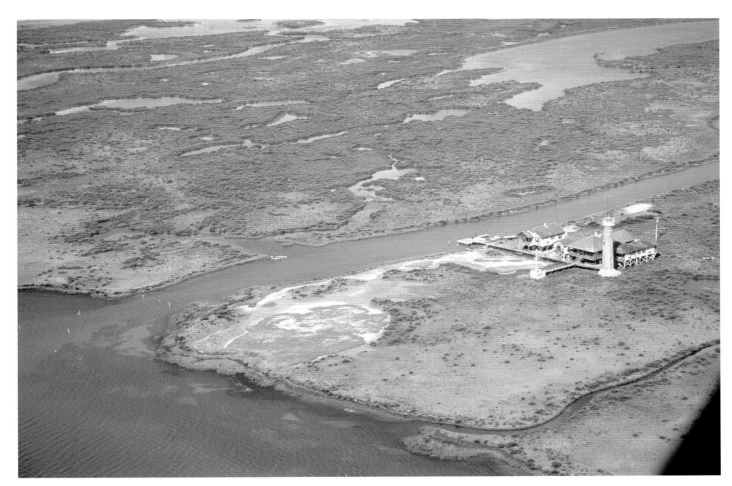

The mangroves and the lighthouse responsible for the name Lighthouse Lakes. These waters are filled with seagrass and fish and bird life, making the trail a wonderful day trip for the adventurous family or group. The Intracoastal Waterway cuts across the bottom of the photograph, separating Lighthouse Lakes from St. Joseph Island to the east.

what we were interested in the day we set out in our kayaks; we were heading for the mangroves within the Lighthouse Lakes.

The first thing you notice when paddling among the mangroves is that you can't see out. Along the coast, you can usually see across the marsh grass to adjacent waters and far horizons. But you cannot see through the mangroves, which is a little disconcerting and makes the trail markings put there by the Texas Parks and Wildlife Department absolutely necessary.

Bill Harvey of the Resource Protection Division of Texas Parks and Wildlife speaks proudly about what has been accomplished on Harbor Island with the Lighthouse Lakes trail. Most maps show Harbor Island as a triangle of solid land sliced out of Aransas Bay by the ship channels, but it is not a single island. It is made up of dozens of islands covered with black mangroves creating a net of interlocking salty streams and lakes. The tidal water is seldom more than shin deep and is usually clear to the bottom. Buffered from the wind and tide by the mangroves' thick roots and dense, sturdy foliage, the submerged seagrass meadows of Lighthouse Lakes create one of the great wildlife habitats of the coast.

In 2000, while Parks and Wildlife biologists were visiting Harbor Island as part of the implementation of the Texas Seagrass Conservation Plan, they viewed the

damage that recreational boat traffic was causing to the area, but they could also see its great recreational potential. People were trying to go in with motorboats, scarring the seagrasses that grow in the shallow water. The area was labyrinthine and therefore largely inaccessible, except at the edges. Still, it gave the agency personnel an idea. They decided to combine aerial photos with mapping software and GPS data to plot routes through the mesh of meandering mangroves. A few other trails of this kind had been established in Florida and California, but this was the first one in Texas.

While following the trail looks easy from a map, the reality is more difficult. We kayakers missed our marker and paddled along the northern edge of the first lake, flanked by mangroves. We finally caught up to Jack, pulled out the map for a high-level conference, and decided that we need to go back the way we had come. I have since been informed that a hand-held GPS unit is a good investment; I believe it.

We retraced our route and decided that we needed to take one of the myriad channels through the mangroves to proceed to the next lake. Princie took the lead down a promising channel that got smaller and smaller and finally dwindled to nothing. There we were, the orange boat followed by the lime green boat followed by the two grapes, all headed down a mangrove channel to nowhere.

Princie's orange kayak resembled a Venetian paddleboat, complete with upturned tips at both ends. It was wedged in the mangroves, unable to turn, and we became a backward caravan. Garland yelled that she had found the path to the next lake; all we needed to do was extricate ourselves. A heron flushed and crabs scurried, all disturbed by the exiting sherbets.

Bill Harvey attributes the success of the Lighthouse Lakes project to the fact that Texas Parks and Wildlife did not encounter any opposition, because they included all the stakeholders from the beginning, eliminating surprises. The trail does not threaten any previously established industry but rather offers a boost to the local economy through ecotourism.[6]

Harvey says it is the perfect kind of project for Parks and Wildlife. Public use and enjoyment of this recreational resource have increased dramatically, yet impact to the ecosystem is virtually zero. This is because the Lighthouse Lakes trail network is for kayaks and canoes and other low-impact craft. Such watercraft and the marked routes allow people to enter the enticing world of a mangrove island without running into the dangers of oyster reefs and sandbars.

The lakes are clear and full of seagrass. The seagrasses shelter small fish and shrimp, and where bait abounds, larger fish congregate, especially redfish. In the combined area of Harbor Island and Redfish Bay are the most extensive seagrass beds outside the Laguna Madre. These beds are the last northern haven of turtle grass and manatee grass, but the most abundant grass is shoalgrass, with its thread-like leaves that trail out in the wake of a kayak, coated in epiphytic algae.

"It's not so much what eats the shoalgrass as what eats the stuff that hangs on the shoalgrass," says one Texas Parks and Wildlife biologist.[7] The juvenile stages

of shrimp, clams, and scallops thrive in the grass beds, feeding off the algae. Shoalgrass and turtle grass were being scarred by propellers before the paddle trail was created and no-prop zones were established for both Harbor Island and Redfish Bay. Fishermen can enter these areas but must either push in with poles or kayaks or use trolling motors that will not damage the grasses.

Ducks, especially redheads, feed on the grasses during the winter, and flocks of egrets frequent the mangroves, protected from predators by a deep channel on two sides and miles of water on the other. Ospreys dive for fish and northern harriers dip and glide over the mangrove islands, showing their white tail patches. During most times of the year, the trail is a birdwatcher's paradise, but we had chosen to paddle out on the first day of duck season. Although outboard motorboats are prohibited from the Lighthouse Lakes, duck hunting and airboats are allowed. Luckily, by the time our sherbeteers launched that day, most duck hunters had already finished their hunts. But the ducks were gone for the day too, and the herons and egrets were few and far between.

In the interests of safety and enjoyment of the trail, it would be better to ban duck hunting from the Lighthouse Lakes or close the trail to kayakers during hunting season. The two activities do not coexist well. The trail took us within fifty yards of duck blinds that had been used earlier in the day; the decoys were still out. The State of Texas owns the bottom of these tidal bays, and the General Land Office has the authority to set the rules for the Lighthouse Lakes. The duck blinds and the hunting could be eliminated and should be from this one small recreation area among many others on the long list of bays that are open to duck hunting.

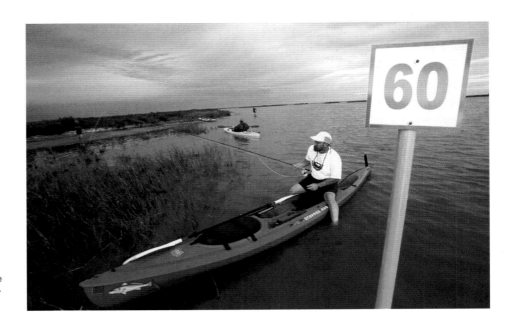

Fishing from a kayak is great sport, particularly in an area like Lighthouse Lakes with its clear water, perfect for fly fishing for redfish.

Our bigger worry as we paddled through the mangroves was the airboats. We felt much more secure in the open water of the lakes, where we could see airboats coming and could readily be seen ourselves. It is scary to be in a mangrove channel hearing an airboat that you cannot see, worrying that it might be upon you before its pilot knows you are there.

In the fight over Harbor Island, Steve Frishman produced a pamphlet with a section titled, "Our Productive Wetlands." This document was based on the first efforts of economists to value the natural environment, work that would be expanded upon by Robert Costanza two decades later. Considering that Frishman's excellent document was written in 1977, it is a masterpiece. The idea that the services provided by a functioning ecosystem have economic value, dollar value, seems new and unfamiliar to us, even today.[8] Like many ecological truths, it makes sense when one stops to think about it, but it is not reflected in our textbooks or our training.

Frishman understood that if the Deeport project were charged with the cost of its environmental destruction, it would quickly become unfeasible. He worked up the numbers and made his arguments. He got people thinking.

The next time the Corps sponsored a hearing in Corpus Christi, citizens organized bus transportation and more than a thousand people from Port Aransas and environs went to spend an evening evaluating the six alternatives being considered by the Corps for their Gulf Coast superport, which coincidentally included an option that looked exactly like Deeport. Colonel Jon Vanden Bosch of the Corps presided over the meeting; then Texas Representative Carlos Truan attended as well, admonishing that while the economic benefits of the plan were necessary, the Navigation District was wrong to disregard public opinion and would have to assume full responsibility for the environmental consequences.

Of the six alternatives, three were onshore facilities, various permutations on the Harbor Island idea, and two were offshore, a monobuoy and a similar plan including a docking island made of dredge spoil. There was also the "no action" plan, which represented the status quo but did include the already approved deepening of the Corpus Christi Ship Channel to forty-five feet. Following the meeting and noting the sentiments of the citizenry, the City of Port Aransas issued a resolution opposing Deeport.

More than six years after its unveiling, the Harbor Island project was named Deeport and the Draft Environmental Impact Statement (DEIS) was released. The DEIS included all manner of numbers about the proposal: over 3,000 acres of wetlands lost, 20 square miles of bay and marsh covered by dredge spoil, the creation of 19,000 new jobs, a projected economic benefit of $8 billion with a cost now of $430 million, not including tanks, pipelines, or maintenance, although maintenance would involve dredging 3.6 million cubic yards annually to keep the channels open.

The DEIS did not, however, include a series of things the citizens thought were important, like studies of how the project would impact tidal flows, inflows, cir-

culation, flooding, and fisheries. Frishman kept the pressure on, picking telling quotes out of the document's more than four hundred pages when its contents conflicted with previous Port propaganda. Of the DEIS he printed this in the *South Jetty:*

> *The statement itself, while remaining neutral on whether the project should be built, states "a permanent loss of the natural environment would result from the construction of the proposed project. This loss includes wetlands, terrestrial habitat, and undisturbed bay and Gulf bottoms. The operation of the harbor will permanently affect the character of the Harbor Island–Port Aransas area," and it adds, "The operation of the port represents the commitment of the community, region, and state to accept the risk, however small, that an accident such as a spill, collision, or explosion could affect all or portions of the estuarine system in the area. Thus, the port may represent a commitment to an industrial activity which could result in the suppression or even elimination of a nonrenewable resource—the estuary."*[9]

It was pretty clear that this kind of commitment was completely absent from the communities that would be most heavily impacted by this project, and the plan began to unravel.

The Corps called yet another public hearing on the DEIS, with the Navigation District speaking for the project and the citizens against it. Citizens voiced their desire for a supplement that would include those studies missing from the current document.

The following month, the port suffered two severe blows to their chances. The EPA urged the Corps to reject the permit as environmentally harmful and redundant to projects already farther along in the approval and construction process, specifically superport facilities at Seadock in Freeport and a site in Louisiana. The U.S. Fish and Wildlife Service followed suit, saying the DEIS was insufficient and that based on what it contained, they recommended denial of the permit. The National Marine Fisheries Service and Texas Parks and Wildlife both came out against the project as well.

Yet still, even after all of this, the Navigation District retained faith in the power of money and politics to outweigh citizen protest and continued their facilitation of Harbor Island's ends. They helped the Coastal States Crude Gathering Company apply for a Corps permit to build a pipeline after Frishman pointed out that their plan, as proposed, lacked a means of transporting the oil from the port to the refineries. The pipeline was to be forty-two inches wide and thirty-nine miles long, and it would require 75,000 cubic yards of dredging. After a flurry of opposition to the pipeline as a separate project, the Corps ruled early in 1979 that it would be included in the Final EIS, and a public hearing would be required, as the pipeline would pass through wetlands and bays.

When you are in these fights, you sometimes reach a point where you know it's over, when you have won. Steve Frishman knew. An article in January of 1979

was the last that the *South Jetty* ran about Deeport. By the end of the year, Frishman had found buyers for his paper and was already looking west for his next great conflict, a project of size and scope worthy of his copious energy and talent.

In 1981, the Port of Corpus Christi was still struggling toward the FEIS, fighting inflation of costs and modifications necessary environmentally.[10] Yet still they hung on. Not until 1983 did the *Corpus Christi Caller-Times* run the headline "Deeport Is Dead."[11] The Port of Corpus Christi equivocated even then, saying that due to energy conservation measures, increased domestic production, disuse of supertankers, and the efforts of the conservationists, they had decided to deactivate the project—that while it had been a worthwhile plan, times had changed.

Deeport serves as a reminder that protecting the coast requires commitment and perseverance. More often than not, this is found in the form of one or two dedicated people who are not afraid to lead a fight against the better funded, better backed powers that seek to run things their way without regard to citizens' interests. These committed people leave a legacy that we inherit; in this case a sleepy town was allowed to remain sleepy. It is the very absence of change that shows how much was accomplished. The word *deactivated*, however, reminds us that these projects never really die but often resurface eventually, illustrating the necessity for each generation to produce its own activists committed to the protection of the coast.

We stopped in a mangrove-lined channel to have lunch; eight kayaks moored together, chicken salad sandwiches all around. A major decision was about to be made: which way would we take to return to the sandy landing area? Should we return the way we had come, the way we knew, or take a chance, jumping back into the mangrove channels? The consequences of an error might be serious—the wind was rising, and the paddling was growing harder.

Consensus achieved, we set forth toward new mangrove channels, Jack leading the way with his aerial map of the Lighthouse Lakes. Off in the distance, the lighthouse rose above the mangroves, a silent monument to times long past, to the era when Franklin Roosevelt came to Port Aransas and stayed at the Tarpon Inn, fishing for its namesake.

If the lighthouse represents the past, the Lighthouse Lakes trail is a testament to the future of the Texas coast, a tangible indication that we have begun to understand the values inherent in the natural system, to appreciate these values and incorporate them into foundations for the future. The General Land Office has provided Texas Parks and Wildlife with a grant to create maps for paddle trails for Armand Bayou, Christmas Bay, Mustang Island, Port O'Connor, and South Bay. The hope is that the more people love a resource by being intimate with it, the more eager they will be to protect it. So for me, the Lighthouse Lakes trail is one of the most hopeful places on the Texas coast.

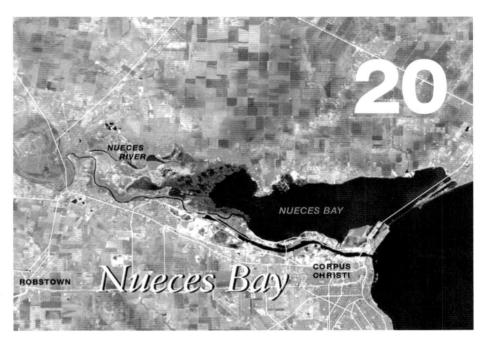

The Nueces River flows into Nueces Bay. The Corpus Christi Ship Channel was cut into the south shoreline of Nueces Bay and is flanked by industrial development. The State Highway 35 causeway connects Corpus Christi with the north shore of Corpus Christi Bay and with the towns of Gregory, Portland, Ingleside, and Aransas Pass. To address the serious reduction in flow from the Nueces River into Nueces Bay, attempts are being made to reconnect the Nueces River with its traditional delta in order to optimize fish, shellfish, and marshland productivity.

The lower coast of Texas is much drier than the upper coast.

The lower coast receives much less rainfall, and the large rivers—the Sabine, Trinity, Brazos, Colorado, and Guadalupe—all flow into the upper and midcoastal bays. South of San Antonio Bay, freshwater inflow is greatly reduced compared to what flows into the bays farther north.

The Mission and Aransas rivers flow through the South Texas brush country into Copano Bay. These are small rivers, with deeply incised banks that seem to hover over narrow riverbeds full of hardwood trees. But do not be fooled by their size. These rivers are the lifeblood of Copano and Aransas bays, providing them with dependable pulses of fresh water, most notably after large storms, but constant over time, peaking in the fall of the year.

Copano and Aransas bays are not hypersaline like the Laguna Madre to the south, a tribute to the power of even limited riverine flow. Much of the land around Copano Bay is not developed, and rivers feeding it have not been dammed. Ranching protects the west and north sides of Copano Bay from resort housing and water demands, and much of the south side of this bay is either farmed or ranched. The only major development is at Rockport, a growing area to the east on the peninsula dividing Copano and Aransas bays.

Lush salt marshes extend for miles along the deltas of the Mission and Aransas rivers. These marshes are dotted with lakes filled with scattered oysters,

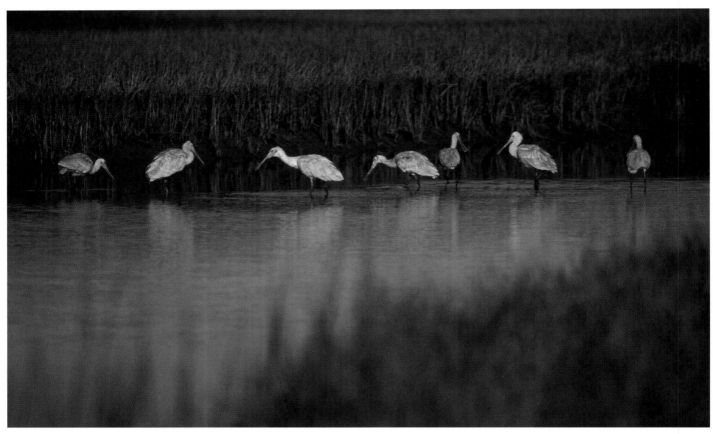

Roseate spoonbills in a marsh pond. Freshwater inflow is the lifeblood of the marshes, deltas, and oyster reefs of Copano and Nueces bays. Groundwater withdrawal threatens inflows from the Mission River. Reservoirs on the Nueces and Frio rivers have already impacted Nueces Bay heavily.

bait fish, and redfish. In summer the wood stork—a large white bird with black wingtips, a macabre bald face, and a thick, down-turned bill—can be found in these delta lakes. Oyster reefs exist in Copano Bay, a sure sign that fresh water is flowing into the bay. Fishermen drift these reefs, enjoying the green water, chasing speckled trout with topwater lures.

Yet even this seemingly isolated bay is threatened by water projects. People in Refugio County talk about how during the drought of the 1950s, the Mission River never stopped flowing, fed as it is by groundwater seeps from the coastal aquifer. Today, however, as part of the plan to divert water from the Guadalupe River to San Antonio as well as to supply water to the north side of Corpus Christi Bay, there are those proposing to sell groundwater from Refugio County. Plans are to use this groundwater during droughts—the very time when the inflows are most critical to Copano Bay. One reason the D. M. O'Connor Ranches united to fight these sales was to keep the groundwater from being mined, dewatering the Mission River and local windmills that support the ranches.

Thirty miles south of Copano Bay lies Nueces Bay, which is fed by the Nueces River. Over the last century, Nueces Bay has seen serious alteration of its freshwater inflows, partly due to dams and partly due to the modification of the Nueces River delta. The contrast with the relatively pristine Copano Bay system could not be starker.

Nueces Bay is a small bay connecting to Corpus Christi Bay. The Corpus Christi Ship Channel is cut into the south shoreline of Nueces Bay and extends across Corpus Christi Bay and Aransas Bay to Port Aransas, where it enters the Gulf of Mexico adjacent to Harbor Island. Nueces Bay is physically separated from most of the ship channel, home to numerous refineries and chemical plants and adjacent residential development. Nueces Bay and these industries form the northern boundary of the City of Corpus Christi. Except for the city of Portland at its mouth, the north side of Nueces Bay is largely undeveloped.

I studied Nueces Bay in the mid-1970s as a young professional working at the Rice Center in Houston on the natural resource and economic development conflicts of the Texas coast. At that time, the proposed construction of a second water supply reservoir for Corpus Christi on the Frio River was the hottest issue on the lower coast. The Choke Canyon reservoir was proposed for construction near Three Rivers.

Choke Canyon was under discussion after Judge Bue had issued the first Wallisville decision in 1973 (see chapter 5); at about the same time as the Choke Canyon proposal emerged, a major fight was brewing over yet another coastal dam, at Palmetto Bend on the Navidad River. These three reservoirs—Wallisville, Palmetto Bend, and Choke Canyon—are known for the controversy that surrounded them. None, however, has proven as difficult as Choke Canyon.

From the beginning of the discussion about Choke Canyon, concern was voiced about the impact that its construction and operation would have on freshwater inflows into Nueces Bay. Historically, Nueces Bay received consistent inflows from the Nueces River, inflows that were necessary to maintain its oyster reefs and shrimp productivity. As proposed, Choke Canyon was a very large reservoir on the relatively small Frio River.

Due to the passage of environmental laws in the early 1970s, the decision making regarding the feasibility of Choke Canyon in the mid-1970s followed a very different process from that of the past. The Corps of Engineers had been sued in Florida in the 1960s over their decision to deny a permit because of damage to mangrove wetlands, and the U.S. Fifth Circuit Court of Appeals had held that laws such as the Fish and Wildlife Coordination Act expanded the grant of authority to the Corps. In permitting of construction in navigable waters of the United States, according to the Fifth Circuit, the Corps had legal authority to deny federal permits for fish and wildlife reasons in addition to the traditional reasons, such as interference with navigation. The Fifth Circuit also indicated

that the National Environmental Policy Act would further expand that power when it came into effect in 1970. Congress subsequently passed federal clean water legislation in 1972, adding water quality and wetland concerns to the federal agency mandate, and then endangered species legislation in 1973, protecting endangered and threatened species. A different set of rules now existed for federal projects and permits.

When the U.S. Bureau of Reclamation proposed Choke Canyon in the mid-1970s, the power of these new laws became evident. The federal and state agencies charged with protecting our natural resources—the U.S. Fish and Wildlife Service, National Marine Fisheries Service, and Texas Parks and Wildlife Department—all spoke critically and seriously about the impact of Choke Canyon on Nueces Bay. Although their preference would have been for the reservoir not to be constructed, no agency had the ability or political will to veto this project. Instead, the agencies concentrated on the mitigation requirements for the reservoir.

Mitigation of environmental damage is required under federal environmental law in many different situations. Under the Fish and Wildlife Coordination Act, the resource management agencies have jurisdiction over federal projects that impact water, clearly allowing them to comment on reservoirs such as Choke Canyon. The Corps of Engineers had been granted permitting authority affecting this reservoir by passage of Section 404 of the Federal Water Pollution Control Act Amendments in 1972. The Corps could issue no Section 404 permit without consideration of mitigation. The state water quality agency had authority under Section 401 of the water act to impose conditions on the Corps permit. And, on top of this, the U.S. Environmental Protection Agency was granted veto power over Section 404 permits.

When Choke Canyon was proposed, these agencies commented strongly and often that they were extremely concerned about the impact of the proposed reservoir on Nueces Bay, and that if this reservoir were to be constructed, substantial mitigation must occur. Ultimately, a compromise was reached whereby Choke Canyon could be constructed but only if there were an agreement to release as much as 151,000 acre-feet of water to Nueces Bay. This release requirement amounted to 60 percent of the capacity of the reservoir and was to be implemented by a release plan to be developed in the future.

Because the Bureau of Reclamation and the City of Corpus Christi agreed to this release, Choke Canyon was approved. Without this agreement on mitigation in the future, there would have been no reservoir. The important question that remained, however, was whether the promise of mitigation would be realized.

Choke Canyon was completed in 1984. It took three years for the reservoir to fill, and a serious drought was in evidence—not an unusual event for South Texas. During the time the reservoir was filling and in the ensuing three years, the required releases to the bay did not occur because the details of the release plan had

never been negotiated. By 1990, salinity levels in Nueces Bay were higher than in the Gulf of Mexico. To some extent, the high salinity levels were due to drought conditions. But the chief problem, of course, was that the Choke Canyon reservoir was holding back all the water coming down the Frio, stopping what little water there was, keeping it from the bay.

In early 1990, I got a call from a woman named Erma Patton, who owned a seafood market in Aransas Pass and received shrimp from Nueces and Corpus Christi bays. Erma and her husband J.P. had helped to form a group called the Coalition About the Restoration of the Estuaries, or CARE, and they asked if we could help force the release of fresh water into Nueces Bay. The Pattons and others in the seafood industry were in the midst of a disaster. The shrimp catch was way down, and they wanted to fight for the mitigation water that had been promised.

We told them it was difficult to know what could be achieved until something was tried, and the attempt to make something positive happen was most important. Working back through the commitments that had been made, we petitioned the state to develop and implement a release plan under state water law. It was not enough to agree to mitigation; the mitigation had to be implemented.

Initially, our filing provoked a strong negative response on the part of Corpus Christi officials and some citizens. The Texas Water Commission and the Texas Water Development Board were the two state agencies most directly involved in water rights at that time. They realized that commitments had been made and that failure to follow through on these commitments could jeopardize future water projects as well as Choke Canyon. In late 1990, the Texas Water Commission issued an interim order mandating short-term relief in the form of water releases. At the same time, a longer-term process was begun to negotiate development of an enforceable mitigation plan.

After several years of serious negotiations, the State of Texas approved an operating plan for providing water to the Nueces estuary and issued an agreed order in May, 1995. Under the agreed order, an operating plan was developed that identified varying amounts of water to be released to the estuary under varying conditions. First and most important, the plan altered the requirement of releasing 151,000 acre-feet per year from the reservoir to a requirement that was based upon flow in the river—a so-called pass-through system. If the reservoir was more than 70 percent full, the equivalent of any additional water flowing in must be passed through the dam, up to an amount of 138,000 acre-feet. No water needed be released from storage. If the reservoir system was between 30 and 70 percent full, incoming flows up to 97,000 acre-feet must be passed through. And when Choke Canyon was at less than 30 percent capacity, as little as none or as much as 14,400 acre-feet would have to be passed through, depending upon the level of water conservation being practiced by the City of Corpus Christi.

The reddish egret is one of the most enjoyable birds on the Texas coast. When fishing, the reddish egret spreads its wings and darts here and there across the shallows, seemingly dancing in the shallow flats.

The pass-through requirements were also specific with regard to certain months of the year. Much greater pass-throughs were required in May and June and in September and October, reflecting the historical pattern of inflows to the estuary and our growing knowledge that yearly average flows alone were not sufficient management tools. This agreed order on Choke Canyon mitigation was the most advanced thinking that state and federal agencies had shown regarding equity to the bay and bay users as well as equity to the citizens of Corpus Christi. It was not what was originally negotiated, but it was a release plan that actually might happen.

Despite the relief provided by the agreed order, the City of Corpus Christi continued to try to find ways to keep as much water as possible behind Choke Canyon and Lake Corpus Christi dams. In June of 1997, the City of Corpus Christi, Texas Natural Resource Conservation Commission (the successor to the Texas Water Commission), Texas Parks and Wildlife Department, Texas Water Development Board, Texas General Land Office, and the Coastal Bend Bays Foundation signed an "Agreement in Principle" regarding freshwater inflows to Nueces Bay. The ultimate goal of this agreement was to put as much as 1,800 acre-feet per month of treated wastewater into the Nueces estuary in substitution for pass-through requirements. Under this agreement, when the water stored in the reservoir was at less than 50 percent of capacity, the pass-throughs required by the agreed order would be suspended and would be replaced by the discharge of treated wastewater into the estuary. However, this major diversion never occurred. Instead, a demonstration project was constructed from the Allison wastewater plant, rather than the major diversion contemplated by the agreement in principle.

In addition to releases, the 1997 agreement in principle required three levels of drought contingencies to be prepared by the City of Corpus Christi and to take effect once the reservoir levels went below 50 percent. Conditions I, II, and III of the City's Drought Contingency Plan were to be implemented, respectively, when system capacity fell below 50 percent, 40 percent, and 30 percent. Essentially, these conditions restrict homeowners' lawn watering activities, causing certain types of landscapes to suffer the effects of the drought.

The lake releases and associated drought contingency measures have been controversial and unpopular with some residents of Corpus Christi. "It's not fair to make us cut back while fresh water is being dumped into the bay," said one resident. Another said: "I don't see any reason for wasting precious water to feed the shrimp. If the city hadn't been releasing all that water, we would maybe not be in this situation."[1]

State Senator Carlos Truan, on the other hand, was a big supporter of the releases, noting that the flourishing fishing industry Corpus had enjoyed in the past had been harmed by the loss of freshwater inflow. "We need to be concerned about the people who look at the water coming into our bays and estuaries as wasted," he urged. "How ignorant that is."[2]

Outcry also came from residents living on the older Lake Corpus Christi, near Mathis on the Nueces River. Water that is passed through Choke Canyon must also be passed through Lake Corpus Christi. During the 1990s, residents on Lake Corpus Christi often had acres of dry lakebed at their back doors. Their docks had no water. They were not enjoying the good life by the lake that they thought they had purchased, and they were mad.

The situation on Nueces Bay was critical in 1995 when the Bureau of Reclamation, the sponsor of the Choke Canyon project, completed a mitigation effort called the Rincon Bayou project. According to Heather Alexander of the University of Texas Marine Sciences Institute of Port Aransas, "freshwater inflows had decreased by over 99% since the construction of Choke Canyon Reservoir in 1982."[3] To offer some relief, the Bureau of Reclamation constructed the Nueces Overflow Channel to connect the Nueces River with Rincon Bayou, and then, by another overflow, to Nueces Bay.[4] The Rincon Overflow Channel was activated when the water level was 1.14 meters above sea level, channeling the overflow into an area of hypersaline flats.[5]

The results of this diversion were fairly dramatic. Freshwater inflow to the upper delta increased by 732 percent.[6] The salinity was reduced by these channels, and there was a corresponding increase in microscopic plant life (phytoplankton), emergent vegetation such as marsh grass, and organisms living in the mud, the benthic organisms.[7] These positive results occurred despite the fact that the current level of inflow was only about 2 percent of the historic inflow prior to 1958.[8]

As a result of this successful experiment, the City of Corpus Christi has reopened the channels to the upper delta. Additionally, the maintenance of these channels is now a requirement of the operating rules of the Nueces Estuary adopted by the Texas Commission on Environmental Quality in April, 2001.

All of these changes—the renegotiated releases, the proposed sewage diversion, and the reconnection of Rincon Bayou—were attempts to make a bad situation better and workable. However, these projects were never intended to restore historic flows but rather to mitigate partially the impact of a very large reservoir on a small system. Nueces Bay was on the verge of dying. The changes were designed to attempt to accommodate both the bay and the growing population of Corpus Christi, and there has already been noticeable improvement.

In the summer of 2002, before the rains came, my nephew Seth Mittag and I fished Nueces Bay. We accidentally hooked several oysters that were alive and well. We motored back into the delta and saw the sea oxeye and *Spartina* marshes, the back lakes full of egrets, herons, pelicans, ibis, and wood storks. Bait fish were plentiful. Speckled trout and redfish were present.

Nueces Bay is not restored, by any stretch of the imagination. However, through the efforts of many varied groups, the bay's decline has been stopped and perhaps turned around. This bay will never again see its historic inflows. There is

just too much demand for water in Corpus Christi. But Nueces Bay is the canary in our coalmine. We should carefully study and monitor it for lessons that will be instructive as we debate how to provide San Antonio and other Texas cities with water.

The first and most deafeningly obvious lesson is that promises regarding mitigation have not been kept. Had the releases originally promised from Choke Canyon been made, Nueces Bay productivity would never have fallen to such low levels. But those promises were not kept. This is an important precedent as we evaluate other promises that certain actions will be taken by certain parties in the future. The Choke Canyon promise was written as a condition to a federal permit, and it has not been kept. No water rights were ever set aside for Nueces Bay. Instead, we have seen a continuing erosion of the release requirement, to the detriment of the bay. In the future, we need to focus much more at the front end on the implementation of mitigation.

In short, an excellent environmental analysis was done regarding the impact of Choke Canyon and the need for significant releases, but there was no political will to follow up these studies with legally enforceable commitments. Instead, the politics have worked the other way. As a result, the bay will never be what it was.

The Nueces Bay experience of promises systematically broken provides a negative backdrop for evaluating future water projects. To the extent that we go forward with projects that may harm the bays, we must be sure citizens are fully informed about the promises being made by those trying to gain access to water supplies. We must make sure that everyone involved in a water transaction understands what is being harmed and what is being promised. And we must be clear about the vigilance needed to hold some entities to their bargains.

In Corpus Christi, legal action was required to force the initiation of the proceedings that ultimately led to the agreed order and then the agreement in principle. Even that legal action did not lead to enforcement of the original bargain but only resulted in the adoption of a weaker bargain. And without the willingness of Erma Patton and her friends in the commercial shrimping business to get an enforcement action going, I honestly believe that the progress that has been made to protect Nueces Bay would not have happened at all.

From a water policy perspective, the experiment on Nueces Bay has been an absolute failure. The resource was harmed. Rather than water being released, the bay was starved. The State of Texas was unwilling, on its own, to enforce the commitments that had been made in order to construct the reservoir. In 2003, after all this backsliding, a bill was introduced in the Texas Legislature to reduce even further the amount of water required to be released to the bay.

If there is one thing to learn from the Nueces Bay experience, it is this: say no to promises, to schemes that would impound water or remove it from its river of origin. Leave it alone and in place. Instead, pursue alternatives like desalinization. In the long term, the cost will be lower than the cost of lost bay productivity.

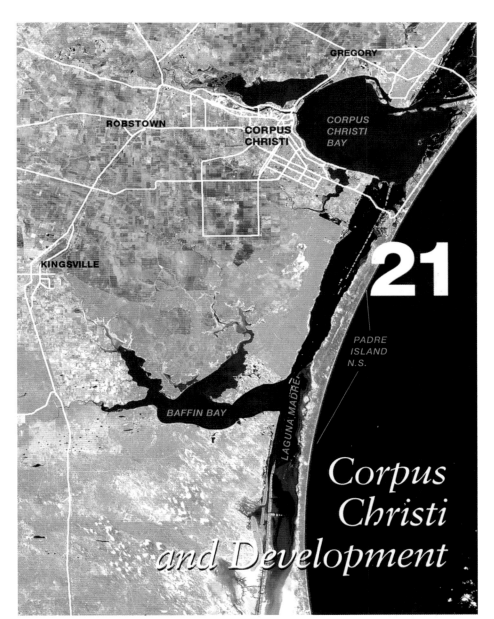

Corpus
Christi
and Development

Corpus Christi sits on Corpus Christi Bay. The Laguna Madre extends southward from Corpus Christi Bay to a large expanse of tidal flats known as the Land Cut because in this area the Gulf Intracoastal Waterway was cut out of land rather than water. The Padre Island National Seashore starts south of the Kennedy Causeway connecting North Padre Island with the mainland and reaches to the East Cut, across from Port Mansfield. Baffin Bay extends inland from the Laguna Madre and is bounded on the north side by King Ranch property and on the south side by the Kenedy Ranch.

"Good morning, it's Moseley," came from the other end of the phone line, and I knew the call was going to be interesting. The caller was Joe Moseley, the brightest coastal engineer I know. Moseley usually has several interesting tidbits of information and often tries to get me involved in schemes that I need to consider carefully before saying yes.

Joe could be a character from Mark Twain. He talked Bob Jones, an excellent environmental consultant, and me into going to the Ukraine and teaching the Ukrainian government about environmental laws and regulations. It turned out that Joe had been trying to win points with the Ukrainian government. The

Chernobyl disaster had occurred about a year earlier, and there was great interest in environmental protection. For a week, Bob and I would go to work and Joe would take off, planning some port deal on the Black Sea.

Joe Moseley was once the executive director of the Texas Coastal and Marine Council, a state agency that has now been eliminated but then had a mandate to investigate issues up and down the Texas coast. The council was the idea of then state senator Babe Schwartz, a legendary coastal figure and the father of the Texas open beaches legislation. Joe and Babe spent many years working together, and Joe learned coastal politics from Babe. What makes Moseley such a good engineer is that he understands policy. He understands how the National Environmental Policy Act is intended to function, and he understands the concept and role of the environmental impact statement. Joe and I try not to wind up on opposing sides of the same project, although it happens from time to time.

Along the coast, a Corps of Engineers permit is needed for virtually any kind of development that touches the tidal water, and to get this permit, some type of environmental documentation is required. The Endangered Species Act applies, as do mitigation requirements for losses of wetlands, seagrass, and tidal flats. Plans have to be coordinated with the U.S. Fish and Wildlife Service and the National Marine Fisheries Service (see chapter 20). Knowing how to maneuver in this permitting environment and resolve the difficult policy and science issues is what differentiates a good coastal engineering firm from the not-so-good ones.

Joe and his partner, Jim Shiner, are headquartered in Corpus Christi, the only large Texas city where the central business district directly faces the coast. The city envelops the southern and western shores of Corpus Christi Bay. High-rise downtown offices overlook the three docks extending into the bay, shaped like the letter T. These T-heads provide mooring for sailboats and shrimp boats and sites for restaurants. Corpus provides a beautiful setting for business, and it is rich in the kind of ecological capital that today serves to attract a skilled work force. Nearby recreational amenities are without equal on the coast. To the north lies Nueces Bay. The Kennedy Causeway connects the south side of Corpus Christi to North Padre Island, and the Padre Island National Seashore extends for eighty miles to the south. No other Texas beach is so long or expansive.

Corpus has a deepwater port and major industrial complex just north and west of downtown. The north shoreline of Corpus Christi Bay is industrial, with the deepwater La Quinta channel running along it, slated to be extended almost to the small city of Gregory. The port and the established industry of a serious petrochemical complex on the bay promote a stable job base. Yet there is a continual push for more, more, more development. *Enough* is a word that does not seem to be in the developers' vocabulary.

Corpus is a prime example of a place where the concept of sustainability meets the reality of economic development, Texas style. Sustainable development

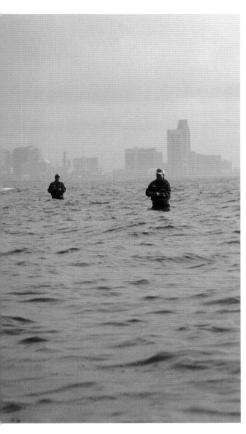

The Corpus Christi skyline rises behind these wade fishermen. Corpus has the greatest amenity value of any major city on the Texas coast, overlooking Corpus Christi Bay as it does. Corpus is where a major conflict between long-term sustainability and short-term economic gain is occurring.

means meeting the needs of current generations without preventing future generations from meeting theirs.[1] It balances economic growth and ecological preservation with an eye toward passing on our natural heritage to those who come after us. It takes into account the carrying capacity of the local environment, allowing for jobs without overtaxing the resource base. If ever there were a place that needed to adopt and implement the concept of sustainability, Corpus Christi is it.

Corpus Christi is the windsurfing capital of the coast. A pebble beach was constructed at Oleander Point, and the U.S. Open Windsurfing Competition was established to take advantage of this windy bay. In the fall, the hawk watching at Hazel Bazemore County Park in the Nueces River delta is unmatched, with over a hundred thousand hawks a day passing through in late September. In 2001 the hawk counters saw almost a million hawks fly over between mid-August and mid-November, 95 percent of them broadwings.[2]

The fishing is excellent north, east, and south from Corpus. It may be the only place on the coast where you can wade fish within view of skyscrapers. The natural abundance around and within Corpus is tremendous, a gift of location that we as a society do not seem to know how to use. The focus of development thinking is so often on some major deal that will change the economy overnight. In an environmental setting where a series of small steps seems more advisable and workable, the thinking instead seems intent on giant leaps.

The single worst development idea on the Texas coast came from Corpus Christi and was made public in Texas only after someone in Washington, D.C., leaked it to the *Washington Post* in 2000. The U.S. Navy conducted gunnery practice on the island of Vieques, in Puerto Rico, and the citizens of Vieques have opposed the navy for years, trying to force them to leave. The fight for Vieques made national news when two F-18s accidentally bombed a communications tower, killing one person and injuring four. The accident provoked rallies and demonstrations, which led to the arrest and thirty-day imprisonment of environmental lawyer Robert Kennedy, among others.[3] It was no surprise that the navy needed alternatives to Vieques.

The surprise was that the economic development promoters from Corpus had been talking to the navy about their Vieques problem, offering the Padre Island National Seashore and the Laguna Madre shoreline as a new venue for combined land, air, and sea maneuvers. These maneuvers would have entailed amphibious vehicles landing on the Padre Island beaches and crossing both the tidal flats and the Laguna Madre. The marine landings were to be staged along with ship-to-shore and air bombardment of the Kenedy Ranch, which borders the laguna.

The outcry against this proposal was strong and immediate. Rancher Tobin Armstrong, a neighbor of the Kenedy Ranch and a Kenedy County commissioner, summed matters up: "It's very, very delicate sand-dune country that has never been farmed because if you put a plow in the ground, it would just start blowing

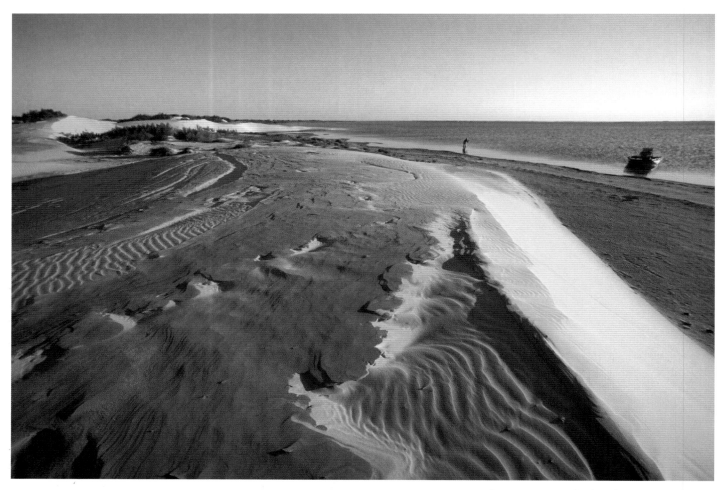

and blowing. You wonder how they could do the things they would obviously need to do and not destroy the thing completely." Mayor Esquival of Kingsville said, "I really believe in our national defense. We are a proactive military city. But there has to be a balance between environment and military needs."[4]

State and national groups pledged to fight the proposal. The Lone Star Sierra Club declared the Padre Island National Seashore "a Texas treasure and one of the last pristine parts of the state"; they promised that thousands of Texans would rally to stop the war games.[5] Fortunately, that was not necessary. The leaked story led to sufficient opposition for the navy to can the proposal before things went that far.

The idea of bombing the shoreline is horrifying because it works directly against the long-term protection and preservation of the Laguna Madre, the fabulous water body that stretches from Corpus Christi Bay southward to Port Isabel

In one economic development proposal, the beaches of the Padre Island National Seashore, the tidal flats, the upper Laguna Madre, and the adjacent ranchland would have been the site of navy air and sea bombardment and amphibious landings. This proposal was stopped by an immediate and strong outcry from several concerned sectors.

and beyond. The upper laguna, just down the way from Corpus, is a major environmental asset of the coast. Part of the reason Laguna Madre is unique is the vast expanse of tidal flats surrounding it. As can be seen from figure 30, there are extensive acreages of tidal flats around the laguna, much more than anywhere else on the coast.[6]

These tidal flats are one of the keys to the productivity of Laguna Madre. Just as plankton and seagrass use sunlight to create carbohydrate in the bays, so do the mats of blue-green algae that form on the tidal flats. The tidal flats are about as productive as seagrass meadows and about 20 to 40 percent as productive as a saltgrass marsh.[7] In the process, the algae create a habitat for flies, beetles, crabs, and other types of small life, which in turn provide food for birds; these tidal flats are essential feeding areas for at least thirty-two species of wintering and migrating shorebirds.

Harsh, baked expanses of sand cloaked in algal mats characterize this habitat. The flats are called wind-tidal flats because the wind, not the moon, controls the rise and fall of the water covering the flats. One effect of the wind-dominated nature of these flats is that they become a "mosaic of microhabitats" rather than a traditional sequence of larger zones with differing characteristics.[8] This mosaic structure means variability in both the extent and location of the microhabitats, and this in turn means that to ensure continuation of the ecological function of the tidal flats, large areas must be preserved.

An environmental sensitivity index was created for the Texas coast to prioritize habitat for protection in the event of an oil spill. The index ranked types of coastline according to increasing fragility, number one being the most durable, like clay scarps, and ten being the most delicate, like salt marshes and mangroves, which take at least twenty years to recover from a spill. Tidal flats rank a seven if they are exposed and receive flushing from the tide, but sheltered tidal flats register a nine because of their high productivity and the impossibility of their subsequent cleaning due to soft bottom sediments.[9]

It is inconceivable that amphibious vehicles could drive over these tidal flats without destroying them. Indeed, the area between the Kenedy Ranch and Padre Island National Seashore contains some of the most extensive tidal flats in the upper Laguna Madre, yet the economic development boosters in Corpus proposed to bring the navy into this area for war maneuvers.

Among the species that depend on the tidal flats is a small bird called the piping plover. A threatened species, the piping plover is a shorebird about seven inches long that makes its living eating insects and small marine invertebrates along the sandy beaches and algal flats. These plovers migrate from the Great Lakes down the river systems to the Atlantic and Gulf coasts. The population is less than six thousand individuals in North America.[10] A 1991 survey found that 55 percent of the remaining birds wintered along the Texas coast.[11] The Texas

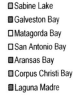

☐ Sabine Lake
■ Galveston Bay
☐ Matagorda Bay
☐ San Antonio Bay
■ Aransas Bay
☐ Corpus Christi Bay
■ Laguna Madre

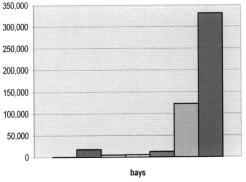

Figure 30.
Tidal flat occurrence on the Texas coast.

Parks and Wildlife Department identifies the reasons for decline of the species as changes in the beaches and lake shores where they nest and spend the winter "due to recreational, residential, and commercial development" as well as beach traffic.[12]

Recent U.S. Fish and Wildlife Service research indicates that a high proportion of wintering piping plovers use algal and sand flats, a factor that was not previously known and that will influence habitat protection endeavors in the future. The same studies show that current development of these flats on the Laguna Madre, continued dredging operations on the Intracoastal Waterway, and the potential threat of oil spills in the Gulf could result in serious losses of plover habitat that may cause extinction of the species in the next fifty years.[13]

The proposal to undertake war games thus not only entailed destruction of the tidal flats; it would also have brought the navy into a major conflict over the impact of its actions on a threatened species protected under the Endangered Species Act. It is a shame to see effort wasted on an idea doomed to fail, an idea so detrimental to the future health and viability of the area's rich natural surroundings.

The key to preservation of the Laguna Madre is to maintain the integrity of the national seashore and keep the big ranches intact. A portion of the King Ranch covers the shoreline from Corpus south to Baffin Bay, and the Kenedy Ranch starts on the south side of Baffin Bay and extends southward beyond the section of the intracoastal cut through tidal flats that are virtually without water much of the time, known as the Land Cut. Baffin Bay is perhaps the most famous fishing spot on the Texas coast for trophy trout. The fishing is fabulous, but the economic development fraternity in Corpus Christi keeps trying to find a way to develop the ranch country to the south of the city.

Consider the Spaceport, a concept straight out of Tomorrowland at Disney World. In 1999, Steve Wurst, the founder of Space Access, started looking into possible sites from which to launch the "next generation of unmanned, reusable rockets." Sarita Kenedy East, the last direct descendant of the Kenedy Ranch's founder, left 130,000 acres of her more than 400,000-acre ranch to the Catholic Diocese of Corpus Christi. Wurst knew the bishop of the diocese from his childhood church in Florida, and he negotiated access to 10,000 acres of the ranch on which to build his Spaceport.[14]

In the Spaceport concept, the spacecraft would take off vertically, soar into orbit, release a satellite, cruise back to land on a 12,000-foot runway, and be ready to fly again in a few days. This would reduce the cost of sending cargo into space by as much as 90 percent and would create the possibility of space tourism in the form of manned trips to the space station.[15] It would also create many ancillary jobs, land development, retail stores for the workers in these ancillary jobs, and jobs for retail sellers, hence the interest.

Texas wooed Wurst aggressively for several years with such measures as the creation of a spaceport authority, tax abatements, and funding for infrastructure

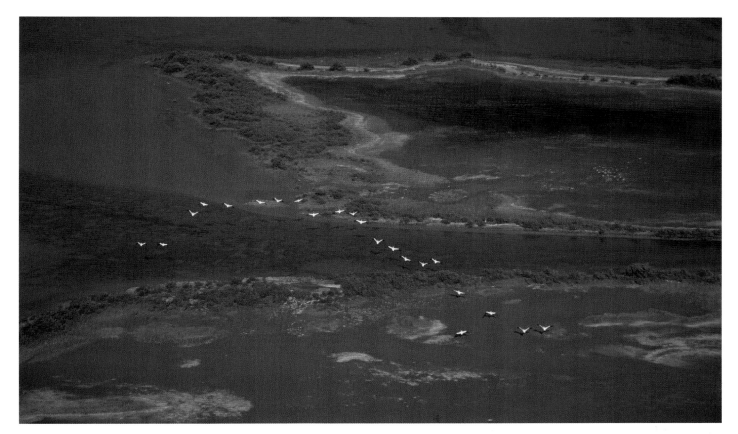

White pelicans soar over tidal flats. The blue-green algae on the tidal flats of the Laguna Madre produce almost as much plant material as submerged grass flats, and 20 to 40 percent of the plant material produced in the salt marsh.

to support the venture. The State of Texas is always a willing partner in these grand schemes. The promise of thousands of temporary construction jobs as well as permanent high-skill jobs and a boost to the South Texas economy got local, state, and private groups working together to create a winning proposal. All that promise did not come without a price tag—an estimated $500,000 in impact studies and eventually $300 million in government revenue bonds, not to mention billions in loan guarantees from the federal government.

As one manager from Space Access put it, "It's very difficult to get an investor to commit $100 million during the initial phases unless we can show them the whole process will be funded and where the other $4.9 billion will come from."[16] And although NASA invested more than $1 billion in both Lockheed and Space Access (the two companies working on reusable rockets), lack of funding always slowed the proceedings. The big stumbling block, however, was securing the federal loan guarantees. "They are really a signal to the commercial industry that investors and the government are friendly to developing this industry," said Representative Solomon Ortiz of Corpus Christi, who sponsored legislation to that effect.[17]

The Kenedy Ranch location was initially high on the list of possible sites; it had plenty of land and air space for the facilities, yet lay close to the ready workforce in Corpus. It seemed to the developers to be the perfect mix of unpopulated yet accessible. "The two Texas sites [Brazoria County and Kenedy County] have been

phenomenally supportive," said Wurst. "They meet all the requirements—proximity to the equator, a large uninhabited area, a close enough proximity to a sufficiently large workforce with possibilities for both barge and rail traffic."[18]

The big problem with the Kenedy County site was that its development would lead to a breakup of the ranchland and would open upper Laguna Madre to development. A barge canal would need to be constructed to the site. Although promises were made that no associated development would take place in the ranch country, promises to limit development in Texas are worthless. I don't believe them for a second. Perhaps more important, there is little water in this area, which was once called the Wild Horse Desert, a land of no rivers and little rain. It cannot support large-scale development, and it should not try.

Ultimately, the ranchers pulled the plug on this bad idea. Tio Kleberg, an owner of the King Ranch, was strongly opposed, citing the inevitable development of surrounding areas and saying: "It would be very bad for the wildlife."[19] In the end, the fate of the spaceport in South Texas came down to a vote of the Kenedy County commissioners. Led by the rancher Tobin Armstrong, the county commissioners voted against it, sending the Corpus Christi developers looking at another site to the south in Willacy County, an area just as water-short as Corpus, another area unable to support large-scale development.

Across from the mainland ranches, Padre Island National Seashore flanks the other side of Laguna Madre with eighty miles of uninhabited, pristine beaches. The national seashore receives over eight hundred thousand visitors each year, the second most frequented park in Texas. Its pale sands and clear waters are home to at least thirteen endangered or threatened species, including breeding sea turtles and migrant birds like the peregrine falcon.[20] I thought Padre Island National Seashore was safe from development pressure, but I was wrong.

Most recently, BNP Petroleum Corporation out of Corpus Christi has launched a campaign to drill in the park and develop the over 60,000 acres of oil and gas leases that it owns on Padre Island and in the Laguna Madre. Although the National Park Service obtained the surface rights to the island, the mineral rights remained private property. And in Texas, these private property rights are firmly protected.

In January of 2001, BNP sought to move forward with drilling and had to face the consultation procedure under the Endangered Species Act due to impacts on the piping plover. However, a most interesting change occurred at the federal level around this same time. In July, 2000, virtually all of the Padre Island National Seashore had been proposed as designated critical habitat under the Endangered Species Act, meaning that approval of drilling activity would have been difficult if not impossible. However, in July of 2001, the U.S. Fish and Wildlife Service removed this protection for the seashore area. The USFWS said: "As discussed in the . . . rule, we considered the effects on exploration and development of

mineral operations that would result from including Padre Island National Sea-shore in the final designation. Based on our analysis under section 4(b)(2), we concluded that the benefits of excluding Padre Island National Seashore were greater than the benefits of including, and therefore, we have excluded that area from the final designation."[21] Don't ever say that oil and gas development are impeded by environmental considerations in Texas. Even the federal government pulls back its protection here.

In 2002, BNP began their first exploratory well, running sixteen-wheel trucks over fifteen miles of beach, bulldozing dunes, and planning a paved road. The Lone Star Sierra Club filed suit, seeking to have the drilling stopped pending a full envi-ronmental review, and citing the National Park Service's *Oil and Gas Management Plan* of 2001, which directs the agency to "phase out driving and development on important local or regional beaches," keeping in mind the nesting habitat of the sea turtles and plovers.[22] As things stand, the only gesture toward this goal is the proposed use of spotters to direct truck traffic during nesting season.

The district court rulings have been against the Sierra Club, and the oil and gas development is moving forward. Attempts are being made to find ways to allow the drilling yet keep the trucks off the beaches. Arguably, the impacts of this activity could be minimized and the damage reduced. But the nagging ques-tion remains—is there no place in Texas that is off-limits to development?

Corpus Christi has many areas where growth can and probably will occur. There are countless acres of open farmland to the west that are available for housing

A drilling rig operating in tidal flats along the laguna shoreline.

development. Beachfront development can and will occur on the barrier island between Port Aransas on Mustang Island on the north and the national park boundary on North Padre Island to the south. There is no shortage of land to be developed.

The privately owned portions of North Padre Island and Mustang Island are areas well known to engineer Moseley. Joe has helped several developers work through issues arising because of the threatened plover and get their Corps of Engineers permits. These permits can usually be obtained if one knows the rules and provides adequate mitigation.

Among other things, Moseley is a specialist in environmental mitigation—the attempt to minimize harm and reestablish those habitats that will be harmed or destroyed by development. His company did the engineering work that led to the successful reintroduction of seagrass behind Galveston Island State Park, and they designed several mitigation projects that, among other things, set aside algal flats for the piping plover, leaving these areas undisturbed. If we are going to allow certain types of development, we need engineers like Moseley to work on solving the problems created by such development.

The biggest development issue on Padre Island right now is Packery Channel, a proposed fish pass and public access channel to open a connection between Corpus Christi Bay and the Gulf where the Kennedy Causeway connects the island with the mainland. Packery Channel has a long history of controversy that seems unlikely to go away any time soon.

Prior to the dredging of the deepwater channel into the Gulf at Port Aransas in 1926, what was then known as Corpus Christi Pass—now called Packery Channel—connected Corpus Christi Bay with the Gulf of Mexico. One of the unintended consequences of the deepwater channel at Port Aransas was that the tidal difference between the Gulf and Corpus Christi Bay equalized, taking away the natural force that had kept Corpus Christi Pass open. In turn, salinity increased, and the fishery suffered.

Over time, pressure mounted to reopen the pass between Corpus Christi Bay and the Gulf. In 1972, Packery Channel was reopened because it was the shortest link between the bay and the Gulf. By 1980, however, Packery Channel had silted in. Lacking financial and political support, it has remained closed since that time.

In 2001, the political climate changed again. Congress authorized the Corps to study reopening Packery Channel, and an environmental impact statement was issued in mid-2002. In a referendum the City of Corpus Christi held on reopening the channel, the citizenry voted to go forward with the project; but Packery Channel remains controversial, mainly because of its influence on island development.

Development of a barrier island is a bad investment, but it is nevertheless pushed by federal, state, and local laws. When a big hurricane comes, taxpayers across the nation pay for localized losses to property in the form of subsidized flood insurance. This is private property, and we live in a state that allows a

private landowner great latitude. Given the current situation in Texas, it seems clear that this private land will be developed in one manner or another. As of this writing, the Corps has just approved the reopening of Packery Channel. With Packery Channel open, development will be faster; without Packery, the rate would likely be slower. That, to me, is the only difference.

Corpus Christi makes me concerned about the future, not so much because of damage already done as because of the grand scheming that continually emanates from this city by the bay. Living within limits sounds so pedestrian, so boring, compared with a spaceport and the promises of great consumption, of more sales, of thousands rather than hundreds of new residents.

The impressive natural resources around Corpus Christi make ecotourism an important concept, representing a basic compatibility between protection and development. So far, we have profited primarily from exploitation, from cutting or extracting or bulldozing or ditch digging. Unless we find other ways to profit, and find them soon, the next big deal could be the one to carve up the ranches and expose the laguna to assault.

Laguna Madre is our most fragile ecosystem. It is hypersaline. It does not have the great pulses of fresh water that are found on the upper coast. The circulation is not good. The laguna is much more vulnerable than any other system on the coast. At the beginning of the twenty-first century, we have the bookends enclosing the resource of Laguna Madre—the King and Kenedy ranches to the west and the Padre Island National Seashore to the east. Keeping the bookends in place is the first objective if we want to save Laguna Madre.

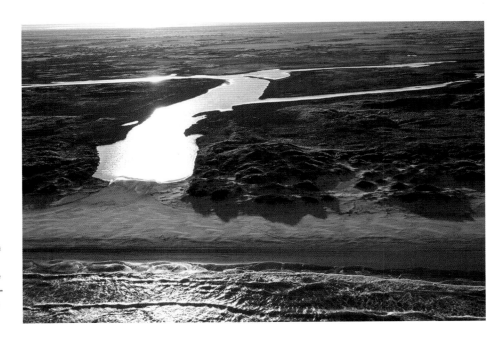

Along the barrier islands, storms open up passes that rapidly silt in again. Some of the larger controversies arise over proposals for artificially maintaining these silted openings between the bay and the Gulf.

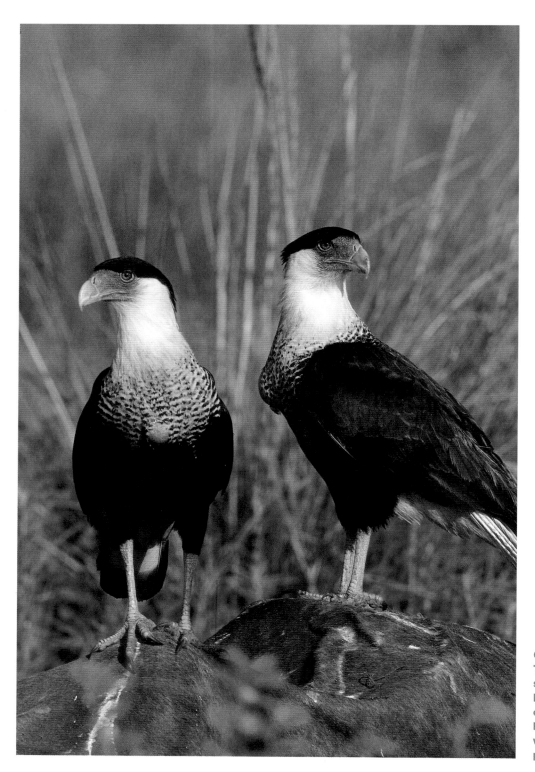

Caracaras feeding on carcass. This photo won the birds of prey section of the 2000 Valley Land Fund photo contest. The landowners are Bud and Jimmy Payne; the photography team was Larry Ditto and Greg Lasley, photo by Greg Lasley.

The Laguna Madre continues on the south side of the Land Cut to Brazos Santiago Pass, connecting it with the Gulf of Mexico. South Padre Island is divided from the Padre Island National Seashore by the dredged channel from Port Mansfield to the Gulf. The Norias Division of the King Ranch is at the top of the map, between Highway 77 and the Laguna Madre.

We met our tour guide, Tom Langschied, in the

parking lot of our motel in Kingsville at 6:00 A.M. in late March. Seven friends scurried to get gear together—John and Princie, Jack and Sue, Dale Cordray, Garland and I—none of us wanting to be the one keeping the others waiting. Tom runs the ecotour program for the King Ranch, and we were to visit the Norias Division, which stretches from Highway 77 to the Laguna Madre, to the south of the Kenedy Ranch. The Norias comprises about 240,000 acres, one of four divisions of a ranch that has a total of about 850,000 acres under single corporate ownership.

Turning off Highway 77 to drive through the entrance gate at the Norias Division was a magical moment for me. As a boy growing up in the Rio Grande Valley, I made the drive north from Raymondville past the Norias Division many times, sixty miles without a service station or a fast food joint. On either side, the fences went to the horizon, punctuated every so often with a gate or an occasional check-in point. This was not public land. It was not a national park. This was Texas private property.

Those of us growing up in the Valley knew that there was natural abundance beyond belief behind those fences. And there were stories, some of them perhaps true, of the fate of those who trespassed beyond the fences to poach the wildlife. Today these private lands are open to the public, for a fee. Some people complain about paying for an ecological tour, but I am for it. The ranches have to make money to stay in existence, and ecotourism is one of several revenue sources they are exploring.

The big ranches of South Texas have managed, so far, to remain a barrier of grass, mesquite, and oaks between the crystal clear water of the Laguna Madre and the encroaching wave of humanity. How long can this barrier be maintained? By paying to see these fabulous ecological preserves, we were not only paying for recreation but also supporting the protection of the Texas coast. After all of those years of being fenced out, of driving by and looking in, I was entering the legend, the mythical King Ranch.

In birding circles, South Texas as a whole is legendary, and many of those birds were in evidence as we pulled into the living compound about half a mile inside the ranch. Our group included some fair birders as well as several novices, and we were delighted by every bird we saw. There were the hooded orioles— black and orange males fighting, twirling down to the ground in a headlock, the world wrestling federation, oriole style. There was a great kiskadee, a flycatcher with a bright yellow breast and black and white markings on its head. A vermilion flycatcher, green jays, color everywhere, and we had only just begun.

I pulled out my new spotting scope and was impressed at how tricky it was to find the birds in the scope. Tom also had his scope, and he found bird after bird, pulling them into clear view. I was fiddling with the focus, trying to get the zoom right, generally exhibiting my lack of expertise with the scope, but I was as happy as I could be, fumbling with my gear, gaining proficiency and experience, beautiful birds literally all around me.

At the King Ranch we needed a guide to gain access to the property, but even when that is not the case, the main reason to get a guide is for his or her expertise. Tom is a professional ornithologist, and it showed from the beginning. Besides being extremely quick with the spotting scope, he knew the birds, easily identifying the ash-throated flycatcher, Couch's kingbird, and the kiskadee. These are not incredibly difficult birds to identify, but one can spend a lot of time paging through a bird book comparing the flycatchers, or worse, the warblers. It helps to have help.

We drove farther into the ranch, facing the early sunlight and glimpsing movement ahead. Two dark forms along the side of the road sharpened into wild turkeys. Coming closer, we saw that the main body of the flock was on the other side of the fencerow, slightly behind some brush. As we slowly drove past, the brush opened to reveal two big toms, their breasts thrust out, the three-inch-long

A South Texas hawk, most likely a redtail, maintains its balance in a mesquite tree buffeted by the wind. The ranches of South Texas provide protection for the Laguna Madre. Ecotourism offers a source of income to keep these large landholdings intact.

beards extending almost horizontally. Like two performers at a show, they fanned their tails, two big guys strutting for the ladies. The morning sun revealed the seemingly brown tail-feathers to be a golden semicircle interspersed with iridescent green and purple, black, and red. That moment made my day.

Deer were everywhere, the bucks sometimes hard to distinguish because they had dropped their antlers after the fall mating ritual. Hunting provides a major source of revenue for the ranch, and it follows strict rules about the harvesting of bucks and does. The ranch managers try to maintain a ratio of one buck for every two does, a high buck to doe ratio by hunting standards, virtually guaranteeing a good response to fall "rattling." This is a technique of striking handheld antlers together, emulating two bucks fighting over a doe, to attract the bucks. Some come to join the fight; some just to sneak away with the doe while the others fight.

South Texas is a windy place, and Tom was concerned that the wind was forecast to gust up to thirty-five miles per hour. The sooner we found our warblers and owls, the better. With that in mind, we moved into the oak woods that run northwest to southeast across the middle of the Norias Division. This area is geologically old and covered with sand dunes. Much of the sandy soil is covered with oak forest, whereas certain areas nearer to the Laguna Madre are exposed dunes and grasslands. Farther west, closer to the highway, mesquite dominates.

The live oak forest is a distinctive habitat on the ranch, complete with leaf litter and understory. Tom stopped the van on a rise, seeing movement in the trees

A deer stands among the grasses that grow to the edge of the Laguna Madre on the King Ranch. Ranch managers try hard to prevent overgrazing during times of drought, concentrating on maintaining the ecological balance.

in the lee of the wind. Our band marched single file into the oaks, dousing ourselves with bug spray to ward off the ticks and chiggers. Small grayish brown birds were moving at the edge of the trees, and we slowly assembled around Tom. He was excited, arm pointing, finger extended, hoping we could follow his line of sight. "There it is," he told us. "An olive sparrow. See it hopping on the ground? And there behind it, the larger bird with the black streaks and reddish back, that's a long-billed thrasher. Wow. This is great. Two of our special birds, right together."

Getting everyone in our group to find each of the birds was not easy. The birds were flitting around, moving behind logs and low limbs, and each of us had a view just different enough from what the others could see to require different landmarks to guide our eyes to the right bird. Tom had a mirror, which can be used to reflect the sun near the bird of interest, but the day was cloudy.

We piled back in the van and had not gone more than a hundred yards when birds exploded out of the oaks beside the road. "There's an Audubon's

oriole," Tom yelled, "and look at all the warblers. There's been a small fall-out. Let's get out and find these birds." The word *fall-out* is music to a birdwatcher's ears, and we all jumped from the van. First we worked the oaks near the road and realized the birds were moving away from us. We circled and came right into the middle of a hotspot, little birds moving to and fro in the oaks, flitting from leaf to leaf, limb to limb, tree to tree.

This was fine birdwatching, but it was also hard. The wind was blowing. The birds were small. Looking for warblers is not like looking at wild turkeys. The smaller species require time and patience and trained eyes. It is hard to follow someone else's eye and directions to a bird. There are only so many ways to differentiate one tree limb from another. *Green* is not a helpful directional word; neither is *tree*. More than one member of the group was heard to add an expletive to the name of a warbler when some people had seen it but others had not. We saw a black-throated green warbler, Nashville warbler, and northern parula; black-and-white, orange-crowned, and yellow-rumped warblers were all confirmed, along with summer tanagers, Audubon's and hooded orioles, and chipping sparrows. We heard the tropical parula, but only two of us saw it.

In the midst of the warbler procession, we heard the love call of a roadrunner—like a loud dove, insistent, hopeful, and somewhat forlorn. It persisted for several minutes, coming closer and closer, and then the roadrunner walked right up to the edge of our warbler-watching party, looking intently at us, clearly wondering what we were doing. We got a close-up look at this bird. It has blue around its eyes and a wonderful brown and black pattern on its back.

Then we started looking for the pygmy-owl. The ferruginous pygmy-owl inhabits the oak forests. This is a tiny owl, measuring only six to eight inches in size, yet other birds fear it. It is rumored to be able to take an Audubon's oriole, which is roughly its size. We were going to find an owl by playing a tape and provoking the pygmy-owl to respond to the sound of the recorded owl, simulating an invader in its territory.

According to our plan, we deployed into the oaks and watched as Tom turned on the tape. Almost immediately, a response came from somewhere ahead, although it was difficult to pinpoint the source. We all had different impressions of where the owl was. For several minutes, Tom played the tape, the owl responded, and we attempted to triangulate the bird. We were crouched down, trying to keep from spooking the owl, when Tom played the tape again. All of a sudden, a larger bird jetted through the forest, right into the area where we had fixed the owl.

"Oh, my goodness," yelled Tom. "That was a sharp-shinned hawk. Did you see if it had the owl in its talons or not?" Several of us had had a clear view of the sharpie and agreed that there had been no pygmy-owl in the departing hawk's talons. However, after its near-death experience, this pygmy-owl was not going to speak up again. Luckily, it had escaped the danger. We went to another

location and without major difficulty found our little owl, complete with false eyes on the back of its head to fool predators.

Over lunch at an old camp house, we talked with Tom about the ranch and its relationship with the natural environment. Even in the time of drought when we visited the place, the grass did not appear overgrazed, the deer were hefty, and the wildlife looked prime. Perhaps more important, the ecological system looked well preserved, seemingly undamaged by 150 years of ranching. The oaks on the ranch are fiercely protected. In a story told about one of the Klebergs, a cowboy declared the need to take out a few oaks so as to get the larger cattle trailers to the road. Mr. Kleberg responded that they needed to find a different route, because not one oak was going to be cut down.

The oaks we saw had been hit hard by Hurricane Brett two years previously, in August of 1999. Many were blown over, although the forest remained intact. A greater worry was fire; the downed trees could provide the fuel for a large fire that might seriously damage the remaining oaks. Hurricane Brett did not cause millions or billions of dollars in damage to human settlements because there are no major settlements nearby. In the television coverage of Hurricane Brett, a reporter from the East Coast who followed the storm, trying to find something that was damaged, finally found a house with its roof blown off in Falfurrias, fifty miles inland. The ranches buffering the Laguna Madre prevent people from building structures in harm's way.

Langschied wants to see the ecotour program at the ranch expanded to include overnight outings and a greater diversity of trips. He wants ecotourism to become a profit center for the King Ranch. He is concerned that birders accustomed to birding for free may hesitate to pay for a quality experience on a private ranch. We are willing to pay someone to take us birding in Costa Rica, or in Africa or India or other international ecotourism destinations. We expect to pay a guide to show us other places, but we are often unwilling to pay someone to take us on a world-class ecotourism experience in our own backyard.

Back in the van, we moved out of the oaks and into the grasslands stretching toward the shores of Laguna Madre. Ahead, we saw two hawks circling in the sky, white tails flashing. The white-tailed hawk is a symbol of the South Texas grasslands, a raptor the ranchers call the fire hawk because it feeds on the insects and other living things fleeing the fires that occasionally break out in the grasslands. On either side of us, sand dunes were clearly visible, white ripples of sand extending to the sky, blown by the ever-present wind. The ranchers talk about the sand dunes "walking" from one location to another, blown from place to place, here covering up oaks, there revealing arrowheads and other artifacts left where the dunes once stood.

You can smell the shoreline of Laguna Madre before you reach it. The seagrass blades float to the surface and are blown downwind until they hit the

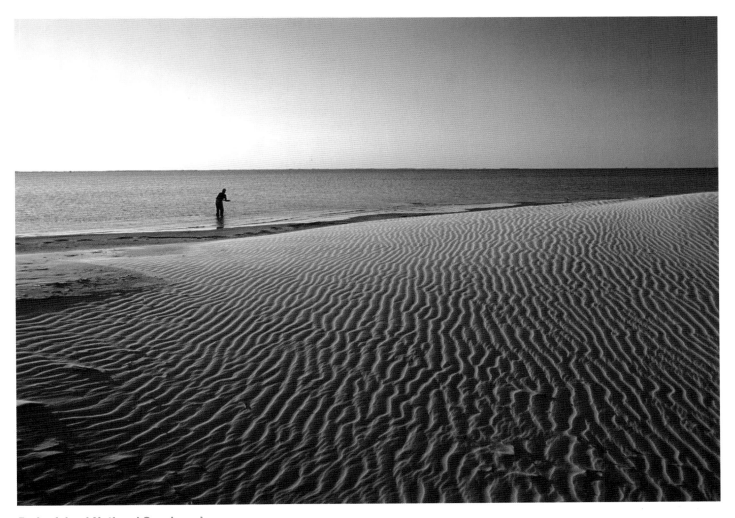

Padre Island National Seashore is across the Laguna Madre from the King Ranch. Together, the ranch and the national seashore protect the Laguna Madre, acting as bookends around this fragile resource.

shore, where they form a thick mat with a distinct odor. On the King Ranch shoreline, we saw no sign of human occupation, not even a cow. There are no transmission lines. There are no condominiums. Only grass, oaks, sky, and white-tailed hawks.

The laguna was white-capping next to us, and a fishing boat bounced its way back to Port Mansfield, twenty or more miles to the south. A dozen laughing gulls hid from the wind behind a spit of land extending out into the laguna. A pair of lesser yellowlegs flew up, voicing their displeasure at our presence, and settled down again, hiding from the incessant wind. This is as remote as it gets on the Texas coast, behind a ranch fence, nineteen miles away from Highway 77, on Laguna Madre.

As if this parade of bird life was not enough to be fully satisfying, the cara-caras to which I feel so connected had been around all morning long: big, strong-looking birds, with white heads extended and red face masks exposed, standing tall on the grass. Now, on the trip back, we saw a huge spiral of black vultures high and caracaras low, just above the mesquite that had recently erupted in its new spring green. We counted more than thirty caracaras in our field of view.

We ended the day with a close-up look at a Harris's hawk, a beautiful dark brown hawk with red shoulders and a white rump. The striking bird posed for us as we moved toward the gate. Harris's hawks are known to hunt together in packs, like wolves, our guide told us. After chasing a rabbit into a brushpile, several hawks stand on one side while a single hawk approaches from the other, flushing the rabbit toward its companions. They then share the meal.

The King Ranch has been an excellent steward of vast lands. It has also been a player in the laguna's ongoing saga regarding dredging of the Intracoastal Waterway and disposal of spoil material—the silt and mud removed in the pro-cess of keeping the channel navigable. The shallow Laguna Madre would not be passable to barges and tugs without a dredged channel, and dredging once is not enough. Over time, the waterway would silt in and close to barge traffic were it not for recurring excavation during maintenance dredging.

The main problem to the ranch comes from the manner in which the Corps of Engineers disposes of spoil material. Spoil has historically been dumped into the open water of the bay, a practice called open bay disposal. This practice de-stroys hundreds if not thousands of acres of seagrass, and it produces horrible water quality for many months, even years, afterward. A shift in wind direction can mean muddy water for miles downwind. Recent studies show that bare patches within the extensive seagrass beds of the Laguna Madre had increased over 280 percent by the late 1980s and are still on the rise. Increased turbidity associated with open bay disposal of dredge spoil accounted for a 60 percent loss of seagrasses at depths greater than four feet.[1] Yet when the Corps evaluated its disposal prac-tices during planning for the next fifty years, they concluded that open bay dis-posal was still their favored method, despite its environmental consequences.

Walt Kittleberger is one of the environmentalists opposing open bay dis-posal of dredge spoil. Walt moved to Port Mansfield from Houston over a decade ago and became a fishing and birding guide. Working with the Lower Laguna Madre Foundation, he has become one of the most dedicated protectors of the lower laguna. Walt counts among his allies the King Ranch, in a partnership similar to the O'Connor family's emerging interest in protecting the Guadalupe River and San Antonio Bay.

When I spoke to Walt about this, he had just returned from a hearing before a subcommittee of the Texas Legislature, and he was enthusiastic because it seemed the committee might take a position supporting offshore disposal of the dredged

The collared peccary—or javelina—is one of the many mammals that might be seen on a South Texas ecotour.

material. Walt was slow to get too pleased, however. As he said, "Today, I don't get excited until something happens."

In his fight over spoil disposal, Walt attempted to utilize the Texas Coastal Zone Management Program to change the dredging practices. The Texas coastal program is presided over by the Coastal Coordination Council, appointed by the governor and administered by the Texas General Land Office.

The decision by the State of Texas to establish a coastal management program was highly controversial. Congress passed the Coastal Zone Management Act (CZMA) in 1973. This federal law is an example of what then president Richard Nixon called new federalism: it does not force states to develop programs. Any state not wanting to participate could choose not to do so. For more than ten years Texas chose not to participate in the federal coastal program. Then, under the leadership of Governor Ann Richards and Land Commissioner Garry Mauro, a state coastal program was developed, and a new agency called the Coastal Coordination Council was created. The new agency had the responsibility of passing rules providing for review of federal permits and projects and certain state permits and projects to determine if they were consistent with the coastal management policies adopted by the council.

In theory, many actions affecting the coast should be subject to review by the council, but the scope and strength of the state's coastal program were limited by the rules implementing it. Although relatively few actions are directly reviewed by the council, major federal actions that require environmental impact state-

ments are subject to Texas coastal review, and that is where Walt is heading. In the legislative hearing, the committee recommended a policy preference for off-shore disposal of the dredged spoil from maintenance dredging of the Intracoastal Waterway. If adopted, such a policy would represent a major change for the State of Texas, and Walt is gratified on that level.

Walt and others, including the King Ranch, have been fighting dredging practices for almost a decade. The King Ranch took a strong position in the early 1990s against use of their land for dredged spoil disposal. When open bay disposal became controversial, the first alternative sought by the Corps was to use King Ranch land for onshore disposal. The ranch would be paid, according the Corps' plan. But the King Ranch not only said no; it said hell, no. When told of the Corps' plan in the early 1990s, the lawyer for the ranch, James Moorman in Washington, D.C., said his clients were adamantly opposed to allowing their land to be used for spoil disposal.[2]

The prospect of an enemy as powerful as the King Ranch certainly changed the dynamics of the fight. The ranch and others began to look at the usage of the Intracoastal Waterway and started raising questions about the lack of commerce there. Relatively little traffic moves along this section of the waterway. The Texas Center for Policy Studies has been studying Laguna Madre environmental issues for over a decade, and Mary Kelly, its former executive director, has been outspoken in her criticism of keeping the waterway open. Kelly views the Gulf Intracoastal Waterway as a giant pork barrel project that subsidizes the barge industry at the expense of the environment and taxpayers.[3]

Kelly is a tough environmental lawyer, has worked extensively on the Texas-Mexican border, and has delved deeply into Mexican environmental policies. She was the first to blow the whistle on a poorly thought-out concept to extend the intracoastal southward from Port Isabel, past the highly polluted Rio Grande and through the Mexican portion of Laguna Madre, terminating at the port north of Tampico. This proposal would have opened up hundreds of miles of pristine bay shoreline in Mexico and would have had substantial negative environmental impacts. Most important, the cargo could be moved across the Gulf rather than down a new artificial waterway through undeveloped territory.

Kelly may have been paid the greatest tribute among the environmental lawyers I know. According to a story that sometimes changes in the retelling, the then governor (or perhaps his assistant) of the State of Tamaulipas, Mexico—the state where the waterway extension was proposed—was once asked what his biggest problems were. Almost without thinking, he responded: "Narcotraficantes y Mary Kelly." Kelly rated right up there with the dope smugglers.

Fights like these are neither pretty nor tidy. The barge industry is powerful. It has long been subsidized by a national program of canal construction and dredging, and the environment is harmed by channel maintenance. Each acre of

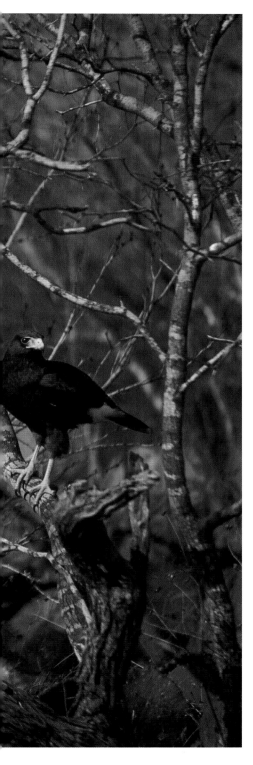

Laguna Madre seagrass is worth at least ten thousand dollars a year in ecosystem services, according to Costanza's calculations, yet the barge industry has taken hundreds if not thousands of acres from the Laguna Madre over the sixty or so years that the Intracoastal Waterway has been in operation and never once had to pay compensation.

The future of the lower laguna depends on properly managing the waterway and protecting the ranches. If the ranches are lost, the barrier safeguarding the laguna will be lost. The greatest threat to the ranches comes from laws on inheritance taxes. When thousands of acres of land are passed from one generation to another, the new owners face a hefty tax bill. According to John Martin of the Valley Land Fund, "When a landowner dies, the heirs are stuck parceling out the land or bulldozing it in order to pay the taxes. The effect of the estate tax law on the private landowner in South Texas is horrendous. If we don't change the tax laws in this country dealing with the very people who have the habitat, we are not going to save anything."[4]

John Martin should know. The Valley Land Fund, formed in 1986, is one of the most successful and important conservation organizations working with ranchers in South Texas. Its purpose is to preserve, enhance, and expand the remaining wildlife habitat of the Rio Grande Valley, including the brush country adjacent to the Laguna Madre. For the ranches of South Texas to survive, we will need to help them. To the greatest extent possible, we should support policies that allow landowners who wish to conserve and maintain these ranches to do so. This means making inheritance laws more flexible and establishing tax credits for certain preservation activities. Perhaps special conservation easements can be purchased across large acreages on a willing buyer, willing seller basis.

The bottom line is that these ranches protect the Laguna Madre. The ranches surrounding it need to remain intact and functioning, as they have been for more than a century, if North America's only hypersaline lagoon is to be preserved. Leaving the King Ranch after our eco-adventure, I reflected on the leadership and stewardship that this institution provides. Their pastures are well maintained and their policies, both internal and external, seem guided by a philosophy that will ensure the continuation of this bounty for future generations to enjoy. On my trip to the ranch, I found more than pretty birds. I found another reason for hope on the coast.

A Harris's hawk—a South Texas specialty bird—perches majestically on a mesquite. These birds have quite a reputation as innovative predators, sometimes collaborating to secure prey.

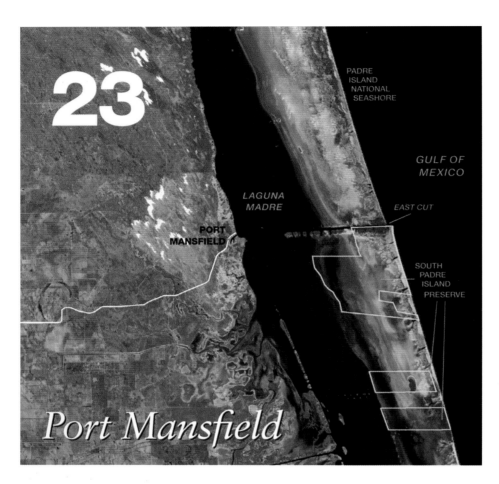

PADRE
ISLAND
NATIONAL
SEASHORE

GULF OF
MEXICO

LAGUNA
MADRE

EAST CUT

PORT
MANSFIELD

SOUTH
PADRE
ISLAND
PRESERVE

Port Mansfield

The road ends in Port Mansfield. Across from Port Mansfield is the East Cut, which separates North Padre from South Padre Island. The Texas Nature Conservancy purchased over 20,000 acres at the north end of South Padre Island, land that at one time was slated for intensive development.

Dick Morrison and I worked together when the Galveston Bay Foundation was formed in late 1986 and have been friends ever since. His son Richard was an associate in my law firm, a young man who wanted to protect the environment as a lawyer. The three of us were headed down the coast from Houston to Port Mansfield to fish, talking all the way.

I love driving down the Texas coast. I like to greet the rivers—the Brazos, San Bernard, Colorado, Lavaca, Guadalupe, San Antonio, Mission, Aransas, Nueces—checking off each one in my head, seeing which are up, which are down. I like to see what birds are out, how the crops look, what kind of shape the brush country is in. To get to Port Mansfield, we turned east at Raymondville and drove in a straight line to the water. You can tell you are close to Port Mansfield by the distinctive odor of seagrass decomposing on the shoreline, just as we had smelled it on the King Ranch portion of the shore.

Dick is a lure fisherman, and he sets out with a box that must weigh fifty pounds. This is not the tackle box of my childhood, a smallish metal box with a handle on top. This is a suitcaselike canvas bag full of plastic boxes brimming with every conceivable type of lure: topwater lures with black bodies and chartreuse heads, soft plastics with chartreuse tails and white stomachs and mottled brown backs, red ones with white tips and a fat stomach—just about every color in the rainbow is present and accounted for.

Years earlier, I had first heard about Walt Kittleberger through Dick. Dick and George Bolin were Texas Parks and Wildlife commissioners together, and they fished out of the Mansfield Club at Port Mansfield. George was one of the original founders of GCCA and a friend of the bays of Texas. Dick called me one day, all upset about plans by American General Realty of Houston to develop the north end of South Padre Island, just across the Laguna Madre from Port Mansfield. He told me he and George and a man named Walt Kittleberger were working together to stop it, and he wanted my help.

The development American General proposed was quite large, a destination resort where people would come and stay for several days, perhaps like Cancun on Mexico's Yucatan Peninsula. Dick asked me to look at the legal issues arising in the context of this proposal and see if I could find a way to help defeat it.

As Texas Parks and Wildlife commissioners, Dick and George had already opposed the widening and deepening of the Houston Ship Channel and the open bay disposal of dredge spoil that would have covered 10,000 acres of Galveston Bay several feet deep in mud. On a particularly dark day during that fight, George got a call from a prominent banker in Houston, who said all George's loans would be called if he continued to oppose the project championed by the Port of Houston and the Corps of Engineers. The way I heard this story, George told some of the other commissioners about this threat, and one of them raced to the bathroom to throw up.

The commissioners went ahead with their opposition to the ship channel project, and the prominent banker called the demand notes, forcing George Bolin to declare bankruptcy. Yet a few years later, George was once again fighting for the health and long-term integrity of the bays, challenging those who tried to dominate him into silence, bucking a system where you get rewarded for silence, for not speaking your mind, for not following your conscience. "You want a contract? Keep your mouth shut." "You want our law business? Keep your mouth shut." Many take the advice to heart. Few voices are heard confronting the power structure square on, and men who have it in them to challenge the overwhelmingly male establishment are even rarer than women willing to do so.

The American General project targeted over 20,000 acres of land on the south side of the East Cut, the man-made channel that connects Port Mansfield with the Gulf of Mexico through Padre Island, creating North and South Padre islands. This land was 26,000 acres of sand dunes and tidal flats with no water

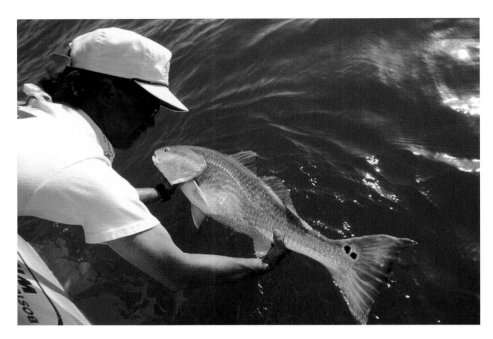

The redfish is a prized game fish on the Texas coast, which has many bays named Redfish Bay. One of these is adjacent to Port Mansfield. Any redfish caught that are larger than twenty-eight inches should be released back into the bay, like this one, because they are part of the breeding population.

supply and no access to transportation. As a destination resort, the proposed development would have transported tourists by bus from Valley airports to Port Mansfield, then ferried them to the south side of the East Cut by hovercraft. Several hotels and at least one golf course were to be constructed on 3,000 acres of land.[1] Fly 'em, bus 'em, and hover 'em on in.

All necessary supplies and workers on the site were to be transported every day from Port Mansfield, which would have been transformed from a little fishing village to a base of operations for the resort. No long-term water supply existed for either Port Mansfield or the island development. Boat traffic would be incessant; supplies would have to be restocked every day for the thousands of tourists projected to use this fine facility.

In order to build on the northernmost 3,000 acres, American General proposed the creation of "coastal conservation districts," special governmental districts created by the Texas Legislature with the ability to issue bonds and raise the taxes needed to build roads, waterways, and utility projects. Senator Carlos Truan of Corpus Christi was one of the major foes of this proposal and helped George and Walt and Dick eventually kill it.[2]

When Dick called me for help, he asked all the right questions. What types of permits were required? Are these Corps permits? Are there state permits? Does the state have any overriding authority here? Were there any endangered species on south side of the East Cut? Would endangered species make a difference?

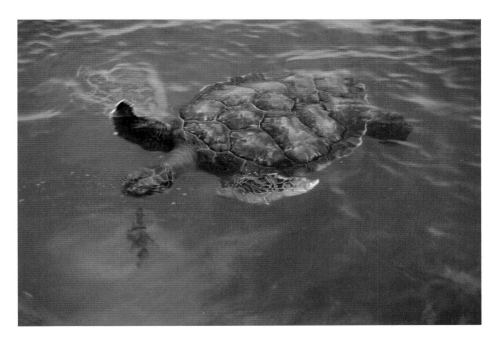

Endangered species such as this sea turtle helped defeat a proposal to develop a destination resort on the sand dunes and algal flats at the north end of South Padre Island, across from Port Mansfield.

I told him that there certainly would be Corps of Engineers permits required. Some type of dock would have to be constructed, and that dock would require a permit under Section 10 of the River and Harbor Act. Most likely, a channel would be dredged into the interior of South Padre Island, also requiring a Section 10 permit from the Corps. If seagrass meadows, tidal flats, or wetlands were to be filled, a permit would be required from the Corps under the Clean Water Act.

The National Environmental Policy Act or NEPA applies to all federal permits. Because the development would not exist "but for" the access provided by the Corps' permitted activity, the entire development would have to be evaluated in an environmental impact statement. As for endangered species, they certainly exist at the East Cut. Sea turtles routinely come in and out of the lower Laguna Madre through the East Cut. Peregrine falcons migrate down Padre Island, and the petite piping plover frequents the algal flats along the laguna side of the island. Brown pelicans, which were listed as endangered at the time, dive for fish in the East Cut. There was no doubt that the Endangered Species Act (ESA) applied.

From a tactical standpoint, the ESA and NEPA are quite different weapons. NEPA requires full disclosure of impacts before resources are destroyed. It is a disclosure act that does not protect the environment in a substantive way but simply requires that procedures be followed to ensure that the federal decision maker—the colonel at the Galveston District of the Corps—understands the con-

sequences. Litigation under NEPA can delay a project, and delay is the friend of those opposed to a project. Until the first spade is turned, the project has not yet happened; without a permit, no spade turns.

The ESA is more substantive. Federal law prohibits the "taking" of any endangered or threatened species by anyone. Taking is defined to include harm and harassment as well as killing and capture, and real estate development can be interpreted as an action that, in certain situations, could lead to a taking of an endangered species. In addition, all federal actions and permits are prohibited from "jeopardizing" the continued existence of any endangered species. If the development would jeopardize the existence of an endangered species, then the permit would have to be denied.

This was music to Dick and George and Walt's ears. Between the impacts of the project on endangered species and the more general impacts to the island and the bay, both NEPA and the ESA would have a major role in the fight against this project. There was no way that a huge resort development like this could be consistent with the maintenance and preservation of the lower laguna. The water demand was way beyond the ability of any infrastructure to deliver it, and wastewater from the development would have destroyed the balance of the laguna. Service vessels would be entering and leaving the harbor twenty-four hours a day, turning a quiet fishing village into a transportation hub. The battle was joined.

American General's full-page advertisements in favor of the creation of a conservation district featured a picture of an ostrich with its head in the sand, depicting the state and its citizens as hiding from the coming reality of coastal development. American General also claimed that the resort would cater to ecotourists who wanted to enjoy the coastal environment.[3]

By claiming ecotourism benefits, American General leaped into one of the major controversies concerning development and the environment. If ecotourism destroys the ecological setting that is the attraction, then it cannot be classified as ecotourism. The issue is one of scale, and American General's plan was way out of scale with the sensitive environmental setting it proposed to develop.

Walt pressed a number of coastal groups to join in the opposition and got mad at their slow response. Vinson and Elkins, the lawyers for American General, tried every hook they could find to push the project through. Chits were called in on both sides. Tempers flared. Friendships were damaged, if not ended. All maneuvers notwithstanding, American General failed to get their conservation district, and they withdrew from the project.

The land proposed for this development changed hands after the big fight, and rumors surfaced here and there that the Nature Conservancy of Texas might purchase it. And then it happened. In March of 2000, the Nature Conservancy purchased 24,500 acres of the land that had been proposed for development by American General. In purchasing the tract, Robert Potts, then director of The

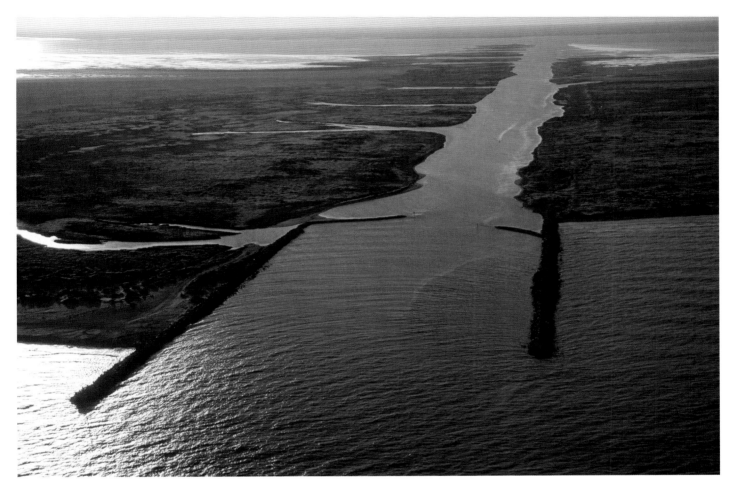

The East Cut at Port Mansfield connects the Gulf of Mexico in the foreground with the Laguna Madre behind the barrier island. The Nature Conservancy purchased 24,500 acres of land, including the area to the left of the East Cut, in March, 2000, after coastal activists such as George Bolin, Dick Morrison, and Walt Kittleberger had stopped development of this fragile and important habitat.

Nature Conservancy of Texas, stated that the property would be critical in the protection of sea turtles, peregrine falcons, and the piping plover.[4] As at the Wallisville reservoir, as with Texas Copper and the Tamburine property on Galveston Bay, and as with the proposal for Deeport on Harbor Island, opposition had led to changed plans and ultimately to preservation.

The Nature Conservancy of Texas plays a unique role along the coast. This is an organization of people who do not join the environmental fights, concentrating instead on working with landowners and purchasing land, either outright or in conservation easements. Their goal is to preserve meaningful parts of ecosystems. They have the ability to raise large amounts of money because they are not involved in opposition activities, making them "safe" for corporate donors.

There is a spectrum of activities and efforts in the conservation community. All players do not have to be activists; all do not have to be land purchasers. Both

functions are necessary. However, it is much more difficult to raise money for activism in Texas than for purchases, and the tendency, the seduction, for many groups is to set aside activism in order to find more money from corporate coffers. At some point, groups can lose their voice if they take too much money from corporations.

Carter Smith, the new director of the Nature Conservancy of Texas, can talk for hours about the habitat of the coast—where native prairie remains, the subtle differences in soil types and vegetation, formation of prairie potholes, the vegetation and birds of the coastal wetlands. Carter was responsible for the Nature Conservancy's property acquisition on the southern half of the Texas coast. He knows this country like a favorite book, and he talks with ease about the conservancy's priorities for areas to preserve. There are six habitat priorities: the freshwater wetland complexes extending south from Port O'Connor; oak motte habitat of the Ingleside barrier; whooping crane habitat; the natural prairie and prairie chicken habitat of the Refugio area; the South Texas thorn brush; and the barrier island habitat for endangered species.

Today, as a result of action by Carter and the conservancy, the American General tract on South Padre is set aside in perpetuity. This land will be operated as a reserve of the Nature Conservancy of Texas or as part of the Laguna Atascosa National Wildlife Refuge, which lies on the mainland across from the southern portion of the 24,500-acre tract. By owning land on both sides of lower Laguna Madre, the refuge and the conservancy can operate much like the ranches and national seashore do to protect the upper laguna.

Fishing with Dick Morrison—being out on the water with a man who has fought for the coast—felt great. We first headed south, fishing across from the American General tract, and then Dick cranked up the motor and headed north, with the King Ranch shoreline on one side and the Intracoastal Waterway on the other. Thirty minutes later, we pulled up behind several small islands, sorted our lures, and jumped into the water. Dick is one of those rare people who really know how to fish, and his son Richard takes after him. Successful fishing calls for a certain zen—feeling your lure, working the rod tip, watching the water, looking for bait moving. I like the concentration, but I am also easily distracted.

One of the topics of discussion when we got back into the boat was the difference in bay bottom from one location to another. Some of the areas we were wading were soft, and in places we sank above our ankles in the gushy mud. Speculation about the cause of these soft-bottom areas led to discussion about other soft-bottom places we knew, including the places where shrimp farms discharge into coastal bays.

Richard has fought shrimp farms near Palacios, and Walt has opposed them on the Laguna Madre and Arroyo Colorado, a tributary to the laguna. Shrimp farms are holes in the ground filled with water, shrimp, nutrients, and waste

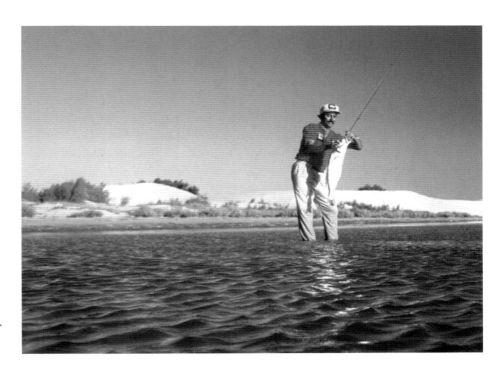

A fisherman with an impressive speckled trout caught off Padre Island. Large speckled trout have near-mythical status as game fish.

material—holes in the ground that discharge untreated and partially treated shrimp waste into the bays. Places where the waste enters bays become a boggy, soggy mess, the bottom covered by organic material that builds up slowly over time, not suitable for life.

Apart from creating nasty discharge sites, a major concern about shrimp farms is that they raise shrimp not native to our Texas coastal waters. These non-native shrimp could get loose and thrive, to the detriment of local species. A second and perhaps more pressing concern is that shrimp farms are breeding grounds for viruses that can infect native populations.

Shrimp farms have been the focus of several heated fights at the state water pollution control agency (formerly the Texas Natural Resource Conservation Commission, now the Texas Council on Environmental Quality). All of us who have fought these farms have encountered a state agency more concerned with issuing permits than with protecting the coast. There has been some relief from the past practices of untreated discharge, but many on the coast remain worried about the damage shrimp farms could do.

Texas, as a state, does not seem overly concerned about the introduction of non-native species to our bays; it is an issue that should spark more debate. We are routinely living with the consequences of global trade, of moving species from

one part of the world where they are part of the ecosystem to another part of the world where they have no predators or where they are not prey for any of the local animals.

The State of Texas allowed grass carp to be released in Lake Conroe, for example, on the promise of the developers around the lake and of Texas Parks and Wildlife that these fish could not reproduce in Texas. Galveston Bay tributaries are now full of grass carp, with numerous youngsters among them. Many of the wetlands of the San Jacinto River have been eaten by these carp, which have few if any predators on the Texas coast. Today we have poorly regulated shrimp farms and there is not much to be done about it, except to monitor the native shellfish and hope that a virus does not get loose. Surely it would serve us better to be very careful about shrimp farms and to concentrate on the management and full use of our own shrimp fishery.

Walt has fought shrimp farms, dredging, and developments, but he makes his living as a fishing and birdwatching guide. He generally takes out only a few birdwatchers with highly specialized needs, those wanting to see or photograph the green coloration on the breeding great egret or the purple bill of the breeding reddish egret. During the breeding season, the rookeries of fish-eating birds are raucous, colorful, and bursting with life.

Walt's specialty as a fishing guide is speckled trout, one of the most highly prized game fish on the coast. A speckled trout is sleek and fast, particularly when compared to the redfish. Schools of trout can often be found by locating hovering gulls that dip down to grab shrimp coming right out of the water to escape the trout. The trout found under the birds are usually small ones, known as schoolies.

Speckled trout are now considered game fish and are protected from commercial fishing. They spawn in the bays during the spring and summer, peaking during May through July. A large female can release as many as a million eggs, most often in the grassbeds where they exist. Specks can be found in any part of the bay, both larvae and adults frequenting in deep channels as well as in grassbeds and flats.

A large speckled trout enjoys near mythical status among anglers on the Texas coast. When you hear about big ones, they are almost certainly females. A four-year-old male speck is eighteen inches long, while a four-year-old female averages twenty-three inches. Big specks of over thirty inches have been caught— truly remarkable fish. Some fishermen concentrate solely on this quest, spending hours walking flats in search of one large sow speck, an objective requiring more patience than I can muster.

A few months after my trip with Dick and Richard, Seth and I fished for speckled trout with Walt, questioning him as we moved from place to place about why a trout might be here and not there. We learned of "guts" and flats and areas

that were only slightly higher than the surrounding bay bottom, providing just enough difference to enable a predator to gain an advantage over its prey. We learned that Walt could catch speckled trout when we could not, a testimony to artistry.

Walt scowled as a series of boats came down the Intracoastal Waterway from the north. He spat out the information that those boats contained "croaker soakers," recreational fishermen who fish with live croaker. These boats had traveled south from the Corpus Christi area, crossing through the Land Cut and coming down into the lower laguna, where the trout had not been fished as hard with croakers.

Use of croaker as bait is highly controversial. A croaker is a small finfish that is quite good to eat. Commercial fishermen have known for years that croaker makes excellent bait for large speckled trout. A coastal anecdote describes a commercial fisherman from Corpus who put a washtub in his flat-bottomed boat and went out every day and loaded it up with specks caught on croaker from the reefs in Nueces and Corpus Christi bays. Every day, another full washtub.

Croaker are a controversial bait used to catch large speckled trout. Fishing with croaker used to be a commercial fishing technique. After banning commercial fishing for speckled trout (as well as redfish), recreational fishermen now use the same technique as commercial fishermen once utilized to catch speckled trout.

Recreational fishermen now make extensive use of croaker as bait. There have been fights at bait camps over which fishermen can claim the few croakers left for sale. Because croaker fishing can be difficult for a new angler, guides often hook the fish for the client and then hand over the rod. Tournaments have been won by so-called anglers who merely took the rod from the guide and pulled the trout into the boat.

Multiple ironies creep into focus here. Recreational fishermen want to see enhancement of the speckled trout population, but their camp also contains the croaker soakers. Recreational fishermen forced commercial fishermen away from speckled trout but are now using commercial fishing practices to catch the big specks themselves. Like redfish, speckled trout live for many years. As we perfect our ability to catch larger and larger specks, primarily with croaker, we are taking the larger breeding females out of the bays. It takes no great leap of imagination to see that if we restricted use of croaker as bait and required that larger trout be released, as we currently do for redfish, both the fishermen and the speckled trout would wind up winning.

Late in the afternoon, Walt and Seth and I fished the water near the East Cut for trout. In the soft afternoon light, we saw pelicans diving after bait fish in the channel, folding their wings, extending neck and bill, slamming into the water. Behind them, the undeveloped sand dunes at the north end of South Padre Island bore silent testimony to the power of a few individuals to make a difference.

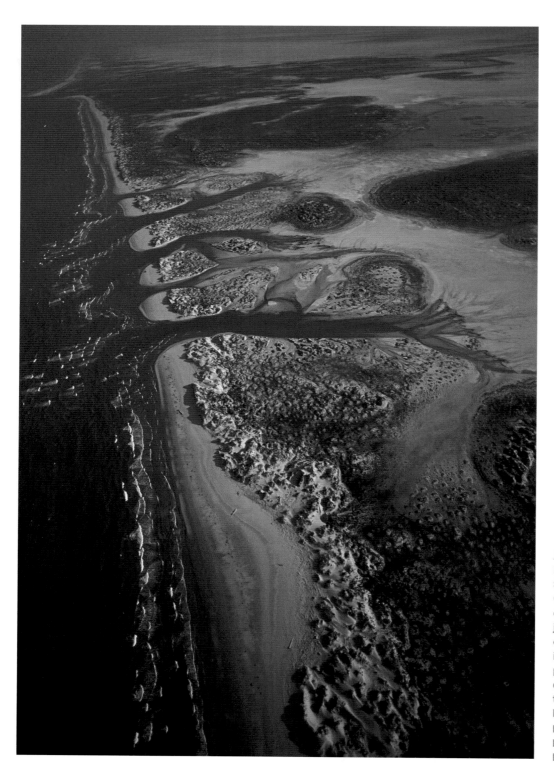

A view southward along Padre Island National Seashore toward the East Cut (where the land extends out into the Gulf behind the jetty) shows a dynamic world of sand. Preserved barrier islands are a great insurance policy against unwise coastal development and promote the long-term health of the Laguna Madre. They also provide fine habitat for peregrine falcons and piping plovers.

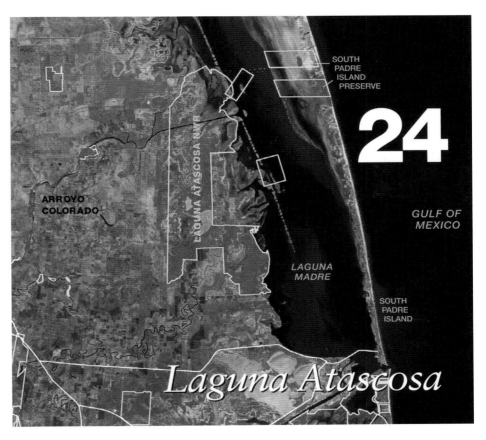

The Laguna Atascosa National Wildlife Refuge is adjacent to the Laguna Madre and lies across from South Padre Island and the southernmost of the tracts now owned by the Texas Nature Conservancy. The large sandy flats between Highway 100 and Highway 1792 north of the Brownsville Ship Channel were recently purchased by the Conservation Fund and will become part of the national wildlife refuge system. At lower right are the South Bay Coastal Preserve and the lands that are now part of the Lower Rio Grande Valley National Wildlife Refuge.

Gib Little cut the motor and coasted to the edge of the Gulf Intracoastal Waterway and into a small side bay, shallow and full of seagrass. The shoalgrass glistened in the early morning sun, the underwater meadow revealed in the clear water of the lower Laguna Madre. The key to fly fishing for reds is to be quiet and observant. We were looking for nervous water—water with a surface pattern distinct from that produced by the prevailing wind. Gib took his position at the front of the boat, legs extending over the side, pulling the boat forward with his feet in the shallow water.

As I looked across the water for tailing redfish, the early morning embraced me. I was fishing with my eyes, looking for movement, all senses alert. I noticed the gray sentry, the great blue heron, standing at the side of the mangroves, suddenly stabbing a careless mullet. Black skimmers flew slowly across the surface, their orange beaks extended like scissors into the water. I looked to one side in response to a splash and saw a Sandwich tern heading back up to the heavens, seemingly stopping in midair to shake its meal down.

Submerged seagrass in the Laguna Madre is an important habitat that must be protected in order to preserve productivity.
Photograph by Jim Blackburn

Suddenly Gib whispered, "There's a pod just to the left of the sun." At first I couldn't see them, but then the tails appeared, ghostlike, wisps of motion flitting to and fro, like lace above the surface. The fish were feeding on crabs and shrimp in the seagrass; we had not bothered them yet, and we intended to keep it that way.

Along with tidal flats, seagrass is what makes Laguna Madre so productive. Four main types of seagrass are found in the laguna: widgeon grass, shoalgrass, turtle grass, and manatee grass. Widgeon grass, an excellent waterfowl food, is often found interspersed with shoalgrass, the primary food source for redhead ducks. Turtle grass is found in slightly deeper areas and is grazed by sea turtles. Manatee grass supplements the sea turtles' diet but is found in less disturbed, more pristine areas.[1]

Seagrasses require clear water conditions and higher salinities, which are found primarily in the southern bays. The Laguna Madre has by far the most, with over 180,000 acres of submerged grasses (fig. 31).[2] The next largest areas of

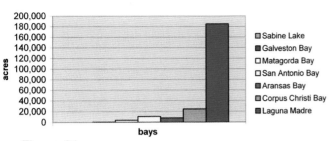

**Figure 31.
Seagrass occurrence on
the Texas coast.**

Flies are the badge of hope and luck
on a fisherman's vest. Fly fishing for
redfish is high sport in the clear
waters of the Laguna Madre.

submerged vegetation are in the Corpus Christi Bay system, with approximately 24,000 acres. The San Antonio Bay system and the Aransas system have much less. Although some ducks and sea turtles eat the grasses, the most important function of the seagrasses—the reason they are a key component in the productivity of Laguna Madre—is that they provide habitat for the epiphytic algae that grow on their leaves. In turn the algae, primarily diatoms, provide food for a host of invertebrates, such as shrimp and crabs, which become food for higher predators.

Human activities impact seagrasses, harming them sometimes in ways we are only beginning to realize. Walt Kittleberger is fighting the Corps over the impacts of their dredge disposal on the seagrass meadows, but recreational boaters cause substantial damage with their propellers as well. I have been in South Bay at the far southern end of the lower Laguna Madre at very low tide, when the water drains off and leaves the grass flats exposed. Water birds of all types descend on the exposed grasses, getting an easy meal. But the most prominent sight is the bare swaths cut in the grass—propeller scars.

To get started after stopping in these shallow areas, boaters often initiate a tight turn, building water under the boat so that the propeller can get out of the mud, but also cutting a doughnut pattern in the grass. Some of the swaths are long straight lines, cut by a boat when its prop extended into the grass but not to the bottom. Some of the swaths are discontinuous, the prop having moved in and out of the grass. In the upper laguna, almost 35 percent of the seagrass meadows are scarred. Scarring also allows wind and wave erosion to enter the cuts, creating an even greater effect, increasing the negative impact.[3]

The Texas Parks and Wildlife Department and the General Land Office are working together to implement the Seagrass Conservation Plan for Texas, origi-

During low water, shallow grass flats are arranged in rows that reveal the prevailing wind direction.

nally adopted in 1996 and revised in 1998. This plan identified at-risk seagrass meadows all along the coast and marked areas boaters were asked to avoid on a voluntary basis. If the voluntary program does not work—and given human nature and Texas' record on voluntary compliance, it probably will not—then mandatory no-prop zones will likely be established.

Over time, boating corridors will likely be established as more and more people use our bays. Corridors would limit the areas impacted by scarring, providing the protection needed for the seagrasses to continue functioning as a pantry. Like in other aspects of today's complex society, as we get more and more people using a resource, rules and boundaries need to come into play to ensure that there will be anything left at all.

On a clear morning on the lower laguna, the grass and redfish have an unreal quality. The tails move gracefully, the blue fringe visible in binoculars as the redfish root among the grasses, forcing hidden morsels out, leaving slight discoloration in the water behind them.

The fly Gib had tied was a shrimp imitation with white and brown hair and two red eyeballs extending from the body. I took a false cast and then released the line. The slight breeze took my fly four feet ahead of the fish and two feet beyond the fish. "Let it rest, let it rest," said Gib. "Now start stripping your line in, slowly, make it hop, strip it, strip it, faster, strip it." Suddenly the body in front of the tail surged forward and I felt the strike. Forgetting all my training, I raised the

Grass flats can be damaged by the propellers of recreational boats. If this damage persists, it may be necessary to establish no-prop areas and travel zones through the bays.
Photograph by Jim Blackburn

rod tip to set the hook rather than jerking the line in my hand, and I missed the fish, which rolled on the surface, causing every one of them to vanish, as if there were no more fish in all the laguna. The memory stays sharply with me, not because of failure but as a remarkable experience on the coast. That morning is one of the clearest, most vivid memories I have—Gib, Garland, and I, floating over a seagrass bed, seeing the birds, chasing reds.

Gib poled us off the grass flat and we moved on to another place. Along the way, he pointed out an old boat that had been blown onto a spoil bank by Hurricane Gilbert in 1988. Gib told us of the family of coyotes that lived there and raised their pups. Morning after morning he would see them, the parents training the pups to fish. As we motored west, we saw a coyote strolling across the flats, watching our every move.

Gib is a fishing guide who likes nature, observing it all and sharing it with those who are interested. He suggested we watch as we rounded a channel bend—there were usually a lot of spoonbills in and around the mangroves. Sure enough, twenty or more pink bodies leaped into the air as we approached, circling and settling down again after we passed, leaving us an image of a pink strip against the blue and green, like an abstract painting.

The main drainage for the Lower Rio Grande Valley on the U.S. side is the Arroyo Colorado rather than the river itself. The Arroyo flows through my boyhood home of Harlingen and passes through Rio Hondo as it makes its way to

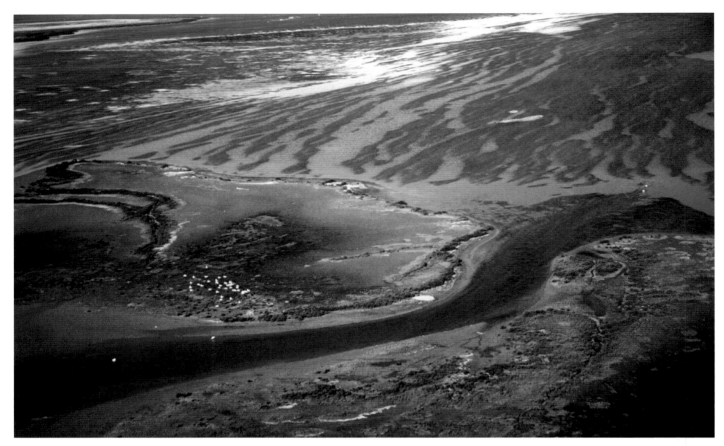

A "gut" cuts through tidal flats and grass flats in the Lower Laguna. These guts often provide excellent fishing.

Laguna Madre. The Arroyo is part of my past—where I learned to water-ski, where I fished for speckled trout at night under the pier lights at Arroyo City. I was enjoying memories of growing up nearby as we moved past an area known as Three Islands and headed west toward the shoreline of the Laguna Atascosa National Wildlife Refuge. As a boy I often visited Laguna Atascosa. My dad taught me to hunt in the grain fields of Bayview on the landward side of the refuge. I used to take a girl I was dating to the refuge, and in retrospect I'm pretty sure she was not all that impressed with her suitor's concept of entertainment.

Laguna Atascosa is simply wonderful. The refuge extends along the shoreline of Laguna Madre and offers the best view of the laguna to be had from the land. A loop road takes visitors from the park headquarters through the South Texas thorn brush and along the laguna shore for several miles. In late spring the retama and mesquite have yellow blossoms, the yucca their white plumes, and the wild olives their white bundles of flowers. The cactus blooms yellow and orange above the green panels, dazzling in the late afternoon sun. The huisache blooms golden cascades. One thing is common to almost all these plants, and that is thorns: thorns of all sizes, colors, and compositions, thorns that jump out at you if you shake the bush. These are serious, puncturing thorns. You have to respect them.

On a good day, when the birds are feeling cooperative, many South Texas specialties can be seen on the loop trail. The Harris's hawk is common here, as are green jays, great kiskadees, and curve-billed thrashers. From the loop road I have often seen ospreys flying back from the laguna, fish tightly gripped in their talons, looking for a post upon which to perch and dine. The refuge is reintroducing aplomado falcons, and I scan the fencerows, hoping for a glimpse.

This federal land is a refuge for the ocelot, the small spotted cat of the South Texas brush. I have never seen one, but Laguna Atascosa is home to the largest known concentration of these endangered cats in the United States. Ocelots live in thick, continuous thorn brush, and they seldom venture out in the daytime. Many of the cats on the refuge have radio collars that routinely transmit their location to researchers who are trying to learn more about these secretive predators.[4]

The refuge gets its name from the large freshwater lake in its center, Laguna Atascosa. For most of the 1990s drought conditions prevailed, and the freshwater lake receded to almost nothing, waiting for the rains to fill it again—waiting, as did much of the Rio Grande Valley. When the lake is full, it hosts ducks and other waterfowl during the winter months, a freshwater oasis right beside the salty laguna. Eighty percent of the population of redhead ducks winter in the laguna and utilize Laguna Atascosa extensively.[5] These ducks used to be found extensively along the east coast, but the seagrass meadows on which they feed have disappeared from many waters, making the Laguna Madre grass flats especially important.

Garland and I had taken an earlier trip with Gib, to do some winter bird-watching as well as fishing, and on that run we asked him to show us the ducks in the water next to the Laguna Atascosa refuge. We approached the Three Islands area from South Padre and turned west toward the refuge. As we entered the channel leading to the westernmost bay, the sky was filled with ducks. Gib cut the motor and we watched as the ducks flew past us and then came back again to resume feeding in their favorite places. Every kind of duck was there—redheads in tight formation, scaup with their black and white features, buffleheads with their white head markings, mergansers with their ungainly look and white wing patches, elegant pintails with their long necks and tails, and the smaller widgeon and tiny teal, flying low and fast.

As the ducks settled down, Gib said quietly to us: "Look. There are tailing redfish all over the place." I counted about fifteen pods of four or five reds scattered all around us. I wanted to catch a red on a topwater fly, and I had seen several pods of reds working along a sandbar. Walking toward the bar, I reminded myself to slide my feet, not pick them up. There were stingrays here, and they resent being stepped on.

I reached the bar and started working my way along the edge, in water about knee deep. Suddenly I noticed a movement to one side and looked over to see a large white bird landing on the sandbar. After a minute or two, I recognized it as

the white morph of the reddish egret, one of the most entertaining birds on the coast. This is a bird that seems to dance when it fishes. It raises its wings and casts a shadow, jumping from place to place, moving the shadow, and then suddenly darting its beak into the water to catch a confused fish.

The bird was only about twenty feet from me and was staying just behind me. As I worked my way along the edge of the bar, the reddish egret followed, dancing every so often as it chased down a fish. The egret and I walked together for some distance before I realized that we were fishing together, that this fish eater was letting me walk ahead and chase the small bait fish up on top of the bar, at which point they were nailed by my fishing partner. For over an hour, that egret and I fished together, strolling along the edge of the bar, a man and a bird. I found myself smiling, watching the egret out of the corner of my eye as the two of us walked along on one of the most rewarding fishing adventures I have ever had, though I never caught a redfish.

Laguna Atascosa extends south along the shoreline to the town of Laguna Vista, where private property starts again. Recently, through the efforts of the Conservation Fund, the U.S. Fish and Wildlife Service (USFWS), and the Lower Rio Grande Valley National Wildlife Refuge, some of the most important land purchases in recent years were made when Frank Yturria, his co-owners, and his neighbors, including the Garcias, sold almost 20,000 acres of land to the federal government.

Yturria is one of the real heroes of wildlife conservation in South Texas. He has ocelots on his ranch north of Laguna Atascosa, and he has welcomed researchers to study and document the endangered cats. The existence of this cat on private property was feared by many ranchers, who are scared of the potential impact of the federal Endangered Species Act on how they can use their land. But not Yturria. The large acreage purchased from the Yturrias, Garcias, and Esperson heirs in-cludes land west of Port Isabel. Bordering the southern edge of the purchase is the Brownsville Ship Channel, a deepwater channel constructed to allow ships through the jetties at South Padre Island and move inland to the protected port.

Most of the project area consisted of land grants that had been in the Yturria and Garcia families since before the Texas Revolution, I learned from Andy Jones, director of the Conservation Fund's Texas office. The landowners' cooperation and desire to have the property remain as wildlife habitat made it possible to complete a complex series of transactions. The purchases involved negotiations with more than sixty owners and heirs of the ranches that had claimed the land and the mineral rights under what were once three small bays. The Conservation Fund arranged the purchases, and the USFWS raised the money from the Wetland Reserve Program, the Migratory Bird Fund, and revenues from recreational hunt-ing and fishing licenses and stamps.[6]

Seventy years ago, the three basins included in this purchase were bays con-nected to the Laguna Madre: Bahia Grande, which is over 6,000 acres in area,

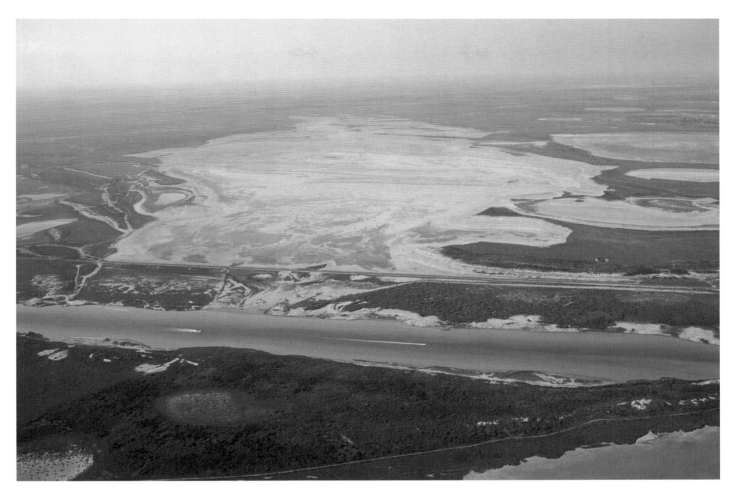

The dry sandy area is Bahia Grande, a former bay that was isolated by the construction of the adjacent ship channel and highway. Through the efforts of the Conservation Fund of Texas and the U.S. Fish and Wildlife Service, this dry basin and two smaller ones are being reconnected to the waterway and restored as wildlife habitat—a major step in the rehabilitation of ecosystems that used to be part of the Laguna Madre.

and Laguna Larga and Little Laguna Madre, about 2,000 acres each. The tidal flow to these bays was reduced with construction of the Brownsville Ship Channel in the 1930s and virtually eliminated by the construction of Highway 1792 a few years later. Once the flow was gone, the bays dried up and the habitat was lost.[7]

Anecdotal evidence suggests that Bahia Grande used to support shrimping and that an island in the middle of the bay hosted more than ten thousand nesting terns as well as abundant other waterfowl. A high rim of land along the landward side of the former bay is known as Redhead Ridge because hunters would shoot the red-headed ducks from this vantage point, but the redheads left when the bays dried up, and the animals that could not leave died off.

Today these three dry basins have become a plague to the people who live nearby. David Blankinship of the Lower Rio Grande Valley National Wildlife Refuge says the dry basins have become a public health hazard due to the blowing salt dust invading people's homes, causing respiratory problems, corroding power lines, and resulting in tens of thousands of dollars' worth of damage to schools and other buildings each year. The people of the surrounding towns are "screaming for relief," Blankinship says, and have committed themselves to pressuring their representatives to resolve the problem with all possible speed.[8]

Now that the USFWS owns the land that was historically a tidal wetland ecosystem, plans are to reflood the basins and bring back the bays. This seems the perfect deal, eliminating a health hazard and reestablishing three bays that were lost because of previous construction. This is the type of thinking that we should be encouraging throughout the coast—bold, innovative, and mutually advantageous. Project leader Ken Merritt of USFWS says that "according to the Texas Parks and Wildlife Department, nature tourists inject an estimated $100 million annually into the local economy, so the acquisition is not only good for wildlife, it's good for people."[9]

One remaining problem is that the Brownsville Navigation District owns the land between Bahia Grande and the Laguna Madre system, and they want to trade it for substantial mitigation credits toward the next project they will need to have approved by the Corps of Engineers. The logistics of this trade are difficult and are producing delays. Blankinship says that if consensus cannot be achieved on the terms of the land swap with the Navigation District, a channel could be dredged across refuge lands, connecting Bahia Grande to San Martin Lake, which is already linked to the Brownsville Ship Channel. Either way, the project will happen.

In the brush of South Texas, every plant has thorns. Backlighted prickly pear cactus looks fuzzy, but the reality is a spiny proposition.

In the meantime, the USFWS continues to prepare engineering studies, designing the width and water control devices that will eventually connect all three dry basins to the circulation patterns of the Laguna Madre system, reestablishing more than 10,000 acres of wetlands and bay habitat near the southernmost edge of Texas. In preparation, local shrimp companies are already working with Ocean Trust, constructing mangrove nurseries, which will help restore Bahia Grande to its former beauty and productivity.

The Fish and Wildlife Service is hopeful that even if the smallest basin, the Little Laguna Madre, is only occasionally refreshed by flood tides, this will be sufficient for the growth of an algal mat that will prevent the erosion and windborne dust that are so problematic for the surrounding communities; the other two basins are deep enough to retain water year-round.

We moved again after the partnership between the egret and me ended for lack of fish. Gib pulled the boat around a corner and into a channel. He pointed to the bay in front of us, a shallow bay that seemed to merge with the sand flats to the west. Gib said this bay was "being born"—it was not there ten years ago. Because of either land subsidence or sea level rise, the area is being flooded by salt water and already supports a small community of organisms. It is a blueprint of what the fish and Wildlife Service is hoping to achieve.

Gib and I walked out into this bay. Small shrimp hopped ahead of us, a blue crab scurried to the side, and a raft of white pelicans glided away from us, keeping their distance but not unduly disturbed. I welcome the new bays that are being born, delivered by the Fish and Wildlife Service; I hope they arrive sooner rather than later.

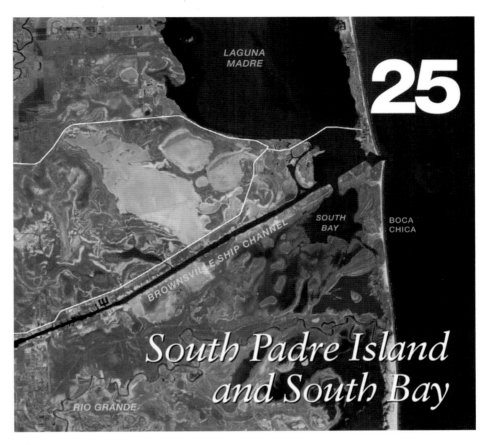

LAGUNA MADRE

BROWNSVILLE SHIP CHANNEL

SOUTH BAY

BOCA CHICA

RIO GRANDE

25

South Padre Island and South Bay

South Bay lies south of the Brownsville Ship Channel, which connects the Port of Brownsville and Port Isabel with the Gulf of Mexico through Brazos Santiago Pass. The developed portion of South Padre Island extends north-ward from the southern tip of the Island. South of the pass lie Boca Chica and the mouth of the Rio Grande. Three bays to be restored—Bahia Grande, Laguna Larga, and Little Laguna Madre—can be clearly seen to the north of the ship canal.

The spring morning had dawned windy and cloudy with intermittent light rain moving across the island. Merriwood Ferguson, an environmental activist and excellent birdwatcher, was taking Garland and me birding on South Padre, and she thought we might have a fall-out in progress; spring migrants often piled into the island on days like this.

I know South Padre Island well, but I did not know about its birds. My father took me fishing on South Padre before there was a bridge. We would take an amphibious vehicle across the Laguna Madre to the jetties that protect the Brownsville Ship Channel from silt and sand. Later I caught my first speckled trout on a silver spoon next to the old causeway, on the island side, wade fishing.

When I was a school kid in Harlingen, we used to go to the island and build bonfires in the sand dunes, dunes that were bulldozed to build the first of many hotels on the island. It was my first experience of loss to development, of the bulldozer's power to destroy. Today I am convinced that had those sand dunes been built by the U.S. Army Corps of Engineers, we would never have allowed

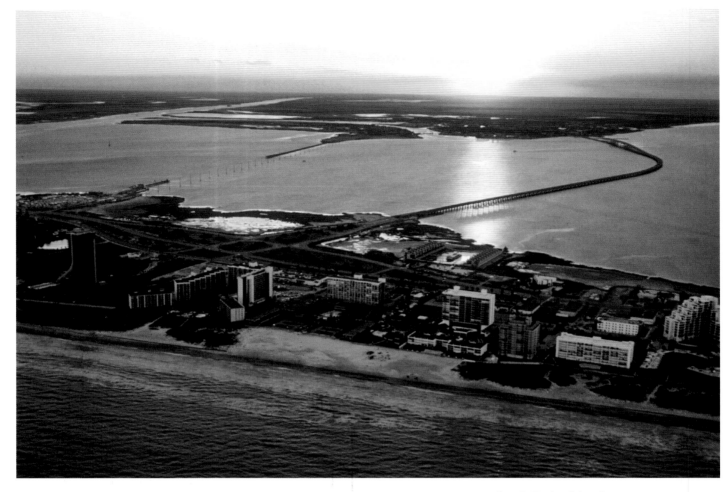

them to be bulldozed. The dunes provided flood protection to the island behind them and to the mainland. Yet because they were natural gifts, they could be destroyed without thought.

Merriwood said we should first go to the end of the island near the turning basin. This is where the surfers congregate near the jetties, the best surf being on the north side of the jetties. Immediately, we ran into birds. Ground feeders were everywhere—indigo and painted buntings, blue grosbeaks, grasshopper sparrows. A northern oriole clung to a tree that was little more than a vine, holding on in the wind.

From there, we went up into the middle of the island, to the few tracts that have not been developed. South Padre Island has experienced a building boom in recent years, with high-rise condos and hotels lining the beachfront and single-family houses filling in the rest of the lots. This is the private sector end of the island, and there is nothing to stop its development. Merriwood drove to the bay side of the island, looking at the vacant lots with mesquite trees, scanning for birds. We saw people leaving a woodlot and asked if the warblers were there. The couple smiled large smiles and urged us to get out and see for ourselves.

I had never seen warblers like this. There was a blue-winged warbler, which I had never seen before. There was the Tennessee, the Nashville, the magnolia, the black-throated green. A black-and-white warbler was moving along a trunk, while a Blackburnian flitted in the tops of the mesquite. Someone spotted a cerulean, but I could not find it. In another tree were blackpoll, hooded, and yellow warblers and a common yellow-throat. A black and orange bird caught my eye as it flew into a tree to one side of me, and I turned to see an American redstart with a rose-breasted grosbeak next to it. Someone said yellow-headed blackbirds had been seen, but I couldn't find them either.

As our brief sojourn clearly showed, these vacant lots with mesquite trees are a tremendous resource. The Valley Land Fund, best known as the group sponsoring a annual Rio Grande Valley photographic contest that celebrates local wildlife, is acting as fast as possible to purchase lots and preserve them for Neotropical migrating birds.

Merriwood and her friend Mary Lou Campbell have been involved in most of the major environmental battles in the lower Laguna Madre. The most remarkable involved the beautiful South Bay, the southernmost bay in Texas, opening off Brazos Santiago Pass, which was deepened and lengthened to form the Brownsville Ship Channel. South Bay is pristine, a seagrass-covered shallow flat with deep natural channels on the side. The middle of the bay is like a large, flat tabletop, covered with seagrass. A unique hypersaline oyster can be found along the shoreline in scattered clumps, together with mangroves and all kinds of birds. South Bay is surrounded on the south and west by *lomas,* clay dunes that rise up twenty feet or more, providing topography, holding brush, and possibly providing habitat for ocelots.

Warblers often can be found on South Padre Island in the spring during the annual migration. The Valley Land Fund has purchased a number of vacant lots bearing mesquite and other trees as preserves for these Neotropical migrants.

The fight for South Bay was a fight over a development proposed for the southern shoreline. In 1986, a couple of developers came up with a scheme for a resort amazing in its scale. Two partners planned to create a 12,500-acre resort city that was supposed to become home to 150,000 people over thirty years. The development was to be constructed along the shoreline of South Bay all the way to Boca Chica, the beach that runs from the south side of Brazos Santiago to the Rio Grande.[1]

As originally envisioned, the "tourist Mecca" included hotels, shopping centers, golf courses, an airstrip, a convention center, no less than nine marinas, and forty-eight miles of dredged canals. This place was called Playa del Rio; an $8 billion dollar oasis-to-be that was to connect to a 15,000-acre tract in Tamaulipas, Mexico, called Playa South.[2] Other ideas included a new bridge across the river and a gambling casino in Mexico.

Playa del Rio sparked strong emotions from both proponents and adversaries. Those in favor spoke enthusiastically of the three thousand jobs the project would create, revitalizing the severely depressed economy of the Rio Grande Valley, one of the poorest regions in the United States. Those opposed spoke of the wetlands and grass flats, only inches deep in places, providing nursery habitat for shrimp and fish; they spoke of the shore as a resting and feeding stop for migrating birds and one of the last refuges for ocelots and jaguarundis as well as many other endangered species.[3] This dry subtropical habitat was virtually unaffected by the industry and agriculture and development that were so rapidly changing the face of the rest of the coast, and the environmentalists and many Valley residents wanted it to stay that way.

To make Playa del Rio a reality, the developers needed two things before they could start building. The first was a lease from the General Land Office to put a road through the Brazos Island State Recreation Area, a public park, and the second was approval from the Corps of Engineers for a permit to fill as much as 8,000 acres of wetlands and tidal flats along South Bay. Playa del Rio would destroy more wetlands than any previous residential or canal project on the Texas coast, if not in the nation.[4]

The environmental consultants for Playa del Rio tried to present the project's backers as environmentally conscientious. They cited the developers' willingness to compromise, which led to their abandoning the marinas and canals they were going to dredge through the bay's clear, shallow waters and the setting aside of 3,300 acres as "nature preserves" instead. The Sierra Club's attorney for the case said it best when she declared: "Any plan to fill in 8,000 acres of wetlands belies sensitivity to environmental concerns."[5]

Destroying vast stretches of productive, unpolluted wetlands and creating on the edges of the development engineered wetlands a fraction of the size of the originals could hardly be construed as a good deal for the wildlife, no matter who

was doing the figuring. In addition to the threat of a lawsuit, the developers had to contend with the Endangered Species Act, the Coastal Barrier Resources Act, and the possibility of the Environmental Protection Agency's veto of their Corps permit, if it ever got approved. Two years after unveiling their proposal, they had not secured this permit and had not started constructing a single building. However, Playa del Rio's president remained optimistic, convinced they would have the permit by the end of that year.

And then fate intervened. Texas and the United States experienced the biggest savings and loan debacle in history, and the federal government found itself in possession of an enormous quantity of real estate, acquired from the assets of the bankrupt banks. The Playa del Rio property passed from the hands of the original bank, which had backed the developers with over $26 million, through two other banks and into the hands of the Resolution Trust Corporation (RTC).

Gulls near entrance to South Bay. The land around South Bay was proposed for a major resort development that would have impacted thousands of acres of tidal flats and seagrasses. Due to the efforts of local environmentalists and an excellent legal team led by Rick Lowerre of Austin, the land was ultimately purchased and set aside as part of the Lower Rio Grande Valley National Wildlife Refuge.

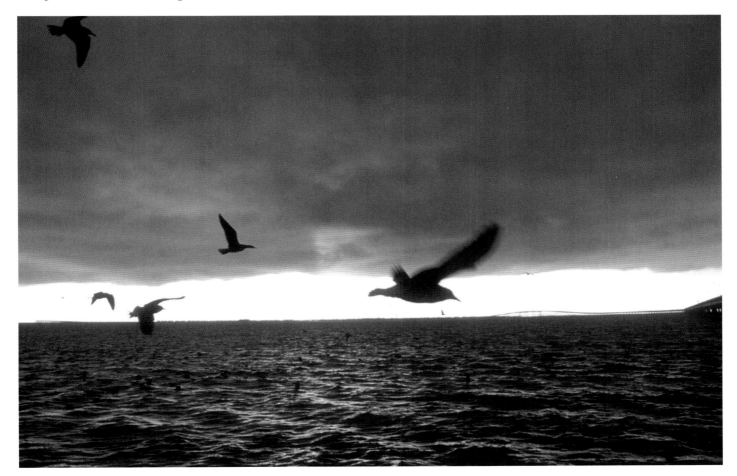

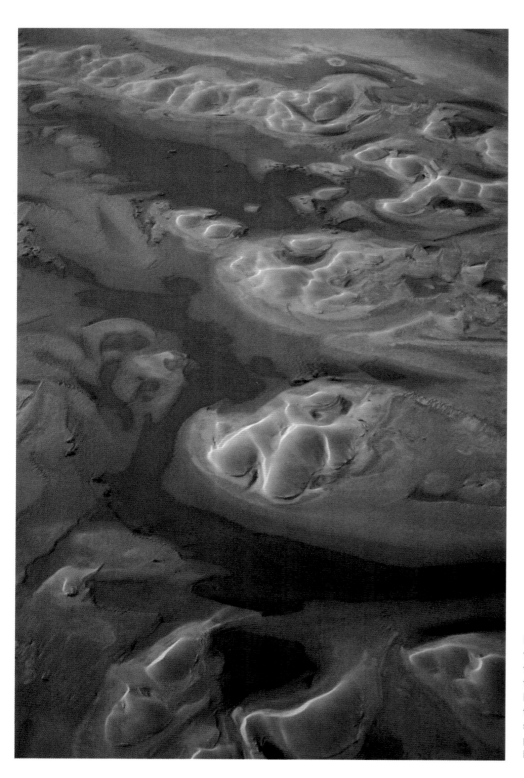

Dunes take on varying forms over the days, months, and years, testament to the changeability of this coastal landform. Much of Boca Chica, the land area from the Brownsville Ship Channel south to the Rio Grande, is now protected by state and federal land purchases.

The RTC was the federal agency created to inventory and sell the assets of the failed savings and loans in order to recuperate from some of their losses. Many developers in Texas had difficult encounters and negotiations with the RTC as it tried to solve a serious financial crisis provoked by fraud and long-shot deals. Rather than negotiating with a friendly if less than solvent local bank, the developers had to contend with the RTC, which was no stranger to big deals, bad deals, and unrealized plans and income statements. In Texas, the RTC was dealing with organized crime in Houston and Dallas—deals in which bad loans had been marked up and sold out of town, and then resold back to the locals at twice the value.

This was when a trio of lawyers from Austin and a senator from Colorado had a bright idea: why not bring environmental agencies and groups into the process of liquidating these properties? If some of them had conservation value, why not at least realize something positive from the debacle?

My friend Rick Lowerre led the team that did some of the best lawyering on this that I have ever seen on the Texas coast. Rick is an unassuming guy with a sly smile and a sparkle in his eye. He helped me get started as an environmental lawyer, taking the time to guide me through the procedures that are the bane of an environmental trial lawyer's existence. His thought now was: "The taxpayers are putting out a whole lot of money, so let's find a way to give them some return."[6] If government agencies and private environmental groups got the first shot at purchasing these lands, taxpayers could get a return on the money that went into the S&L bailout, a return in the form of city green spaces and public recreation areas.

Senator Tim Wirth of Colorado sponsored an amendment to the RTC's procedures, requiring an inventory of the lands to identify which had "natural, cultural, recreational, or scientific values of special significance." The RTC, however, did not favor the idea, because its mandate involved getting as much for the land as possible, and environmentalists pay less than developers.[7]

Steve Fritts of the RTC said the agency was responsible for more than twenty thousand parcels of land in Texas alone, and that onsite inventories would be practically impossible. The inventory was a good idea but difficult to implement, and for several years, the results were more confusing than helpful. But the trio from Austin stayed on point, with one of them, Bill Bunch, insisting that if debt for nature were good for Latin America, it should be good here in the United States too.

In 1989, the year the RTC started reselling properties, the Nature Conservancy offered $9 million for the Playa del Rio tract at the mouth of the Rio Grande on South Bay. The trust, however, refused to sell, holding out for a higher percentage of the property's previously expected value and believing developers might pay a higher price.[8]

But the great expectations of the 1980s real estate market had gone bust; two years later, RTC still had not managed to sell the land. When the RTC revised its price down to $7 million, the Nature Conservancy argued that its value had

actually sunk to $4 million because the tract could no longer be developed, as it had already been classified as environmentally sensitive.[9]

This did not stop either Mexican or U.S. developers from examining the property's potential, and the RTC even went so far as to accept an offer from one company. By this time, however, Playa del Rio had come to the attention of Governor Ann Richards, and she expressed her desire for the land to become a wildlife refuge, with public access to the beautiful beach at Boca Chica. At this point Land Commissioner Garry Mauro reversed an earlier decision granting a road easement, claiming he had always wanted the property to be a reserve.[10]

Seven years after the original plan came to light, more people than ever were concerned about the fate of the beaches and brush country just this side of the border. The developer filed suit in both state and federal courts contesting the ownership of the property, and the Sierra Club and Frontera Audubon Society filed suit in federal court so that the FDIC (the successor to the RTC) would have to do an EIS before selling the land to developers. Again, Rick Lowerre's team had been at work. In a great piece of legal thinking, he had identified the fact that the disposition of this real estate was now federal action subject to the National Environmental Policy Act. At the least, an EIS would have to be completed.

All the national environmental groups were in agreement about one thing—Playa del Rio needed to be part of the Rio Grande Valley Wildlife Corridor (now the Lower Rio Grande Valley National Wildlife Refuge).[11] The Wildlife Corridor was a project in the works by the Department of the Interior, which by 1993 had already spent $64.5 million to buy up over 61,000 acres of land in South Texas.[12] The idea behind the corridor was to buy enough contiguous tracts of land to provide safe passage for wildlife all along the Rio Grande.

The ocelots at Atascosa, the last population of any size in the United States, were showing signs of inbreeding, and this could only be alleviated if the cats could roam from Laredo to Playa del Rio to meet other cats without being run over or shot as soon as they left their refuge of origin. The environmental groups spoke of this along with the aplomado falcon, piping plover, and at least twenty other species listed as threatened or endangered that depended on this land for their survival.[13]

U.S. District Judge Filemon Vela heard the case, and when David Frederick, the third lawyer of the trio, finished presenting the environmentalists' side, Judge Vela would not let the Playa del Rio sale proceed. When the attorney for the FDIC asked what he could tell a potential owner about the FDIC's current position on the disposition of the land, Judge Vela replied: "Take it back. Tell them the court has told you to take it back."[14] The U.S. Fish and Wildlife Service was eventually authorized $5.8 million and acquired the property for inclusion in the Wildlife Corridor.[15]

The purchase of Playa del Rio brought the total acreage of the Lower Rio Grande Valley National Wildlife Refuge to 72,500, but that is only slightly more than half of the total land proposed for purchase or lease for wildlife preservation

along the four southernmost counties in Texas. Larry Ditto, manager of the Lower Rio Grande Valley NWR, spoke of the importance of Playa del Rio: "It has more species of animals, especially bird life, than any other tract in the refuge, and is especially important for migrating songbirds, hawks, and wading birds," he said.[16]

Environmental groups, refuge managers, and officials of the surrounding cities were all enthusiastic about the potential of the Playa del Rio tract to boost ecotourism in the region and in that way to benefit the economy in a sustainable way, one much more in keeping with the feel of the land than the glitz of the "Gulf-front destination resort" that the developer initially intended.

The fight over South Bay once again drives home the importance of the work undertaken by Costanza and his colleagues. Each of our bays and its environs have value. As discussed in several chapters, the estuaries, the marshes, the swamps and floodplain bottomlands, the submerged grasses, and the tidal flats all provide natural services that can be valued.

The acreage of these ecological elements has been set out (figs. 2, 5, 30, 31). By taking the number of acres of each ecosystem type and multiplying it by the value Costanza's team calculated for the ecosystem services provided by that ecosystem type, we can produce an estimate of the value of the various bay systems in terms of dollars per year. It is important to note that there are many values that are not included in these calculations, such as recreational fishing and birdwatching, yet the numbers are nonetheless staggering.

Combined, our coastal bays are worth a little over $22 billion per year in ecological services by these calculations (fig. 32). These are values provided each year by these ecosystems to our society. These ecological functions are assumed and taken for granted. When the fishery ceases producing fish, we will pay attention. But can we not foresee these losses and take heed?

I want to return to the lost sand dunes of South Padre, the dunes that I watched being bulldozed for the high-rise developments. Why is it that a natural seawall can be destroyed? Why is it that a man-made flood protection wall will be protected? This destruction mind-set is what Costanza and his colleagues were pointing out— that we can evaluate the natural value and express it. The question is: will we Texans use information such as this?

South Bay itself is now a coastal preserve, set aside by the General Land Office and managed by Texas Parks and Wildlife. The management plan for the South Bay Preserve notes that the bay serves as a nursery for forty-one species of finfish and nine species of shellfish, one of which seems to be unique to the area. South Bay boasts not only the largest oyster concentration in the Laguna Madre system but also an oyster variety more tolerant of salt and turbidity than are the other oysters along the coast. The bay acts as a feeding and resting or wintering habitat for resident and migratory birds including spoonbills, pelicans, teal, and redhead.[17]

☐ Sabine Lake
■ Galveston Bay
☐ Matagorda Bay
☐ San Antonio Bay
■ Aransas Bay
☐ Corpus Christi Bay
■ Laguna Madre

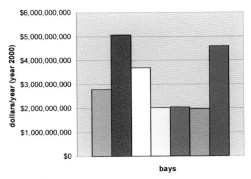

Figure 32.
The value of ecosystem services provided by the Texas bays each year, calculated using the concepts of Robert Costanza and colleagues.

The lomas adjacent to South Bay offer protection and forage for indigo snakes, horned lizards, and three kinds of small wild cats. The diversity of habitats makes for highly productive ecology in a relatively small geographic area. There is some recreational and commercial fishing on the bay and occasional hunting of waterfowl occurs, but mostly, evidence of human activity is minimal—which is a great part of the charm of this southernmost and remotest of the Texas bays.

At South Bay, once again important land and water resources have been preserved thanks to environmental activism. Without the willingness of Frontera Audubon and Sierra to intervene, to challenge the proposed sales and fight for conservation uses, South Bay would not be a coastal preserve today, and there would be no wildlife refuge adjoining it. Instead, a series of channels would have been dug through this fragile habitat, and the water would be full of nutrients from Playa del Rio yard runoff and sewage, leading to algal blooms and other problems. Without innovative lawyers like Lowerre and his team, excellent legal concepts would never have made their way to court.

It is clear that the next big battle on South Padre Island will be over the proposal to construct a second bridge to the island, one proposed to come across at Laguna Vista and enter the island five miles to the north of the present bridge. The proposed new bridge has become even more of an issue since a barge was pushed into the Queen Isabella Causeway, making it impassable and leaving the island cut off but for ferries for several months during the repairs.

I would rather not see the bridge built connecting Laguna Vista to the island. Such a connection would work against Port Isabel, the current point of connection to the island, and it would cause new development at Laguna Vista, nearer to the refuge, farther up the Laguna. There are privately owned tracts on the island that are sure to be developed in the future. We do not need a new causeway to support that development. It will happen anyway. What we need is continued activism to preserve the places that can still be purchased in their natural state, offering physical refuge for the wildlife and spiritual refuge for people who visit.

South Padre Island is a different place than when I was younger. The dunes we camped in are gone. High-rise development abounds. I am amazed that if we preserve pieces of habitat like the vacant lots with mesquite, incredible bird life still comes. We are lucky that Playa del Rio did not happen, that we were given time to save South Bay.

Interest to build a second causeway to South Padre Island is increasing, a proposal likely to generate considerable controversy.

Gib Little took me and Garland to the back of South Bay, across the tabletop to the edge of the area where Playa del Rio would have been. I got in the flyfishing basket on the front of the boat as Gib poled us from the rear. We inched along the shoreline for more than an hour, Gib pointing out redfish and the occasional speckled trout for me to try to catch. The shoreline was filled with wading birds of all types and sizes, from tiny sandpipers and dowitchers to the lovely reddish egrets and herons. Together, we celebrated the reprieve of South Bay.

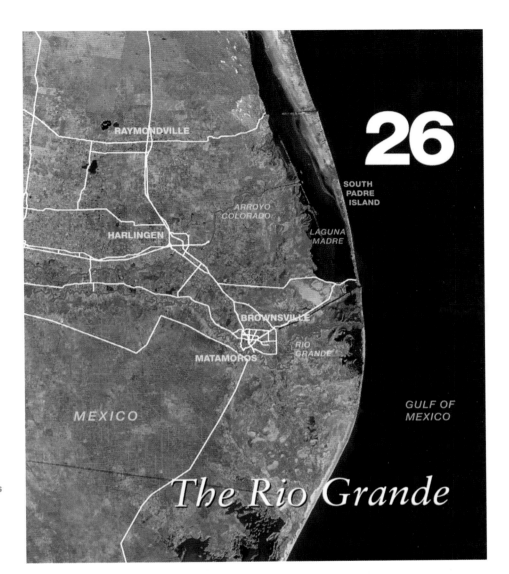

26

SOUTH
PADRE
ISLAND

LAGUNA
MADRE

GULF OF
MEXICO

RAYMONDVILLE

ARROYO
COLORADO

HARLINGEN

BROWNSVILLE

RIO
GRANDE

MATAMOROS

MEXICO

The Rio Grande

The Rio Grande separates Texas and Mexico. This once mighty river divides the Texas Laguna Madre from the southern portion in Tamaulipas, Mexico. In 2001, the Rio Grande stopped flowing, and the mouth connecting it to the Gulf silted in.

At the start of the twenty-first century, the Rio Grande

quit flowing into the Gulf of Mexico. A sandbar formed, separating the river from the Gulf, and its flow stopped. No one meant for it to dry up. It just happened. Water officials in the Rio Grande Valley tried to fix it by dredging the mouth open, but the river silted in again.

If you ask up and down the river, plenty of people are willing to pass out blame. The Rio Grande rises in Colorado but is nearly exhausted of water by the time it flows past El Paso in far West Texas. Most of the flow south of El Paso comes from the Rio Conchos in Mexico. The United States has a treaty with Mexico that requires a certain amount of water to be delivered to the Rio Grande, but when the last drought arrived, the water did not come down the Rio Grande.

Water levels in the two big reservoirs built along the Rio Grande where it forms the international boundary—Falcon and Amistad—fell drastically during

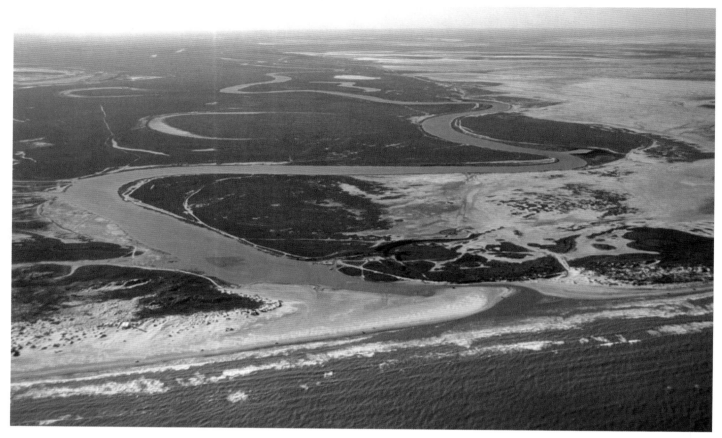

the drought. In turn, water supplies to the Rio Grande Valley farmers in far South Texas were disrupted. The farmers blamed the Mexicans for damming the Rio Conchos, for stealing water, for violating the treaty. The Mexicans blamed the United States for cloud seeding and weather manipulation and for forcing them into a bad treaty that gave the United States Mexico's water. Fingers pointed everywhere, but few were willing to look at their own actions and inaction. Denial and politics as usual, two halves of a historic formula.

The disappearance of the Rio Grande is a benchmark—an indelible statement of failure. We should be humbled by the drying up of the Rio Grande. We may be great in many ways, but we cannot make that river flow into the Gulf. We can dig it open, but it silts back up.

The mouth of the Rio Grande was an estuary. Although smaller, the mouth and lower portion of the Rio Grande functioned just like a bay. With the siltation of the mouth, this ecological function was lost. The river was disconnected from the life cycle of the fish and shellfish of the Gulf of Mexico. This estuary was lost.

The Rio Grande is shown here shortly before it dried up. The cessation of flow in the Rio Grande is a twenty-first-century wakeup call to action. I have lived to see a river die. I am afraid that I may not live long enough to see us act as stewards of our rivers, of our natural resources, of the earth.

The severing of the river from the Gulf was a sobering moment. To Mary Kelly, now with the group Environmental Defense, it meant a renewed effort to try to address the shortcomings in the agreements and actions of the two countries that have jointly killed this river and its estuary. Mary and others are attempting to get past finger pointing and develop plans for action. It is never too late to try to reclaim the Rio Grande. And make no mistake about it—on the Rio Grande, we are already faced with trying to revive a river, trying to rework a complex water situation spanning hundreds of miles so as to bring a river back to life.

It makes much more sense to prevent damage and sustain existing functions rather than allowing these to be destroyed and then attempting to reclaim them. So far, the pattern in the United States has been the opposite. We seem unable to get out of a loop in which we first destroy something of value and then try to reclaim it, an inefficient and ineffective approach. This pattern applies to the Everglades, the Colorado River in the western United States, and the salmon runs on many of the rivers of the Pacific Northwest.

In Texas, amazingly enough, we have not yet destroyed the ecological value of the coast. We have estuaries that are functioning and that have enormous value. Texas and Louisiana and Mississippi are now the primary providers of oysters and crabs for people in the Chesapeake Bay area, once the center of the nation's crab and oyster harvest. Recreational fishing on the Texas coast is excellent. The birdwatching is outstanding. The resources have been impacted, but most are still highly functional.

Must we destroy these resources before we wake up to their value? Can we heed the wakeup call of the drying Rio Grande? We are rational beings. Why do we have to lose something to value it?

In writing this book, I have been nagged by the thought that those of us attempting to protect the Texas coast have failed to understand the fundamental quality of the change we are trying to provoke. When Herman Daly talks about full cost pricing and empty world versus full world thinking, it seems so clear, so rational, so easy, yet it is anything but easy. We are, in effect, challenging the very nature of public works projects and economic development concepts in the United States.

Environmental thinking scares many people, my mother included. I will never forget when I returned from speaking in Oregon and told her about the young people I had met who were so concerned about the spotted owl. My mother shot back that she would bet I was more concerned about those owls than about jobs. She had immediately concluded that the environmental position was against people, against employment. I know there are ways to serve both sets of needs, but this was not how my mother in Louisiana perceived the conflict out in Oregon.

That exchange has stuck with me over the years. I return to it for a reminder of the strong anti-environmental sentiment being disseminated, of the widespread view that we who care about the earth are about hugging trees rather than people.

It is a false image, but it is nonetheless pervasive. And even among professed environmentalists, I think many do not fully understand the type of battle we are fighting. This is not an easy or short battle; it is long term and it is fundamental, much like fighting for freedom from an oppressor. Only a few will lead, and those who lead may be hurt.

Environmental thinking is about the collective whole rather than the individual, the system rather than the cog. Ecology is about connections, how the whole functions, what systems support life. It is about cooperation, not domination.

Aldo Leopold believed in the power of a land ethic concerned about protection of the ecological system. He saw a land ethic as an evolutionary possibility and an ecological necessity, and he pioneered the idea of human-caused change being of a different rate and scale than evolutionary change. He articulated several paradoxes—"the conqueror" versus "man the biotic citizen" and "land the slave and servant" versus "land the collective organism." His conclusion was that an ethical relationship must exist between humans and the natural system.[1]

Rachel Carson was likewise a visionary, emphasizing the magnitude of changes we have generated with our chemicals, clearly showing that nature cannot adapt to these rapid changes. She insisted that the public had the right to know about these impacts, to hear the truth: that ecological change affects all of us. In nature, nothing exists alone. She lamented that humans often needlessly destroy other living organisms, and she pleaded for the development of a concept of reverence for life and other living things. She too foresaw the necessity of our having a relationship with the natural system, rather than domination of it.[2]

Today on the Texas coast, there is no real desire to know the truth about impacts to the coastal ecosystem. The major mechanism for learning the truth about impacts is the science of environmental impact analysis. In my opinion, the highest calling for science today is to help us, as a society, understand the harm that is caused by various types of activities. Yet most of the leadership of Texas views impact analysis merely as red tape, feared for its ability to slow down preapproved projects, rather than as a key element of an analysis of feasibility. The Texas coast suffers from the tyranny of the done deal—imposition by the leadership of their will, regardless of consequences, regardless of analytical findings.

Alternatives and full cost pricing are ways to challenge the tyranny of the done deal. We cannot continue to think about water projects and transportation projects as we have in the past. Our view of water supply is basically the same one that ruled the aqueduct systems of the Romans two thousand years ago. Our view of ports is similar to that of the ancient Greek city-states, each fighting the others for competitive advantage. Yet with a full exploration of alternatives—alternate sites, regional economic and mobility needs, and alternate methods such as desalinization—we have the ability to minimize harm to natural systems, if not avoid it altogether.

Many projects being pursued today and harmful to the coast are improperly priced. The concept of natural value is not incorporated into our decision-making process when we decide where to put a new container port or a new spaceport, or when we decide to dispose of spoil material from Intracoastal Waterway by dumping it in Laguna Madre. This means the full cost of projects is not reflected in the cost estimates being prepared by our engineering firms.

Essentially, these projects are being subsidized in some manner, and the most common form of subsidy is harm to the natural system. Thus the cost of water for San Antonio may be subsidized by damage to San Antonio Bay; the cost of barge transportation is subsidized by damage to Laguna Madre; the cost of aluminum sold by Alcoa is subsidized by mercury contamination of Lavaca Bay; the cost of the Bayport container port would be subsidized by the loss of the oyster reefs due to a deeper channel through Galveston Bay.

If we incorporated the idea of ecological value into our thinking, we would certainly evaluate projects differently. When we value a resource, we want to know what harm might be done to it. What is missing is the commitment to seek and tell the truth and to have that truth reflected in analysis and decision making.

Why are we not asking these probing questions? The first place to look for answers is the current reality of our political system. The role of money in the political system is pervasive, ever present. Lobbyists are active at all levels. Projects are often pursued because of political factors rather than environmental factors— or even economic factors. Interests that can afford to hire lobbyists year-round are laying the groundwork for legal changes by supporting candidates with particular points of view. I believe the current situation on the Texas coast to be corrupt from a moral if not a legal standpoint.

Someone spoke to me not long ago about corruption in a third world country, about how great our system was because we did not have to pay people off to get a project done. Yet I do not believe that our system is any better simply because we can make our payoffs over the table instead of under the table. Legalizing the payoff does not make it right. If anything, it is more offensive to me to admit that our coastal resources are for sale to someone who made a legal political contribution.

As I have studied what happens on the coast, I have been struck by the disconnection between the legal system and morality. We are corrupt to an extent that is hard to believe; yet we pat ourselves smugly on the back as a nation of laws. When Galveston or Matagorda or San Antonio Bay dies, and my arguments were not heard because of campaign contributions to some elected official, am I supposed to feel gratified that our system is not corrupt in the same way as in some third world country?

I have recently discovered that the Texas Coastal Management Program is not performing as mandated by state legislation. Texas law requires that all projects in the coastal zone be evaluated to determine their consistency with the Texas

coastal program, yet many of the agencies charged with following this law are not undertaking a coastal consistency review. One agency has gone so far as to sign a memorandum of agreement with a federal agency that prevents the appeal to the Coastal Coordination Council (provided for under Texas law) from occurring.

As a state, all we seem to be concerned about is ensuring that federal money continues to flow to the Texas coast. If we have to pretend to have a coastal regulatory program in order to qualify for these funds, then we pretend.

The antidote to corruption lies in morality and values. In this arena the first reason for optimism is the emergence of Christian ecotheology in the 1980s and 1990s. As stated in chapter 6, concepts of reverence for life and living things, and of stewardship, are now part of the theology of denominations that represent upward of 90 percent of Christians, and most religious Texans are Christians. The potential for rapid change that this theology represents cannot be overstated. So far, the major limitation has been the failure to present this adopted theology at the individual church level. The theology exists, but it has not so far been disseminated and implemented. That situation can and will be altered, but how quickly will this theology emerge on the Texas coast?

In the next decade or so, we will determine the future of Copano, Aransas, San Antonio, Matagorda, and Galveston bays as well as Sabine Lake in our decisions about freshwater inflows. We will decide whether the ranches of South Texas are to be maintained in order to protect the Laguna Madre. We will decide about container ports and maintenance dredging and wastewater discharge conditions. All of us who care about the Texas coast, who are concerned about whether these resources are passed on to our children and their children, need to be seriously considering what we are going to do to protect the coast. Everyone who goes fishing, boating, or birding, or who heads for the bays to swim, surf, sail, eat a mess of gumbo, or even just to gaze at the water—all of us are in this together.

Moneyed interests currently control what happens to coastal resources. Someone has to stand up to the forces that would sell the coast and its resources. Discussion groups and social gatherings cannot get us there. Protection of the Texas coast is about action. This is not a job to be left to others. Each of us needs to act.

Jack Matson, an expert on innovation, developed the concept of "intelligent failure" and has concluded that fear—of failure, or of ridicule—is one of the greatest constraints to innovation and change.[3] On the Texas coast, there is the very real fear that one may be harmed financially if one speaks out on certain issues. We have seen it happen. Yet action in the face of such fears is essential if we are to change the circumstances that portend such negative consequences for the bays. To deny the fears is to empower them. We need to admit the fears, understand them, and then learn to act in spite of them. The key is to divide the duty—I only need to make sure that I overcome *my* fear. This action represents a small personal commitment, not an overwhelming social obligation.

It works. I have described several instances of a few people making major gains for the coast by standing up and fighting. I have tried to recognize many of them in these pages. Projects that would have destroyed important natural resources have been stopped by brave individuals acting in the face of fear. If those who want to destroy the natural resources of the coast know that they will face a fight every time they seek to build projects that could be built elsewhere with less impact, they will choose the less impacting alternative every time. At least as important as winning is the willingness to fight.

One September a long time ago, I arrived on the planet earth. I did not ask to be here, and I feel no responsibility or culpability for the state of world society when I arrived on earth. It simply was. Much of my life as a teacher and a lawyer has been spent trying to understand the system established by those who came before me, because I do feel a tremendous responsibility for the state of affairs in existence when I die. That legacy will be one to which I contributed, however slightly. As I see it, my responsibility is to work for a better environmental relationship between humans and the earth than existed when I arrived.

I refuse to believe that we are unable to adjust our thinking to save the Texas coast. I will not accept that we must destroy it before we can save it. To fight for the coast is to pursue the evolutionary possibility Leopold described, and evolution is fraught with mistakes, wrong pathways, and poor adaptations interspersed with the correct maneuvers and avoidance of pitfalls. We will not make the journey if we do not take the first steps. We may make missteps, but as long as they are based on honest effort, they are worthwhile because they contribute to our progress.

The process is frustrating for observers and participants alike, but there is progress to report. The Formosa fight, for example, led to a number of agreements and to corporate change (chapter 15). The third agreement between Diane Wilson and me and Formosa was on the subject of sustainable development. This agreement failed in some respects and was eventually dissolved by mutual agreement. However, before it ended, it generated a corporate sustainable development policy that I consider to be a remarkable document.

Formosa adopted several key principles. First, the corporation declared the need to take a holistic view that included society at large and the earth as well as the corporation. Second, it was the desire of the corporation to "do no harm," with objectives of zero emission of pollutants, healing and restoration of the earth, and support of the community structure. Third, the corporation stated that it wanted to work through problems in a collaborative process—cooperation rather than domination. Fourth, Formosa specifically recognized a series of spiritual and ethical values, including a sense of place and responsible stewardship.

I will not pretend that these principles were implemented or that the sustainability agreement achieved miraculous results. It did not. The sustainability agreement failed. It fell apart due to human failings and I hope that it may yet be

reconstructed. But failure is part of the process. The point is that precedent exists for adoption of a set of of innovative agreements and principles that could make a difference. If every industry on the coast would undertake similar innovations with community groups, the change would be significant.

Another example of evolutionary possibility is a new nonprofit organization headquartered in Houston, called Houston Wilderness. The organization was formed to capitalize on the ecological wealth depicted on the map discussed in chapter 4. When Charles Tapley and I prepared that map, the ecological abundance of the Houston region—Sabine Lake, Galveston and Matagorda bays, the marshes of the upper Texas coast, and the Wallisville–Trinity and Lake Jackson–Columbia bottomlands—was known to few and was not generally appreciated in the Houston community. That is now changing.

Houston Wilderness was incorporated by Rosie Zamora, a member of the board of directors of the Greater Houston Partnership, its president Jim Kollaer, and me. I have disagreed with many of the positions of the Greater Houston Partnership, which represents the business community. Yet the business world is changing. Owners now have choices about where to locate their companies; business is less tied to such factors as mineral deposits and ports and is more concerned with amenity packages to attract employees. The ecological wealth of the Texas coast is an important type of capital in the recruitment of jobs. Employees want outdoor opportunities, and businesses will come to places that offer these. A synergy thus exists between business and the protection of our natural capital. Houston Wilderness will make a difference, at least on the upper Texas coast.

A third evolutionary action is the movement of the big ranches of the mid-and lower coast into ecotourism and activism in the name of stewardship. The D. M. O'Connor Ranches have become champions for water stewardship on the Guadalupe River and San Antonio Bay systems, and the King Ranch has fought spoil disposal on the Intracoastal Waterway while developing an ecotourism program (chapters 17, 22).

One of the most successful ecotourism programs on the Texas coast is run out of the Fennessey Ranch in Refugio County on Copano Bay. For over a decade, this ranch has supplemented its income with excellent ecotourism that brings in birdwatchers from all over the world to enjoy the natural abundance of the coastal bend. These ranchers exemplify the proposition that people can make money off ecological capital without destroying it.

To save the Texas coast, we must value it and we must defend it. The first step is to get to know it. I drag my lime green kayak with the yellow hatch cover to the water's edge and slide through the *Spartina* grass. The mullet move out before me, splashing above the muddy bottom. Up ahead I see a white pelican, moving into a marsh channel, turning to look and wink at me, welcoming me back to my sanctuary, reminding me that if I stay a while, I will be recreated.

Will future generations be able to enjoy the wonder and mystery of the Texas coast as we have been able to do? The answer to that question lies with those of us living today. We have the ability to change—to do things differently with regard to coastal impacts. And change is accomplished one person at a time.

The white ibis has a large curved bill that it plunges into the soft mud of the marsh, foraging for food. The ibis is a companion of those fishing the marshes in their kayaks.
Photograph by Jim Blackburn

Notes

Chapter 2.
Water and Sabine Lake

1. The acreage of the bay systems varies from source to source. With the exception of the Laguna Madre, the acreages included in figure 1 were taken from M. Nipper, J. A. Sanchez Chavez, and J. W. Tunnell, Jr., eds., *Gulf Base: Resource Database for Gulf of Mexico Research*, World Wide Web electronic publication <http://www.gulfbase.org>, September 9, 2003; and U.S. Environmental Protection Agency, *Ecological Condition of Estuaries of the Gulf of Mexico*, EPA 620-R-98-004 (Gulf Breeze, Fla.: Environmental Protection Agency, Office of Research and Development, National Health and Environmental Effects Research Laboratory, Gulf Ecology Division, 1999, 80 pp.). The acreage for the Laguna Madre at mean sea level was taken from John W. Tunnell, Jr., and Frank W. Judd, eds., *The Laguna Madre of Texas and Tamaulipas* (College Station: Texas A&M University Press, Texas, 2002), 9. These figures were cross-checked with the figures from the National Estuary Programs for the Galveston and Corpus Christi/Aransas systems (W. A. White et al., *Current Status and Historical Trends of Selected Estuarine and Coastal Habitats in the Corpus Christi Bay National Estuary Program Study Area*, Corpus Christi Bay National Estuary Program publication 29, July, 1998; W. A. White et al., *Trends and Status of Wetland and Aquatic Habitats in the Galveston Bay System, Texas*, Galveston Bay National Estuary Program publication 31, April, 1993.) Much of the difference in acreage appears to be caused by which secondary bays are allocated to which system and whether the measurement is mean low tide, mean high tide, or mean sea level. On the Laguna Madre system, the acreage of water nearly doubles between mean low and mean high tide, according to Tunnell.

2. Richard C. Harrel and Miles A. Hall, III, "Macrobenthic Community Structure before and after Pollution Abatement in the Neches River Estuary (Texas)," *Hydrobiologia* 211 (1991): 241–52; personal communication, Richard Harrel.

3. National Park Service, "Threats," and "Everglades 101," last updated June 10, 1999, <http://www.nps.gov/ever/eco/threats.htm> (accessed June 18, 2002).

Chapter 3.
Wetlands of the Upper Texas Coast

1. Solid Waste Agency of Northern Cook County v. United States Army Corp of Engineers, ___ U.S. ____ (2001).

2. Daniel W. Moulton and John S. Jacob, *Texas Coastal Wetlands Guidebook*, Texas Sea Grant Publication TAMU-SG 00-605 (Bryan: Sea Grant, 2000).

3. Wetland information is difficult to isolate for the various bay systems. Some sources give very high values, which may include all types of wetlands or all wetlands in the watershed. When compared to National Estuary Program documentation, some of these estimates showed three times greater acreage. For the purposes of figure 2, the acreage of marsh was determined using the National Wetlands Inventory data to isolate wetlands associated with each estuary. To do so, maps of each county were created using the Interactive Mapper and adjusted to isolate the appropriate area. The totals of wetland coverage (by class of wetland) were then calculated using the online map utilities. The acreage of marsh was calculated from the maps generated for emergent marsh classifications (PEM, E2EM). Sabine Lake was arbitrarily assigned an additional 100,000 acres in Lousiana to represent the interconnection with Louisiana marshes that are shared with Calcasieu Lake. Variation from other sources arises from difficulties in identifying exact dividing lines between the various primary and secondary bay watersheds. See National Oceanic and Atmospheric Administration (NOAA), "The Ecological Condition of Estuaries in the Gulf of Mexico" (1990), in EPA, Estuaries of the United States (July 1999), <http://www.epa.gov/ged/docs/EcoCondEstuaries GOM_screen.pdf> (accessed October 24, 2000); U.S. Fish and Wildlife Service National Wetland Inventory Center, Wetlands Interactive Mapper Tool, <http://wetlands.fws.gov/mapper_tool.htm> (accessed November 1, 2000), hereafter cited as USFWS, Wetlands Mapper ; W. A. White et al., Current Status and Historical Trends . . . Corpus Christi Bay; W. A. White et al., Trends and Status . . . Galveston Bay.

4. Gay M. Gomez, *A Wetland Biography: Seasons on Louisiana's Chenier Plain* (Austin: University of Texas Press, 1998).

5. "EPA Global Warming: State Impacts—Texas," Climate Change and Texas, 1997, <http://www.epa.gov/globalwarming/impacts/stateimp /texas/> (accessed May 13, 2002).

6. Executive Summary, TNRCC Greenhouse Gases Draft Report, presented at public work session, January 18, 2002; data from U.S. Department of Energy report, 1999, <http://www.tnrcc.state.tx.us /oprd/sips/greenhouse/> (accessed June 10, 2002).

7. G. Marland, T. A. Boden, and R. J. Andres, "Global, Regional, and National CO_2 Emissions," in Trends: A Compendium of Data on Global Change (Oak Ridge, Tenn.: Carbon Dioxide Information Analysis Center, Oak Ridge National Laboratory, U.S. Department of Energy, 2001), <http://cdiac.esd.ornl.gov/trends/emis /tre_glob.htm> (accessed June 10, 2002).

Chapter 4. Smith Point

1. Michael Berryhill wrote the section on Victor Emanuel as well as some parts of the chapter involving Joe Nelson, Sammy Ray, and Joe Whitehead in 2000 for inclusion in this book.

2. The map of the ecological capital of the Houston region is an original, copyrighted map prepared by Charles Tapley and Jim Blackburn and is reprinted with permission. The original map was drawn by hand by Charles Tapley, based on interpretation of aerial photographs. The boundaries of the various ecosystems are approximate.

3. The percentage contributions shown in figure 3 are representative; both the actual percentages and the pounds of production vary considerably from year to year. Texas Department of Agriculture, 2000, <http://www.texasoysters .org> (accessed June 5, 2002); Michael Haby, "A Review of the Texas Seafood Industry," Marine Advisor, July, 1996.

4. Texas Department of Agriculture, as cited in note 3.

5. See <http://blueblee.com/cgi-bluebee /dermo/aboutdermo>.

6. H. Lieth and R. H. Whittaker, eds., *Primary Productivity of the Biosphere*, Ecological Studies, vol. 14 (New York: Springer-Verlag, 1975).

Chapter 5. Wallisville

1. Swamp acreages for the bays were calculated using data from USFWS, Wetlands Mapper, utilizing the palustrine forested class (PFO). The major issue concerned how far up the river systems to take the analysis. The decision to take the analysis two counties deep up the river system was somewhat arbitrary, intended to give an indication of the relative abundance of flooded forests.

2. William L. Longley, ed., Freshwater *Inflows to Texas Bays and Estuaries: Ecological Relationships and Methods for Determination of Needs* (Austin: Texas Water Development Board and Texas Parks and Wildlife Department, 1994).

3. Texas Water Development Board, "Hydrology Data for the Bays," 2000, <http://hyper20.twdb.state.tx.us/data /bays_estuaries/hydrologypage.html> (accessed August 16, 2000).

**Chapter 6.
The Houston Ship Channel**

1. Herman E. Daly, *Beyond Growth: The Economics of Sustainable Development* (Boston: Beacon Press, 1996).

2. Energy Information Administration: Petroleum Supply Annual 1999, vol. 1, <http://www.eia.doe.gov/emeu/iea /table36.html> (accessed 2000).

3. Ibid.

4. *Chemical and Engineering News: Facts and Figures for the Chemical Industry* (Washington, D.C.: American Chemical Society, 1998); *Chemical Week* (New York), February 2, 2000, p. 44, and April 26, 2000, p. 49. Information for these charts is supplemented by internal information from Formosa Plastics.

5. "CW Price Report," *Chemical Week* (New York), April 4, 2001, p. 32.

6. "Toxic Release Inventory," 2000, <http://www.epa.gov/tri/> (accessed August 29, 2003).

7. Sonoma Technology, "Assessment of the Health Benefits of Improving Air Quality in Houston, Texas," prepared for the City of Houston by Frederick W. Lurman et al. (Petaluma, Calif.: Sonoma Technology; Institute for

Economic and Environmental Studies, Califorla State University; and Department of Community and Environmental Medicine, University of California–Irvine, 1999).
8. David Zwick and Marcy Benstock, *Water Wasteland* (New York: Grossman Publishers, 1971), 135.
9. James Noel Smith, *The Decline of Galveston Bay* (Washington, D.C.: Conservation Foundation, 1972).
10. Ibid.
11. "Toxic Release Inventory," 2001, <http://www.epa.gov/tri/> (accessed August 29, 2003).
12. "Draft 2002 List of Impaired Waters," <http://www.tnrcc.state.tx.us/water /quality/02_twqmar/02_categories /TMAR45.pdf> (accessed July 18, 2002).
13. Max Oelschlaeger, *Caring for Creation: An Ecumenical Approach to the Environmental Crisis* (New Haven, Conn.: Yale University Press, 1994).

**Chapter 7.
Galveston Bay and Bayport**
1. Data on both fishing pressure and catch per unit effort are from T. A. Warren, L. M. Green, and K. W. Spiller, *Trends in Finfish Landings of Sport-Boat Anglers in Texas Marine Waters*, May 1974–May 1992, Texas Parks and Wildlife Department, Management Data Series no. 109, 1994.
2. Lonnie Jones and Aysen Tanyeri-Abur, "Impacts of Recreational and Commercial Fishing and Coastal Resource Based Tourism on Regional and State Economies" (draft), for the Sea Grant Program, October, 2000.
3. U.S. Fish and Wildlife Service, The Economic Importance of Sport Fishing, 1996, <http://www.tpwd.state.tx.us /texaswater/sb1/econom/econsportfish /econsportfish.html> (accessed December 12, 2000).
4. Testimony to Congress of Kurt J. Nagle, President of the American Association of Port Authorities, 1997.
5. *Container Ports: Lessons from Long Beach,* film released by the Galveston Bay Conservation and Preservation Association, 2000.

Chapter 8. Galveston Island
1. Robert W. McFarlane, "An Environmental Inventory of the Armand Bayou Coastal Preserve," prepared for the Galveston Bay Foundation, Galveston Bay National Estuary Program publication 8, March, 1991.
2. Robert Costanza, R. D'-Arge, R. de Groot et al., "The Value of the World's Eco-system Services and Natural Capital," *Nature* 387 (May 15, 1997): 253–60. For the present purpose, Costanza was contacted for detailed explanation of his calculations, and the dollar values presented in *Nature* (given in terms of 1994 U.S. dollars) were adjusted to reflect the value of the dollar in 2000. This was done using the Federal Reserve Bank of Minneapolis online consumer price index/inflation calculator.

Chapter 9. Christmas Bay
1. The prayer is inspired by a similar prayer articulated beautifully by Terry Tempest Williams in *Refuge: An Unnatural History of Family and Place* (Vintage Books: New York, 1991).
2. Hilmar Moore, e-mail correspondence with Jim Blackburn, 2001.
3. The same is true for much of the Texas coast, particularly the Laguna Madre. See Tunnell and Judd, eds., *Laguna Madre*, 116.

Chapter 10. Lake Jackson and the Columbia Bottomlands
1. For various aspects of bird migration, see the following: U.S. Fish and Wildlife Service, Migration of Birds, Circular 16, revised edition (Department of Interior, 1979); Clifford E. Shackelford, Edward R. Rozenburg, W. Chuck Hunter, and Mark W. Lockwood, "Migration and the Migratory Birds of Texas: Who They Are and Where They Are Going," Texas Parks and Wildlife PWD BK W7000-511 (5/99), 1999; G. V. T. Mathews, *Bird Navigation* (Cambridge: Cambridge University Press, 1968); Frederick C. Lincoln, *The Migration of American Birds* (New York: Doubleday, Doran and Company, 1939).

2. Portions of this chapter were written by Michael Berryhill for use in this book. I would also like to acknowledge Sharron Stewart and Mike Lange for their help in establishing the chronology of events.
3. Sidney A. Gauthreaux, Jr., "Bird Migration: Methodologies and Major Research Trajectories (1945–1995)," *Condor* 98, no. 2 (1992): 442–53; Sidney A. Gauthreaux, Jr., and Carroll G. Belser, "Displays of Bird Movements on the WSR-88D: Patterns and Quantification," *Weather and Forecasting* 13 (1998): 453–64; Sidney A. Gauthreaux, Jr., and Carroll G. Belser, "Bird Migration in the Region of the Gulf of Mexico," in N. J. Adams and R. H. Slotow, eds., *Proc. 22 Int. Ornithol. Congr.*, Durban, 1999, pp. 1931–47.
4. Proposed Columbia Bottomlands NWR Land Protection Compliance Document, U.S. Fish and Wildlife Service, 1995.
5. Senate Natural Resources Interim Subcommittee, Interim Report to the 75th Legislature on the U.S. Fish and Wildlife Service's Columbia Bottomlands Protection Plan, September 1996, p. 14 (which includes the Four-County Task Force report, also dated September, 1996; the quote is on p. 12 of the separate publication of that task force's report).
6. Interim Report, p. 9.
7. Ibid., transmission letter.
8. Final Proposed Austin's Woods Conservation Plan, Land Protection Compliance Document and Conceptual Management Plan, Austin's Woods Units of the Brazoria National Wildlife Refuge Complex, U.S. Fish and Wildlife Service, 1997.

Chapter 11. Sargent
1. Lynn M. Alperin, "History of the Gulf Intracoastal Waterway," in *National Waterways Study, Navigation History* NWS-83-9 (Alexandria, Va.: U.S. Army Corps of Engineers Water Resources Support Center, Institute for Water Resources, 1983).

Chapter 12. Matagorda Bay

1. Texas Water Development Board, "Hydrology data for the bays," 2000 <http://hyper20.twdb.state.tx.us/data/bays_estuaries/hydrologypage.html> (accessed August 16, 2000).
2. George Ward, personal communication, 2000. The quotes were created from memory of the conversation and were sent to George for verification. He authorized them.
3. Ibid.
4. This graph is adapted from Costanza et al., "Value of the World's Ecosystem Services." For the purpose of this book, hectares were converted to acres and the 1994 dollar values presented in Nature were adjusted to reflect the value of the dollar in 2000, using the Federal Reserve Bank of Minneapolis online consumer price index/inflation calculator.
5. Jobaid Kabir, "Environmental Flow Needs in Operating Highland Lakes," presentation by the LCRA, November 14, 2000.

Chapter 13. Mad Island

1. Portions of this chapter were written by Michael Berryhill and Cara Forster as original material for inclusion in this book. I also want to acknowledge Brent Ortego for his many helpful suggestions on this chapter.
2. Information about Shanghai Pierce is from Brewster Hudspeth, "Ten Things You Should Know about Shanghai Pierce," TexasExcapes.com, <http://www.texasescapes.com/TexasPersonalities/ShanghaiPierce/ShanghaiPierce.htm>.
3. "Spill Response Contingency Plan for the Clive Runnells Family Mad Island Marsh Preserve," <http://www.glo.state.tx.us/oilspill/atlas/ACP> (accessed May 8, 2002).
4. Personal communication between Cara Forster and James Shuler, Mad Island Marsh Preserve, May 13, 2002.
5. Quoted in Thomas LeVrier, "Feathers Fly as Bird Population Decreases," Houston Chronicle, July 2, 2002.
6. "Christmas Counts Graph," <http://www.birdsource.cornell.edu/cbc/index.html> (accessed November 8, 2000).
7. "Midwest Sandhills," <http://www.npwrc.esgs.gov/perm/cranemov/cranemov.htm> (accessed March 19, 2002).
8. Tom Paul, Dan Rosenberg, and Tom Rothe, "Migration," revised and reprinted 1994, <http://www.state.ak.us/local/akpages/FISH.GAME/notebook/bird/crane.htm> (accessed March 19, 2002).
9. Aldo Leopold, A Sand County Almanac (London: Oxford University Press, 1949).
10. "What Will I See?" 2000, <http://www.fermatainc.com/ttt_trail.html> (accessed April 20, 2002); Ted Eubanks and John R. Stoll, "Avitourism in Texas: Two Studies of Birders in Texas and Their Potential Support for the Proposed World Birding Center," prepared for Texas Parks and Wildlife Department, October 12, 1999.

Chapter 14. Palacios

1. Coastal Conservation Association, "Conservation of Gulf Red Snapper," written August 2, 2000, <http://www.ccatexas.org> (accessed March 20, 2002).
2. Richard Stewart, "Shadows on Peace Avenue: Viet Community Fears Upswing of Gang Violence," Houston Chronicle, December 14, 1986.
3. Mark Smith, "The Resurging Texas Klan: Memories of War, Vietnamese Influx Embitter Veteran," Houston Chronicle, July 1, 1990.
4. Personal communication with National Marine Fisheries Service; "Commercial Fishery Landings," 2000, also available on the NMFS website, <http://www.nmfs.noaa.gov/Commercial.htm> (accessed June 7, 2002).
5. NMFS, "Commercial Fishery Landings," 2000.
6. Stephanie Auil-Marchalleck, Page Campbell, Linda Butler, and Lance Robinson, Trends in Texas Commercial Fishery Landings, 1972–1999, Texas Parks and Wildlife Coastal Fisheries Division Management Data Series no. 194, 2001.
7. Personal communication with Ed Lambright, May 7, 2002.
8. Terry J. Cody et al., Texas Shrimp Fishery Management Plan, Texas Parks and Wildlife Department Fishery Management Plan Series no. 2, 1989.
9. Texas Parks and Wildlife Department, "Shrimp Life Cycle," last revised September 22, 2000, <http://www.tpwd.state.tx.us/fish/specinfo/shrimp> (accessed March 19, 2002).
10. Graph prepared by Robert McFarlane using data from J. M. Nance, Stock Assessment Report, 1999, Gulf of Mexico Shrimp Fishery, NMFS Southeast Fisheries Center, Galveston Laboratory, 2000. 14 pp.
11. Personal communication, Robert McFarlane.
12. Final Shrimp Fishery Regulations, 2000, 25 TexReg, p. 10157.
13. Ibid., p. 10170.

Chapter 15. Lavaca Bay and Formosa Plastics

1. Jim Blackburn and Mae Wu, "Case Study: Voluntary Agreements in Environmental Management at Formosa Plastics," Environmental Quality Management, Autumn, 1998, p. 19; Jim Blackburn, "Report on the Blackburn-Formosa Agreement," February, 1998.
2. Blackburn and Wu, "Case Study"; Michael Ford and Jim Blackburn, "Wilson-Formosa Zero Discharge Agreement: Report of the Technical Review Commission," 1997.
3. Alcoa/Lavaca Bay, Texas EPA ID# TXD008123168, <http://www.tceq.state.tx.us/permitting/remed/supefund/calh.htm>.
4. James Gooris and Robert Trebatoski, Texas Water Commission Natural Resource Damage Assessment, Pre-Assessment Screening Document of Lavaca Bay, 2453, 1990, quoting from Charles Holmes, "Trace Metal Seasonal Variations in Marine Sediments," Marine Chemistry 20 (1986).
5. Jones and Neuse, Inc., "Evaluation of Mercury in the Lavaca Bay Area and Its Relationship to Alcoa's Dredge-Spoil Disposal Operations," draft report to

John Mayfield, Environmental Superintendent, Alcoa, 1990.

6. Record of Decision, Alcoa (Point Comfort)/Lavaca Bay Site, Point Comfort, Texas, CERCLIS #TXD008123168, United States Environmental Protection Agency, Region 6, Superfund Division, December, 2001.

Chapter 16. Port O'Connor

1. Joe Doggett, "Organization Marks 25 Years of Helping," *Houston Chronicle,* March 4, 2001.
2. Texas Parks and Wildlife Department, <http://www.tpwd.state.tx.us/fish/hatch/gccabro.htm>; "Fly Fishing on the Texas Coast," <http://gorp.away.com/gorp/publishers/pruett/txcoast/chpt2_4.htm>.
3. "Fly Fishing on the Texas Coast."
4. Coastal Conservation Association, "STAR Tournament," <http://www.ccatexas.org/CCATexas> (accessed June 24, 2002).
5. CCA, <http://www.ccatexas.org/CCATexas/>. What_Is_STAR.asp?SNID=1002014488>
6. See <http://www.chesapeakebay.net/info/red_drum.cfm>.

Chapter 17. San Antonio Bay and Sustainability

1. Daly, Beyond Growth, 49.
2. South Central Texas Regional Water Planning Group, "South Central Texas Regional Water Planning Area, Executive Summary and Regional Water Plan, Volume I," Texas Water Development Board, San Antonio River Authority, HDR Engineering, Inc., et al. January, 2001.
3. Stephan Schmidheiny with the Business Council for Sustainable Development, *Changing Course* (Cambridge Mass.: MIT Press, 1992).
4. TXEMP model solution for San Antonio Bay provided by Gary Powell, Texas Water Development Board, fax communication, March 7, 2003.
5. Permit application filed with Texas Commission on Environmental Quality, 2002.
6. TXEMP model solution graphic, n. 4.
7. The estimates come from the graphs in other sections of this book. For example, figure 4 gives the percentage distribution of oysters, figure 29 gives the percentage distribution of crabs, figures 20 and 21 give the harvest of shrimp by port, and figure 12 gives the recreational man-hours spent in the San Antonio Bay system. The Texas Parks and Wildlife estimate in the following paragraph is from personal communication, Cindy Loeffler, Texas Parks and Wildlife. The Texas Water Development Board has estimated San Antonio Bay recreational output at $13.3 million per year and $79.6 million for commercial fishery, both inland and offshore landed in surrounding counties (Aysen Tanyeri, Lonnie Jones, and Hong Jiang, "Guadalupe Estuary, Economic Impacts of Recreational Activities and Commercial Fishing," prepared for the Texas Water Development Board, Department of Agricultural Economics, Texas A&M University, March, 1998). All of these estimates are unsatisfactory in that there is no value given for the production of shrimp in the San Antonio Bay system that are recruited back into the Gulf and landed at ports away from San Antonio Bay, and no estimate is given of estuary's value in providing habitat for the wintering whooping crane. The decision was made to use the Texas Parks and Wildlife figure of $55 million per year because it is conservative and defensible.
8. Aldo Leopold, "The Green Lagoons," in *A Sand County Almanac* (New York: Oxford University Press, 1949), 141.

Chapter 18. Rockport

1. "Whooping Crane Population," Original Wild Migratory Population, 2000, <http://www.learner.org/jnorth/images/graphics/cw_crane2000pop.jpg> (accessed March 21, 2002).
2. "The Majestic and Endangered Whooping Crane (Grus americana): An Alberta, Canada Perspective," <http://www.raysweb.net/specialplaces/pages/crane.html> (accessed March 21, 2002).
3. The source for the harvest percentages is Michael Haby, "A Review of the Texas Seafood Industry," *Marine Advisor,* July, 1996.
4. "Resource Issues: Freshwater Inflows/Global Warming," <http://www.bringbackthecranes.org> (accessed March 21, 2002).
5. Vince Guillory, "Blue Crab Life History and Ecology: Taxonomy and Classification," last revised July 1, 2001, <http://www.blue-crab.net/bchist.htm> (accessed March 12, 2002).
6. Ibid.
7. Herman E. Daly and John B. Cobb, Jr., *For the Common Good* (Boston: Beacon Press, 1989).

Chapter 19. Port Aransas and Lighthouse Lakes

1. Cara Forster and Michael Berryhill contributed to the writing of this chapter.
2. *Port Aransas South Jetty,* May 4, 1972.
3. *Port Aransas South Jetty,* September 6, 1973.
4. *Port Aransas South Jetty,* April 28, 1977.
5. *Port Aransas South Jetty,* October 13, 1977.
6. Telephone interview with Bill Harvey of TPWD, Resource Protection Division, March 26, 2002, conducted by Cara Forster.
7. Harvey telephone interview.
8. Steve Frishman, *Superport: A View of the Proposed Harbor Island Deep-Water Port at Port Aransas* (Port Aransas: South Jetty Publishing Company, 1977). For fuller treatment of ecosystem services and their value, see the article already cited by Costanza and colleagues, "The Value of the World's Ecosystem Services and Natural Capital"; Daly, *Beyond Growth;* and Linda Starke, ed., *State of the World 2002: A Worldwatch Institute Report on Progress toward a Sustainable Society* (New York: W. W. Norton, 2002).
9. *Port Aransas South Jetty,* August 10, 1978.
10. Port of Corpus Christi Newsletter, Spring, 1981.
11. "Deeport Is Dead," *Corpus Christi Caller-Times,* September 9, 1983.

Chapter 20. Nueces Bay

1. Rosemary Barnes, "Water Releases Gall Some Residents," *Corpus Christi Caller-Times*, May 12, 1996.
2. Kathy Glasgow, "Estuary," *Corpus Christi Caller-Times*, February 4, 1990.
3. I would like to thank Heather Alexander of the University of Texas Marine Sciences Institute for reading an early draft and catching errors in the manuscript. The three paragraphs that follow are paraphrased from e-mail correspondence with her.
4. Bureau of Reclamation, *Concluding Report: Rincon Bayou Demonstration Project*, vol. 2: *Findings* (Austin: United States Department of Interior, Bureau of Reclamation, Oklahoma-Texas Area Office, 2000).
5. H. A. Alexander and K. H. Dunton. "Freshwater Inundation Effects on Emergent Vegetation of a Hypersaline Marsh," *Estuaries* 25 (2002): 1426–35.
6. G. H. Ward, M. J. Irlbeck, and P. A. Montagna, "Experimental River Diversion for Marsh Enhancement," *Estuaries* 25 (2002): 1416–25.
7. P. A. Montagna, R. D. Kalke, and C. Ritter, "Effect of Restored Freshwater Inflow on Marofauna and Meiofauna in Upper Rincon Bayou, Texas, USA," *Estuaries* 25 (2002): 1436–47.
8. Personal correspondence, Heather Alexander, University of Texas Marine Sciences Institute, Port Aransas.

Chapter 21. Corpus Christi and Development

1. World Commission on Environment and Development, *Our Common Future* (Oxford: Oxford University Press, 1987).
2. "Hazel Bazemore Hawk Watch," <http://birding.about.com/library/weekly/aa092499.htm> (accessed July 2, 2002).
3. Associated Press, *Houston Chronicle*, April 19, 2000. (For this and other newspaper articles cited for which titles are not given, electronic copies are in the possession of the author.)
4. J. Gonzalez, *Houston Chronicle*, July 2, 2001.
5. Associated Press, *Houston Chronicle*, June 23, 2001.

6. The tidal flat coverage for the Laguna Madre in figure 30 comes from Tunnell and Judd, eds., *Laguna Madre*. Tidal flat coverage for other bays comes from USFWS, Wetlands Mapper. From figure 9.1 in Tunnell and Judd, it appears that tidal flat coverage in the Corpus Christi Bay area may be greater than is indicated in figure 30 of the present volume.
7. W. Pulich, Jr., and S. Rabalais, *Primary Production and Nutrient Fluxes on South Texas Tidal Flats*, Report to U.S. Fish and Wildlife Service, Office of Environment, Region 2, Albuquerque, New Mexico, 1982, 30 pp., cited in Tunnell and Judd, eds., *Laguna Madre*, 114.
8. Tunnell and Judd eds., *Laguna Madre*, 116, 125.
9. Miles O. Hayes, Erich R. Grundlach, and Charles D. Getter, "Sensitivity Ranking of Energy Port Shorelines," in *Proceedings of the Specialty Conference on Ports '80*, American Society Civil Engineering, Norfolk, Va., May 19–20, 1980.
10. "Piping Plover," <http://www.tpwd.state.tx.us/nature/endang/animals/piplover.htm > (accessed September 27, 2003).
11. S. M. Haig and J. H. Plissner, "Distribution and Abundance of Piping Plovers: Results and Implications of the 1991 International Census," *Condor* 95 (1993): 145–56.
12. "Piping Plover."
13. "Endangered and Threatened Wildlife and Plants, Wintering Piping Plovers, Proposed Rules," U.S. Fish and Wildlife Service, Federal Register, July 6, 2000, vol. 65, no. 130, p. 41782.
14. Tara Copp, "Space Firm CEO's Path to S. Texas Realization of Dream Will Pay Off for Area, He Says," *Corpus Christi Caller-Times*, March 5, 2000.
15. M. Carreau, *Houston Chronicle*, February 20, 1999.
16. Tara Copp, *Corpus Christi Caller-Times*, November 1, 1999.
17. Ibid.
18. Tara Copp, *Corpus Christi Caller-Times*, December 1, 1999.
19. M. L. Grant, *Corpus Christi Caller-Times*, February 6, 2000.

20. Sierra Club Action Alerts, "Your Comments Needed Now to Stop Oil and Gas Drilling on Padre Island National Seashore," April 23, 2002, and "Stop Drilling on Padre Island National Seashore," March 5, 2001, <http://texas.sierraclub.org/> (accessed May 10, 2002).
21. "Endangered and Threatened Wildlife and Plants, Wintering Piping Plovers, Final Rules," U.S. Fish and Wildlife Service, Federal Register, July 10, 2001, vol. 66, no. 132, p. 30060.
22. National Park Service, Oil and Gas Management Plan, December 27, 2001, <http://library.doi.gov/fedreg/1078.html> (accessed July 9, 2002).

Chapter 22. The King Ranch

1. Tunnell and Judd, eds., *Laguna Madre*, 97.
2. Josh Lemieux, "Dredging Critics Get Huge Ally," *Houston Chronicle*, October 8, 1993.
3. Mary Kelly and Antonio Diaz, "The Gulf Intracoastal Waterway from Corpus Christi to Brownsville: Little Value, Big Cost," update to Subsidized Destruction 1994, 2001, <http://www.texascenter. org> (accessed June 27, 2002).
4. M. Baro, *Corpus Christi Caller-Times*, March 18, 1998; personal communication, John Martin. For more information about the Valley Land Fund, see <http://www.valleylandfund.com>; see also Gary Clark, "Ready! Aim! Photo Shoot!" *Houston Chronicle*, May 10, 2002.

Chapter 23. Port Mansfield

1. R. G. Ratcliffe, "Senate Panel OKs Measure to Clear Way for South Padre Resort," *Houston Chronicle*, April 4, 1991.
2. Ratcliffe, "Senate Panel."
3. R. G. Ratcliffe, *Houston Chronicle*, April 19, May 10, 1991.
4. James Pinkerton, "Conservancy Buys South Padre Land: City Leaders Laud 24,500-Acre Deal," *Houston Chronicle*, March 31, 2000; see also Pinkerton, *Houston Chronicle*, 29 March 2002.

Chapter 24. Laguna Atascosa

1. Warren Pulich, Jr., "Chapter 1: Introduction," in *Seagrass Conservation Plan for Texas,* Texas Parks and Wildlife Resource Protection Division, 1998, <http://www.tpwd.state.tx.us/conserve/coastal/seagrass/mainframe.htm> (accessed July 9, 2002).

2. According to the seagrass conservation plan, there are 235,000 acres of seagrass along the coast. Tunnell and Judd identify 180,000 acres in the Laguna Madre complex, with about one third in the upper laguna and two thirds in the lower laguna. Pulich, "Chapter 1: Introduction"; Tunnell and Judd, eds., *Laguna Madre,* 87–88.

3. Tunnell and Judd, eds., *Laguna Madre,* 99.

4. Ken Anderson, "The Last Ocelots in the United States," <http://www.kenanderson.net/ocelots/index.htm> (accessed March 21, 2002).

5. "Gems: Laguna Atascosa National Wildlife Refuge (LANWR)," last revised July 24, 1996, <http://www.tpwd.state.tx.us/conserve/txgems/laguatas/laguatas.htm> (accessed July 9, 2002).

6. Jack Lynn, "The Conservation Fund in Partnership with U.S. Fish and Wildlife Service and U.S. Department of Agriculture Adds Vital Land to Lower Rio Grande Valley National Wildlife Refuge," news release, March 30, 2000, <http://www.conservationfund.org.htm> (accessed May 17, 2002).

7. Personal communication with David Blankinship, Lower Rio Grande Valley National Wildlife Refuge, May 28, 2002.

8. Blankinship, pers. comm.

9. Lynn, "Conservation Fund in Partnership."

Chapter 25. South Padre Island and South Bay

1. Bill Dawson, *Houston Chronicle,* September 8, 1986. (Electronic copies of newspaper articles cited are in the possession of the author.)

2. James Pinkerton, *Houston Chronicle,* November 3, 1992.

3. Dawson, September 8.

4. Ibid.

5. Quoted in Dawson, September 8.

6. M. Parrish, *Houston Chronicle,* December 10, 1989.

7. Ibid.

8. *Houston Chronicle,* April 10, 1991.

9. James Pinkerton, *Houston Chronicle,* January 5, 1993.

10. Ibid.

11. Ibid.

12. Ibid.

13. James Pinkerton, *Houston Chronicle,* February 10, 1998.

14. James Pinkerton, *Houston Chronicle,* January 23, 1993.

15. Pinkerton, February 10, 1998.

16. Ibid.

17. "Gems: South Bay Coastal Preserve," Management Plan, 1989, <http://www.tpwd.state.tx.us/conserve/txgems/southbay/south.htm> (accessed May 22, 2002).

Chapter 26. The Rio Grande

1. Aldo Leopold, "The Land Ethic," in his *Sand County Almanac,* 201–26.

2. Rachel Carson, *Silent Spring* (Boston: Houghton Mifflin, 1962).

3. Jack Matson is a prize-winning innovator who has developed courses in innovative design based on "intelligent fast failure." Jack has taught at and been director of the Leonhard Center for the Enhancement of Engineering Education at Pennsylvania State University College of Engineering. While on the faculty at the University of Houston he created a course titled "Failure 101," for which he won national recognition.

The red-winged blackbird favors freshwater marshes. The Sabine Lake system is ringed by freshwater and brackish marshes as well as the more traditional salt marshes, making it unique on the Texas coast. Sabine Lake's marshes extend into Louisiana, a fact Texans seldom consider in water policy issues. Today, the intrusion of salt water is one of the major threats to these fresh and brackish systems.

Index